CREATORS

BOOKS BY PAUL JOHNSON

George Washington

Art: A New History

A History of the American People

The Quest for God

The Birth of the Modern

Intellectuals

A History of the English People

A History of the Jews

Modern Times

A History of Christianity

CREATORS

*From Chaucer and Dürer
to Picasso and Disney*

PAUL JOHNSON

HarperCollins*Publishers*

HarperCollins books may be purchased for educational, business, or sales promotional use. For information, please write: Special Markets Department, HarperCollins Publishers, 10 East 53rd Street, New York, NY 10022.

FIRST EDITION

Designed by Nancy B. Field

Printed on acid-free paper

Library of Congress Cataloging-in-Publication Data is available upon request.

ISBN-10: 0-06-019143-0
ISBN-13: 978-0-06-019143-6

06 07 08 09 10 ❖/RRD 10 9 8 7 6 5 4 3 2 1

Contents

1. The Anatomy of Creative Courage 1

2. Chaucer: The Man in the Fourteenth-Century Street 17

3. Dürer: A Strong Smell of Printer's Ink 35

4. Shakespeare: Glimpses of an Unknown Colossus 49

5. J. S. Bach: The Genetics of the Organ Loft 77

6. Turner and Hokusai: Apocalypse Now and Then 94

7. Jane Austen: Shall We Join the Ladies? 114

8. A. W. N. Pugin and Viollet-le-Duc:
Goths for All Seasons 136

9. Victor Hugo: The Genius Without a Brain 153

10. Mark Twain: How to Tell a Joke 170

11. Tiffany: Through a Glass Darkly 186

12. T. S. Eliot: The Last Poet to Wear Spats 203

13. Balenciaga and Dior:
The Aesthetics of a Buttonhole 225

14. Picasso and Walt Disney:
Room for Nature in a Modern World? 247

15. Metaphors in a Laboratory 276

Notes 287
Index 301

CREATORS

1

The Anatomy of
Creative Courage

*O*N 1988 I PUBLISHED A BOOK called *Intellectuals*. It surveyed
the genre and provided essays on a dozen examples. It was a
critical book whose unifying theme was the discrepancy between
the ideals professed by intellectuals and their actual behavior in
their public and private lives. I defined an intellectual as some-
one who thinks ideas are more important than people. The book
was well received and was translated into a score of languages.
But some reviewers found it mean-spirited, concentrating on the
darker side of clever, talented individuals. Why had I not more to
say about the creative and heroic sides of the elite? Therein lies
the genesis of this work, *Creators*, dealing with men and women
of outstanding originality. If I live, I hope to complete the trilogy
with *Heroes*, a book about those who have enriched history by
careers or acts of conspicuous courage and leadership.

Creativity, I believe, is inherent in all of us. We are the proge-
ny of almighty God. God is defined in many ways: all-powerful,
all-wise, and all-seeing; everlasting; the lawgiver; the ultimate
source of love, beauty, justice, and happiness. Most of all, he is
the creator. He created the universe, and those who inhabit it;
and, in creating us, he made us in his own image, so that his per-
sonality and capacities, however feebly, are reflected in our
minds, bodies, and immortal spirits. So we are, by our nature,
creators as well. All of us can, and most of us do, create in one
way or another. We are undoubtedly at our happiest when creat-
ing, however humbly and inconspicuously. I count myself doubly

1

fortunate in that God gave me the gift of writing, and the ability to draw and paint. I have made my living by words, and I have derived enormous pleasure throughout life by creating images on paper or canvas. Whenever misfortunes strike, or despondency descends, I can closet myself in my study, or walk across the garden to my studio, to seek relief in creation. The art of creation comes closer than any other activity, in my experience, to serving as a sovereign remedy for the ills of existence. I am fortunate again in that the spheres in which I work are universally acknowledged to be "creative," and provide visible testimony to what I have done, in the shape of forty-odd books, countless magazine and newspaper articles, and tens of thousands of drawings, watercolors, and paintings. Other forms of creation are not always so obvious. A man or woman may create a business, one of the most satisfying forms of creation because it gives employment and the opportunity to create to other people as well—tens, even hundreds of thousands. And the business is there for all to see, in a huddle of buildings, possibly spread over many acres, or in products sold in the shops and used and enjoyed by multitudes. But some forms of creativity cannot be seen or heard or experienced. My former editor, Kingsley Martin, said to me once: "I have never had a child. But I have made three gardens from nothing. Two have disappeared, and the third will doubtless do so also after I die." But all three once produced flowers and fruit and vegetables, and made many people happy. And indeed, nothing is so conspicuous and luxurious an act of creation as a fine garden— or so transitory, as witness the utter disappearances of the magnificent gardens of antiquity registered in written records.

Some forms of creativity, no less important, are immaterial as well as transient. One of the most important is to make people laugh. We live in a vale of tears, which begins with the crying of a babe and does not become any less doleful as we age. Humor, which lifts our spirits for a spell, is one of the most valuable of human solaces, and the gift of inciting it rare and inestimable. Whoever makes a new joke, which circulates, translates, globalizes itself, and lives on through generations, perhaps millennia, is a creative genius, and a benefactor of humankind almost without compare. But the name of the man or woman remains

unknown. I say "or woman" because women, whose lives are harder, need jokes more than men and make them more often. The first joke in recorded history (about 2750 BC) was made by a woman, Sarah, wife of Abraham, and the joke and her laughter are recorded in the book of Genesis, 18:12.15, Sarah being rebuked by the Lord for her frivolity. There was an old-fashioned stand-up comic called Frankie Howerd, whose art is imperfectly recorded in scraps of old movies and in video footage. I once found myself sitting near him at a tedious public dinner and said: "You have a creative face, Mr. Howerd." "How so?" "One has only to look at it, and begin to laugh." "You are flattering me." "No, sir. You comics, who create laughter from what nature has given you, are among the most valuable people on earth. Statesmen may come, and generals may go, and both exercise enormous power. But the true benefactors of the human race are people like you, who enable us to drown our inevitable sorrows in laughter." He was moved by this, and I suddenly noticed large tears coursing down his old cheeks, furrowed by decades of anxiety about raising chuckles (or, as he used to put it, "titters") in drafty music halls. That creative face of his took on a new dimension of tragicomedy, and he wiped his tears and whispered: "That's the nicest thing anyone has ever said to me." Then he told me, and acted out, the notorious joke about the one-armed flutist, and the incident dissolved in laughter.

Since we are all made in God's image, there is creativity in all of us, and the only problem is how to bring it out. A farmer is creative—none more so—and so is a shoemaker. A ticket collector on a red double-decker once remarked to me: "I run the best bus route in London." His pride was proprietorial, and clearly he felt he was creating something, rather like Pascal, the moral philosopher, who in the mid-seventeenth century first conceived the idea of an omnibus service for big cities like Paris. I sometimes talk to a jovial sweeper, who does my street, and who comes from Isfahan, in Persia, wherein lies the grandest and most beautiful square in the world, the work of many architects and craftsmen over centuries, but chiefly of the sixteenth. I asked him if he felt himself creative, and he said: "Oh, yes. Each day they give me a dirty street, and I make it into a clean one, thanks be to God."

People do not always discern the creative element in their lives and work. But those who do are more likely to be happy.

However, though all are potentially or actually creative, there are degrees in creativity, ranging from the instinct which makes a thrush build its nest, and which in humans is reflected in more complex but equally humble constructions, to the truly sublime, which drives artists to attempt huge and delicate works never before conceived, let alone carried out. How to define this level of creativity, or explain it? We cannot define it any more than we can define genius. But we can illustrate it. That is what this book attempts to do.

All creative individuals build on the works of their predecessors. No one creates in vacuo. All civilizations evolve from earlier societies. Speaking of the great centuries of Mycenaean culture, the Attic Greeks had a saying: "There was a Pylos before Pylos, and a Pylos before that." We would like to know the name of the creative genius who first produced elaborate cavern paintings in north Spain, perhaps as early as 40,000 BC, becoming, as the evidence suggests, the first professional artist. But there is no evidence of individuals in this huge artistic movement. There is, however, some shadowy evidence of the existence of a man of (apparently) universal genius, who acted, as it were, as the man-midwife of ancient Egyptian civilization. Imhotep was a vizier or prime minister or chief servant of a succession of pharaohs in the Third Dynasty, beginning with Djoser, who reigned from 2630 to 2611 BC, and ending with Huni, half a century later. Imhotep's activities were so multifarious, and covered so long a period, that one scholar has suggested that the name Imhotep is a conflation of two people, father and son, but there is no actual evidence for this surmise. Imhotep was, among other things, an architect, and he caused to be built the famous stepped pyramid at Saqqâra. This was the first large-scale pyramid that, by virtue of its internal engineering, remained stable (it survives to this day), escaping the fate of earlier large structures which collapsed in what the Greeks were later to call a *katastrophē*. Imhotep's pyramid was thus the precursor of the colossal pyramids created at Giza under the Fourth Dynasty. Equally important was the complex of buildings attached to the stepped pyramid. They are signed with

Imhotep's name, and they confirm a tradition, which was preserved throughout the history of ancient Egypt and finally reached written form about 250 BC, that Imhotep was the first man to build in stone. And certainly his funerary complex is a formidable work of architecture, looking surprisingly modern, its pilasters beginning the long progression of forms which first culminated in classical Greek temple architecture from 700 to 400 BC, and which is with us still.

Imhotep's name occurs in another group of works at Saqqâra, and it is clear that he was a creative artist of large accomplishments. But he was more than that. As chief priest and secular minister to Djoser, he lived at a time when Egyptian civilization, building on the work of the first two dynasties (and the predynastic rulers), achieved its characteristic forms, which then acquired permanence and canonical authority, and lasted for more than 2,000 years. This is most noticeable in the hieroglyphics, which emerged strongly under Pharaoh Menes, the great statesman who united Egypt about 2900 BC, but assumed their wonderful stylistic elegance under Djoser and his immediate successors. This too must have been the work of Imhotep, suggesting that he brought together, while chief executive of the kingdom, a group of leading craftsmen in all forms of art and workmanship and, through them, imposed a uniform way of creating. I know of no other case in history in which a single man played so determinant a part in the creation of a civilization, or rather of its outward and visible forms. He must have been a man of exquisite taste, as well as of inventive genius and powerful will. The Egyptians themselves recognized his uniqueness. By the late period (c. 750–332 BC), he had been deified, as a god of healing, among other things, and the first architect. Numerous bronze and stone statuettes of him survive, the latest being about AD 400, well over two millennia after his death, and he survives in the Greek pantheon too as a healing god, Asklēpios.[1]

The fact that Imhotep's reputation as a genius survived so long, and that he was worshipped (on the island of Philae, for instance) as a great creative artist and man of science, almost into the dark ages, when Athens and Rome themselves were in precipitous decline, shows that creativity is sometimes handsomely rewarded by successive generations benefiting from it.

We build pantheons and mausoleums, we create academies of "immortals" (as in Richelieu's Paris), we adorn a Poets' Corner in Westminster Abbey, preserve an Arlington Cemetery or an Escorial or an Invalides or a Valhalla overlooking the Rhine. In such hallowed places repose the mortal remains of honored individuals, including creators. Some creators reap astounding financial rewards, too. Luca Giordano, an accomplished seventeenth-century artist with a large practice but skills and invention essentially of the second rank, left the immense sum of over 300,000 gold ducats to his heir. Picasso (as we shall see) was commercially the most successful artist who ever lived, and when he died in 1973, his estate in France (deliberately underestimated for tax purposes) was worth $280 million. We make other acknowledgments, too, these days, awarding Nobel prizes, honorary degrees, and the like. But Nobel awards often emit the unmistakable whiff of politics, other prizes often seem futile—France now has more than 4,000 literary prizes but precious little in the way of literature—and honorary degrees are a kind of recondite joke among the cognoscenti, though alas not up to the standard of Frankie Howerd's face in raising a laugh. In contemplating worldly success, I often think of the stately, seriocomic figure of Roy Jenkins, a British politician of the third quarter of the twentieth century, who collected baubles, such as peerages and honorific posts (he was chancellor of Oxford University) with immense enthusiasm and diplomatic skill. He was a hard worker who, on the verge of his eighties, wrote two large-scale biographies, of Gladstone and Churchill, which became best sellers, though his work in general shows no evidence of great creative power. Nonetheless, he collected more honorary degrees than any other man in history, exceeding Einstein's total by a considerable margin. Lord Jenkins once told me, with some satisfaction: "I believe—in fact I am certain—that I am the only one who has done the double-double." On inquiring, I found that this meant he had received honorary degrees from both Yale and Harvard, and Oxford and Cambridge. I do not know what he did with this immense collection of parchment scrolls. My philosopher friend A. J. ("Freddie") Ayer, also much honored, used his scrolls to paper the downstairs lobby of his London house. In

general, those who covet and obtain worldly honors do not cut impressive figures. One of the most curious sights of Oslo in the 1890s was Henrik Ibsen, walking to a public dinner, wearing his decorations. So keen was he on medals that he actually employed a professional honors broker to get them from every government in Europe. He wore them on his dress clothes, reaching to his waist and even below it, and he often pinned a selection to his everyday suits. Thus weighted down and clanking, he strode nightly to his favorite café, for schnapps. Unlike Lord Jenkins, he was a creator of some substance. But his habit was unbecoming unless (and this seems unlikely) his intent was humorous.

What strikes me, surveying the history of creativity, is how little fertile and productive people often received in the way of honors, money, or anything else. Has there ever been a more accomplished painter than Vermeer—a painter closer to perfection in creating beautiful pictures? How Vermeer must have cared about what he was doing! And how hard and intensely he must have worked to do it! Yet when he died, his widow had to petition the local guild for charity—she and her children came to abject poverty. That has been the fate of so many widows of fine artists. Sometimes the poverty of creators is not the fault of the system but of individual weakness. Guido Reni earned immense sums in his day, but he gambled them all away and had to hire himself out as an artist's day laborer. Franz Hals was also prolific but drank up all his wealth; or so his enemies said—I suspect the truth is more cruel. It seems to me horrifying that the widow of Johann Sebastian Bach, a hardworking man all his life, at the top of his profession as organist and composer, and a careful and abstemious man too, should have died in poverty, as did the sister of Mozart, another prodigiously industrious and successful maker of music. Both these men were creators on a colossal scale, and consistently produced works of the highest quality. But they could not achieve security for their families.

It is always distressing, too, to find a creative spirit driven, or driving himself, to writing begging letters. Beethoven teetered on the edge of this abyss.[2] Dylan Thomas fell over it and plunged deep into its humiliating depths. Half the contents of the fat volume containing his collected letters are appeals, mainly disingen-

uous if not downright mendacious, for money.[3] If Thomas had devoted half of the time and energy he lavished on begging to actually writing poetry, his oeuvre might have been twice as big. I recall his plump, tousled, cherubic, but dissolute figure, wandering distracted in the garden of my Oxford tutor, A. J. P. Taylor, in 1947 or 1948. Taylor had a house belonging to Magdalen College, and there his wife, who adored Thomas, had installed a caravan, in which for a time the poet lived, not so much writing poetry, as she supposed, as composing cunning begging letters, often incidentally abusive of her and her hospitality. But no one who studies them will suppose that creators are a particularly amiable or grateful tribe.

Take, for instance, the case of Richard Wagner. He was a writer of begging letters who might have served as a model for young Dylan Thomas. In fact Thomas was highly critical of Wagner. He wrote to his mentor, the novelist Pamela Hansford-Johnson: "[Wagner] reminds me of a huge and overblown profiteer, wallowing in fineries, overexhibiting his monstrous paunch and purse, and drowning his ten-ton wife in a great orgy of jewels. Compare him with an aristocrat like Bach!"[4] But Wagner could have taught Thomas a lot about begging. Here, for instance, is the composer writing to Baron Von Hornstein: "I hear you have become rich. . . . In order to rid myself of the most pressing obligations, worries, and wants which rob me of my peace of mind, I require an immediate loan of ten thousand francs." To the blind Theodor Apel he wrote: "I live in desperate penury and you must help me! You will probably feel resentful but, O my God, why am I driven to ignore your resentment? Because for a whole year I have been living here with my wife in utter poverty, without a penny to call my own." Wagner often used his starving wife in his begging letters. To Eduard Avenarius he wrote: "My wife beseeches you most humbly to give the bearer of this note 10,000 francs for her." Liszt, a recipient of begging letters from Wagner, was often subjected to the wife method: "My God! How hard I always try not to weep [for the necessary funds]. My poor wife!" Or: "I can beg. I could steal, to bring happiness to my wife!" Liszt was also beseeched to do Wagner's begging for him. Thus: "Listen, Franz! I had a divine inspiration! You must get me an

Erhard grand piano! Write to the Widow [Erhard] and tell her
that you visit me three times a year, and you definitely require a
better grand piano than my old lame one. . . . Act with brilliant
impertinence. *I must have an Erhard!*"[5]

In fact, Wagner never lived in poverty. He needed and begged
for cash, and used it (plus credit) in vast quantities, because of
his methods of composition. To understand creation, and cre-
ators, better, it would be useful to have a list of what creators
need to inspire their faculties. Carlyle, for instance, required
absolute silence, and his letters resound with his angry and usu-
ally unsuccessful attempts to obtain it. Proust, too, sought the
total elimination of noise and had the walls of his apartment
lined with cork. Dickens needed mirrors in which to pull faces
imitative of his characters. Byron required night. Walt Disney
needed to wash his hands, sometimes thirty times in an hour.
Other creators are less specific. But Wagner was adamant. What
he needed to write the verse of *The Ring*, and then to compose it,
was quite simple: overwhelming luxury. He needed luxury in his
surroundings, his rooms, the air he breathed, the food he ate, the
clothes he wore. In order to live in a world of imagination, he
wrote, he "needed a good deal of support and my fancy needs
sustenance." He insisted: "I cannot live like a dog when I am
working, nor can I sleep on straw or swig cheap liquor." Wagner
required a beautiful landscape outside his windows, but when he
wrote music, the silence had to be absolute and all outside
sounds, and sunlight, had to be excluded by heavy curtains of the
finest and costliest materials. They had to draw with "a satisfying
swish." The carpets had to be ankle-deep; the sofas enormous;
the curtains vast, of silk and satin. The air had to be perfumed
with a special scent. The polish must be "radiant." The heat must
have been oppressive, but Wagner required it. Berta Goldwag
wrote: "He wore satin trousers. . . . He needed an unusual degree
of warmth if he was to feel well enough to compose. His clothes
(which I made for him) had to be heavily padded, for he was
always complaining of the cold."[6] Frau Goldwag was not an ordi-
nary supplier of clothes. She was the leading Viennese couturier
and milliner, who normally dressed society ladies. At a time when
he was bringing forth begging letters, Wagner sent her a list of

his sartorial requirements. They included four jackets, "one pink, one very pale yellow, one light grey, one dark green." His dressing gowns had to be of "pink with starched inlets, one ditto blue, one green, one quilted dark green." He required pink, pale yellow, and light gray trousers, plus "one dark green like the quilted dressing gown." He also commanded six pairs of boots, in pink, blue, gray, green, yellow, and white. Wagner sent Frau Goldwag orders for coverings for all his rooms, ranging from blue bedcovers with white linings through ribbons, "as many and as beautiful as possible," to "a large quantity, 20–30 yards, of the lovely heavy pink satin material." He left detailed instructions on how his rooms were to be painted and adorned. Thus the dining room must be "dark brown with small rosebuds," the music room "brown woollen curtains with Persian pattern," the tea room "plain green with violet velvet borders and gold trim in the corners" and the study "plain brown-gray with purple flowers"— and so on through the whole house. Through these rooms strode the composer, according to one woman witness: "Snow-white pantaloons, sky-blue tail coat with huge gold buttons, cuffs, an immensely tall top hat with a narrow brim, a walking-stick as high as himself, with a huge gold knob, and very bright, sulphur-yellow kid gloves." So far as I know, other musicians did not object to Wagner's sartorial tastes. Fellow creators sympathized. Indeed Dumas *père,* when Wagner called, felt he had to receive him wearing a plumed helmet, a military belt, and a Japanese silk gown. Dressing the part appeals to creators. Handel always composed in court dress. When Emerson wrote his essay on Michelangelo, he insisted on wearing a special dress coat he had bought ("acquired" was his word) in Florence.

Whether or not Wagner was the son of the actor, poet, and painter Ludwig Geyer, or of his legal father, Friedrich Wagner, a police actuary, there was plenty of theater in his genes, and the theatrical manner in which he liked to dress and live was natural. It was, too, suited to his music, whose rich and luxurious themes, harmonies, and orchestration seem entirely in keeping with his personal tastes. *Luxe, calme et volupté*: Baudelaire's famous line has a resonance in Wagner's work that is not wholly coincidental. Both men created according to new principles and impulses that

were pushing to the fore in the late 1850s. Wagner began the first act of *Tristan und Isolde*, which many historians judge the beginning of modern music, shortly after Baudelaire published *Les Fleurs de Mal*, often described as the beginning of modern literature. Each man recognized the importance of the other. And Baudelaire was also a persistent, shameless, and utterly self-centered writer of begging letters.

Does any of this matter? Wagner felt, passionately, that he was pursuing a lonely and overwhelmingly difficult task in creating a new kind of music, against all the forces of inertia, conservatism, and mediocrity in the world of opera, and that he not only needed but thoroughly deserved all the material help he could get. In the end he received such help in abundance, and he often failed to acknowledge it. He was indeed selfish, egotistical, ungrateful, and unkind to an unusual degree, and there is nothing edifying about his life and career, except his creative work. But that is an exception which makes all the difference. Wagner not only transformed the way in which opera is written and performed but created an oeuvre of extraordinary beauty and large dimensions, which delights, awes, and terrifies ever larger audiences a century and a half after the works were composed. Beneficiary of generous friends and colleagues in life, who were ill-rewarded for their help, he has been, in death, the benefactor of humanity. That is a typical creator's story.

But is there a typical creator? I do not think there is, and the essays that follow, dealing with a wide selection of creative figures in the arts, seem to confirm this view. What can be said is that creation is always difficult. If it is worth doing at all, we can be sure it is hard to do. I cannot think of any instance in which it is accurate, let alone fair, to use the word "facile." Mozart composed with, at times, astonishing speed. When he was nineteen, for instance, he wrote all five of his violin concertos in a single summer. They are of extraordinary quality, and the way in which he learned from one and applied the lessons to the next is almost as impressive as the relentless vivacity with which he wrote each in turn. But there was nothing easy about them, and it is overwhelmingly obvious, reading the scores and his autographs and letters, that he worked extremely hard. When, indeed, did he not?

It was the same with, say, Charles Dickens. Prolific he might be, and mesmerizingly quick in developing great themes and scenes. But it was all hard, dedicated work, in which he poured out everything that was in him, unsparingly, recklessly. "I am in a perfect *frenzy* of *Copperfield*," he wrote, in the middle of creating one of his greatest novels. The word "frenzy" is well chosen. It applies, also, perhaps, to others: to Balzac, in "the fit of writing" (as he called it), and at times to Dostoyevsky.

Much of composition and creative activity is pursued under daunting difficulties. Wagner might demand (and normally get) luxurious comfort in order to write his scores. But it must be remarked that for much of his career he was a political outcast, in trouble over his involvement in the events of 1848–1849 and sought by the police, forbidden to enter many parts of Germany, and banned from seeing performances of his works wherever the writ of the imperial police ran. An even more distressing case was that of Caravaggio, and the fact that he had only himself to blame did not make things easier for him. In 2005 exhibitions of his late works were held in Naples and London, and very poignant occasions they were. All these works had been painted while Caravaggio was on the run, doubly so for he was wanted by the Roman police for murder, and by the Knights of Malta, a peculiarly relentless organization, for a variety of misdeeds. He could not maintain a regular studio or rely on permanent assistants. Often he had to paint in improvised surroundings that his younger contemporary Rubens, for instance, would have regarded as insupportable. Yet during this period of distress, worry, and fear, constantly on the move, he produced twenty-two major works of art, of astounding originality and often of vast size. It is a fact we must bear in mind, in considering the failings of creative people, that to produce their work often involves prodigies of courage, as well as talent.

An unusual degree of courage is demanded of those whose desire and ability to create are limited by physical debility. But courage and creativity are linked, for all serious creation requires intellectual courage. It is frightening to enter your workroom early in the morning and face an empty canvas, a blank sheet of paper, or a score sheet, knowing that you must inscribe the

marks of a completely original work. The fact that you have done it before helps, if only in the sense that you know you can do it. But this never quite removes the fear. Indeed, creative courage, like physical courage in battle, comes in a limited quantity—a form of personal capital, which diminishes with repeated demands on it, and may even disappear completely. Thus, toward the end of World War I, the conflict that imposed more repeated demands on men's courage than any other in history, veterans of conspicuous courage, holders of many awards for gallantry, suddenly refused to face the enemy again, and were arrested for cowardice, or sent to hospitals: Freud treated some of them in Vienna and wrote about them. Equally, creative people who have repeatedly overcome daunting challenges may suddenly, as they age, lay down their tools and refuse to go "over the top" again. This happened to Carlyle, after he finished *Frederick the Great*. I suspect that it was happening to Dickens in his mid-fifties, and that this is why he turned to reading his existing works instead of writing new ones—reading was an activity requiring physical daring rather than intellectual courage. His attempt to write *The Mystery of Edwin Drood* was a last defiant effort to regain his pristine valor; he died before completing it.

Creative originality of outstanding quality often reflects huge resources of courage, especially when the artist will not bow to the final enemy: age or increasing debility. Thus Beethoven struggled against his deafness, amid a chaos of broken piano wire, wrecked keyboards, dirt, dust, and poverty, to achieve the extraordinary drama and serenity of his string quartets, Op. 130, 131, 133, and 135, surely the most remarkable display of courage in musical history. Painters have had to deal with deteriorating eyesight: this happened to Mary Cassatt, who, being a woman, was unusually aware of the physical demands painting imposed on the artist. In 1913, having resumed work after two years of inactivity imposed by eye trouble, she wrote: "Nothing takes it out of you like painting. I have only to look around me to see that, to see Degas a mere wreck, and Renoir and Monet too."[7] She ceased to paint completely after two operations for cataracts failed. Her dealer, René Gimpel, visiting her at her villa in Grasse in March 1918, wrote of his distress to find that "the great devo-

tee of light" was "almost blind." "She who loved the sun and drew from it so much beauty is scarcely touched by its rays. . . . She lives in this enchanting villa perched on the mountains like a nest among branches. . . . She takes my children's heads between her hands and, her face close to theirs, looks at them intently, saying 'How I should have loved to paint them.'"[8]

An even more distressing case was that of Toulouse-Lautrec, but it was also an inspiring one, in some ways, for his inherited disabilities, of a most painful and shaming kind, brought out prodigies of courage and willpower. A life of horror and self-degradation was redeemed by a mass of creative work of superlative quality. Though he did not reach his thirty-seventh birthday, and was often too ill to paint, the quantity of his oeuvre is impressive and the quality high. He was born to wealth and came from one of France's grandest families, which had once possessed the rich city of Toulouse and still owned thousands of acres of fertile land. But the family had a fatal propensity to inbreed. Henri and four of his cousins were victims of the doubling of a recessive gene carried by both his parents and his uncle and aunt. One female cousin merely suffered from pain and weakness in her legs. But three others were genuine dwarfs and badly deformed as well, one of them spending her entire life in a large wicker baby carriage.

Henri was a little more fortunate. Fragility at the growth end of his bones hindered normal development and caused pain, deformation, and weakness in his skeletal structure. This condition became obvious in adolescence. It baffled the doctors and proved impossible to treat. As an adult, he had a normal torso but "his knock-kneed legs were comically short and his stocky arms had massive hands with club-like fingers." His bones were fragile and would break without apparent cause. He limped, and he had very large nostrils, bulbous lips, a thickened tongue, and a speech impediment. He sniffed continuously and drooled at the mouth.[9] Most men with his afflictions would have done nothing with their lives but hide and brood. In fact Lautrec compounded his troubles by becoming an alcoholic and contracting syphilis, though he had been warned against the woman who infected him.

But he had courage, and his courage not only enabled him to

fight against his ill health and debilities by hard work but also to do amazingly daring things with his pencil, pen, and brush. Along with his bravery, his dwarfism may actually have helped his art. He had to stand right up to the canvas and thus avoided impressionist fuzz. Though he is normally grouped with Monet and the rest, he was no more an impressionist than Degas and Cassatt. He became a linear artist of great skill, the best drafts-man of his time in Paris, Degas alone excepted, and he developed a strikingly original sense of color. The kind of courage that allowed him to show himself at all, and to work, made it possible for him to penetrate the behind-the-scenes worlds of the circus, the music hall, the theater, and the brothel. Isolated himself, and weird, he nurtured a strange gift for capturing the bizarre charac-ter and vigor of a star performer. His subjects leap out at us from the canvas or print, grotesquely vibrant like himself, as vivid as their greasepaint—once seen, never forgotten. His images had a perceptible influence on the whole course of twentieth-century art, and it is impossible to imagine modern design without his colors, shapes, ideas, and frissons. A creative martyr in his way, a hero of creativity.

Equally striking, in this category of courage, are the life and work of Robert Louis Stevenson, which can now be studied day by day in the eight rich volumes of his collected correspon-dence.[10] Like Toulouse-Lautrec, Stevenson was a sick man from childhood—not a dwarf or a cripple, but a man with weak and unreliable lungs, which finally killed him when he was in his early forties. As his letters show, there were few days, and fewer still weeks or months, when he could work normal hours with-out a conscious effort of will. He found writing (as he admitted) hard, especially to begin with. The kind of originality he demanded of himself added a huge extra dimension of difficulty, and his health added yet another. Few writers have shown such constant courage over the whole course of a career. Few have hit the original note so often as he did, with *Kidnapped, Treasure Island, The Master of Ballantrae*, the marvelous verses for children, and strange tales like *Dr. Jekyll and Mr. Hyde*. Given the effort everything took and the brevity of his career—less than two decades—his output was impressive. I can never pass a set of his

Collected Works in a library or a bookshop without, as it were, taking off my hat to this brave man.

This creative courage is of many different kinds. What are we to think of the quiet, withdrawn, silent, uncomplaining courage of Emily Dickinson? She continued to write her poetry, and eventually amassed a significant oeuvre, with little or no encouragement, no guidance, and no public response, for only six short poems were published in her lifetime and these against her will. She worked essentially in isolation and solitude, a brave woman confronting the fears and agonies of creation without help (or hindrance either, as perhaps she would have said). Then there is the courage of persistence, in the face of failure or total lack of recognition, as shown by David Hume, whose brilliant *Essay on Human Understanding* "fell dead-born from the press," as he put it; or Anthony Trollope, whose first novel, *The Macdermots of Ballycloran*, was (so far as he knew) never reviewed at all, and sold not a single copy. There is the courage of age, too. My old friend V. S. Pritchett, the best critic of his day and a short-story writer of genius, told me in his eighties how he had to drag himself "moaning and protesting" up long flights of stairs to his study at the top of his house in Primrose Hill, without fail every morning after breakfast, to begin his invariable stint of work—and this continued into his nineties. Another old friend, the novelist and playwright J. B. Priestley, described to me how (in his late eighties) he sat at his desk at nine each morning and practiced little strategies—cleaning his pipe, sharpening pencils, rearranging papers and implements—to delay the dreaded but inevitable moment when he had to begin putting words on paper again. All the same, creation is a marvelous business, and people who create at the highest level lead a privileged life, however arduous and difficult it may be. An interesting life, too, full of peculiar aspects and strange satisfactions. That is the message of this book.

2

Chaucer:
The Man in the
Fourteenth-Century Street

GEOFFREY CHAUCER (C.1342–1400) was perhaps the most creative spirit ever to write in English. Indeed it could be argued that he created English as a medium of art. Before him, we had a tongue, spoken and to some degree written. After him, we had a literature. He came, to be sure, at a good time. In his grandfather's day, England still had a hieratic-demotic language structure. Only the plebeians habitually spoke English, in a variety of bewildering regional forms. The ruling class spoke French and wrote in Latin. Edward I and his son Edward II spoke French. They understood some English, though they certainly did not, and probably could not, write it. Edward III, born in 1312—he was a generation older than Chaucer—spoke English fluently. The Hundred Years' War, which he launched five years before Chaucer was born, opened a deep chasm between England and France that made the close interaction and simultaneous development of their culture no longer possible. The use of French in official transactions went into precipitous decline. The rise of English as the language of law and government was formally recognized by the Statute of Pleading (1362), when Chaucer was a young man. It ordered that in all the courts, all cases "shall be pleaded, showed, answered, debated and judged in the English tongue."[1] The following year the lord chancellor, for the first time, opened Parliament with a speech in English.

At the same time, the number of people literate in English was increasing rapidly. In Chaucer's lifetime, scores of first-class schools, led by William of Wykham's great foundation, Winchester College (still in existence), were founded, together with twenty distinct colleges of higher education at Oxford and Cambridge. Four times as many English manuscripts survive from the fourteenth century as from the thirteenth. There are, for instance, twenty medical manuscripts in English from the thirteenth century, 140 in the fourteenth, and 872 in the fifteenth.[2] By the time Chaucer died, there were about 200 stationers and book craftsmen operating in London. The number of "clerks"—a new term to describe men whose business it was to write and copy documents—was already formidable—120 in the Chancery alone.[3] Men (and some women) were acquiring libraries for their private pleasure, to supplement the growing number of institutional libraries in monasteries, colleges, and cathedrals. When Chaucer died, over 500 private book collections existed, and the price of paper had fallen so fast that a sheet of eight-octavo pages cost only one penny.[4]

Chaucer's entry into history thus came at an auspicious moment for writers. Yet it was not so much an entry as a transformation. He found a language; he left a literature. No man ever had so great an impact on a written tongue, not even Dante, who transformed Florentine into the language of Italy. For Chaucer had the creative gift of appealing strongly to a great number of people, then and now. Before him there was very little. *Beowulf* is in Old English, almost incomprehensible today to English-speaking readers, and dull, too. No one ever reads *Beowulf* unless forced to do so (in schools or universities) or paid to do so (as on the BBC). *Gawayn and the Green Knight* is little more attractive. Of Middle English works, Langland's *Piers Ploughman* is taught or read as a duty, never for pleasure. Chaucer is in a class by himself, and a class joined by no one until Shakespeare's day. He was, and is, read for delight, and in joy. Over eighty complete manuscripts by Chaucer have survived, out of many hundreds—perhaps over 1,000—published in the fifteenth century. Many of them bear the marks of continuous circulation and perusal. When printing came to England, Caxton pounced on *The Canterbury Tales* and published it, not once but twice. It has been in print for 520

years, and even today it is one of the texts that teenagers begin in compulsion but finish in delight. And Chaucer has attracted a body of commentary and elucidation over the centuries which is rivaled only by Shakespeare.[5]

How did this happen? What was so special about Geoffrey Chaucer that gives him this unique status as the founder of English literature? We here enter one of the personal mysteries that always seems to surround acts of creation. For, on the surface, there was nothing particularly outstanding about Chaucer. He might be described as *un homme moyen sensuel* of the fourteenth century. The three contemporary portraits we have of him, the basis of an extensive iconography in the fifteenth and sixteenth centuries (and thereafter), show him as a jolly, prosperous, happy member of the late medieval upper middle class.[6] He was the son of a successful London vintner, John Chaucer (c. 1312–1368), and was educated at home. His family provided an excellent upbringing. Vintners have tended to be well-traveled, sophisticated men, with many links abroad, especially in Italy, France, the Rhineland, and the Iberian countries, often in high circles. John Ruskin, one of the best-educated Englishmen of the nineteenth century, was likewise the son of a vintner and was taught at home. When Chaucer was a teenager, his father secured him a post as page in the household of Lionel, afterward duke of Clarence, third son of Edward III. Lionel, who was two years older than Chaucer, married first the greatest Anglo-Irish heiress of the day and then the leading Italian heiress, Violante Visconti.[7] It would be difficult to think of a more sophisticated "finishing" for the young Chaucer. He was thereafter at ease in any society, including the highest, at home and abroad. Lionel had a taste for magnificence, which Chaucer admired. When he set off to claim his Visconti bride in 1368, he had a train of 457 men and 1,280 horses, and at the wedding the aged poet Petrarch was a guest at the high table. By this time, of course, Chaucer had moved on. In 1359 he was in France with Edward III's invading army and was taken prisoner and ransomed. He married (probably in 1366) Philippa, and had three children by her: Thomas, Louis (or Lewis), and Elizabeth. Philippa was the daughter of Sir Paon Roet of Hainault; more important, she was the sister of Kather-

ine Swynford, third wife of John of Gaunt, Edward III's richest and best-connected son. This connection ensured that Chaucer had Gaunt's powerful patronage throughout his career. He thus held many positions at court and in the royal service, including membership in several important diplomatic missions—to Genoa and Florence (1372–1373), to Spain, and to France and Lombardy (1378). From 1374 on, he held a lucrative post as head of the London customs, with an official house. In 1386, he was knight of the shire for Kent, where he had a house and lands. He also served (in 1391–1400) as deputy forester for Petherton in Somerset, where he likewise had an estate. His official duties mean that he crops up in the records at least 493 times, and is, or ought to be, better known to us than any other English medieval writer. But these records are disappointingly impersonal, and efforts to bring Chaucer's official activities to vigorous life have been only partly successful.[8]

What does seem clear, however, is that Chaucer's career at the courts of Edward III and Richard II had its ups and downs. Though his connection with Gaunt brought him jobs, perks, and money, it also involved him in party politics, which could bring trouble as well as rewards. In 1389 he was appointed to the great office of clerk of the King's Works, which put him in charge of Westminster Palace, the Tower, and eight of the royal residences; the next year St. George's Chapel, Windsor, where the Knights of the Garter were installed, was added to his duties. This clerkship was a position of considerable power and a means of acquiring wealth. But a year later, he resigned it and moved himself to Somerset. Politics? It seems likely. Chaucer certainly suffered in 1386, during the rule of Thomas, duke of Gloucester, who ousted the "John of Gaunt Gang" from power. This was the year of the only political reference in Chaucer's poetry, the line "That all is lost for lack of steadfastness." Chaucer deplored cowardice in any context, politics included.[9] But he seems to have flourished under Henry IV, as his gratuity of £20 a year was promptly renewed by the new monarch. Much of his life was spent at the very heart of medieval government at Westminster, since he had a home in the garden of the Lady Chapel of the Abbey, on the spot where later was built Henry VII's magnificent late-Gothic

chapel; and Chaucer's body was the first to be placed in the section of the Abbey that we now call the Poets' Corner.

The richness and variety of Chaucer's career gave him opportunities few English men of letters have enjoyed. He traveled at the highest level all over western Europe, and he saw at close quarters the workings of half a dozen courts. He was involved professionally with the army and navy, international commerce, the export and import trade, central and local government finance, parliament and the law courts, the Exchequer and Chancery, the agricultural and forestry activities of the crown estates—and of private estates too—and the workings of internal commerce and industry, especially the building trade. Diplomacy and the church, politics and the law, the nation's well-being in war and peace—all these spheres were familiar to him. He must have met and conversed with almost everyone of consequence in England over many decades, and with plenty of notables from the Continent too. Among those with whom we know he had dealings were great merchants like Sir Nicholas Brembre, Sir William Walworth, and Sir John Philpot; the Lollard Knights, followers of William Wycliffe (Sir Lewis Clifford, Sir John Clanvowe, Sir Richard Sturry, and Sir William Neville); diplomats and officials such as Sir Guichard d'Angle, Sir Peter Comtenay, the Bishop of Durham Walter Skirlawe, Sir William de Beauchamp, and Sir John Burley; and grandees like Gaunt himself.[10] Chaucer worked at the heart of the establishment of Plantagenet England and was familiar with its corridors of power. He knew how to get a tally paid by the Exchequer and, the most valuable trick of all, how to get a writ through Chancery, with its Great Seal attached. He knew, too, how to get entrée to the King's Privy Chamber, and how to get a room allotted to him in a royal palace or tent city. At the same time, he never lost contact with his middle-class and trading origins. He carried with him the prudent habits of the City of London and the country lore of a modest mansion in the Kentish Weald—he knew inns and staging posts, shops and workplaces, smithies and ferryboats, cross-Channel packets, and inshore fisheries. He certainly spoke and read French and Italian, and probably some German, Flemish, and Spanish. Like many another English autodidact, including at least two monarchs,

King Alfred and Queen Elizabeth I, he knew enough Latin to translate Boethius's *De Consolatione Philosophiae*, and he was familiar with the works of Dante, Boccaccio, and Petrarch (he may, indeed, have met the last two).[11]

That Chaucer was influenced in his writing by French and Italian literature, then much more advanced than England's, was inevitable and, indeed, can be demonstrated by internal evidence in his work. He often followed continental forms. Thus his first masterpiece, *The Book of the Duchess*, a poem of 1,334 lines written in 1369, when he was in his late twenties, followed the French device of the dream, as does the 2,158-line *House of Fame* (unfinished), written in 1374-1385 at intervals during his busy official career. His longest poem, *Troilus and Criseyde*, of 8,239 lines, from the second half of the 1380s, is taken direct, so far as the story goes, from Boccaccio's *Il Filostrato*. But that is only the final stage in a long genealogy of borrowings going back through Guido delle Cotoune via Benoit de Sante-Maure to Dares Phrygius and Dictys Cretensis. Apart from the story, Chaucer's poem has little in common with Boccaccio's, striking a note of high seriousness and sadness quite lacking in the Italian.[12] Chaucer looked to others for structure and metrical tricks, but never for content. This is particularly noticeable in his relationship with Dante, whom he admired—who hasn't?—but essentially ignored. Their minds and worlds of thought were quite different. Indeed, Chaucer, with a clear reference to Dante, admits in *Troilus*, "Of heaven and hell I have no power to sing."[13] We have here the first indication of a great divide already opening between English and Continental literature—an English concentration on the concrete and practical, as opposed to the abstract.

A more pertinent question is what made Chaucer a poet in the first place. With a successful official career already launched, why turn to verse with what can only be called professional determination and ardor? Though Chaucer never tells us what drove him to literature, he more than once complains how hard it is to become a master of words. As he writes in yet another dream poem, *The Parliament of Fowls*, a delightful fantasy of birds choosing their mates on St. Valentine's Day (1382):

That lyf so short, the craft so long to lerne,
Th'assay so hard, so sharp the conquerynge.

No poet, grumbling as he trudges upstairs to his study to begin the day's quota of lines, has ever put it better. Why, then, did Chaucer embrace the craft with such tenacity? Here, I think, the Continental evidence is highly relevant. Poets, so far as we can tell, had no status in England in 1360. It was a different matter across the Channel, as Chaucer discovered. At the courts of France and Burgundy poets were held in high regard and were able to advance their own careers, and help their families, by pleasing verse-loving, sentimental princes. Chaucer found that in Italy Dante was the one truly national figure; Dante's fame, beginning shortly after his death in 1321, had spread everywhere by the time Chaucer came to Italy. Boccaccio and Petrarch, both still living, were also celebrated and revered, the toasts of courts, the favorites of princes. Such favor was not, as yet, to be had in England, but it could be earned. Chaucer also noted that celebrity and favors were most commonly secured by such poets when they turned their skills to *vers d'occasion,* jubilee poems to mark princely feasts and red letter days. He wrote accordingly. Thus his *Book of the Duchess* was almost certainly an allegorical lament on the death of Blanche of Lancaster, first wife of his patron, John of Gaunt; and *The Parliament of Fowls* celebrated the marriage of his king and benefactor to Anne of Bohemia.[14]

That Chaucer, a man of robust practicality, with his eye to the main chance, was influenced by such considerations of worldly glory and reward cannot be doubted. One of his perks was a daily measure of wine, and his connections ensured that it was of high quality. He must often, as he sipped it at his writing desk ("to refosculate his spirits," as Hobbes put it), have reflected that the craft, hard though it was, brought its rewards in this world. Yet this is plainly not the whole story, or even half of it. No one who reads *Troilus and Criseyde* or *The Canterbury Tales,* his two great masterworks, can mistake the pervading note of relish: Chaucer loved to write. Writing was life to him—breakfast, dinner, and supper; meat and drink; the purpose, solace, comfort, and reward of existence.

His early essays in verse gradually built up a great reservoir of self-confidence, so that the thin trickle of ideas, similes, metaphors, devices, and word ecstacies gradually turned into an irresistible torrent, a raging, foaming river of felicity that brought him great happiness to pour upon the page. Such self-confidence is of the essence of creation. In a writer of genius like Chaucer—or Shakespeare, Dickens, and Kipling, the English writers he most resembles—confidence with words, ideas, images, and sheer verbal acrobatics takes over the personality, so that exercise of the skill becomes a daily necessity, and expression of what lies within the mind is as unavoidable as emptying the bladder and bowels (a comparison which would have appealed to Chaucer's earthy tastes). Chaucer wrote because he had to write, out of compulsive delight.

He was intoxicated with words, as we shall see. But he was also entranced by men and women, their endless variety, their individual foibles and peculiar habits, their weird tastes and curious manners, their innocence and their cunning, their purity and lewdness, their humanity. What went on in his mind, as he observed his fellows—and no writer's work ever gave better opportunity to see a wider spectrum of activities—was the astounding, almost miraculous, indeed divine comedy of people; and the phrase had a much closer application to his work than to Dante's. Chaucer could be, when it was right, censorious and condemnatory, scornful and satirical; he could laugh and even sneer, inveigh against and rage at the wicked and petty. But it is clear he loved the human race, and the English in particular—they were his literary meat. Such love of humanity had to come out, just as did the hot, foaming words in which he expressed it.

So in the late 1380s or early 1390s, Chaucer, having written in *Troilus* a great poem of dignified beauty, began *The Canterbury Tales*. It was as though the whole of his life had been a preparation for this astonishing summation of the fourteenth-century English. There is nothing like it in the whole of western literature. Balzac's *Comédie Humaine* and Zola's *Rougon-Maquart* novels are, by comparison, sketchy and incomplete, as well as gruesomely long-winded compared with Chaucer's matchless brevity. The England of his day is all there in the Prologue and the connecting links and in the tales themselves—church and state; rich and

poor; town and village; saint and sinner; honor; greed, deception, and guile; innocence and virtue both heroic and quotidian: all the pride, pathos, grandeur, pettiness, and sheer appetite of life as he had watched it in his time. In creating this vast, wide-ranging work of art he pinched ideas from others, and some of his plots are lifted whole, but all is transformed and made into something new, rich, and strange by his genius. Moreover the essential structure of a pilgrimage to Canterbury, with each of a mix of pilgrims forming a cross section of life, each telling a tale, is essentially Chaucer's own. Nothing could have been more apposite for his experience and peculiar skills. It is an outstanding example of a creative idea producing a volcanic explosion of consequential ideas, which pour forth from the source in an irresistible flow.

Chaucer was probably the first man, and certainly the first writer, to see the English nation as a unity. This was his great appeal to his contemporaries, for the long war with France produced a sustained wave of patriotism, people no longer seeing each other as Norman or Saxon but as English, who no longer read French much and who wanted to read about themselves in English.[15] What Chaucer gave them was this, and something more. His was the English they spoke. It was one of his great creative gifts, which no one else was to possess to the same degree until Shakespeare came along, that he could write in a variety of vernaculars. There was the basic distinction, well understood by his time, between hieratic and demotic, or what people called "lered" or "lewed" (learned or lewd). The word "lewed" or "lewd" already meant vulgar but had not yet acquired its connotation of obscenity. Lered was full of Latinizing and French words; *lewd* was made up of much shorter words largely of remote Germanic origin, including vulgarisms the knightly class was not supposed to use (the men did; not the ladies, as a rule). Chaucer could not only write in both vernaculars (others could do that); he could also mingle them. In his dream poem *The House of Fame,* he as author has a dialogue with the Eagle, an upper-class bird which is so lered that it can rhyme "dissymulacious" with "reparacions" and "renovelauches" with "aqueyntaunces," but can also, when it feels inclined, descends to demotic speech:

With that this egle gan to crye,
"Lat be," quod he, "thy fantasye!
Wilt thou lere of sterres aught?"
"Nay, certeynly," quod y, "ryght naught."
"And why?" "For y am now to old."
"Elles I wolde thee have told,"
quod he, "the sterres names, lo,
And al the hevenes sygnes therto,
And which they ben." "No fors," quod y.
"Yis, pardee!" quod he; "wost'ow why?"

As has been observed, the Eagle (like Chaucer), has achieved and is proud of a bidialectical ability. For phrases like "lat be," "ryght naught," "no fors"—which meant "no matter"—and "pardee" (*par dieu* or "by God!") were vulgar speech.[16]

It is the strength of Chaucer that he was conversant with the technical terms in which, for example, lawyers, intellectuals, military men, engineers, etc., talked about their trades; but he also mocked such jargon. Thus the yeoman in *The Canon's Yeoman's Tale* says, "We seem wonderfully wise" because "Oure terms been so clergial and so queynte." The Shipman, speaking in the Epilogue to *The Man of Law's Tale*, says he will not use scholarly jargon:

Ne phisylas, ne termes queinte of lawe
Ther is but litel Latyn in my mawe!

Sometimes, however, Chaucer gets a character to use technical waffling (as Shakespeare was to do, often) to get a laugh. Thus the alchemist's vocabulary of the canon is repeated by his yeoman:

As boole armonyak, verdegrees, boras,
And sondry vessels made of erthe and glas,
Oure urynates and oure descensories,
Violes, crosletz, and sublymatories,
Cucurbites and alambikes eek . . .[17]

Chaucer's characters in *The Canterbury Tales* range from his knight, "a verray, parfit gentil knight," as he is described—a

gentleman remote from vulgarity of any kind—and the extremely
genteel prioress, Madame Eglentynes:

> Ful weel she soong the service dyvyne,
> Entuned in hir nose ful semely,
> And Frenssh she spak ful faire and fetishly,
> After the scole of Stratford atte Bowe,
> For Frenssh of Paris was to hire unknowe

down to common artisans like the Miller and the Host, the
innkeeper Harry Bailly. The fact that the key role of commentator
is given to Bailly indicates Chaucer's leaning toward the plebians
for purposes of dramatic impact—they had never before appeared,
except symbolically, in English letters. Bailly is a man of "rude
speech and boold" but is nonetheless allowed to be bossy, even
dominant. Chaucer had already made it clear, in the person of the
Eagle, that "I can lewdly to a lewed man speke," and he insists in the
Tales that "The wordes moote be cosyn to the dede." His text
abounds in rough phrases: "I rekke not a bene," "I counte hym nat
a flye," "A straw for your gentilnesse!" There is a good deal of actu-
al swearing, and not just of Madame Eglentyne's variety—"Hir
gretteste ooth was but by Seint Loy"—but lower stuff, "by my fay,"
"a Goddes name," "by Saint Ronyon," down to what even today
would be recognized as actual swearing and obscenity. The Host
himself interrupts what he considers a tiresome passage, denounc-
ing it as "drast," adding, "Thy drasty rymyng is nat woorth a
toord!" But although Chaucer has the Parson rebuke the Host for
swearing, he also has the Parson use the word "piss" (as does the
well-worn Wyf of Bath, who has used up five husbands and is look-
ing forward to a sixth; and, less surprisingly, the Canon's Yeoman
and the Miller).

What is more, Chaucer not only has the Miller tell his shock-
ing tale but affects surprise that the majority enjoyed it: "for the
moore part they longhe and pleyde." In my day *The Miller's Tale*
was virtually banned for schoolchildren because it was so "rude,"
but that did not prevent me from relishing it. It is one of the
most accomplished of his stories and, moreover, includes a bril-
liant little portrait of the Miller himself. "Full big he was of

brawn and eek of bones," says Chaucer, calling him a skilled wrestler who could heave a door off its hinges, "Orbreke it at a renning with his heed." Broad as a spade, he had a wart on the "top right" of his nose, and, sticking out of it, a tuft of hairs, "Reed as the brustles of a sowis eris." His nostrils were black and wide and his mouth like "a great forneys," with which he blew his bagpipe, leading the pilgrims "out of towne."

Chaucer says the Miller was "a janglere and a goliardes"—a gossip and a comedian—whose stories were "moost of sinne and harlotries," so it is not surprising that his tale is about a pretty young wife of an elderly and doom-ridden carpenter—a wife who not only commits adultery with a smooth young student but fends off a tiresome parish clerk, who is besotted with her, by tricking him, in the dark, into kissing her exposed bottom, believing it to be her mouth. When the student himself tries the trick, the clerk, prepared, brands him with a hot poker, and this brings the tale to an amazing climax.[18] For all its vulgarity, the story is related with great sophistication, and here it is worth noting that Chaucer, having experimented with all the meters then current among poets, is always adept at fitting his verse to his matter. He was a great experimenter but with a purpose, and in all his major works the type of verse he uses is eminently right. His favorite line was decasyllabic, and he uses it almost invariably in his mature work. But whereas in *Troilus* he favors the seven-line stanza or "rhyme royal," as befits an epic of moving solemnity, for the fast-moving narrative of *The Canterbury Tales* he usually prefers the couplet. Chaucer, like all great tale-tellers, aims at deliberate speed; and as with other brilliant comedians who came later—one thinks of Shakespeare himself, Swift, and Waugh—uses enviable economy of means in his funny bits, the couplet of short sharp words being perfect for his purpose. He never uses two words where one will do, and *The Miller's Tale*, a virtuoso exercise in brevity and keeping to the point, shows him at his best.

To set the scene for low life, immediately following the Knight's elegant tale of chivalry and romance, Chaucer has a comic passage, in which the Host calls on the Monk to tell his story, but the Miller rudely interrupts to tell his. The Host objects that the Miller, or Robin as he calls him, is "dronke of ale." The Miller replies: "That I

am dronke, I know it by my speech." But he insists nevertheless on going ahead with his "legende" of "a carpenter and his wyf" in which a clerk (scholar) "hath set the wright's cap." This provokes an explosion from the Reeve: "Stint thy clappe! Let be thy lewed drunken harlotrie!" He says it is outrageous to bring a wife into disrepute. The Miller pooh-poohs the objection: there are a thousand good wives for one bad, and personally he trusts his own wife. So off he starts, and Chaucer apologizes for the nature of the story, adding that if the reader objects to it all he has to do is turn the page (it is one of Chaucer's many innovations that he speaks directly to the reader in this confidential way). The tale is indeed lewd, although redeemed by the enchanting heroine (or perhaps anti-heroine) Alison, the eighteen-year-old wife, "wilde and yong," her body as lithe and slim as a weasel's; she was a sight even more "blissful" than a young pear tree. Chaucer dwells lasciviously on how she plucks her eyebrows and dresses in the height of fashion, concluding that it is impossible to imagine "So gay a popelotte or swich a wenche," skipping and jumping like a lamb, with a sweet mouth, a "joly colt," "Long as a mast and upright as a bolt," in short "a primerole, a piggesine, For any Lord to leggen in his bed."

It is clear that this enchantress is to be allowed to get away with anything, and she does: not only does she cuckold her husband with the student; she also makes a fool of the amorous parish clerk by tricking him into kissing her bottom—which done, "'Teehee,' quod she, and clapte the window to." This is the first teehee in history, a peculiarly feminine expression of malicious laughter. Chaucer's language in this tale is uncompromising. Alison exposes "hir naked ers" to be kissed, and her lover, in turn, has a hot poker thrust up "amydd the ers." It is true that Chaucer does not actually use the word "cunt," though in describing the student making a pass at Alison he writes, "And prively he caughte hire by the queynte," which comes to much the same thing. However, Chaucer, feigning surprise, says at the end of his tale that nobody objects to the language—"Ne at this tale I saugh no man hym greve"—though Oswald the Reeve is furious simply because he is a carpenter by trade and objects to someone of his calling getting the worst of it.

However, the Reeve gets his revenge when it comes to telling

his tale by making the butt a Miller. This unfortunate man is humbugged not by one student but by two, who seduce his wife and his daughter and ensure that he gets a biff on the boko as well. The interest of his tale, for us, is that it deals in dialect: in fact it has been called "the first dialect story."[19] People in Chaucer's day were already very conscious of regional speech—Chaucer himself says in *Troilus* "there is so great diversite in Englissh and in writing of oure tonge"—and he repeatedly draws attention to the antagonisms of accents. The Parson, who objects strongly to northern alliterative styles in verse, replies, when the Host asks him for a tale:

> But trusteth wel, I am a Southren man,
> I kan nat geeste "rum, ram, ruf" by lettre,
> Ne, God woot, rym holde I but litel bettre.

Chaucer evidently wanted his poetry to circulate widely north of the Trent. He does not engage in alliteration in the northern manner, but he makes his two triumphant students obvious northerners, not only by stressing their different pronunciation, using *a* or *aa* where Southerners would use *o* and *oo*, but demonstrating differences in word endings and grammar. Thus for the third person singular of the present tense, the students use an *s* ending, whereas their southern antagonist, the Reeve, uses the *th* ending. Indeed Chaucer's ingenious and consistent use of dialect in this story is beautifully done and, I suspect, was noted by many of his literary successors who wanted to use this device to enliven their own dialogue, notably Shakespeare in both parts of his *Henry IV* and in *Henry V*.

The relish with which Chaucer relates tales of low life shows his enormous appetite for comedy and his association, which was to become a staple of English literature from his day till the mid-twentieth century, of buffoonery with the lower classes. He was indeed the first to establish this convention, and he established it in such a masterful fashion that it endured over half a millennium. But bawdry is only a part of his repertoire—his aim is comprehensiveness and a variety of modes. He was the first English poet to deal in a lethal combination of satire, irony, and sarcasm. It

emerges strongly in *The Pardoner's Tale*. The Pardoner, a seller of indulgences, is a complete and shameless rogue; but Chaucer, not content with exposing his impudence, shows how good he was at his job and how powerfully he preached against sinfulness. The Pardoner had also been taught to use the figure of Death to scare his hearers. But at this point, as often happens with the greatest writers, the creative spirit takes over and Chaucer suddenly produces a passage of intense pathos about an old man who wants to die and cannot. The drunken rioters of the story set out to find and slay Death and, by an ironic twist, meet someone equally anxious to meet Death but for quite different reasons. The passage is great poetry, and worth quoting in full:

> Right as they wolde han trodden over a style,
> An old man and a poure with hem mette.
> This old man ful mekely them grette,
> And sayde thus, "now, lordes, god yow see!"
> The proudest of thise ryotoures three
> Answered agayin, "What, carl, with sory grace,
> Why artow al for wrapped save thy face?
> Why livestow so longe in so greet age?"
> The old man gan loke in his visage,
> And sayde thus, "for I ne can nat finde.
> A man, though that I walked into Inde,
> Nerthr in citee nor in no village,
> That would change his youthe for myn age;
> And therefore moot I han myn age stille,
> As longe time as is goddes wille.
> Ne death, alas!, ne wol nat han my lyf;
> Thus walke I, lyk a restless caityf,
> And on the ground, which is my modres gate,
> I knokke with my staf, both erly and late,
> And seye, 'leve, moder, leet me in!'
> Lo, how I vanish, flesh, and blood, and skin!
> Allas! Whan shul my bones been at reste!"[20]

This image of the old man knocking on mother earth to be let in is typical of Chaucer's immense power to conjure up visions that tear the heart. Chaucer is a man of all moods and occasions, and

not only creates settings but creates the actual vocabulary in which he expresses them. His impact on our language has never been excelled, even by Shakespeare. All his creative life he was looking for words or creating new ones. He had a vocabulary of 8,000 words, twice as many as his contemporary John Gower, and many more times than that of most literates of his age. About half his words are Germanic, half of Romance origin: he ransacked common speech for short Anglo-Saxon words, and French and Italian for more flowery ones. It is true that Shakespeare had three times as many (about 24,000), but Shakespeare was an inheritor of Chaucer's word bank, as well as a massive depositor in his own right. Chaucer saw French and Italian poetry not so much as models to imitate but as verbal shop windows from which he could steal words that as yet had no English equivalents. He thus added over 1,000 words to our language—that is, these words cannot be found in earlier writers.[21] They included these: jubilee, administration, secret, voluptuousness, novelty, digestion, persuasion, erect, moisture, galaxy, philosophical, policy, tranquillity. These are mostly polysyllabic, weighty words, used by scholars and professional men. Chaucer balances these additions by taking from the common stock of ordinary speech thousands of others and putting them into the written language for the first time. Moreover, he uses these words not only to give directness and vivacity to his verse but to ornament and silver it by producing brilliant figures and similes, often alliterative, and always neat and vivid. We do not know how many of these figures he invented or which were sayings in the London and Kentish vernacular he favored. All we know is that they first made their appearance in his work. And they are still current. Among the alliterations are "friend and foe," "horse and hounds," "busy as bees," "fish and flesh," "soft as silk," "rose-red," "gray as glass," and "still as a stone." We do not still say "jangled as a jay"; but we say "snow-white," "dance and sing," "bright and clear," "deep and wide," "more or less," "old and young," "hard as iron." "No doubt" and "out of doubt" are Chaucerisms. So are "as the old books say" and "I dare say." Chaucer also had a neat way of working proverbs, sayings, and popular witticisms and comparisons into his verses. Thus in *The Friar's Tale* we come across the Earl, "who

spak one thing but he thoughte another," and in *The Knight's Tale* there is "The smylere with the knyf under the cloke." In *The Nun's Priest's Tale* we are told "Modre will out, that see we day by day," and in *The Reeve's Tale* there is "So was hir joly whistle wel y wet." It is Chaucer who first warns us, "It is nought good a sleeping hound to wake" and who writes of setting "the world on six and sevene."[22]

Chaucer's coinage was words—old, new, borrowings, inventions, transformations—but his game was life. He has an affinity with all living things, and brings them before our eyes with astonishing skill. Here (in *The Nun's Priest's Tale*) is the cock:

> His combe was redder than the fyn coral,
> And batailled as it was a castle wall;
> His byle was blak, and as the jet it shoon;
> Lyk azure were his legges and his toon;
> His nayles whiter than the lylye flower,
> And lyk, the burned gold was his colour.
> This gentil cok hadde in his governaunce
> Seven hennes for to doon at his plesaunce,
> Which were his sustres and his paramours,
> And wonder lyk to hym, as of colours
> Of whiche the faireste hewed on his throte
> Was cleped fair damsysele Perlelote.

And here is the household tom:

> Lat take a cat, and fostre him wel with milk
> And tendre flessh, and make his couch of silk,
> And lay him seen a mous go by the wal,
> Anon he waiveth milk and flessh and al,
> And every dayntie that is in that house,
> Swich appetit hath he to ete a mous.

But it is humans who rouse Chaucer's creative powers to the highest pitch. In a sense he loves them all so long as he can show them in action to delight his readers. It has been well observed that *The Canterbury Tales* is an allegory of the human race. Chaucer (like Shakespeare) takes people as they come and, as

Dryden says, in presenting them, "he is a perpetual fountain of good sense." What is more, like Shakespeare, Chaucer wants people, wherever possible, to speak for themselves. It is startling, and quite unprecedented, what a large proportion of the *Tales* is in direct speech. Indeed much is in dialogue. Thus the Friar speaks of a sermon he has just given:

> "And there I saw oure dame—ah, where is she?"
> "Yord in the yerd I trowe that she be,"
> Sayd this man, "and she wol come anon."
> "Ey, maister, welcome be ye, by Seint John!"
> Seyde this wyf, "how fayre ye, hertely?"
> The friar arises up ful curteisly,
> And hir embraceth in his armes narwe,
> And kiste her sweete, and chirketh as a sparwe
> With his lippes: "Dame," quod he, "right weel,
> As he that is your servant every deel,
> Thanked be God, that yow yaf soule and lyf!
> Yet saugh I not this day so fair a wyf
> In al the chirche, God so save me!"
> "Ye, God amende defaults, sire," quod she.
> "Algates, welcome be ye, by my few!"
> "Grant mercy, Dame, this have I founde alway!"

Chaucer's dialogue is so crisp and lively, so easy to say, and so apposite in the way it advances the tale—and he prefers it, so often and advantageously, to straight narrative—that I have often thought how competent and professional he would have been as a dramatist. There was no stage in his day, more's the pity. Otherwise he might have astonished us all with his plays. We have here, then, a proto-Elizabethan, denied a role of roles for want of a theater. All the same, he is beyond doubt the great creative voice of medieval England, bringing it to us in all its fun and pity, laughter and tears, high spirits and low jests. Dramatist he may not be, but he is the showman beyond compare.

3

Dürer:
A Strong Smell of
Printer's Ink

ALBRECHT DÜRER (1471-1528) was among the most cre-
ative individuals in history. As soon as he could hold a
pen, he was drawing. A drawing of himself, done when he was
thirteen, survives, showing him with long, silky hair and wearing
a tasseled cap, pointing earnestly to his image in a mirror. It sur-
vives because his father loved it and kept it, and it is not only bril-
liant but highly accomplished: evidently the boy had been
drawing for many years, probably from the age of three, which is
when most natural artists begin.[1] It is hard to believe that he let a
single day of his life pass without creating something, even when
he was traveling—for Dürer discovered (as I have) that
watercolors are perfect for a traveling artist, light to carry, easy to
set up, and ideally suited for a quick landscape or townscape
sketched while there is half an hour to spare. His topographical
watercolors were the first landscapes done by a northern Euro-
pean and the first use of watercolor outside England; and consid-
ering the novelty of the topic and the medium they are
extraordinarily accomplished.[2]

Dürer's initiation in adopting the new medium—watercolor—
so that he could record his travels and never waste a day was
characteristic both of his intense, unremitting industry and of
his voracious appetite for new artistic experiences. His output
included 346 woodcuts and 105 engravings, most of great elabo-

ration; scores of portraits in various media; several massive altar-pieces; etchings and drypoints; and 970 surviving drawings (of many thousands).[3] Virtually all his work is of the highest possible quality, and he seems to have worked at the limit of his capabilities all his life. Indeed he was always pushing the frontiers of art forward, and the number of firsts he scored in technical innovation is itself striking. The Leonardo of northern Europe (but with much more pertinacity and concentration), Dürer had a scientific spirit that compelled him to ask why as well as do, and to seek means of doing better all the time by incessant questing and searching.

We see Dürer as a great individualist, and that is right. He virtually invented the self-portrait, not because he was an egoist but because starting a sketch of himself filled in odd moments before he began a new task (a habit of painters who cannot bear to be idle for even a few minutes). Such sketches, once begun, tend to acquire an artistic momentum of their own and develop into full-scale elaborate oil paintings—as happened to Dürer several times, so that we are more familiar with his physique and appearance than with those of any other artist before Rembrandt. He also drew his family, as an extension of his individuality: there survive several masterly portraits of his father; a touching portrait of his young bride, Agnes; and a charcoal drawing of his aged mother, who had borne eighteen children, fifteen of whom died before reaching adulthood. This drawing of his mother combines total realism ("never omit a line or a wrinkle in a portrait" was one of Dürer's obiter dicta) with affectionate respect. Then, to combat forgery, Dürer was the first to devise his own logo, AD—and a most distinctive one it is, the best of any painter's. This too adds to his individuality. Dürer lived in a period when German artists, following the Italian practice, were beginning to move rapidly from medieval anonymity to Renaissance personality. This applies particularly to the four great German artists who were his contemporaries—Matthias Grünewald, one year older; Lucas Cranach the Elder, one year younger; and Albert Altdorfer and Hans Holbein the Younger, both born in the early 1490s. These wonderfully gifted and purposeful men carried German art to a high pitch of creative power which had been inconceivable until then, and which (it has to be said) German artists

have never since come even close to equaling. All five were intensely individualistic, but of the group Dürer was by far the most fully realized as an independent creator, as we can see from the vast range and unmistakable flair of his work and, not least, because he left a substantial corpus of printed writings about art and related subjects, and a number of his highly distinctive personal letters have survived.[4] We see and know Dürer, and what we see and know we like. It must have been good to have in him in your house and hear him talk (and watch him draw).

Yet, individual though he was, Dürer came from an age when art was still to a considerable extent a collective occupation, taking place in workshops in which specialists performed their functions side by side, tasks were shared, and the less responsible portions were assigned according to a strict hierarchy of skills and experience. There were the *Lehring*, apprentices; the *Geselle*, trained worker-craftsmen; and the *Meister*. The number, size, and complexity of these workshops had been enormously increased in the generation or so before Dürer's birth by the rapid increase of wealth, a feature of most parts of Europe but particularly notable on both sides of the Alps and, above all, by the industrial phenomenon of printing, especially in Germany and Italy.[5]

Printing might be described as the mass production of images on flat surfaces, especially paper. It was the first technological revolution to accelerate the speed at which humanity hurries into the future, and almost certainly the most important because it affected every aspect of life. Printing from movable type was the work of the Mainz goldsmiths Johann Gutenberg and Johann Fust in 1446–1448, twenty years before Dürer was born. By 1455 Gutenberg had completed and published the world's first printed book, a Bible, and the importance of the event was immediately recognized. The impact on knowledge was huge because the first encyclopedia was published in 1460, soon to be followed by the first Bible in German—vernacular works formed a high proportion of the earliest books.[6] The salient characteristic of printing was cheapness. Before printing, owning manuscripts had been the privilege of the rich or institutions; only the largest libraries had as many as 600 books, and the total number of books in Europe as of 1450 was well under 100,000. By 1500, when Dürer was approaching his thir-

ties and printing had been going for forty-five years, the total was over 9 million.[7]

Born in Nuremberg, a highly prosperous and sophisticated south German town, notable for its skilled artisans of every kind, Dürer was at the heart of the printing revolution. The town got its first printing press in 1470, the year before he was born, and it rapidly became not merely the leading town in the German book-producing industry but the center of the international printing trade. The master printer Anton Kolberger, Dürer's godfather, kept twenty-four presses going at top speed, employed 150 workmen, and ran a network of connections with traders and scholars throughout Europe. Dürer's parents had been able to secure so prominent and prosperous a sponsor for their son because Dürer senior, like Gutenberg, was a goldsmith (as was Kolberger as a young man), and a successful one. The family had come from Hungary (where Dürer means "door") but were patronized by Nuremberg's prosperous citizens by the time Dürer was born. Goldsmithing was close to the printing trade for all kinds of technical reasons, including reproduction. Mass production of images had preceded the invention of movable type, both God and Mammon playing a part: the commonest items were religious prayer cards and playing cards. But goldsmiths also traded in mass-produced designs of the cheaper forms of jewelry. Indeed goldsmiths almost certainly invented engraving in iron and copper a generation before they invented printing. South German goldsmiths, between 1425 and 1440, impressed paper on plates engraved in their workshops to produce large numbers of examples of printed designs to help in the transfer of repeated or symmetrical elements, for training and record keeping, and for sale. All the centers of early engraving—Colmar, Strasbourg, Basel, and Constance—evolved from goldsmithing, and the first really accomplished engraver-printmaker who produced enough of his work to sign himself with his monogram "ES" (c. 1460) was a goldsmith.[8] By the time Dürer was born, the greatest of the early engravers, Martin Schongauer, operating from his goldsmith's workshop in Colmar, was monogramming all his prints—a new art had been born too by 1471.[9]

Dürer was naturally apprenticed in his father's workshop, but

after three years he told old Dürer that he wished to specialize as a designer-artist. His father was disturbed but cannot have been surprised, given his son's superb graphic skills. Goldsmithing was the high road to fine art in fifteenth-century Europe. Literally hundreds of German and Italian painters and sculptors were the sons (and in a few cases the daughters) of goldsmiths. Dürer, an exceptionally alert and studio-wise teenager, may actually have asked his father to apprentice him to Schongauer as an engraver, then the state-of-the-art medium in mass production. He had seen the master's work, loved it, copied it, and revered its creator. But by the time he actually got to Colmar, Schongauer had just died. Instead, Dürer senior apprenticed his son to a Nuremberg artist, Michael Wolgemut, who specialized in woodcutting and wood engraving. This made good commercial sense, particularly in view of the family's close connection with the printer Kotburger. The new process for engraving on metal allowed finer work—that was why a brilliant draftsman like Dürer was so keen on it. On the other hand, printing woodcuts or books with woodcut illustrations was much cheaper and was central to the rapidly expanding consumer market in books.[10]

It was, moreover, woodcuts which eventually made Dürer the best-known and most loved artist in northern Europe, probably the wealthiest, and the central figure in German art up to and including our own times. Nor, as a medium, is the woodcut to be despised. Its blocks are made from well-seasoned planks, a foot thick, cut from the length of soft trees, such as beech, alder, pear, sycamore, and walnut. It is a relief printing technique in which a pen, pencil, or brush is used to draw a design (the block is often whitened by paint) that becomes the printed surface, raised above the rest of the block, which is cut away. The design is cut as follows: a sharp knife is used to make two incisions on each side of the drawn line—one incision inclines away from the line and the other toward it, so that the line is left with a conical section between two V-shaped declivities. Once these lines have been established, the surplus wood surface is removed, using chisels, scoops, and gouges, leaving a network of lines or hatchings on the remains of the surface. In practice, the cutter, if skillful, can create signs which give the impression that the print is a drawing, with cross-hatching.

The best woodcuts are not only drawn by the artist but also cut by him—though occasionally the artist forms a partnership with a particularly skillful cutter who knows his ways. Printing from woodcuts involves putting a lot of pressure on the surface of the blocks, so the lines cannot be cut too thin. This is why engraving on metal, which can take more pressure, is and has always been more precise than woodcutting.[11]

Wolgemut and his brilliant apprentice worked together to make the woodcut more sophisticated and sensitive, and when Dürer finished his articles in 1489, he went on his "wander years" to the Netherlands and other parts of Germany to meet expert artists and acquire knowledge and technique. His passion for improving his art was perhaps his strongest single emotion and fed his ever-expanding creative gifts. There exists in Basel an actual woodblock, *St. Jerome in His Study*, drawn and carved by Dürer, and autographed on the reverse: "Albrecht Dürer of Nüremberg." With Wolgemut, and from 1490 in his own workshop, Dürer created several immense series of woodcuts, which his godfather published: a small-size *Passion* group, which became the equivalent of a best seller; a volume of moral tales with forty-five woodcuts by Dürer; and an immensely successful series of 116 illustrations to a *Book of Follies* (1494) by Sebastian Brant. Brant completed a translation of Terence's comedies for which Dürer provided 126 drawings, but for some unknown reason the work was never published. What we have are the drawings on the blocks, six blocks already cut, and seven prints from blocks which have disappeared. Together they give an extraordinary insight into the work of a busy illustrator in the 1490s (the decade which saw Columbus in the Americas) working for the popular publishing industry.[12]

Dürer's first real masterpiece in woodcutting was his *Apocalypse* series of 1496–1498, which was followed by a number of superb individual prints including *Sampson and the Lions* and *The Knight of the Landsknecht*. He continued to produce work from wood all his life (with the help of assistants and expert cutters), and it is likely that he made more money from this source than from any other, as the print runs were often very long. From the early 1500s he began work on his *Large Woodcut Passion* —its elaboration and power and the sheer daring of its conception have never been surpassed in this

recalcitrant medium. He followed this with a magnificent series, *Life of the Virgin*; and some special work for Emperor Maximilian. The latter included a woodcut portrait (1578) that went all over Europe and became an iconic image, and an enormous triumphant arch assembled from 192 large woodcuts printed in 1517–1518. Both his *Small Passion* (three images) and his *Large Passion* (sixteen images) were published in book form, being a new kind of book—the illustrated art book. Dürer also, as a by-product of his publishing work, did presentation drawings—a *Passion* sequence (1504) of which eleven sheets have survived, in pen and black wash on green paper; and a superb ornamented page for a personal *Book of Hours* for the emperor, in red, green, and violet ink (1513), perhaps the most exquisite work in the entire history of book illustration.[13]

Dürer did not, however, give up his original object of mastering the new art of engraving, building on the fine work of Schongauer. In effect he perfected engraving technique, stressing contour, texture, and light by means of a new linear vocabulary, and rendering solid form by the sophisticated use of perspective. He extended his subject matter of engraving to include virtually everything depicted in painting, and for the first time made the large-scale engraving an independent work of art of the highest quality. By 1500 he was using gray tones, made up of tiny flecks and lines, which enabled him to create illusions of deep space. He pounced on the even newer art of etching (using acid to bite on a prepared ground of copper), which in the first decade of the sixteenth century had evolved from the practice of engraving high-quality armor for princes—Dürer actually designed such a set for Maximilian; and although the armor has been lost, the design drawings remain. In 1514 he produced what are undoubtedly the three finest engravings ever made: *Knight, Death, and the Devil*; *St. Jerome in His Study*; and *Melancholia*. *St. Jerome* is straightforward, a virtuoso exercise in the difficult art of internal perspective and the production of complex tonal qualities using only fine lines. The other two are enigmatic. *Knight* has been interpreted in Germany for nearly half a millennium as an allegory of heroism and national courage overcoming all obstacles, physical and moral. *Melancholia*, shown as a woman symbolizing art and intellect, appears to be a comment on the nature of creativity and the sadness (as well as joy) that it inevitably brings—

quite possibly a reflection of Dürer's own tortured psychology. The extraordinary skill with which these masterworks were composed and executed, and the mystery surrounding them (for even *St. Jerome*, it has been argued, carries hidden messages), have made them the summit of Dürer's achievement and the most hotly debated of any German works of art. They seem to ask: can the creative spirit go any further?[14]

The answer, of course, is that it can, and Dürer himself took it further, in several directions. Although, for the sake of clarity, I have written so far about his work for mass production, Dürer also pursued, simultaneously, the art of creating unique images in pencil, ink, and paint. He was not only at the center of the printing revolution in Germany but on the northern fringes of the Renaissance. It was centered mainly in Italy but, in its cult of the humanistic recovery and study of ancient Latin and Greek texts— and of carrying their message into modern life—it was also a phenomenon throughout Europe. Dürer was a scholar as well as an artist, accumulating a sizable library, and as avid to learn more about the world by reading as to improve his art by watching the masters at work. His closest and lifelong friend was the German humanist Willibald Pirckheimer, to whom he poured out his heart in noble letters, some of which survive. In 1494, when he was twenty-three, Dürer was obliged by his father to take a suitable wife, Agnes, daughter of a successful master craftsman, Hans Frey. Agnes was intelligent and played the harp well, and Dürer's drawing of her as a bride shows affection. But while we might have expected a succession of portraits (not least, one of her playing the harp), none appears to have survived. There is some evidence that they did not live happily together, and Pirckheimer, who hated Agnes, says she was cruel to him. It may well be that husband and wife differed over religion, for Dürer lived into the opening phases of the Reformation and was an admirer and supporter of Martin Luther and a friend of Luther's co-reformer Philip Melancthon, whom he portrayed splendidly. If Agnes, as I suspect, was a conservative daughter of the church, that would explain much.

However, Agnes benefited Dürer enormously in one respect. She brought with her a dowry of 200 gold crowns, and with this Dürer financed a trip to Italy, Venice especially, the first of two

journeys (1494-1495 and 1505-1507). These travels were formative for Dürer in a number of ways. They produced his travel watercolors. They introduced him to southern light—and heat. In Germany he suffered greatly from Nuremberg's cold winters, icy springs, and uncertain summers. He wrote to Pirckheimer from Italy, rejoicing in the sunshine: "Here I live like a prince, in Germany like a beggar in rags, shivering." The pull of the warm south, always strong among creative Germans, from Emperor Frederick II ("Stupor Mundi') to Goethe, was transforming for the eager young artist. And there was so much to learn! In Venice he met the Bellini family and watched Gentile, one of the two painter sons of the patriarch, Jacobo Bellini, paint his monumental *Procession of the Relics of the Cross in St. Mark's Square*, in which the artist made use of his travels to Constantinople and the East. Dürer did a drawing of this key work and made copies of engravings by Mantegna (the greatest Renaissance exponent of classical lore) and Antonio Pollaiolo, and of drawings by Lorenzo di Credi. He saw the works of—and possibly met—Giorgione, "Big George," founder of the second phase of the Venetian revolution in painting, master of Titian and all the rest. Dürer became friends with Giovanni Bellini, most exquisite of the Venetian painters, who shared Dürer's devotion to realistic portraiture and passion for landscape. Bellini was old by the time of Dürer's second visit but "still the best," as he reported. The two men admired each other without reserve.

Indeed by the time Dürer returned to Venice, he found himself almost as famous there as in Germany, so much were his woodcut books admired (and copied). Modest as always, humble in his insatiable desire to acquire knowledge and skill, he found himself constituting a bridge between northern and southern art, a conduit along which flowed ideas and innovations from Italy to Germany and vice versa. During pauses between his big woodcutting and engraving projects, Dürer drew and painted—in watercolor, tempera, and other color media—a variety of living things: plants, flowers, and above all animals, such as squirrels, foxes, and wolves. The realism with which he depicted fur amazed the Italians. Giovanni Bellini asked to borrow one of the "special brushes" Dürer used for fur. Dürer gave him a brush. "But I've got one of these already," said Giovanni. "Ah!" said Dürer. There had been, since the mid-fifteenth

century, a growing market among rich Italian princes and bankers for Netherlandish oil paintings, especially major diptychs and triptychs for high altars for their private chapels—one example being an enormous triptych commissioned by the Florentine banker Tommasi Portinari from Hugo van der Goes, now in the Uffizi. But Dürer was the first German artist whom leading Italian patrons and collectors considered worthy of joining this select company. When he set up a workshop in Venice during his second visit to Italy, it was visited not only by painters and collectors but by the doge Lorenzo Loredan, who offered Dürer 200 florins a year to stay in the city and adorn it. It was in this workshop that Dürer painted, at the request of the German merchants in Venice, his wonderful work *The Madonna with the Siskin* (1507). There, too, he created his finest and most ambitious painting, *The Feast of the Rose Garland* (1506). This amazing work, in which the Virgin and Child are enthroned amid a vast collection of saints, monarchs, angels, musicians, and spectators—including Dürer himself—is a summation of all that he had so far learned about art, a tour de force of form and color, simple delight, and exquisite virtuosity. It is also a striking blend of everything Dürer had learned in Italy (especially from Bellini) and the German mystic soulfulness so alien to the Italian vision.[15]

Much as he had learned, however, Dürer wished to learn more. He traveled by horse to Bologna, where he was hailed as a "second Apelles," then on to Florence and Rome. He made his own copies of innumerable Italian works of art, including drawings by Leonardo— according to Vasari, done in watercolor on canvas, so they could be seen from both sides. In Italy, too, Dürer began the process of creating his own intellectual encyclopedia of art. He drew a fundamental contrast between German and Italian art knowledge. Germans often knew *how* to paint because they possessed practical knowledge handed down from one generation to another in the workshop. But the Italians also knew *why*. They had theory. They had studied the ancients and built on that knowledge—a library of handbooks on perspective and the human body; proportion and anatomy; musculature and facial expressions; the way in which bodies moved, horses functioned; and the physics and chemistry of everyday life.

Hence when Dürer returned from Italy after his second visit in 1507, he began work on a series of treatises on art that were both theoretical and practical, and were the first to be written on the subject in German. His first, four-part treatise, *Vier Bücher von Menschlicher Proportion*, concerns the proportions and functions of the human body. He preceded the writing by taking a series of measurements of men, women, and children, to discover the dimensions of "typical" and ideal bodies, with interrelationships (of heads, legs, arms, and chest and of each to total height). He used various measurement systems, improving on classical authors such as Vitruvius, insufficiently methodical in his eyes, and on the methods used by Alberti in *De Statua* (1434). Books 1 and 2 dealt with alternative systems of measurement. Book 3 concentrated on the practical requirements of the working artist, including rule-of-thumb workshop devices and the actual drawing instruments required. Book 4 dealt with the way in which the human body moves. This brilliantly innovative treatise, which exists in a fair copy (Dresden), written in Dürer's own hand in 1523, has (like his work on paper) a German thoroughness usually lacking in Italian counterparts, and is written throughout in superb German prose. German, thanks partly to Luther, the first prose stylist, was coming to maturity as a language, and Dürer took advantage of its new glories, especially in the conclusion to the third book, which deals with aesthetics and the relationship between man, art, and God. These books supplemented Dürer's own elaborate drawings of the human body.[16]

Dürer was always conscious of the needs of the young, eager artist in the workshop, and his manual for the student, the *Vuderweysung der Messung*, published in 1525, is full of practical instruction on the parabola, the elipse, and the hyperbola; on using conic sections; and on the geometry of three-dimensional bodies, using principles from Plato and Archimedes, but with sensible German updating. He deals with basic architecture, perspective, the principles of the sundial (fixed and moving), and the kind of astronomy useful to the artist. His last book, probably published in 1527, deals with fortification, a topic on which artists needed to be knowledgeable as part of their money-earning trade. Dürer's work, apart from being the first in German, is a skillful blend of theoretical and

practical science, and a great deal more comprehensive than any-
thing produced in Italy at that time.[17]

By the third decade of the century, Dürer was so well known,
through his woodcuts, engravings, and printed work, that he was a
European celebrity of the same stature as Erasmus. In 1520–1521
he went on a journey to the Netherlands, traveling in some style
and taking along (through the kindness of his heart) his wife Agnes
and her maid. The ostensible reason for the trip was to pay his
respects to the new emperor, Charles V, who was being crowned in
Aachen. Charles's predecessor, Maximilian, had made Dürer a
handsome annuity, and the artist wanted Charles to renew it. He
stayed first with the bishop of Bamberg, presenting the bishop
with a beautiful *Madonna*, in return for letters recommending him
to the mighty whom he had not yet met. But these letters were
scarcely needed. Dürer was received everywhere with acclaim from
fellow artists and commissions from the elite. The city of Antwerp,
art capital of the Low Countries (which were not yet divided by reli-
gious conflict), offered him 500 gold florins a year to work there.
Dürer was accompanied by a traveling studio and assistants, and
he completed twenty portraits on the trip, as well as over 100 draw-
ings. These are supplemented by his diaries, which give a good
account of the coronation and other events he witnessed. Always
keen on verisimilitude, he did a portrait of an old man, said to be
ninety-three, as a model for St. Jerome. He painted the Danish king,
Christian II (this work has been lost), and did a beautiful portrait
drawing of Erasmus. He met Patinir, Joos van Cleve, and Lucas van
Leyden. In Zeeland he went to see and draw a beached whale, and
caught a chill (or malaria) that gave him rheumatism for the rest of
his life. He inspected Michelangelo's *Madonna* in Brugge (Bruges),
and many other masterworks. He returned, dazed, honored, and
exhausted, to Nuremberg, where he spent the last seven years of his
life as its most famous citizen. (Luther called the town "the eyes
and ears of Germany," with Dürer as its eyes.) Though writing—
transmitting his knowledge to future generations—was now his
passion, and drawing his delight, he continued to paint for increas-
ingly large sums: he made portraits, altarpieces, and decorations in
the city hall. The most comprehensive catalog of his paintings,
compiled by Fredja Anzelerosky (1991), lists 189 works, the total

including those that are now lost and those destroyed in World War II. His friend Pirckheimer says that Anges was greedy, and that she forced Dürer to work much too hard in order to amass gold. It is true that Dürer left the large sum of 6,874 gold florins, and several unfinished commissions, including a huge altarpiece that he should, perhaps, never have agreed to do. But then Dürer was a lost man without hard work.

He is best remembered not so much as an artistic celebrity but as a simple workman in art, with the tools of his trade in his hand: the sharp knives, gravers, scorpers, tint tools, spit sticks, rollers, and mallet of the woodcutter; pots of black and brown ink; chips of wood everywhere; the gravers, gouges, rockers, and roulettes of metal engraving; the needles of the etcher; drypointers and styluses, scrapers and burnishers, and literally hundreds of pens, brushes, charcoal sticks, and graphite pencils from Cumberland plumbago. His workroom had scores of aromatic smells: linseed oil and egg white, walnut essence, sizes and glues, gesso and tempera, hog smells from the brushes, coal and carbon dust, chalk and earths for color mixing, squirrel skins for minute eye brushes, turps and other dryers, lavender oil, waxes and resins, varnish and gypsum, powerful acids for biting into metal, and the reek of fresh canvas rolls and treated wood panels. His hands, to judge from his self-portraits, were big (like the hands of most painters) and worn by the trade, with cuts, calluses, old scars, and acid stains; imperfectly washed; the nails black, or red and raw from carbolic—the hands of a man who worked with them all his painstaking life.

Dürer's enormous corpus of prints and drawings proved, over the centuries, to be of more use to aspiring artists (and, indeed, to masters) than the work of any other draftsman. They are notable for clarity, precision, extreme accuracy, feeling for texture, superb proportion and design, and—often—great depth of feeling. If Dürer saw something remarkable, he wanted to draw it instantly and preserve it for posterity. Many of his drawings emphasize the structure and solidity of a living object, and his watercolors of towns and buildings convey the various distances from the viewer with extraordinary fidelity of tone. All these drawings teach. In 1515 he got hold of a detailed drawing of an Indian rhinoceros, taken from a creature sent to Lisbon

from Goa. The animal was, alas, wrecked and drowned on its way
to Genoa, and Dürer never saw it. But from the material he had,
he produced a woodcut of astonishing power, presenting the ani-
mal as an armored being, and the image has been the archetype
of the rhinoceros, all over the world, ever since. Indeed in Ger-
man schools it was still in use in biology lessons as late as 1939.
His images of two hands joined in prayer has likewise achieved
world celebrity. There are few areas of representation of the visu-
al world on which Dürer has not left an ineffaceable mark—not
surprisingly, since the number of his pages in circulation had
reached the tens of millions even before the advent of steam
printing.

As early as 1512, when Dürer still had sixteen years to live,
Cochlaus's *Cosmographia* stated that merchants from all over
Europe bought Dürer's woodcuts and engravings and took them
home for native artists to imitate. Toward the end of the sixteenth
century there was a phenomenon in German-speaking territory
known as the "Dürer revival," during which his works were reprint-
ed and collectors, led by Emperor Rudolf II in Prague and Emperor
Maximilian I in Munich, collected his paintings, prints, books, and
drawings. His fame increased in the eighteenth century, and he
became an artistic symbol, part of romanticism (especially for
Goethe and for artists like Caspar David Friedrich and then, under
Bismarck, for German nationalism). On the morning of 6 April
1828, the three-hundredth anniversary of his death, 300 artists
gathered at his tomb to pay homage. His life and work were made
an object of the full battery of German academic scholarship begin-
ning in the 1780s, earlier than those of any other great artist, and it
is likely that more large-scale exhibitions have been held for Dürer
than for anyone else. This attention, far from producing satiation,
has served to emphasize for successive generations the freshness of
his vision and the crispness of his line. No other man has been
more creative, in black and white, and it was Erasmus who first
noticed—and said so—that it was a crime to try to color Dürer's
prints.

4

Shakespeare: Glimpses of an Unknown Colossus

S HAKESPEARE is the most creative personality in human his-
tory. Born in Stratford in April 1564, he became a profession-
al writer toward the end of the 1580s, in his early twenties, so his
writing career covers barely a quarter of a century to his death, at age
fifty-two, in April 1616. During this time, besides acting often and
engaging in speculations and investments both in Stratford and in
London, he wrote thirty-nine plays that have survived, and collaborat-
ed on a number of others; he also wrote a dozen major poems and
hundreds of sonnets.[1] During his lifetime his plays were already being
performed abroad as well as all over Britain, and even at sea off the
coast of west Africa; they have since been translated into every known
language and acted all over the world. They have become the basis for
over 200 operas by composers great and minor, including Purcell,
Rossini, Verdi, Wagner, and Britten, and have inspired works by
Mendelssohn, Berlioz, Tchaikovsky, Prokofiev, and scores of other
masters. The 103 songs that dot his plays have been set to music by all
the composers of art songs.[2] Shakespeare's works have inspired over
300 movies and thousands of television adaptations, and have provid-
ed material or ideas for most professional playwrights from Dryden to
Shaw and Stoppard. His poetry is a mainspring of imaginative English
literature and a formative influence on its foreign equivalents, espe-
cially French, Italian, German, Spanish, and Russian.

Shakespeare's imaginative and artistic fecundity—and depth—

are an apparent demonstration of the unimportance of heredity or genes in creative lives. His father, John, was a provincial glover, who prospered for a time as a small-town worthy, then declined; his mother came from a higher social group, with landed connections, but also provincial. There is no evidence of any kind of previous literary or artistic activity on either side of his family. He was educated at the Stratford grammar school and was (probably) a schoolmaster before forming a connection with a traveling theater company and then coming to London as an actor-playwright (rather like Dickens's Nicholas Nickleby). His undistinguished origins have led some to suppose that the real author of his works was Sir Francis Bacon, the lord chancellor. But this is crude intellectual snobbery—any number of great writers have come from nothing and nowhere. "Baconian theory" rests on cryptograms, chiefly the nonce word "honorificabilitudinitatibus" in *Love's Labours Lost* (V. i), which Bacon is supposed to have invented to be rendered in Latin as "These plays, F. Bacon's offspring, are preserved for the world." But in fact the word was not coined by whoever wrote the play—it is found in an English text as early as 1460. In any case Shakespeare's life is well documented: there are sixty-six references to him in contemporary documents, which include overwhelming evidence of his connections with theater in general and his plays in particular.[3] Many of his contemporaries were fully aware of his greatness, as is attested to by the twenty-four commendatory poems and prefaces written between 1599 and 1640.[4] Thanks to the love and devoted work of two of his colleagues, John Hemminges and Henry Cordell—who took a great deal of time and trouble to put together the First Folio, published in 1623—some sixteen of Shakespeare's plays were saved from oblivion, and the rest, eighteen of which had been published earlier in corrupt quartos, were printed more or less as Shakespeare wrote them. Of the many hundreds of plays written and staged in the years 1580–1620, more than half have disappeared without trace, but we can be reasonably sure we possess Shakespeare's oeuvre almost in its entirety.[5]

I do not propose to discuss Shakespeare's output in detail, merely to examine his creation of two characters, Falstaff and Hamlet, and the plays in which they appear. First, however, it is

useful to note Shakespeare's chief characteristics as a writer, and the way in which they helped his creative process.

We begin with his practicality. He was what Jane Austen was later to call a "sensible man." He worked empirically, by trial and error, by learning his job and experimenting. He was rational. Always keen to get on, he was never guilty (to use his own words) of "vaunting ambition, which o'erleaps itself and falls on the other side." He became a player probably by accident when a visiting company had a vacancy through illness in Stratford, and Shakespeare, already an amateur, filled the gap so well that he was asked to turn professional. He worked for several companies in the 1580s, playing "kingly parts," and later was Adam in his own *As you Like It* and the Ghost in *Hamlet*, as well as appearing in Ben Jonson's comedies and Jonson's tragedy *Sejanus*. But Shakespeare seems to have grasped, early on, that his gift for writing plays was greater than his skills as an actor could ever be; and he was an established playwright by 1592, when a bad outbreak of plague closed the London theaters for nearly two years. He then (in addition to going to provincial towns) explored the possibility of becoming a nontheatrical man of letters by writing his two great narrative poems, *Venus and Adonis* and *The Rape of Lucrece*.

Such work might have served. But when the theaters reopened in May 1594, an opportunity opened to participate, as actor, writer, and investor, in a new theatrical venture, the Lord Chamberlain's Men, a group of skilled professionals who soon made themselves, and remained, the leading theatrical company in London (and so in the world).[6] Shakespeare was named from the start as part of the undertaking, which began at the "private" theater at court in January 1594, when plays were performed indoors in artificial light to select audiences of 500 or so. The company then went on in the summer to lease the theater north of the Thames in Shoreditch, which was "public," seated over 1,000, and worked by daylight. This playhouse was the first to be professionally designed and built (in 1576). It was created by the father of Shakespeare's great acting colleague Richard Burbage. James Burbage was a joiner, and the theater was a work of highly sophisticated carpentry, built to provide endless dramatic opportunities.

Here, and later at another professional theater on the South Bank, the Curtain, Shakespeare matured as a dramatist. In 1599, he, Burbage, and others formed a syndicate to dismantle the timber of the theater and use it, plus much other material, to build a newly designed state-of-the-art theater, the Globe, also on the South Bank at Southwark, to escape the jurisdiction of the London city fathers, who were puritanical and anti-plays. The Globe could seat 3,000 and was a highly profitable venue, supplemented in winter, from 1609 on, by a "private" indoor theater, the Blackfriars.[7] As a "sharer," Shakespeare held ten percent of the Globe shares, and a similar portion of other enterprises of the Chamberlain's Men (after the accession of James I in 1603 they were known as the King's Men). His company played more often at court than any other did: between 1 November 1604 and 31 October 1605 the company presented eleven plays, seven by Shakespeare (*Love's Labours Lost*, written specially for court performances; *The Comedy of Errors*; *Measure for Measure*; *Othello*; and—twice—*The Merchant of Venice*).[8] Shakespeare made a good deal of money out of the theater, a fact to which his investments in land and housing in Stratford testify; and he remained connected with the company till his death. No other playwright had such a long and continuous connection.[9]

Shakespeare's practicality also expressed itself in his willingness to write, and his skill at writing, plays suitable, in general and in detail, for the theater to be played in; the actors available to perform; and the public, both "public" and "private," to be entertained. (The public audiences paid one penny minimum; the private audiences sixpence.) Shakespeare made brilliant use of all the facilities of the new professional theaters in his staging—the underfloor, the stage, the canopy level, the top level, and the apparatus for raising and lowering actors—while bearing in mind the limitations of the indoor "winter" theaters. It is notable that, as theatrical facilities expanded, Shakespeare's plays made more use of them. For instance, in *Cymbeline* Jupiter descended by machinery, as did Diana in *Pericles* and Juno in the masque in *The Tempest*. But machinery and big theaters were never essential to Shakespeare's effects; this is one reason why his plays were, and are, easier to stage well than those of his leading contemporaries: Marlowe, Jonson, Beaumont and Fletcher, and

Webster.[10] Shakespeare was always willing to write and rewrite to order or to suit the resources available. He was particularly successful in writing women's roles played by the teenage boys who formed an essential part of the company. He wrote, as a rule, short but emphatic and incisive parts (Lady Macbeth, Desdemona, Ophelia). He was also capable of writing much longer and subtler characterizations (Rosalind, Cleopatra) if an outstanding boy was available. As for the public, Shakespeare was adept at appealing to both the elite and the "vulgar" or "groundlings" in the same play. Still (as the scene in which Hamlet instructs the players indicates), he was striving to improve the public taste, especially in acting. Like all the greatest artists, he created his own public, teaching the audiences to appreciate what he had to offer, and he left the theater a much more subtle and sophisticated world than he found it.[11]

Linked to Shakespeare's practicality were his distrust for the abstract and his dislike of theory. He was in no sense an intellectual, that is, someone who believes ideas are more important than people. His plays are essentially about people, not ideas. He was not, in the eyes of intellectuals like Ben Jonson, an educated man; and though he knew a lot, it had all been picked up by word of mouth—listening to people talk about what they knew well—and by private reading. He had no whiff of the university, no "system," whether from the medieval scholars or the ancient Greek philosophers. He was not trying to deliver a new "message." Though associated with the young earl of Southampton, and through him with the dangerous earl of Essex—who tried to overthrow the stable Elizabethan regime in 1601, thus getting himself beheaded and Southampton imprisoned—Shakespeare never dipped his pen in ink to give them a word of support. He was not a revolutionary in any sense or in any field. Quite the reverse. He valued stability. He had the instincts of a provincial middle-class tradesman who was doing well. He was a conservative who actively disliked radical ideas, as he made clear in his most openly opinionated play, *Troilus and Cressida*. He reiterated the dislike strongly and often in his history plays, where he deplores all attempts at a general redressing of wrongs, especially by violence against the existing order.[12] Shakespeare's conser-

vatism, his preference for the present order of society with all its imperfections (of which he was well aware and which he frequently exposed), was tempered by a desire for "improvement," in public morals and private manners, by the gradual and peaceful adoption of better ways of doing things. This love of "improvement" rather than revolution would have made Shakespeare an eminent Victorian.

He rarely allows his opinions open expression, preferring to hint and nudge, to imply and suggest, rather than to state. His gospel, however, is moderation in all things; his taste is for toleration. Like Chaucer, he takes human beings as he finds them, imperfect, insecure, weak and fallible or headstrong and foolish—often desperate—and yet always interesting, often lovable or touching. He has something to say on behalf of all his characters, even the obvious villains, and he speaks from inside them, allowing them to put forward their point of view and give their reasons. Charles Lamb, a keen student of Shakespeare's characters, took the view that only the "bloat king" in *Hamlet* was without redeeming qualities. Yet even King Claudius is sharp and shrewd in pointing out—to himself, too—the difference between worldly standards (which are his) and divine ones: he knows the difference between right and wrong. Actors, as Shakespeare intended, have found ways to play Iago, Macbeth, and Shylock in such splendor as to turn these bad men not indeed into sympathetic characters but into powerful studies in distorted values, who grip our attention and make us shiver. And there are literally scores of figures who flick across his scenes and whose weaknesses and follies amuse rather than disgust us. They are the common stock of humanity: flesh, not stereotypes; individuals with quirks and peculiarities; men and women who have stepped out of the street onto the stage to be themselves. They form a mighty army of real people.[13]

Shakespeare gives his characters things to say that are always plausible and often memorable. "The wheel is come full circle." "All the world's a stage." "There is nothing left remarkable beneath the visiting moon!" "Our remedies oft in ourselves do lie." "Sweet are the uses of adversity." "It was Greek to me!" "The evil that men do lives after them, the good is oft interred with their bones." "Oh,

that way madness lies." "Thy face is as a book where men may read strange matters." "Throw physic to the dogs—I'll none of it!" "To the last syllable of recorded time." "Murder will out." "A blinking idiot." "A Daniel come to judgment." "A good deed in a naughty world." "Ill met by moonlight." "Night and silence—who is here?" "Lord, what fools these mortals be!" "A heart as sound as a bell." "Put money in thy purse." "Thereby hangs a tale." "The green-eyed monster." "Trifles light as air." "A foregone conclusion." "This sceptred isle." "Call back yesterday." "Uneasy lies the head that wears the crown." "I am not in the giving vein today." "A horse, a horse, my kingdom for a horse!" "That which we call a rose by any other name would smell as sweet." "A plague o' both your houses!" "I am Fortune's fool." "The dark backward and abysm of time." "A very ancient and fish-like smell." "Time hath a wallet at his back in which he puts alms for oblivion." "Dost thou think, because thou are virtuous, there shall be no more cakes and ale?" "Why, this is very midsummer madness." "My salad days, when I was green in judgment." Shakespeare fills seventy-six pages of the *Oxford Book of Quotations.*

Indeed, if there is one area in which Shakespeare lacks moderation, it is the world of words. Here he is, in turn, excitable, theoretical, intoxicated, impractical, almost impossible. He lived in a period drunk with words, and he was the most copious and persistent toper of all. He was an inventor of words on a scale without rivalry in English literature—Chaucer, fertile though he was, came nowhere near. There are different ways of calculating how many words Shakespeare coined: one method puts the total at 2,076; another at about 6,700. There were 150,000 English words in his day, of which he used about 20,000, so his coinages were up to 10 percent of his vocabulary—an amazing percentage.[14] Some were words he took out of the common stock of speech and baptized in print: abode, abstemious, affecting, anchovy, attorneyship, weather-bitten, well-ordered, well-read, widen, wind-shaken, wormhole, zany. He created words by turning nouns into verbs and vice versa, or by adding suffixes. There are 314 instances of his using "un-" in this way, as when Holofernes says in *Love's Labours Lost* that Dull is "undressed, unpolished, unconcealed, unpruned, untrained or, rather, unlettered, or,

rather, unconfessed fashion." Some of these "un-" words, such as uncomfortable and unaware, rapidly became common use. He added "out-" too—outswear, outvillain, outpray, outfrown. Some of these neologisms did not catch on. There were 322 words that only Shakespeare ever used. Others, as noted above, caught on fast—bandit, for instance; ruffish; charmingly; tightly. Some words were rejected at the time but then rediscovered in his texts by romantics such as Coleridge and Keats—cerements, silverly, and rubious, for example. Sometimes Shakespeare just had fun with coining words like exsufflicate or anthropophaginian. Or he flicked off expressions in sheer polysyllabic exuberance— "corporal sufferance" instead of bodily pain, or "prenominate in nice conjecture." Among his new, long words were plausive, waf- fure, concupiscible, questant, fraughtage, prolixious, tortive, insisture, vastidity, defunctive, and deceptious. (The last is a rival to "dublicitous," coined by an American secretary of state in 1981.) But although he could be polysyllabic and prolix for effect, Shakespeare used short English words of Anglo-Saxon origin to drive the plot forward and produce action, as in the tense, tightly written murder scene of *Macbeth*, where everything is cut to the dramatic bone. And he used short words for beau- ty, too, as in what many think his most striking poem, *The Phoenix and the Turtle* (1601), on the chill but powerful subject of pure, deathless love. These thirteen quatrains followed by five tercets are composed with virtuosic skill almost entirely of short, usually one-syllable, words.[15]

Phoenix was clearly written to be read aloud—if well spoken it is much more easily understood—and to a musical background, possibly to be sung. Reading Shakespeare to oneself, or watching it acted on a purely spoken stage, is a falsification, for the musi- cal dimension is omitted. The age was musical, the last spasm of the polyphonic art of the Middle Ages in which England led the world, and the theater reflected this love of music. Even the grim and gruesome Henry VIII composed music, and his daugh- ter Elizabeth fought tooth and nail to preserve the sacred musi- cal splendors of her Chapel Royal from the Puritan vandals. Shakespeare, as his verse—whether blank or rhymed—testifies, had a wonderful ear for sound, and that he loved music is

unquestionable—it runs in and out of his plays at every available opportunity, not just in the hundred songs but at almost every part in the acting. Elizabethan theater companies included actor-musicians and professional instrumentalists who could play difficult instruments like hautboys (oboes), horns, and trumpets in a variety of ways. Music was used to accompany onstage battles, duels, processions, and ceremonies; to signal doom or increase tension (as in movie and television drama today); to mark changes in character or tone in the action; to enhance magic and masques; and in general to add depth to a play. The prosperity of the Chamberlain-King's Men, the increasing size of their theaters, the taste of the times, and, not least, Shakespeare's own passion for music and his ingenuity in working it into his scenarios and verse meant that music played an increasing role in his work, especially in his last plays. *The Tempest* is a musical play, like the earlier, experimental *Midsummer Night's Dream*; so is *A Winter's Tale*. Shakespeare emphasized musical abstraction by casting his lines overwhelmingly in verse rather than prose and by stressing imagination and the metaphysical—even the supernatural—rather than realism, though, being the worldly man he was, he interpolates the earthy and the real, as in *The Tempest*, with vivid scenes of shipwreck and drunken comedy, to keep the feet of his audience firmly on the ground even while he was mesmerizing their senses.[16]

On many occasions Shakespeare's atmospheric musicians paraded openly onstage. At other times they played behind curtains or under the stage, which had a trapdoor and cavity for the use of gravediggers, prisoners, and similar underground characters.[17] Shakespeare several times made use of "sleep music" to induce slumber in his characters for dramatic purposes. In *The Tempest* Ferdinand is sung to sleep by the enchanting "Come unto these Yellow Sands." For *Henry IV, Part 1* (as we shall see), Shakespeare had use of a Welsh-speaking teenage boy who played the monoglot daughter of Glendower and sang her husband Mortimer to sleep with a Welsh lullaby. Shakespeare also used music and singing to broaden his character studies. Thus in *Measure for Measure*, Marianna's self-indulgence is emphasized by the song "Take, Oh Take, Those Lips Away!" In *Twelfth Night*

Feste's beautiful song "O Mistress Mine" tells us about the rela-
tionship between Sir Toby Belch and Sir Andrew Aguecheek and
their sovereign lady. In *A Winter's Tale*, at the end of the fifth act,
Paulina brings Queen Hermione's statue to life with the words
"Music! Awake her! Strike! Tis time. Descend. Be stone no more.
Approach!" It is not difficult to imagine the music accompany-
ing these dramatic words, which are immediately followed by the
reconciliation between Hermione and her husband, King
Leontes, and the rebirth of love with which the play ends.

Though some textual indications (alarums, excursions, etc.)
indicate particular instruments—trumpets signify the anger of bat-
tle; "ho'boys" signify fear creeping in—the texts rarely indicate the
musical comments that were frequent throughout a play. As
Shakespeare grew more experienced, it is possible to trace a steady
and impressive increase in artistry, both in the use of music and in
the many art songs themselves, in presentation. So modern pro-
ductions that are not "scored" or "orchestrated" leave out a dimen-
sion of the plays. That of course is one reason why Shakespeare's
texts lend themselves so easily (and often) to opera. The 200-plus
operatic versions mentioned earlier do not include the fashion for
"music plays" of the seventeenth century, which may have begun
during Shakespeare's lifetime but which certainly dominated the
reopened stage after the restoration of the monarchy in 1660, when
a music-starved public flocked to listen to musical adaptations of
plays, especially Shakespeare's. Purcell and Dryden played impor-
tant roles in this development, which saw *Macbeth*, *The Tempest,* and
A Midsummer Night's Dream established as favorites. The *Dream* also
inspired Purcell's *Fairy Queen* (1692), though the latter is more a
series of masques than a play and does not include settings of
Shakespeare's words.[18] The rage for musical versions of Shake-
speare was a nineteenth-century phenomenon that continued into
the twentieth century and on into the twenty-first. In musical
inspiration Shakespeare is easily ahead of all rivals, Goethe coming
next with about sixty musical settings; then Byron and Scott, with
fifty-five each; and Victor Hugo with fifty-two. Very occasionally
the composer excels the playwright—thus Verdi's *Falstaff* is a better
opera than *The Merry Wives of Windsor* is a play. But in almost every
other case the subtle verbal music of Shakespeare's texts defies

improvement by the composer. Verdi's early opera *Macbeth* is a travesty of that monument to poetic horror, Shakespeare's play; and the musical *Kiss Me, Kate*, though highly successful and often revived, mainly serves to set off the theatrical fun and brilliance of *The Taming of the Shrew*.

Shakespeare, then, was a virtuoso in words and sounds; and in his plays, though anxious always to follow a story line which is plausible and (when appropriate) historically accurate, he is equally, perhaps more, keen to create opportunities for his virtuosity. He quickly learned that, in the theater, an unsophisticated, perhaps uneducated, audience does not necessarily need to understand precisely everything that is said onstage in order to enjoy displays of verbal dexterity, ingenuity, and sheer poetry—a point also well understood by Molière, Shaw, and Stoppard. Shakespeare never forgot the groundlings, but he never lowered his sights either. He always gave his best, and stretched his intelligence and genius for words to its limits, knowing he could pull the public after him.

The two parts of *Henry IV*, written toward the end of the 1590s as the climactic year 1600 (the peak of Shakespeare's invention, the miracle time) approached, are wonderful exercises in stagecraft and sheer invention, creativity at its most active and unexpected. The last years of Elizabeth were a time of strident patriotism and also of war-weariness, the coexistence of two such incompatible emotions being precisely the kind of psychological paradox that Shakespeare understood and relished. He wanted to make a theatrical epic of the doings of the great soldier-king Henry V, who combined an overwhelming victory with a superb peace. But to do this he needed—or felt he needed—to present Henry's youth and show how Henry became the man he was as king. This was not easy. The historical records, as reflected in sources like Holinshed's Chronicles, Hall, and so forth, show that "Harry of Monmouth" began his military experience in his early teens on campaign with Richard II in Ireland, and that thereafter, with heavy military responsibilities in Wales and on the northern borders—sometimes both at once—he was rarely out of the saddle and camp. But like other battle-hardened young men he could also be dissolute, and stories about an unruly youth got about. Shakespeare, unwilling to accept the marvelous Henry V as a natural development from the teenage warrior Harry,

seized on such tales to create a prolegomenon to his epic, a satisfy-
ing study in repentance and redemption.[19] It did not quite turn out
like that. Creative forces in a writer, as Shakespeare was always dis-
covering and as anyone who studies the creative process knows
well, have an inveterate habit of taking over and calling the score.
Thus *Henry IV* elongated itself into two formidable plays, among
the best Shakespeare ever wrote, which proved enormously popu-
lar, being printed during Shakespeare's lifetime in quarto and
duodecimo, more often than any other of his works.

Shakespeare was already an expert in theatrical counterpoint,
the interplay of comedy and seriousness (or tragedy), marking the
contrast by putting the former in prose—often racy dialogue or far-
cical bombast—and the latter in blank verse. In the first part of
Henry IV he raises counterpoint to a new art form. For this purpose
he invents two extraordinary characters, Hotspur and Falstaff. I say
"invents," but both were real, Hotspur being Earl Percy, son and co-
rebel of the duke of Northumberland, who led Henry IV a danger-
ous dance; and Falstaff being based on Sir John Oldcastle, a Lollard
knight. Indeed Falstaff was originally called Oldcastle, but Oldcas-
tle's family, powerful at court, kicked up such a fuss at seeing their
forebear caricatured that the author changed the name (and nearly
ran into more trouble with the family of the great warrior Sir John
Fastolf).

Still, these two characters are essentially Shakespearean inven-
tions. Hotspur is designed to contrast, as a bellicose and manly fig-
ure, with young Harry Monmouth's dissolute pub-crawling.
Hotspur takes himself by the scruff of the neck and appears fully
rounded: hotheaded, angry, and short-tempered, but beguiling and
straightforward—a man who loves horses and war; hates gassing; is
truthful, loyal, and brave; has huge sex appeal (to both sexes,
indeed); is impossible to dislike. This is one of the greatest parts
Shakespeare ever wrote, and it was the favorite of Laurence Olivier—
I was lucky enough, as a teenager, to see him perform it gloriously
in 1945—fitting his peculiar gift for leaping about the stage bel-
ligerently, shouting poetically, and, not least, dying with dramatic
pathos. Shakespeare is forced by the logic of his own escaped cre-
ation to oblige Harry Monmouth to apologize to Hotspur for
killing him, and he gives the dying antihero-turned-hero a wonder-

ful death speech, ending in a spectacular stammer, for Hotspur cannot pronounce his *w*'s and so cannot say his last words "I am food for w—" (worms).

The death of Hotspur almost turns *Henry IV, Part 1* into a tragedy, for earlier, in Act II, scene iv, Shakespeare shows the warrior in a touching scene with his adoring but perky wife, Kate, the two exchanging brilliantly animated dialogue and the antiwar Kate trying to stop him from going off to campaign, calling him "Mad-headed ape" and "paraquito," and saying, "A weasel hath not such a deal of spleen as you are tossed with." This relationship broadens out, in Act III, scene i, into the finest scene Shakespeare had yet written. It provides a chance for a virtuoso actor to display Hotspur's charm, rage, and skill with words and to knock all the other actors into the corners with the sheer power of Hotspur's personality. Hotspur has another, longer, love scene with Kate, itself in counterpoint with a love exchange involving Mortimer, who has married the daughter of Owen Glendower, the Welsh prince and magician. The princess can speak no English, only Welsh, but she sings Mortimer to sleep marvelously, as even Hotspur has to admit. Hotspur is a man who hates verbosity in any form, despises euphemisms; anything smacking of what we would now call the politically correct he repudiates. He dislikes suburban genteelism and rebukes Kate for her dainty swearing:

> Heart, you swear like
> A comfit-maker's wife: Not you, "in good sooth!" and
> "As true as I live" and
> "As God shall mind me!" and "As sure as day!'
> And giv'st such sarcenet surety for thy oaths
> As if thou never walk'st further than Finsbury.
> Swear me, Kate, like a lady as thou art,
> A good mouth-filling oath.

All this is said with love. Hotspur plainly adores his Kate, even as he is winding her up, and she knows it. But for Owen Glendower, the Welsh windbag—the first Welsh windbag in history—he has nothing but contempt, not believing a word of Glendower's boastful claims of his ability to summon supernatural aid:

Glendower: I can call spirits from the vasty deep.
Hotspur: Why, so can I, and so can any man;
 But will they come when you do call for them?

Hotspur, Glendower having left the stage for a moment, tells his son-in-law, Mortimer, and his uncle, Worcester, that he is tired of the man's "mincing poetry" that "sets my teeth on edge," tired of being told of finless fish, molten ravens, clip-winged griffins, crouching lions, vamping cats, and such "skimble-skamble stuff" (a Shakespearean invention). Hotspur says that Glendower kept him up, the previous night, "at the least nine hours," by telling him the different names of the devils "who were his lackeys." Then comes a wonderful metaphor:

O, he is as tedious
As a tired horse, a railing wife
Or a smoky house. I had rather live
With cheese and garlick in a windmill, far,
Than feed on cakes and have him talk to me
In any summerhouse in Christendom.

What Shakespeare discovers, in writing this play, is the value of persiflage or colorful abuse for livening up a theater, a device rediscovered again and again by playwrights, notably John Osborne in his revolutionary work *Look Back in Anger* (1956).

This brings us to Falstaff, both the dispenser of persiflage and, still more, its object, as we learn immediately when he appears and asks Prince Hal for the time:

Prince Harry: What a devil hast thou to do with the time of
 day? Unless horns were cups of sack, and minutes capons,
 and clocks the tongues of bawds, and dials the signs of
 leaping houses, and the blessed Sun himself a fair hot
 wench in flame-coloured taffeta, I see no reason why thou
 shouldst be so superfluous to demand the time of day.

Thus succinctly and eloquently is Falstaff presented to us, full-grown in sin and ridicule, and thereafter he is truly launched to

fend for himself. He is progressively revealed as a soldier and a swordsman—he always carries a sword or has one handy, talks sword drill ("Thou knowest my old ward: here I lay and thus I bore my point"), and even has some military pride, saying he is ashamed of his feeble drafted men ("I'll not march them through Coventry, and that's flat"). He is a gross, obvious, and implausible liar, nevertheless declaring his passion for truth ("Lord, lord, how this world is given to lying! . . . Lord, lord, how subject we old men are to this vice of lying!"), and an arrant coward posing as a man ("Instinct is a great matter, I was a coward by instinct"). He is a thief and a parasite ("Hook on! Hook on!"), who not only borrows money he has no intention of repaying, from his rich old fellow student ("We have heard the chimes at midnight"), but sponges on the tavern keeper Mistress Quickly to the point where she is almost bankrupt. He is, by any normal standards, a thoroughly bad and worthless man. Yet he appeals to us because he does not mind abuse, is without malice, and remains good-humored almost to his deathbed, when "a babbled o green fields."

More importantly, Falstaff is a philosopher, albeit a comic one, who soliloquizes in prose on many of the chief topics of life. The plays hinge on honor and what it means, its worth, and how to win it. Hotspur searches for honor seriously but has no illusions:

> By heavens methinks it were an easy leap
> To pluck bright honour from the pale-faced Moon,
> Or dive into the bottom of the deep,
> Where fathom-line could never touch the ground
> And pluck up drowned honour by the locks.

To this, in a splendid piece of counterpoint, Falstaff has a riposte in Act V, when Prince Harry, goading him into battle, says, "Thou owest God a death." Falstaff, left alone and afraid, admits "Honour pricks me on" but adds, "How if honour pricks me off when I come on? How then? Can honour set-to a leg? No. Or an arm? No. Or take away the grief of a wound? No. Honour hath no skill in surgery, then? No. What is known? A word. What is that word 'honour'? What is that 'honour'? Air. A trim reckoning! Who hath it? He that died o'Wednesday. Doth he feel it? No.

Doth he hear it? No. Tis insensible, then? Yea, to the dead. But will it not live with the living? No. Why? Detraction will not suffer it. Therefore I'll have none of it."

This piece of cold realism is the rational hinge on which the plays turn. Perhaps it ought to be read out at every presentation of medals at Buckingham Palace or the White House.

Although Falstaff's counterpoint with Hotspur is the highlight of the play, it is merely one of Falstaff's soliloquies, which are, as it were, a comic adumbration of the long poetic philosophizings of Hamlet, which Shakespeare was to write a year or two later. Falstaff's thoughts, spread over the two plays, cover a huge range of subjects; they give his character depth and width, subtlety and sinewy cogitation; they make him, in their own way, a formidable commentator on life. Here are the chief subjects he covers: the need for a horse; cowardice and roguery; compulsion and its evils; instinct; the trials of being old and fat; the fear of getting thin, and of death; being robbed; his dreadful recruits; a dead hero; himself rising from the dead; lying; having a boy page; security; his own eternal youth; the dreadful "consumption" of his purse; smoothie-chops; the weaknesses of old men; his personal valor; the disadvantages of drinking and the corresponding value of sherry and sack; and, finally, the need for foolish fellows to provide a subject for jokes. Falstaff argues that life is hard and laughing essential to endure it. Hence he presents himself as a valuable creature, not only witty in himself but "the cause of wit in others"—and we agree.

In the second part of *Henry IV* we see little of Prince Hal with Falstaff. That joke is over, and indeed ended when the prince, as soon as he became king, rejected his old drinking companion so brutally that Falstaff was too shocked to soliloquize. Falstaff reels off to darkness and death, recorded early in *Henry V* when his deathbed is harrowingly and touchingly described by Mistress Quickly. Instead, in *Henry IV, Part 2* we see Falstaff twice—on his way to battle and on his return, with his old student friend Shallow in his Gloucestershire country fastnesses. Shakespeare rarely deals with the countryside proper, preferring—perhaps with his London audience in mind—arcadian fantasias such as the Forest of Arden in *As You Like It* to rural realities. But in Act

III, scene ii, we meet the heart of rustic England as Shakespeare himself knew it in his native Warwickshire. Falstaff comes to raise troops by "pricking" them for the draft, under Shallow's supervision as a justice of the peace, and he and his contemporary reminisce about their supposed wild doings as students at the Inns of Court—doings which Falstaff tells us are largely imaginary—and the episode ends with one of his soliloquies on the tendency of elderly gentlemen to invent stories about their youth. The scene is very well done—Shakespeare at his adroit best—and it serves to indicate that Falstaff, despite his country origins, is no longer at home there: he has become a metropolitan denizen, seeing country folk as fit only to be exploited.[20]

Falstaff is at home in the London underworld, and Shakespeare shows it to us in Act II, scene iv, one of the finest pieces of theatrical low life ever written and a superb example of tragicomedy involving deadly persiflage leading up to a sword exchange between Falstaff and his Ancient (or under-officer) Pistol. This scene shows us two virtuoso exponents of vulgar abuse in action—the tavern whore Doll Tearsheet, and the half-educated Pistol, who has picked up a smattering of classical lore together with a muddled acquaintance with Christopher Marlowe's play *Tamerlaine*. Doll calls him "the foul-mouthest rogue in England," and when Pistol, drunk, makes a lascivious grab at her, she lets fly. "What you poor, base, rascally, cheating, lark-linen mate! Away, you mouldy rogue, away, I am meat for your master. . . . Away you cutpurse rascal, you filthy bung, away! By this wine, I'll thrust my knife in your mouldy chaps an you play the saucy cuttle with me! Away, you bottle-ale rascal, you basket-hilt stale juggler, you!"

Pistol replies in his own brand of mangled verse. Mistress Quickly is a malapropist of quality, who tells Pistol to "aggravate your choler." But Pistol is something more, a man who pounces on classical names and uses them without knowing what they signify. He compares the angry Doll to Irene ("Have we not Hiren here?") and threatens to drown her "In Pluto's vile lake" wherein are "Erebus and tortures vile!" He asks in his wrath:

Small pack-horses
And hollow pampered jade of Asia,

Which cannot go but thirty miles a day,
Compare with Caesars and with cannibals
And Trojan Greeks?

Well might Mistress Quickly comment: "By my troth, captain, these are very bitter words." They are certainly confusing ones, and they are followed by a mass of others. To get rid of him Falstaff is obliged to use a rapier, and "hurt him i' the shoulder," provoking Doll's admiration. The two end the scene in a bed off-stage before Falstaff goes off to the wars.

It is gritty realism and grimly comic, indicating that Shakespeare was familiar with low city taverns and their habitués, or at least knew how to conjure them up in words. But the scene has a serious point. At the close of the 1590s, thanks to the expeditions England had sent to France, Flanders, and Ireland, drunken soldiers were familiar and much detested figures in London. Particular opprobrium attached to the title "captain," once honorable, now common, and with a dreadful reputation for insolent and riotous behavior, so that Mistress Quickly uses "swaggerer" as a deadly term of abuse and horror—"I am the horse when one says 'swagger.' Feel, master, how I shake, look you, I warrant you." Doll sneers at Pistol's elevation to the rank of commissioned officer—"God's light, with two points on your shoulder! Much!" Two points made him only a lieutenant, but Mistress Quickly addresses him as "captain" and Doll adds:

Captain? Thou abominable damned cheater, art thou not ashamed to be called captain? An captains were of my mind they would truncheon you out, for taking their name on you before you have earned them. You a captain? You slave! For what? For tearing a poor whore's ruff in a bawdy house? He, a captain? Hang him, rogue, he lives upon mouldy stewed prunes and stale cakes!

She adds: "These villains will make the word . . . odious" (that is, the word "captain"); "therefore captains had need look to 't."

Queen Elizabeth herself would have agreed heartily with Doll's sentiment. She was incensed by the inflation of captains,

and watched with dismay when they demanded knighthoods for their services, and were even given knighthoods by Essex in Ireland, using his vice-regal privileges—the scandal of the "Essex knights" was one of the steps leading to his final downfall.[21] Queen Elizaebth saw *Henry IV, Parts 1 and 2* at court and thoroughly approved. In her reading of the plays, Shakespeare was protesting about the shocking behavior of overpromoted military men, be they captains or knights, and holding them up to well-deserved ridicule. Hence the old tradition that she personally asked Shakespeare to "continue the fat knight in the play more, and show him in love." She was so eager to see it acted, runs another tradition, that she commanded it to be finished in fourteen days and was very well pleased with the representation. The result was *The Merry Wives of Windsor*, given at the castle itself on 23 April, the evening of the annual Garter ceremony. Written in a fortnight and not at the author's own choosing as to plot or anything else—he may well have been sick of the fat knight by this point—the play is not vintage Shakespeare but a commercial farce fit for a one-night stand. It contains some memorable phrases nonetheless—"The King's English" makes its first appearance, and "all the world's mine oyster"—plays surprisingly well, and is often performed. It is written almost entirely in prose and is the only play of Shakespeare's with a contemporary setting in an actual English town. The merry wives show a cunning acquaintance with topical idiom, especially lawyers' talk and printers' argot. But Falstaff is a mere butt. His soliloquies are strangely absent, and it was left to Verdi, 300 years later, displaying an astonishing skill in matching notes and sounds to words, to raise the fat knight into immortality again.[22]

Shakespeare, by now, had his mind on other things, above all his greatest creation, perhaps the most formidable, extensive, complex, subtle, and penetrating work of art ever carried to perfection, making the works of Leonardo and Michelangelo, Beethoven and Mozart, Dante and Goethe seem inferior by comparison—*Hamlet*. Shakespeare wrote this play at the summit of his powers, and that fact shows in almost every line. The play is long, very long. The idea came from a twelfth-century Danish folktale written in Latin by Saxo Grammaticus, and was retold by

François de Belleforest in his *Histoires Tragiques* (1570). From 1589 on there are references to an English tragedy of Hamlet, but the text has been lost irrecoverably. The play is a revenge play, and since the murder takes place before it opens, and the act of revenge cannot occur until the last scene, a huge dramatic hole has to be filled in. Shakespeare took the main plot as he found it, but he added the Ghost of Hamlet's father; the coming of the actors; and the performance of a play within a play to test the reaction of King Claudius, the suspected murderer; the terrifying scene between Hamlet and his mother after it; Ophelia's madness and drowning; Osric; Forinbras; the role of Laertes as an avenger; the grave digger and the churchyard funeral; and much else. Most of all, however, he expanded Hamlet's own revenge role into an immensely complex and difficult (but always likable, indeed lovable) character, whose will to act is paralyzed by endless streams of thought which crowd into his brain and which he expresses in superb poetry.

Shakespeare's mind was always fertile—full of ideas and ingenious ways of expressing them—but at this particular juncture in his writing life his creative impulses were so powerful, and his skill in expressing them was so rapid, sure, and inexhaustible, that he not only fills the hole but constantly enlarges it and pours in more so that it overflows. At some time during the play's editing and its early history onstage he seems to have discarded passages, many of which are fine, to bring the performance time down to reasonable limits. Even so, the play is very long; if enacted in full and with suitable intervals, it lasts five hours or more. I acted Hamlet in my last year at school—it is, curiously enough, despite all its sophisticated subtleties, the one great part in Shakespeare that a schoolboy may perform with some chance of success—and at the time I came to know by heart not only the frighteningly long central part but virtually the entire play. I had to cut it for performance down to three hours or so, and found the cutting a painful, almost unendurable process. For the lines contain no fat, only meat, and meat of such quality that to cast any portion aside seems a crime against art.

What is required of the actor who plays Hamlet—and all actors, all over the world, strive to do so at least once in their

career—is a rare gift: the ability to speak his lines with all deliberate speed but in such a way so as to convey their meaning clearly to the audience, and lose none of their poetry. John Gielgud, whom I saw when I was a teenager and on whom I modeled myself, had this ability to an unusual degree, and grappled with the part most manfully and beautifully. But there is so much of it anyway, and the play is so rich in drama and fascinating mysteries, that a bad performance, despite its length, is rare. It was popular from the start and has remained so ever since, all over civilization, and beyond.

The play is doom-laden, atmospheric and dark, lit by flashes of light springing from its sudden scenes of vivid action. It opens in darkness on the battlements; the Chamberlain's Men's professional theaters, with their levels, were peculiarly well suited to platform scenes, and the skill with which Shakespeare makes use of them is admirable. Then comes the Ghost, a terrifying and tortured figure, the part Shakespeare chose for himself—and one can understand why. The Ghost's appearance and words underline the message of foreboding the soldiers on the platform have already hinted at: "Something is rotten in the state of Denmark"—or England, or wherever *Hamlet* is played. We have here, right from the start, a general analysis and criticism of society, presented as a body subject to debilitating disease.

Hamlet is there to cure the ills of the state—to "reform it utterly," to use his own term, but he deplores the fate which has given him this role: "O cursed sprite, that ever I was born to set it right." *Hamlet* is a play of delays, and the delay in allowing the prince to appear is indicative of its whole tone: he misses the opening scene entirely; and in the big court scene that follows, he joins the dialogue late and reluctantly and brings the doom and gloom—and night—of the battlements right into the glitter of the royal circle. There is no sunlight in the play, except perhaps wan glimpses in the graveyard scene, and it takes place almost entirely in the interior, mainly within a medieval castle with its massively thick walls, small windows, and endless shadows. Hamlet emphasizes the darkness with his "customary suits of sable black" and he never smiles, except in mockery, contempt, or savage exultation.

It is vital to grasp that Hamlet is a magnetic figure: tall,

handsome, radiating the masculine glamor of his warrior father and the evident physical appeal of his sensual mother, still beautiful even in her forties (or fifties). He is clever, brilliant indeed, very knowledgeable over a wide range of subjects, graceful, eloquent, respected everywhere and by all for his appearance and talents as much as for his status. He is a paragon; and when Ophelia, a young girl indeed but with her father's brains and sensitivities of her own, sees Hamlet in desperate mental agony, she is driven to exclaim:

> O what a noble mind is here o'erthrown!
> The courtier's, soldier's, scholar's, eye, tongue, sword,
> Th' expectancy and rose of the fair state,
> The glass of fashion and the mould of form,
> The observed of all observers, quite, quite down!

This Hamlet, then, is a splendid personage, and the play is pervaded by a sense of waste and loss, first at his inability to act, then by death. The soldiers on the platform expect him to take charge, the king and queen expect him to enliven their court, the actors take it for granted he will direct them in their profession— all turn to him, waiting for a lead. But here's the rub, as Hamlet puts it. He is a thinker. He lives and acts in his head, not his body. (And when he does act, it is on impulse, without thought and thus rashly.) He is aware of his besetting weakness; and early in the play, reflecting on the powerful state his father ruled, and deploring its dissipation, which "takes from our achievements," he pounces on his own sin:

> So, oft it chances in particular men
> That, for some vicious work of nature in them—
> As in their birth, wherein they are not guilty,
> Since nature cannot choose his origin,
> By the o'ergrowth of some complexion,
> Oft breaking down the pales and forts of reason,
> Or by some habit that too much o'erleavens
> The form of plausive manners—that these men,
> Carrying, I say, the stamp of one defect,

> Being nature's livery or fortune's star,
> His virtues else, be they as pure as grace,
> As infinite as man may undergo,
> Shall in the general censure take corruption
> From that particular fault.

Of course, what Hamlet and the Ghost see as a fault, we—the audience, the readers—see as a virtue. It is Hamlet's thoughts, the need to express which, with all his poetic power, inhibits his action, that make the play. His head contains a philosophy of the world, and he periodically delves into this interior well of reflection to raise copious vessels of crystal words.

He begins this process when the court retires to feast in Act I, scene ii, and Hamlet, already despairing and feeling impotent, reflects on suicide, the weariness of the world, the perfidy of his mother ("Frailty, thy name is woman") and the wickedness of incestuous lust. In Act I, scene iv, he sees the Ghost and gives a shout of prayer and horror—"Angels and ministers of grace defend us!"—followed by an anguished and complex question about the meaning of a supernatural entrance into normal life. After the Ghost has spoken his message, Hamlet talks of memory, duty, the need to record resolution, the taking of oaths to action. He tells the men on the platform, his friend Horatio in particular, "There are more things in Heaven and Earth, Horatio, than are dreamt of in your philosophy," and it is at this point that he decides on a policy of dissemblance, feigning madness, and bids his friends to swear silence and help. It is important to grasp that, throughout the play, Hamlet, while expressing often penetrating and highly rational sentiments, is in a highly disturbed state: his so-called madness is merely a hyperextension of his inner turmoil. Hamlet is on the brink of a breakdown but never over it, and his perilous and exposed position on his "cliffs of fall" gives him an extraordinary clarity of sight and expression, so that he blazes with insight.

Ophelia, as always, comes close to seeing what is happening, without understanding whence or why. He looked at her, she says, as if he would paint her portrait, then

raised a sigh so piteous and profound
That it did seem to shatter all his bulk
And end his being.

He went out of the room, she relates, blindly but with his eyes
fixed on her ("to the last bended their light on me"). Hamlet sees
the innocent girl as the one point of virtue and grace in the deca-
dent, soiled court, but he also, reflecting on the weakness of
woman, fears that she is already corrupted; and in Act III, scene i,
he speaks harshly to her and pours out of his overflowing anxi-
eties a torrent of desperate fears about the wickedness of the
world—especially for women—and bids her go to a nunnery to
escape them.

Just before this he has baffled Polonius with his reflections
on age ("Though this be madness," the old man says, "Yet there is
method in it. . . . How pregnant sometimes his replies are!").
Hamlet then greets the sinister Rosencrantz and Guildernstern
with a number of shrewd and fascinating remarks ("There's
nothing either good or bad but thinking makes it so") and a
magnificent discourse in prose—the most scintillating prose pas-
sage Shakespeare ever wrote—on how he sees the world as a "ster-
ile promontory" and the air, "this majestical roof fretted with
golden fire," as "a foul and pestilential congregation of vapours."
There follows a passage on the nobility of human—"What a piece
of work is a man! How noble in reason, how infinite in faculty, in
form and moving how express and admirable, in action how like
an angel, in apprehension how like a God"—and so forth. When
Hamlet has dealt with the players, giving them a brilliant lesson
in speaking and acting, he is led to reflect on his cowardice and
inactivity, his inability to match a player's passion with his own,
though his anguish is real, not assumed. He rages at himself and
at the king:

I am pigeon-livered and lack gall
To make oppression bitter, or ere this
I should a fatted all the region kites
With this slave's offal.

But he then bids his brain work and plot, and conceives the scheme of enacting a play to shock the king into admitting his guilt. He follows this, just before his fateful meeting with Ophelia, with the most painful of his soliloquies, again reflecting on suicide ("To be, or not to be, that is the question") and the choice between life and death, decided more by fear than by reason. He tells the players how to perform his inner play, dispensing much wisdom—no professional actor can fail to learn something from Act III, scene ii—then speaks to Horatio on the virtues of friendship and the grace of simplicity of spirit ("Give me that man that is not passion's slave"), then takes his friend into his confidence and bids him observe the king when the inner play is performed.

Then follows the heart of *Hamlet*, the play scene, and the king's terror, his anguished cry of "Lights, lights!" to drive away the darkness which, as always in the play, is crowding on the scene. To Rosencrantz and Guildernstern, sent to summon him to attend his mother, Hamlet compares himself to a pipe, on which they are playing, "to pluck out the heart of my mystery," adding "and there is much music, excellent voice in this little organ." As the darkness becomes even more stygian, Hamlet says to himself:

Tis now the very witching time of night
When churchyards yawn, and hell itself breathes out
Contagion to the world. Now could I drink hot blood.

But he also commands himself not to hurt his mother—"I will speak daggers to her, but use none." On his way, he sees the king, unprotected, praying. "Now might I do it pat," says Hamlet, but again stays his hand, as he fears that to kill Claudius now, in an odor of sanctity, will send the wicked man to heaven or at least save him from hell—"O, this is hire and salary, not revenge." He cannot know that the king is unable to pray sincerely, and despite all his power and position fears divine retribution:

In the corrupted currents of this world
Offence's gilded hand may shove by justice,
And oft tis seen the wicked prize itself

Buys out the law. But 'tis not so above.
There is no shuffling, there the action lies
In his true nature, and we ourselves compelled
Even to the teeth and forehead of our faults
To give in evidence.

It is as though Hamlet's subtle, sometimes confused but
always honest, musings have inspired the king, too, to think in
moral terms, even though he cannot repent materially by giving
up all he has acquired by murder. *Hamlet* is a profoundly moral
play, showing morality (as well as evil) to be contagious. The
queen, intending to read Hamlet a lecture, is instead inspired by
his passionate arrival (in which he kills the hidden Polonius) and
his accusation that she has committed

such a deed
As from the body of contraction plucks
The very soul, and sweet religion makes
A rhapsody of words,
And left a noble man for a villain.

He speaks with such power that she is transformed and can-
not bear him to continue:

O Hamlet, speak no more!
Thou turnst mine eyes into my very soul
And there I see such black and grained spots
As will not leave their tinct.

He gives her a pointed lesson on the subject of sexual conti-
nence, and admits, "I essentially am not in madness, But mad in
craft." Thereafter the queen edges away from her husband and
toward her son.

The play now moves inexorably toward its conclusion. Ham-
let is sent to England; discovers Claudius's plot to have him
killed; returns; and, in the graveyard, finds the drowned Ophelia
about to be buried. His reflections on the dead, on death, on
oblivion and the rotting of the proud, the successful, and the all-

powerful in the cold earth, and his exchanges with the grave digger, make one of the best scenes in the play—among the most pregnant Shakespeare ever wrote—working up to the moment of action when he leaps into the grave, gathers Ophelia into his arms, and quarrels fatally with her brother Laertes. This leads directly to the duel and the murderous climax of the play with all the principals—king, queen, Laertes, Hamlet himself—dead on the stage.

It is characteristic of this stupendous drama that the long passages of heroic reflection, which never bore but stimulate, are punctuated by episodes of furious action, the whole thing ending in a swift-moving climax of slaughter. No one can sit through *Hamlet* and absorb its messages—on human faith and wickedness; on cupidity, malice, vanity, lust; on regeneration and repentance; on love and hate, procrastination, hurry, honesty, and deceit; on loyalty and betrayal, courage, cowardice, indecision, and flaming passion—without being moved, shaken, and deeply disturbed. The play, if read carefully, is likely to induce deep depression—it always does with me—but if well produced and acted, as Shakespeare intended, it is purgative and reassuring, for Hamlet, the confused but essentially benevolent young genius, is immortal, speeding heavenward as "flight of angels sing thee to thy rest." It is, in its own mysterious and transcendental way, a healthy and restorative work of art, adding to the net sum of human happiness as surely as it adds to our wisdom and understanding of humanity.

All Shakespearean texts are enlivened, almost bejeweled, with words and phrases which he has sewn into them from the great caskets of his verbal inventions. They become part of our language, sometimes of our daily speech; often when we search our minds for something special to say or write, Shakespeare comes to our aid—nowhere more so, or more frequently, than in *Hamlet*. It is his jeweler's shop, not so much of conscious quotation as of instinctive ownership of memorable phrases, which are part of our heritage, so that when we use them we are almost—even quite—unaware of speaking *Hamlet*'s lines. Shakespeare has scattered a basketful of verbal confetti over our common speech. "Hoist with his own petard." "Such divinity doth hedge a King." "Sweets to the sweet,

farewell." "The readiness is all." "A hit, a palpable hit." "The dead vast and middle of the night." "I know a hawk from a handsaw." "Caviare to the general." "Rich not gaudy." "A king of shreds and patches." "How all occasions do inform against me." "Shuffled off this mortal coil." "The time is out of joint." "Leave her to heaven!" "I must be cruel only to be kind." "To hold the mirror up to nature." "More in sorrow than in anger." "Wild and whirring words." "Abstract and brief chronicles of time." "This fell sergent, death, is strict in his arrest." "There's rosemary, that's for remembrance." "Absent thee from felicity a while." "Good night, ladies, good night sweet ladies." "It smells to Heaven." "There's a divinity that shapes our ends, rough-hew them how we will." "You must wear your rue with a difference." "A fellow of infinite jest." "There's a special providence in the fall of a sparrow." "Oh, my prophetic soul!" "A nipping and an eager air." "Neither a borrower nor a lender be." "Her privates we." "Hair stand on end like quills upon the fretful porcupine." "The play's the thing." And so on. We quote *Hamlet* almost as we breathe.

Shakespeare creates so fast, so often, so surely, so ubiquitously, not least so imperceptibly, that his creativity is woven into our national life as well as our literature, indeed the literature of the world. He reverberates in us. What more is there to say? We never hear of Shakespeare boasting—though the Elizabethans were, by and large, great boasters, vainglorious creatures. There is nothing in the records he left, his dispositions in law or fact, the things men said about him in his day or after his death, the traditions that surrounded his name, to indicate he had any awareness of his astonishing powers and the magnitude of his achievement. Yet must he not have known he was a great, an extraordinary man? If so, that is one topic on which this man of so many, and so potent, words chose to remain silent.

5

J. S. Bach:
The Genetics of the
Organ Loft

*J*OHANN SEBASTIAN BACH (1685-1750) is the best example
in our civilization of the importance of heredity or genes in
the development of creativity. Or perhaps it would be more accu-
rate to say that he illustrates how heredity can provide the foun-
dation from which creative genius of the highest order springs.
Nothing is heard of the Bachs before about 1550. Very little is
heard of them after about 1850. But during the 300 years in
between—that is, from the age of Luther to the age of Bismarck—
members of the Bach family, radiating from Thuringia all over
Germany and even beyond, constituted the human core of Ger-
man music, especially of its Protestant north. At times, the word
"Bach" became synonymous with "musician" in the world of
choir stalls and organ lofts.

Bach himself was keenly aware and modestly proud of his
family's musical heritage. In his industrious and systematic way
he investigated the family origins, tracing them back to the man
he regarded as their founder, Veit Bach, who flourished around
1540. Veit Bach was a baker, but his hobby was playing the
cythinger, or small cittern, and in the view of Bach, his great-
great-grandson, he was the founder of the family's musical
fortunes—though another Bach of Veit's generation, probably
his brother, called Hans Bach, founded another branch of the
family also prolific in musicians. So successful were Bach's inves-

77

tigations into the family history that, in 1735, he set down all he had found out in an elaborate document, the *Ursprung*. The original has not survived, but a careful copy of it made by his granddaughter, Anna Carolina Caroline Bach, in 1774–1775, has; and her father, Carl Philipp Emanuel, Bach's son, who inherited from his father not only formidable musical skills but a taste for dynastic history, made important additions to Anna's text, from his own knowledge and discoveries. The *Ursprung* reveals biographical data concerning eighty-five male members of the family, the overwhelming majority of whom were musicians. Modern musicology, epitomized in *The New Grove Dictionary of Music and Musicians*, lists eighty Bachs who were distinguished musicians of one kind or another. [1]

The Bachs lived mostly in the Thuringian duchies of Saxe-Coburg-Gotha, Saxe-Weimar-Eisenach, and Saxe-Meiningen and the principalities of Schwarzburg-Arnstadt, though they penetrated Saxony and north Germany as far as the North Sea and Baltic coasts, working in major towns like Leipzig, Dresden, Hamburg, and Lübeck. Their employers were, almost without exception, minor or middle-ranking German dukes, princes, and electors; churches and colleges; and municipalities. The Bachs were, without exception, middle class. None rose to riches. None fell into destitution. They were fervently philoprogenitive: Bach families of ten, twelve, or fifteen children were the norm, and J. S. Bach himself had twenty children by two wives. Some Bachs rose no higher than town trumpeter (though this was not a contemptible post: Rossini's father was one, and proud to be). Others were instrumentalists (especially violinists) or organists, combining the latter career with posts as choirmasters, conductors, and composers.

In the earlier generations, they often had to struggle to raise themselves above the rank of *Spielmann*, or singer, which did not entitle them to citizenship; later, they often rose to the higher ranks—professional titles, then and now, are of great importance in Germany—of *Kantor*, *Konzertmeister*, *Kappelmeister*, and *Stadtpfeifer*. Some of them made musical instruments, especially organs, violins, cellos, and claviers, or advised instrument makers. The Bachs married, almost without exception, wives from their own class, usually from musical families, who could combine annual child-

bearing with copying musical parts and performing in family concerts as singers or instrumentalists. The Bachs formed extended family networks of great resilience and helped each other in difficult times. They were overwhelmingly Protestant (usually Lutheran), churchgoing, pious, and law-abiding.

It must not be thought that the Bachs were dull. Some of the earlier Bachs played violins and other stringed instruments in taverns and dance halls. A sixteenth-century Hans Bach, ruffed and carrying a violin, survives in a contemporary print, with a vase in one corner:

> Here at his fiddling see Hans Bach!
> Whatever he plays, he makes you laugh.
> For he scrapes away in a style all his own
> And wears a queer beard by which he is known.

Two seventeenth-century Bachs, identical twins and both of course musicians, were so alike, especially when they chose to wear similar clothes, that even their wives could not tell them apart, and they could indulge in occasional wife swapping without their spouses' noticing. Their playing, too, was indistinguishable. One of these twins, Ambrosius, was the father of Johann Sebastian Bach. [2]

The Bach family was by no means the only one in early modern Europe to produce multiple musical virtuosos. Another outstanding example is the Scarlatti family, prominent in Sicilian music in the eighteenth century but also popping up in Rome and Lombardy. Of this tribe Alessandro Scarlatti (1660–1725), an older contemporary of Bach, was an outstanding composer of cantatas (see the list in *New Grove*, XVI, pp. 562–565) and the founder of the Neapolitan school of opera, with sixty-five operas to his credit, plus collaboration in a dozen more. One of his sons, Domenico Scarlatti (1685–1757), born the same year as Bach, also wrote operas but is chiefly known for his 555 keyboard compositions, especially sonatas, which he performed with outstanding skill. Four other Scarlattis achieved musical distinction, but many more made their living by the art. Five of Alessandro's siblings and three of his own children were professional musicians. [3]

Still, it was among German-speaking families that the musical traditions were strongest. The Hoffmanns, the Wilches, and the Lammerhirts were clans of performers and composers. Another example, the Webers, produced, in Carl Maria Weber (1786–1826), a composer of such gifts that, had not tuberculosis carried him off (one of a tragic group of victims at that time, which included Keats, Géricault, and Bonnington), he would now be in the ranks of the greatest men of music. The Webers were originally millers but flourished musically in Lübeck, where Carl Maria's father was music director of the theater and Kappelmeister to the bishop. (That would have been an unusual combination in Bach's day, when clerics who employed musicians on church work disapproved strongly of operatic connections; but times were changing by the 1790s.) The sons of the elder Weber's first marriage studied under Michael Haydn. (Michael and his famous brother Franz Joseph Haydn were not at all from a musical family; their father was a wheelwright.) Carl Maria's uncle, Fridolm Weber, had several musical daughters, and a book could be written about them. Josepha, the eldest, was a soprano, with coloratura quality, and Mozart wrote for her the role of Queen of the Night in *Die Zauberflöte*. He described her as "a lazy, gross and perfidious woman, and as cunning as a fox." Of her sister, Aloysia, Mozart said she had "a beautiful, pure voice." He fell in love with her, proposed marriage, was rejected, and then dismissed her as "false, malicious and a coquette." Third time lucky, he met their younger sister, Constanze, and married her—happily, one is glad to say. The youngest daughter, Sophie—"good-natured but feather-brained," according to her brother-in-law—was present during his last hours and wrote a touching account of them many years later, which she gave to his biographer George Nissen.[4] The Mozarts were likewise a musical family, though Mozart's grandfather was a bookbinder. Mozart's father, Leopold, was a fine violinist, a composer, and a musical theorist and teacher of distinction—Mozart was lucky in his parent, as he very well knew. Two of Mozart's sons started musical careers but did not get very far. His sister Maria Anna, or Nannerl, played the piano well. She composed, too, though none of her works survives. When Vincent and Mary Novello visited her in Salzburg in

1829, nearly forty years after her brother's death, they found her "blind, languid, exhausted, feeble and nearly speechless," living in great poverty and loneliness. [5]

This kind of neglect was less common in the Bach family, which looked after its own. Born in Eisenach, Luther's town, Johann Sebastian, the youngest child of eight, had a happy childhood until 1694, when his mother, daughter of a prosperous furrier, died; she was followed by his father in 1695. At nine, then, J. S. Bach was an orphan, and he and his brother Jacob were taken in by their elder brother Christoph. Thereafter, one relative after another came to J. S. Bach's aid, both in providing sustenance and in ensuring that he got a good musical education. (Bach reciprocated: a teacher of extraordinary gifts and innovative methods, he not only taught music to his six sons but also took in—free—among his pupils six male Bach nephews and cousins.) Bach's musicology was thus looked after by the family; but the truth is that once he had acquired a mastery of the keyboard (and the violin, which he played to a professional standard), and of musical notation, a process accomplished by his early teens, he became an autodidact and remained one all his life. Whenever he could, Bach (like Dürer) traveled to meet masters, such as Buxtehude in his case. He also traveled to try out fine organs he had heard about. But essentially he learned about music by poring over scores in music libraries and, whenever possible, copying them out himself. From the age of thirteen he spent countless hours copying French, Italian, and German composers, chiefly of organ music but also of other instruments and even ensemble scores. A story has been handed down that, at age fourteen, he wanted to study a certain score. His brother Christoph forbade it; he copied it out by moonlight; Christoph found the copy and kept it, and Bach did not get it back until Christoph died. There is another story that Bach, traveling in north Germany, was short of money and hungry and, outside an inn, fell on two fish heads thrown out of the kitchen window. To his astonishment each head contained a gold coin, and this little miracle enabled him to complete his studies and travels. [6]

Bach's career can be easily summarized. In 1702–1703 he was a violinist at the court of Weimar; from 1703 to 1707 he was organ-

ist at the Neukirche in Arnstadt. From June 1707 on he was organ-
ist at St. Blasius, Mulhouse; during this period he married his
cousin Barbara Bach. Then followed a job as chamber musician
and organist to the duke of Saxe-Weimar, from 1708 to 1717, and
seven children. In 1717 he became Kapellmeister to Prince Leopold
at Köthen. In 1720 Barbara died and Bach married a Wilcke, Anna,
daughter of a court trumpeter (so both his wives came from musi-
cal families). In April 1723 Bach became director of music at
Leipzig and Kantor of the Thomasschule there. He remained in
this city for the rest of his life, fathering a further thirteen children.
In his last years, fearing blindness, he submitted to two operations
by the traveling English eye surgeon John Taylor, who also operat-
ed on Handel. Both operations failed and may have hastened his
death, blind, on 28 July 1750.

Although Bach was in continuous musical practice for nearly
half a century, he was hardly what we would now call a celebrity. In
his first official post he was described as a "lackey" and all his work-
ing life he was at the beck and call of petty princes, church admin-
istrators, or town councillors, who often combined ignorance with
arrogance. When he wished to move from Weimar to Köthen, the
reigning duke was so incensed by the tone in which Bach handed in
his resignation that he imprisoned Bach for a month in the ducal
jail. The experience seems to have left no mark on Bach whatsoev-
er. Thereafter he was periodically involved in disagreements with
his often difficult superiors, especially in Leipzig. Bach's conduct
was uniform. He was the reverse of arrogant, but he had a quiet,
natural pride in his skills and performance and a shrewd sense of
what was due to him, in salary, responsibilities, treatment, assis-
tants, and deference. His demands were always reasonable; and it
must be said that his employers almost invariably ended by meet-
ing them. In return he rendered services which were always punc-
tilious and usually distinguished. Bach was by far the most
hardworking of the great musicians, taking huge pains with every-
thing he did and working out the most ephemeral scores in their
logical and musical totality, everything written down in his fine,
firm hand as though his life depended on it—as, in a sense, was
true, for if Bach had scamped a musical duty, or performed it with
anything less than the perfection he demanded, he clearly could

not have lived with himself. It is impossible to find, in any of his scores, time-serving repetitions, shortcuts, carelessness, or even the smallest hint of vulgarity. He served up the highest quality, in performance and composition, day after day, year after year, despite the fact that his employers, as often as not, could not tell the good from the bad or even from the mediocre. Bach's one taste of celebrity—and that was diluted—came in May 1747, when he was sixty-two and visited King Frederick the Great of Prussia at Potsdam. The king, a musician of some competence (as a flutist), gave him a theme and asked for a fugal improvisation, which Bach performed on the spot to general applause. Not content with this impromptu, Bach, on his return home, wrote it down, then used the result as the basis for an elaborate work in four parts for harpsichord, violin, and flute, which he called *Musikalisches Opfer* ("Musical Offering"), sent to the king, and published. [7]

If Bach had a fault, it was his cerebral but also instinctive and emotional insistence on the highest standards, in himself and others. It is important to grasp that Bach was not only a man of strong religious beliefs and great moral probity but a dedicated musician who felt that music was one way (and, to him, the best way) of speaking to and serving God. He was a rigorous Lutheran in creed, sometimes uneasy when serving Calvinist masters or Lutherans with strong Pietist leanings, but not (so far as we can see) bigoted. Indeed, by the standards of eighteenth-century Germany—where the Wars of Religion had ended as recently as his own childhood (and the Peace of Westphalia, which ended the devastating Thirty Years' War, had been signed just thirty-seven years before he was born)—he was ecumenical, certainly irenic. The vast majority of his religious compositions were written to be performed in a Lutheran church. But there is nothing in them offensive to non-Lutherans. Unlike his contemporary Handel, Bach does not exude Protestant religiosity. He could and did compose settings for the Latin liturgy and hymns. That, indeed, is how his Mass in B Minor began, with a setting for the Kyrie and Gloria, gradually expanding over the years into a complete Latin mass of astounding power and complexity, which could be, was, and still is—today more than ever—performed with equal enthusiasm and devotion by Catholics and Protestants. His great *St. Matthew Passion*, which together with the mass marks

the summit of his artistic achievement, is set in German, the ver-
nacular regarded as suspect for services by south German
Catholics. But, again, it is regarded with reverence by many Chris-
tians today as the most faithful and exalted musical presentation
of Christ's suffering and death. Bach was a Lutheran by birth, edu-
cation, taste, and, not least, loyalty. In a deeper sense, he was a
Christian, and his Christianity took the primary form of worship-
ping God through sound. That sound, whether performed by him-
self or others, had to be of the highest quality, always and
everywhere. Anything less would be an insult to the deity, or at best
a gross dereliction of duty. Moreover, quality was not enough. Bach
was aware of the great originality of his mind both in devising new
musical forms and in perfecting old ones. He knew he could serve
God best by demonstrating his originality. Hence he had a religious
compulsion to create; and his creations had to stretch his own
powers to the uttermost, and are therefore hard for anyone else to
play.

 Bach was criticized at the time, by those who did not under-
stand his religious motivation, for making high technical
demands, in instrument playing and singing, the norm for his
entire range of compositions. The musical theorist Johann
Adolph Scheibe (1708–1776) wrote of Bach in his periodical *Der
Critische Musikus* in 1737: "Since he judges according to his own
fingers, his pieces are extremely difficult to play; for he demands
that singers and instrumentalists should be able to do with their
throats and instruments whatever he can play on the keyboard.
But this is impossible." It is true that Bach, although he had been
a brilliant treble in his boyhood, was less interested in the voice
than in instruments, especially keyboard instruments. He cer-
tainly imposes hardships on the voice in many pieces. It is also
true that Bach wrote mainly for himself and for musicians direct-
ly under his control or supervision, and for pupils he was train-
ing for the highest pitch of accomplishment. He did indeed
publish some work, but not for the general musical public, and
least of all for amateurs. He published for professional musicians
of high quality who belonged to his school—a much narrower
group than, say, Handel's followers and admirers. Bach was
known and revered among the north and central German musi-

cal community, but beyond it his accomplishments were unrecognized (as a rule) and would not have earned him much repute even if they had been better known.

Even in Germany, and even among the musical community there, though Bach was seen as a great master, few (if any) then recognized the sheer scale of his achievement. Only nine of his significant works were published in his lifetime. Yet, unlike any other composer in history, Bach wrote examples (often in formidable numbers) of every type of music then known (opera alone excepted), usually deepening their seriousness and extending their variety, adding new dimensions by experimenting with fresh combinations of instruments or pushing the technical frontiers. His encyclopedic reach was a matter not of vision or vainglory but of work. He produced something new virtually every week of his life—one is tempted to say almost every day—since (like Dürer with his watercolors), Bach composed even when traveling. He wrote music in his head, memorized it, and only afterward tried it out on the keyboard (this information comes from his son Carl Philipp Emanuel). The output tended to reflect his current work, since he wrote (as a rule) for immediate performance—as, of course, did Shakespeare. Thus most of Bach's organ work was written while he was principally an organist, at Arnstadt, Mulhouse, and Weimar. At Köthen, as Kappellmeister, he specialized in chamber music. His vocal works date mostly from his long spell in Leipzig, though he also produced a vast amount of keyboard music during these years, for a variety of purposes. What we have of Bach today, despite two centuries of vigorous searches in archives, forms only a part of his output. He kept his scores about him during his lifetime, and his pupils sometimes copied them. At his death in 1750 the scores were divided among his surviving children and his widow; and it was then that the process of sale, dispersal, and loss began, continuing until the end of the eighteenth century, when his value began to be appreciated again. The losses were enormous—over 100 church cantatas disappeared without trace, and more than half his secular cantatas. Even so, what remains is astonishing. There are over 200 church cantatas, including a few doubtful ones; thirty-four secular cantatas; five masses, plus two settings

for the Magnificat, five from the Sanctus, and two other sections; six passions; eight motets; 253 chorales and sacred songs; 260 organ works, plus many "possibles" among those classified as "spurious or doubtful"; about 200 works for other keyboard instruments; seven works for lute; about forty chamber works and twenty-five for orchestra; and a dozen studies in canonic music and counterpoint. There are probably about 1,200 works all told, out of—perhaps—1,600 or 1,700 composed; a few are short, but only a tiny number are slight. Considering the amount of time Bach had to spend playing, conducting, arguing with officials, teaching, and copying, this output is astounding—the man was a copious, gushing, unceasing fountain of creativity.[8]

It is important to grasp that Bach's life, including his creative life, centered on the organ. Indeed, to appreciate his power fully, you need to know exactly how an eighteenth-century organ works, as well as how to play one—knowledge I do not possess. The reed is the oldest of all musical instruments—human beings learned to play on reeds at the time artists were painting the caves at Lascaux and Altamira—and mechanical reed players or organs go back at least to the early first millennium BC (in Greece). By Roman times, whether worked by water or by wind, organs were becoming sophisticated; there is a fascinating reconstruction of one organ, based on a surviving fragment, in the Budapest Museum. Organs continued to evolve throughout the Dark Ages, Middle Ages, and the early modern period, becoming larger and more intricate. Until the industrial revolution at the end of the eighteenth century, they were by far the most complex machines ever made—watches and clocks were sometimes as elaborate, but much smaller. Organs were, however, machines, not instruments—that is, the quality of the sound was produced not by human skill in manipulating keys or stops or covering holes with greater or lesser pressure, or by wielding bows with varying strength. All the organist and the keyboard can do is signal to the machine what note to play. The machine does the rest, and the quality of the note depends on how it is made and set. (A harpsichord has much the same mechanical character, but not a pianoforte, in which the pianist's hands are fully in control of the musical quality.) The second point about the organ as a

machine is that it deals in sound power, not music. Some early medieval organs could produce enormous sounds, but they tended to be noise rather than music. We know of one organ that required two players and seventy blowers, operating bellows, which produced a noise "like thunder." This might have some useful role in the liturgy or a service, but not a musical one. How to turn wind power into art is the central problem of playing the organ and composing for the organ, and I suspect it is one that will never be finally solved. Operating an organ is, and always has been, a source of great anger. A twelfth-century English drawing shows two organists, at a keyboard, shouting at fan bellows blowers and wagging furious fingers at them. These blowers may have been lazy, producing too little air power; or they may have been overzealous, producing too much—so that the sound emitted from the pipes horrified the players. We do not know. Even harder to portray in line is the continual warfare between those who play the organ and those who make organs. Since the eighteenth century, when the art of organ building began to mature, the builders have exercised enormous amounts of time, ingenuity, money, and creative energy on making organs capable of emitting the widest possible ranges of sound and every gradation of volume. They regard the organist as a constitutionally ungrateful creature for not showing the gratitude they feel they deserve. But organists are not so much ungrateful as angry at what they regard as the aural insensitivity of the makers, who construct machines that are impossible to play in a musical manner. I cite as an example of this anger the article on organ playing in the old *Grove's Dictionary of Music*, written by the great organist Dr. Percy Buck. He points out that inconsiderate, unmusical organ construction can produce horrible noises, which "all but the most hardened organ-players find insupportable"; or sounds which, while enjoyed by an uninstructed public, are distasteful to musicians. The article is written in a tone of despair. Buck makes five practical suggestions for improving the musicality of the organ, but he admits that the builders will take no notice: it is of no use for people like himself to give advice—"organ-builders with one accord seem to have set their faces against it." [9]

Bach himself was well aware of the tension between perform-

ers and builders, being personally involved in the design, building, rebuilding, testing, and repair of dozens of major organs in Germany. By his day the organ was a bewildering and often monstrous instrument. Often, a single instrument consisted of five distinct organs: great, swell, choir, solo, and pedal, sometimes with an echo, celestial, and altar organ as well. The pipes would be numbered in hundreds, sometimes thousands, with, for instance, nine different pipes to produce the same C: rohrflöte, quintadena, gedackt, Lieblich gedackt, flute dolce, spillflöte, nachthorn, salicet, and normprinzipal. All organs had four main parts: first, the mechanism for collecting and distributing wind, that is, the bellows, wind trunk, wind chest, and soundboard grooves; second, the key action or Klavier and key movement, which the organist controlled directly; these were supplemented, third, by the draw-stop action, controlling the type or types of pipes the organist was using; and fourth, the couplers and pedals, which created or refined composed sounds. The last three are the concern of the organist, and it was regarding the functioning of these controls, and the sounds they produced, that Bach chiefly dealt with the builders. During his day, and especially in the last twenty-five years of his life, magnificent organs were built all over Europe, particularly the great organs of Naumburg, Dresden, Breslau, Potsdam, Uppsala, Pisa, Tours, Paris, Gouda, Weingarten, Herzogenburg, and Haarlem. Bach saw and played on only two of these, but he was familiar with some great German organs built from 1700 to 1750, which were of comparable size and quality. No performer or composer of his age, perhaps of any age, knew more about organs than he did. His problem was how to use the vast resources of the eighteenth-century organ to produce the maximum quality and flexibility of sound in performance, and how to write organ music for such performances.

To do this, he mastered, refined, and expanded the musical science peculiar to organ playing (and, to a limited degree, to the harpsichord) known as registration. On an organ, the registers, or separate stops, control the "on" and "off" positions for the pipes, and so determine the entire tonal capacity of the instrument. By deciding which stops he uses, the organist settles the nature of the sound produced, as opposed to the note, which he

picks through the keyboard. Organ registration as a science consists partly of the advice tendered by the builders about the optimum use of the stops, singly or in combination, to produce particular tones; and partly by the markings of composers or master organists in the scores of particular works. Bach spent much of his life working on registration, both in general terms and for particular organs. His son Carl Philipp Emanuel Bach wrote: "No one understood registration as well as he. Organ builders were terrified when he sat down to play one of their organs and drew the stops in his own manner, for they thought the effect would not be as good as they were planning. Then they heard an effect that astounded them."[10] This skill, never surpassed before or since, was the result of long experience, familiarity with numerous fine organs, and experiments on their mechanisms acquired in building and rebuilding them—much scrambling about in organ lofts. Bach trained pupils to use his methods and acquire his instinctive sense of registration when confronted with a new score. Hence he seldom wrote down in his organ works his advice on registration, but it must be understood to constitute a dimension of the scoring in addition to the melodic line and the harmonics. He did put names of stops in the Concerto in D Minor (after Vivaldi, the composer he most admired) and two choral preludes. Four chorale preludes have pitch levels, and in some large choral works he put such marks as *forte, piano, Rückpositiv, Oberwerk,* and *organo plenoso.*

Bach composed for the organ all his life; but, unlike his predecessors, he rarely put together works that could be played on either organ or harpsichord. For the harpsichord, he worked on systematic groups of pieces to be used both in teaching keyboard skills and in composing. The works known as the *Well-Tempered Clavier,* twenty-four preludes and fugues (Book 1 of *Forty-Eight Preludes and Fugues*), the *Goldberg Variations,* and *The Art of Fugue* constitute a didactic survey and exploration of the keyboard types, fashions, and opportunities of his day. These works have never been equaled, and experts can—and sometimes do—spend an entire lifetime exploring them. *The Art of Fugue,* which exists in autograph, takes the performer through simple fugues to counterfugues, double fugues, and triple fugues, culminating

in a mirror fugue, fugues with interpolated canons, and a quadruple fugue. What is so notable about these exercises is not only the pedagogic skill, which reflected Bach's phenomenal success as a teacher, but the thematic and harmonic variety, and the sheer creative ingenuity with which Bach honors the keyboard.

A keyboard instrument usually needs to be tempered because the concords of triadic music—octaves, fifths, and thirds—are often incommensurate in their pure form. The scale has to be tuned to make most concords improve so that none or few sound definitely wrong. Despite the existence of the *Well-Tempered Clavier,* it is not known whether Bach favored equal tempering, but this is certainly the method his son Carl Philipp Emanuel preferred. Today equal tempering is used universally for modern works, but in the twentieth century it became fashionable to temper instruments unequally for early music, including Bach's. Controversy rages over the issue and will continue to do so. As Bach knew, and often made clear, music is a complex business because of the natural imperfections of the sonic scale and the inadequacy of man-made instruments. Perfect solutions were impossible, and standards, including his own, had to be personal. We do not know whether Bach, writing for the instruments then available, would have wished to hear his keyboard work transcribed and played on the modern piano (though we do know that he looked forward to and worked toward such an instrument). Nor do we know whether performances of his organ work on the vast organs built in the nineteenth century (let alone the high-technology monstrosities of the twentieth and twenty-first) would have pleased or irritated him. Albert Schweitzer, the most passionate of Bach scholars, was quite sure Bach would have approved of technical advances: "What a joy it is [to play Bach] on the beautiful Walcker organs [built c. 1870–1875]," and "How happy Bach would have been to have had a fine piano on his third manual by the Venetian shutter-swell." This is true, in general terms: Bach was too strong (and therefore generous) a creative personality to resist innovation in any form on principle. But it is evident from his record with new organs that he would have inspected the nineteenth-century and modern monster organs with a highly critical eye, and would have insisted on many modifications before using them. These organs would of course

have inspired fresh compositions to stretch their powers to the utmost. Bach would also, almost certainly, have taken up a third, personal position—as opposed to those who insist on special instrumentation and arrangements for his music to get an "authentic" sound and those who consider such practices pedantic. Bach was not only a creative genius. He was also, like Shakespeare, a "sensible man." He was judicious, a great musical judge, articulating the laws of music from the bottomless well of his knowledge and from his wholesome gift for right and righteousness. This characteristic comes out well in the only authentic image of him, now at Princeton. The big broad face and head radiate sense and wisdom as well as virtuosity.

Bach's work for orchestra was composed on the eve of the sonata-form revolution of Haydn, Mozart, and Beethoven, which created the modern symphony and its orchestra. That he would have embraced the symphony with joy we cannot doubt. As it was, he pushed the concerto form to its limits, as in the six concerti grossi for varying combinations of instruments that he wrote in 1711–1720 and dedicated to the margrave of Brandenburg: it is not surprising that these Brandenburg Concertos are his most frequently performed and widely enjoyed works. What is remarkable in Bach is that his ear for the nuances and possibilities of keyboards was matched by his gift for using all the tonalities and graces of stringed instruments. We see this in the exquisite sonatas and partitas for solo violin, and still more in the unaccompanied cello suites. The way he combines captivating rhythms, the most refined harmonies, and breathtaking counterpoint, perfectly adapted to the strengths (and weaknesses) of these two instruments, is something, perhaps, no other composer could have achieved. Often in his chamber music he was breaking new ground: he emancipated the harpsichord from its supporting role as a continuo instrument and made it a full partner in his sonatas for violin, viola da gamba, and flute (a wind instrument he understood perfectly). And no one before had written for solo cello, or believed such music possible.

Being judicious, Bach was not so much a revolutionary as an improver, reformer, and systematic innovator. He did not abandon any form, but changed and rarefied it. His Mass in B Minor

was not a statement—"I shall write such a mass as no one has ever heard before!"—but a patchwork of bits and pieces assembled over a long period and then polished into a unity of overwhelming power. As in many of Shakespeare's plays, there was an element of chance and haphazard opportunities in Bach's music. It exemplifies a point I have come across again and again in studying the history of great works of creation: a deliberate plan is not always necessary for the highest art; it emerges. (Consider, for instance, Michelangelo's work in the Sistine Chapel, Dickens's *Pickwick Papers*, Mark Twain's *Huckleberry Finn*, and Verdi's *Rigoletto*.) A book could be written about the great Mass in B Minor, which transformed the genre and now ranks with Beethoven's *Missa Solemis* and the requiems of Mozart and Verdi—all three unified compositions. The B Minor Mass emerged over twenty years: the Sanctus was written in 1724 and the Credo not long before Bach's death. He seems to have put together a series of large-scale movements to serve as models, rather than create an unprecedented masterpiece on a stupendous scale. But in effect the latter is what he did, and no one today notices the joins or the chronology, or cares tuppence about the work's prehistory.

The *St. Matthew Passion*, on the other hand, was conceived as a unity, with notable links between the chorales and systematic tonalities, and virtually all the movements are connected with one another. Moreover, Bach introduced a number of striking innovations in this 300-year-old form of church music for Holy Week, which give this Passion its unique power. Evidently he knew what he was doing—composing a masterpiece on the grandest scale. Being, as always, businesslike, he did it for a particular occasion in 1727 or 1729 (there is dispute over the date); and there were two more performances of a revised version in 1736. Then came silence for more than ninety years. Between 1750, when Bach died, and 1800, no complete work by him was printed. He was regarded as an out-of-date musical pedant. There was then a muted revival, but even by 1820 little of his music was in print—it was impossible, for instance, to get hold of scores of the Brandenburgs, or the *Art of Fugue* or the "Forty-Eight." Mendelssohn, a musical prodigy with a deep regard for the old masters, first heard of this stupendous, forgotten *Passion*

from his great-aunt Sara Levy. He then met the music director Carl Friedrich Zelter, who had a complete score. Zelter thought the *St. Matthew Passion* too big and difficult to perform. He changed his mind, however, when Mendelssohn arranged a private performance in his own home in the winter of 1827. Mendelssohn, then age twenty, worked on the vast score with the comic actor Edouard Derrient, who was also a musicologist, and remarked: "To think that it took a comedian and a 'Jew-boy' to revive the greatest Christian music ever written." Mendelssohn engaged and trained the musicians and singers and conducted the first concert hall performance in Berlin on 11 March 1829. The word had got around that a great musical event was taking place, and the hall was packed, the reception enthusiastic, and the Bach rebirth a fact. Afterward, at Zelter's house, there was a grand dinner of the Berlin intellectual elite. Frau Derrient whispered to Mendelssohn: "Who is the stupid fellow sitting next to me?" Mendelssohn (behind his napkin): "The stupid fellow next to you is the great philosopher Friedrich Hegel!"

Bach never sought fame, only perfection. He had his sense of worth, but his real interest was in creating and revising musical works of the highest quality, for all types and combinations of instruments and in all forms. When not creating (or playing, often a form of creation in itself), he was revising his scores. He was never wealthy and often had difficulty accommodating his vast family in comfort. When he died, he left some cash, bonds, silver vessels, furniture, and instruments, including a spinet, eight harpsichords, two lute-harpsichords, ten stringed instruments (among them a Steiner violin of some value), and a lute. They were valued, all together, at 122 thalers and 22 groschen, probably more than Bach had ever earned in a single year. But this legacy had to be divided between nine surviving children and his widow, Anna Magdalena. There were also his scores, and these were divided too. His widow gave her share to the Thomasschule, and died poor ten years after her husband. How their sons allowed this to happen is a mystery. But then there are many mysteries about Bach, not least how one man's brains and fingers could have created so much to delight and uplift the human race as long as it endures.

6

Turner and Hokusai: Apocalypse Now and Then

OSEPH MALLORD WILLIAM TURNER (1775-1851) was a creative genius on the scale of Bach, in the sense that his manner of painting was entirely original, unmistakably his own—it is impossible to confuse him with anyone else—and conducted on a prodigious scale. But whereas Dürer, like Bach, worked in and expanded all the forms of his art then practiced, and added to them, Turner was from first to last a painter of landscapes and buildings (exteriors and interiors), of seas and skies, mountains and lakes, rivers and forests, and nothing more. He never did portraits, still lifes, animals, or human figures (except as staffage). Within his chosen field, however, he was a master who has never been approached, let alone equaled.

Turner's family came from Devon, but he was born in London, in Covent Garden, and spent all his life in London, except for traveling strictly for professional reasons (he never took a vacation as such). He seems to have drawn or painted from the age of three, and he started to sell his work when he was very young: "When I was a boy I used to lie on my back for hours watching the skies, and then go home and paint them; and there was a stall in the Soho Bazaar where they sold drawing materials and they used to buy my skies. They gave me 1s. 6d. for the small ones and 3s. 6d. for the larger ones."[1]

Turner's father, a wig maker and barber, recognized Turner as an artistic genius when the boy was ten or thereabouts, and not only raised no objections to an artistic career but actively promoted it

with all the means in his power. As soon as Turner began to make money, the father gave up his business and turned himself into his son's salesman, promoter, and studio assistant, functioning as such from about 1790 to his own death in 1829. (The mother went mad, was committed to the Royal Bethlehem Hospital, or Bedlam, in 1800, and died there in 1804.) At age ten Turner worked in the offices of an architectural draftsman, Thomas Malton; at age fourteen he entered the Royal Academy Schools; he was briefly an assistant scene painter at the Pantheon Opera House in Oxford Street; and then he participated in the Academy of Dr. Thomas Monro, copying watercolors by J. R. Cozens and Edward Dayes in the company of his contemporary Thomas Girtin. That was the extent of Turner's professional training.

He never lacked recognition or sales. His first watercolor was accepted by the Royal Academy in 1792, when he was sixteen, and his first oil in 1796, when he was not yet twenty-one. He was elected an ARA in 1799, at age twenty-five, and a full Royal Academician (RA) in 1802 at age twenty-eight. He never did anything in his life except draw and paint (though he performed some teaching duties for the Royal Academy). He worked all day, every day. His family life was nothing, though we know he had two regular mistresses and fathered two daughters. Work occupied his entire life until a short time before his death, at age seventy-six, in December 1851.[2] Unlike the works of Dürer and Bach, virtually all he did has come down to us, for he marketed it with great skill and energy or preserved it for the nation. Its extent is staggering: nearly 1,000 oil paintings, some very large and elaborate; and about 20,000 drawings and watercolors.[3] In addition, he left many sketchbooks, some still intact. He etched and engraved and supplied materials for endless publications in the commercial book market, imposing hard bargains on the men of business with whom he dealt. But these activities were ancillary to his major trade, which was to sell large oil paintings to rich collectors at the highest possible prices. For this purpose, he exhibited every year at the Royal Academy and also designed, built, and ran his own studio-gallery, with Etruscan red walls and proper overhead lighting. He guarded it like a gold vault, with peepholes to ensure that no one took advantage of his absence to copy or take notes.

Turner had no master. As a teenager he once imitated Philip de Loutherbourg, a French immigrant whose turbulent nature scenes made a sensation in the 1790s. More seriously, he studied Richard Wilson, the first English landscape painter of any eminence, and through Wilson the great Claude Lorrain, whose sunsets were hugely admired by English collectors and artists in the second half of the eighteenth century—and were fiendishly difficult to imitate. Turner admired and learned from Claude to the point where he sought to create his own version of Claude's *Liber Veritatis* of mezzotints by publishing, in fourteen parts (1807–1814), a book of prints called the *Liber Studiorum*, each with five pictures (characterized as marine, mountainous, pastoral, historical, or architectural), which Turner etched in outline, leaving the mezzotint to subordinates. The idea was to advertise himself and "show how to do it," rather like Bach's *Art of Fugue* or the *Well-Tempered Clavier*. Essentially, however, Turner worked on his own, seeking and taking no advice, attracting no pupils (other than by his classes at the Royal Academy), acquiring few followers, and founding no school. He was from the start, and remained till his death, sui generis. While making use of Claude, he could not refrain from a sneer: "People talk a great deal about *Sunsets*, but when you are all fast asleep, I am watching effects of sunrise—far more beautiful—and then, you see, the light does not faint and you can paint them."[4]

Turner began his professional career with major topographical subjects, watercolors of London and the Thames Valley, and oils of the inshore waters of the Estuary. Later he went on painting tours in Yorkshire and the north, and in Wales, forming connections with people (such as the Fawkes family in Yorkshire and Lord de Tabley in Cheshire) who acquired collections of his works. He first went abroad in 1802, to Paris (during the brief Peace of Amiens). Then after the final fall of Napoleon in 1815, he went annually to the Netherlands, Germany, the Alps, and Italy. Unlike Dürer, he never set up a studio abroad, and he painted few pictures in oils (other than sketches) on these trips. But he filled hundreds of sketchbooks and did numerous finished watercolors.[5] In general, whether Turner worked outside or in his studio depended entirely on practical considerations. To get his

basic visual material he had to work in the open, drawing with great speed and accuracy. He sketched as if he were writing, his hand never still, taking in details every second and often not glancing at the paper as his hand covered it with lines.[6] On his first trip to Venice (1819), he allowed himself only five days. On the first day he took a gondola from the entrance to the Canale di Cannaregio, upstream to where the railroad station now is, then slowly down the Grand Canal to the Salute church, and then into the Baccino, with pauses to sketch the more complex bits. In this way he produced eighty sketches in one day, or possibly two days. Turner formed his own notions of the economics of art and the best means of combining quality with productivity. He knew that a watercolor produced on the spot was more likely to be better than one painted in the studio from a line sketch. (I too have found this to be invariably so.) So if the weather was good he always painted watercolors (and sometimes oils) outdoors, as in the superb series of Yorkshire vales and moors, Lakeland hills and lakes, Welsh hills and cityscapes, especially Oxford, which he did in the late 1790s and early 1800s. These included cathedral interiors, also done on the spot, of great size and magnificent complexity—his watercolor of the Ely crossing is perhaps the finest thing he ever did.

As he grew older, however, and more keen on productivity (more avaricious perhaps), he resented the time taken up by coloring on his trips—you can draw in the rain, but you cannot paint, especially in watercolor. Turner (as he told Sir John Soane's son) calculated that he could do fifteen or sixteen pencil sketches in the same time he took for one color sketch.[7] So he trained himself to memorize colors, a difficult business. After about 1805 he painted outdoors in oils only on special occasions, as the apparatus took so long to set up and dismantle, and the medium tended to determine where he could sit and the viewpoint—an irksome parameter for an artist like Turner, one of whose greatest skills was in finding spectacular viewpoints. But he always carried a small box of watercolor paints, brushes, and a water bottle in his pockets so that he could snatch a color view as soon as he saw it. On his first trip to Venice he painted in watercolor four sketches (almost miraculously brilliant) of the effect of light on the city and its waters, entirely for his

own information and records. These sketches came to light only after his death.[8] He never missed an opportunity to record a rare effect, but he was also prepared to wait for it. When his coach was overturned in the Alps, and its passengers were marooned in the dark and snow, Turner whipped out his paint box and, ignoring his freezing hands, produced a magnificent watercolor. But R. J. Graves, who watched him in Naples, said: "Turner would content himself with making one careful outline of the scene and . . . would remain apparently doing nothing, till at some particular moment, perhaps on the third day, he would exclaim: 'There it is!' and, seizing his colors, work rapidly until he had noted down the peculiar effect he wished to fix in his memory."[9] "Apparently doing nothing" conceals the fact that Turner, on a working trip, was never idle, often doing several works at once, turning from one, which was drying, to concentrate on another, sometimes with four or five sketches spread out on a table at once.

He was secretive always when working. One young painter (later Sir Charles Eastlake, president of the Royal Academy), who was with Turner in the West Country in 1813, said that Turner often made sketches "by stealth." On this trip, eyewitnesses recorded Turner's going out in a small boat in heavy weather. The rest were seasick, but Turner "sat in the stern-sheets intently watching the sea and not at all affected." He sketched or sat recording wave motions in his mind, "like Atlas unmoved." Sea trips were followed by walks on which Turner paused occasionally to sketch. He was "a good pedestrian, capable of roughing it in any mode the occasion might demand." One evening he had a technical argument with De Maria, a scene painter for Covent Garden, who resolved it by watching the ships in the Tamar. "You were right, Mr. Turner, the ports cannot be seen. The ship is one dark mass." "I told you so, now you can see it—all is one mass of shade." "Yes, I can see that is the truth, and yet the ports are there." "We can take only what we see, no matter what is there. There are people in the ship—we don't see them through the planks." "True."[10] Turner was a hardy man. Sun, ice, heat, cold, and stormy seas meant nothing to him when art was to be created. When he was sixty-seven, he wanted to make accurate sketches for a big oil he was planning, to be called *Snow Storm:*

Steam Boat off a Harbour's Mouth. He had himself lashed to the mainmast of the *Ariel*, in what turned out to be a gale, and continued sketching.

Turner was an exceptionally active man, traveling rapidly all over Europe and Britain to feed his creative passion. He was also a very physical man: small but muscular; tough; wiry; with powerful lungs, strong jaws, hands with a fiendish grip, and large feet. He glowed with power in a room. But he was also, in his own semiliterate way, an intellectual, much more interested in ideas than in people. He had more effect on painters, in the long run, than any master since Rembrandt and should be seen as the ultimate progenitor of the modern movement in art. His craftsmanship was important, but it should be noted that the dynamics of his art were strongly intellectual (and emotional). Like Bach (and unlike Dürer), he was little educated outside his craft but (like Beethoven, for instance) he read widely, and wildly, all his life, seized on ideas, thought about them, transformed them, and applied them to his art. Modern research has revealed that the literary and intellectual content of his work is much greater than had been supposed.[11]

Turner, unlike most other English artists, characteristically picked up public themes, such as the slave trade, Greek independence, and industrialization. He gave his works literary references, often quoting classical or even modern poetry, and sometimes writing his own (clumsy but vivid). He believed that painting is a form of language and that its object is to tell the truth about nature, seen objectively. He believed also that paintings have a moral purpose, to instruct and improve, but they do so physically by showing the effect of light on objects. In no sense was he an abstract or "uncommitted" painter. By the time he was twenty he had learned from observation that light was the key to all painting—objects merely reflected it. Salisbury Cathedral was an edifice of stone, but what it looked like (since its Chilmark limestone reflected light with astonishing variety and fidelity) depended entirely on the time of day, the weather, and the season. To understand light, Turner studied optics and the current theory of color. He knew classical theory, as explained by Aristotle and Pliny; he was familiar with Newton's seven-color system,

and had read what Kant and Goethe had to say about color. He followed the works of Thomas Young and read *Chromatics* by George Field, who spent much of his life improving the colors available to artists. He read the manuscript essay "Letter on Landscape Colouring" by Sawrey Gilpin, who did the cows and sheep in some of Turner's early landscapes. But in the end Turner had to work out for himself a right and systematic way of distinguishing colors and of actually getting them onto the canvas—a very different matter—when they were suffused by light of different kinds and intensities. It was here, above all, that his creative genius manifested itself.

From his early twenties, Turner was highly original in using color and depicting light—light seen on buildings, radiating from skies, reflected on still or angry water, seeping through mist and spray. Some of his big early watercolor oil paintings, though supposedly derived from Dutch models, in fact concern concepts the Dutch masters were unaware of, such as polycentric sources of light and light received and reflected at different instants of time on the same canvas. Once Turner began taking light seriously and scientifically, his color automatically went up the scale and it continued to do so for the rest of his life. By 1810 he was credited with founding the "white school," which waged war against the browns and sepias of the old masters. Oddly enough, most contemporaries (painters and "experts"), with eyes and minds conditioned to the lower color key of Claude, Poussin, and their infinite followers—Ruisdael and Cuyp, too— had lost the capacity to look directly at nature and its colors, and saw Turner's high chromatic vision as "invention." The *Examiner* (supposedly radical politically and avant-garde aesthetically) referred to his "intemperance of bright color." The *Literary Gazette* accused him of replacing the "magic of nature" with "the magic of skill," when in fact he was doing the opposite—using truth to destroy artificial conventions.[12]

"White painters" (like virtually all catchphrases or neologisms for schools of art—gothic, mannerist, baroque, rococo, impressionist, fauve, etc.) was a hostile expression, coined by Sir George Beaumont, a wealthy amateur and collector who helped to found the National Gallery. Though imperceptive, Beaumont

exercised some power, and scared Turner's little band of followers. They melted away into mediocre anonymity, and he carried on alone, quite impervious to the insults. He was already saving money by 1805, investing it in sound government securities; by 1805 he was financially independent, and thereafter he gradually became a very rich man, eventually leaving over £150,000 in cash, an immense sum in 1850. He was probably the richest painter since Luca Giordano, who left his son a princely inheritance of 300,000 gold ducats; and perhaps the richest of all before Picasso. One of Turner's greatest works, *Frosty Morning* (1813), which was very "white" then—before destructive "cleaning" ruined it—was unsold. So was *Apulia* (1814), which Turner thought his best to date and hoped could win the top annual prize at the British Institution. But moods and fashions change, as he discovered—often with disconcerting speed and for no apparent reason. In the year of Waterloo, both his *Crossing the Brook* and *Dido Building Carthage* won instant and enthusiastic approval. He followed this big success by painting the superb virtuoso golden-light picture *Decline of the Carthaginian Empire* (1817), and he was soon building a new gallery of his own to show off his large oils. In 1818 he produced the magnificent *View of Dort*, which raised the chromatic pitch still higher. Henry Thomson RA, who got an early viewing, described it to the diarist Joseph Farington RA as "very splendid with colors so brilliant it almost puts your eyes out." Constable, not a man to praise his contemporaries, least of all Turner, called it "the most complete work of genius I have ever seen." It was bought by Turner's Yorkshire patron, Walter Fawkes, remained in Fawkes's family, and is still, happily, in perfect condition.[13]

Throughout the 1820s and 1830s Turner continued to astonish and sometimes shock the art public with large landscapes of ascending chromatic design.[14] He did hundreds of vignettes and sometimes large illustrations for the publishers of high-quality travel books. The illustrated topographical coverage of Britain, which had begun in the 1760s, was by now pretty well exhausted: Turner did the ancient cities and, especially, the rivers—Seine, Rhine, Rhône—of Europe, the lakes and mountains of Switzerland, and the delights of cities like Venice. He seized on the coming of the age of steam as an excellent chance to bring

modern technology into his art, and to create new opportunities of light and color. In 1832 he produced a superb watercolor of steamboats on the Seine, *Between Quillebeuf and Villequier*.[15] He followed this with one of his tragic masterpieces, *The Fighting Téméraire* (1839), tugged to its last berth to be broken up in 1838–1839, a marvelous atmospheric evocation of the symbolic triumph of steam over sail as the tiny steam tug pulls the vast hulk of the powerless battleship into oblivion. The *Téméraire* was a popular ship, built of 5,000 oaks and launched in 1798; with ninety-eight guns and a crew of 750, it stood next in line to Nelson's *Victory* at Trafalgar. Turner was twenty-three when the *Téméraire* was launched, thirty at Trafalgar, and sixty-three when he painted its last voyage; he felt he had lived with the vessel all his life. The painting he called "my darling." He refused to sell it, often. During most of the nineteenth century it was under glass, and it is exceptionally well preserved (it was the subject of a special exhibition at London's National Gallery in 1995). The public loved it. John Ruskin, the young art critic, who in the 1830s became an outspoken advocate and defender of Turner's work, wrote of it: "Of all pictures not visibly involving human pain, this is the most pathetic that ever was painted." Thackeray wrote in *Fraser's Magazine* (July 1839): "The old Temeraire is dragged to her last home by a little, spiteful, diabolical steamer. . . . This little demon of a steamer is belching out a volume . . . of foul, lurid, red-hot, malignant smoke."[16] But of course the smoke of the powerful new steam engines was Turner's delight. He welcomed the visual opportunities afforded by progress. An enthusiastic rail traveler, he rejoiced in high speed, often begging fellow travelers to come to the window with him to watch visual effects as the train hurtled past the scenery. His *Rain, Steam, and Speed*, at the time and ever since one of his most popular pictures, records the positive virtues of the new steam age. [17]

Turner, then, was intermittently a highly popular artist—by the 1840s he was probably the world's best-known figure in art. That was, as David said, an amazing thing to happen to a "mere landscape painter." But Turner was also violently attacked. One might say that the savage assaults on his late work, where light and color are supreme, and mere objects are often barely dis-

cernible, were the first castigations of "modern art," anticipating by a generation the rage which greeted Édouard Manet. The attacks continued after Turner's death, the most celebrated being Mark Twain's comparison of *The Slave Ship* to "a cat having a fit in a platter of tomatoes"—followed by much other similar abuse.[18] In the 1840s Turner needed Ruskin's defense, though he was ambivalent about it: "He sees more in my pictures than I ever painted." But Ruskin refused to praise Turner's last four paintings: *The Departure of the Fleet* and three depictions of scenes taken from Virgil's *Aeneid*. Ruskin said they were of "wholly inferior value." Turner's best biographer, Finberg, described them as "too feeble to give offence." All of them ended in the Tate, which destroyed *Aeneas Relating His Story to Dido*. But today they are much admired.[19]

Turner aroused mixed reactions among his contemporaries. J. W. Archer summed him up as "So much natural goodness mixed with so much bad breeding." It was Turner's manner that prevented him from becoming president of the Royal Academy, a position he coveted (he was made vice president, though). Mary Lloyd, another observer, noted: "His face was full of feeling, and tears readily came to his eyes when he heard a sad story." There are many anecdotes of his sharpness, rudeness, covetousness, and concern for his trade secrets. If an artist looked too closely at his work, he snarled: "I paint my pictures to be looked at, not smelt." He raged with fury if asked to comment on, or as he thought authenticate, an old painting of his: "You have no right to tax my memory with what I might have done one hundred and fifty years ago." When owners brought an unsigned work of his to show him, they were rebuked—"I won't look at it! I won't look at it!"—and he would leave the room.[20]

Yet Turner not only taught painting at the Royal Academy; he also (from time to time) gave advice. "First of all, respect your paper!" "Keep your corners quiet." "Centre your interest." He advised all artists to buy materials, especially paints and brushes, of the very best quality. He used his own first earnings to buy good paints and top-quality paper. He kept in close touch with suppliers of art materials, and jumped at the opportunity to experiment with a new pigment. Between 1802 and 1840, the fol-

lowing new pigments became available: cobalt blue, chrome yellow, pale lemon chrome, chrome orange, emerald green, synthetic ultramarine, Chinese white, veridian, barium chromate, and chrome scarlet. It can be shown that in most cases Turner was an earlier user of the novelties.[21] Before using oils regularly he had been a watercolorist for ten years, and this practical training gave him great respect for the power, quality, and subtlety of pigments.

Turner was an astonishingly fast worker, like Hals and Fragonard before him, and Sargent after him. We have an eyewitness account of a big Turner watercolor from Walter Fawkes's daughter-in-law:

> One day at breakfast when Turner was staying with Fawkes in 1818, Fawkes said to him: "I want you to make me a drawing of the ordinary dimensions that will give some idea of the size of a man of war." The idea hit Turner's fancy, for with a chuckle he said to Walter's eldest son, then a boy about fifteen, "Come along, Hawkey, and we will see what we can do for papa." The boy sat by his side the whole morning and witnessed the evolution of "A First Rate Taking in Stores." His description of the way Turner went to work was very extraordinary. He began by pouring wet paint onto the paper until it was saturated. He tore, he scratched, he scrubbed at it in a kind of frenzy, and the whole thing was chaos—but gradually, as if by magic the lovely ship, with all its exquisite *minutiae*, came into being, and by lunchtime the drawing was taken down in triumph."

Turner was not only a fast but a ruthless painter. He applied, repeatedly, over a sketch scumbles, glazing, and impasto. He completely redid some of his paintings on the Academy's walls, on varnishing day. His *Regulus*, painted in Rome in 1828, had its lighting scheme completely transformed by Turner as it hung on a wall of the British Institute in London, while a a wide-eyed Sir John Gilbert watched:

> He was absorbed in his work, did not look about him, but kept on scumbling a lot of white into his picture—nearly all

over it. The picture was a mess of red and yellow in all varieties. Every object was in this fiery state. He had a large palette, nothing on it but a huge lump of flake white: he had two or three biggish hog-tools to work with, and with these he was driving the white into all the hollows and every part of the surface. . . . The picture gradually became wonderfully effective, just the effect of brilliant sunshine absorbing everything, and throwing a misty haze over every object. Standing sideways at the canvas, I saw that the sun was a lump of white, standing out like the boss of a shield.[22]

Turner's creative working methods are, alas, a reminder that painting is to some extent an ephemeral art. Few great masterpieces are as good today as when first painted. (Vermeer's are a possible exception.) The skies of Claude, which dazzled his contemporaries and were still astonishing in the late eighteenth century, have lost much of their lustre 200 years later. Ruskin, in *Modern Painters*, warned his readers that Turner's highest quality was transitory. He said that Turner painted works for "immediate delight," and had "no thought for the future." "No picture of Turner's," Ruskin added, "is seen to perfection a month after it is painted. . . , How are we enough to regret that so great a painter should not leave a single work by which in succeeding ages he might be entirely estimated."[23] Ruskin called this process of deterioration "sinking in," and cited *Childe Harold's Pilgrimage, Italy* (1832) as an example of decay, "now a mere wreck." Other examples of deterioration are *Waves Breaking against the Wind* (1835), *Chichester Canal* (1828), *Benedetto Looking towards Fusina* (1843), and *Landscape: Christ and the Woman of Samaria* (1842). Joyce Townsend, who has made a study of decay in Turner, thinks that the works which were not finished by Turner and so were unvarnished and were not fiddled about by him on the walls of the Royal Academy are the ones most likely to have retained their original appearance. She gives three examples of well-preserved works: *The Arch of Constantine* (1835), *Venice from the Canale della Giudecca di S. M. della Salute* (1840), and *Peace—Burial at Sea* (1842). Some of the earliest works have lasted best, such as *Morning among the Coniston Fells* (1798), which is still perfect.[24] Another example of a well-preserved painting is *Lifeboat*

and Manby Apparatus Going Off to a Stranded Vessel Making Signals (Blue Light) of Distress (1831), a daring piece of work that Turner was wise enough to leave alone. Sometimes, however, the deterioration was not his fault. In his great *Richmond View and Bridge*, the reds have faded. A new red, recommended to him by the chemist Sir Humphry Davy, proved feeble over time. And in the late nineteenth century and the early twentieth century Turner's work suffered grievously at the hands of "restorers." Thus *Frosty Morning*, by all accounts one of his most astonishing works when first painted, had most of its top surface removed, and now looks dull. Still, Turner himself was careless. He said he kept most of his unsold works or those he did not wish to part with "down below." That meant a cellar. It was damp, which led to spotting, and liable to floods in heavy rain. (The Tate too, inexcusably, allowed the floods in 1928 to reach its Turners.) In Turner's studio, mold grew on egg-based primings, and there were other horrors.[25] It is hard to say which has damaged Turner's oeuvre most: his methods of work, his carelessness in storage, or the brutalities of twentieth-century British restorers.

Along with his astonishing creative virtues, Turner had one appalling weakness: he could not draw, or paint, the human form. His staffage is always feeble, sometimes embarrassingly so. It is true that Turner shared this incapacity with his great hero Claude. But the latter was painfully aware of his defect and did everything in his power to correct it—though to no avail. Turner was not conscious of how bad his figures were; at any rate, he said nothing on the subject and certainly took no steps to put things right by attending life classes (as a younger contemporary, Edward Lear, did, saying his figures were not good enough, though they were a world above Turner's). It is odd that Turner did not seek to acquire the astonishing skill of Canaletto (whom he admired and in some respects learned from), a master of townscape who devised a remarkably quick and successful—if a little formulaic, not to say mechanical—method of doing the figures with which his canvases teem. Despite his debility, Turner put in bad staffage when it was not really necessary to have any. When he made a figure prominent—for instance, in his study of Bonaparte on a lonely beach with a howling dog—the result is disastrous.

. . .

*W*HEN WE SWITCH FROM TURNER to his older contemporary Hokusai Katsushika (1760–1849), who was born a generation earlier but survived to within a year or two of Turner's death, we find an instructive comparison and contrast. The two men were creativity personified, in quantity, quality, and every other respect. Turner transformed landscape, during his lifetime, into the greatest of all visual arts, and left the world of painting permanently changed—indeed, artists all over the world are still learning from him (if they have the sense and sensitivity). Hokusai, in effect, created Japanese landscape painting from nothing, but he also portrayed Japanese life in the first half of the nineteenth century with dazzling graphic skill and an encyclopedic completeness that have never been equaled anywhere, throwing in Japan's flora and fauna for good measure. Both men were born into artisanal poverty (Hokusai was the adopted son of a mirror maker). Neither had artistic forebears. Each learned to draw at the earliest possible age, about three, and contrived to do so incessantly, throughout a long, industrious life. Neither did anything else or wished to do anything else.

Both men were born in a capital city and were streetwise. But Turner's London was the wealthiest city in the world, and he succeeded there early, becoming and remaining rich. By contrast, Hokusai's Tokyo (then called Edo) was a huddled collection of villages just entering a period of intermediate technology. When Hokusai was five, the first large group of colored prints was published there, and it soon became possible for gifted, hardworking draftsmen to earn a living in the nascent publishing industry. Like Dürer, Hokusai began with woodblocks, but unlike Dürer he did not come from the wealthy bourgeoisie; he had no useful connections, no well-endowed wife. He worked fanatically hard all his life and made only a bare living. Whatever he did manage to save went to pay the gambling debts of a reckless son and a still worse grandson. During the "Tenpo crisis" of 1836–1838 (when Edo emptied as a result of plague and agricultural depression), he was reduced to hawking his wares in the street. There was a restless rootlessness to him, reflected in the fact that he

changed his name, or rather the signature on his works, more than fifty times, more often than any other Japanese artist; and in the fact that during his life he lived at ninety-three different addresses.[26] The names he used included Fusenko, meaning "he who does only one thing without being influenced by others"; "The Crazy Old Man of Katsushika"; and "Manji, the Old Man Mad about Drawing." After he fell into a ditch, as a result of a loud clap of thunder, he signed himself "Thunder" for a time.

Like Dürer, whom he resembled in many ways, he was a combination of proper pride in his skills and modesty, fired by the determination to improve himself and do better. This comes out strongly in a letter to his publisher, accompanying a self-portrait at age eighty-three, with a curious snatch of autobiography:

> From the age of six, I could draw forms and objects. By 50 I had turned out an infinite number of drawings. But I am not happy about anything I did before 70. Only at 73 did I begin to understand the true form and nature of birds, fish and plants. By 80 I had made a lot of progress. At 90 I will begin to get to the root of it all. By 100 I will have reached a Superior State in art, undefinable, and by 110, every dot and line will be living. I challenge those who live as long as me to see if I keep my word.[27]

Hokusai's curriculum vitae, so far as we know it, tells a somewhat different story.[28] When Hokusai, having learned woodcutting, began regular employment in the studio of Katsukawa, Shunshō, prints of actors (in which his master specialized) and courtesans, known as "beauties," were almost the only salable images. They dominated Hokusai's early work, and he became adept at them. But technology was changing and taste expanding. Western prints were creeping in, carried by Dutch traders. In 1783 the first copperplate etchings were made in Japan. From his earliest years as a trained printmaker, Hokusai strove to expand the subject matter of Japanese art. As he put it later, he "studied all schools." But as art rose to its feet, the state, dominated by the authoritarian shogunate, put on the shackles. In 1791 censorship seals became obligatory on all prints, and state interference

intensified throughout Hokusai's lifetime until, in 1842, a full system of control was imposed and many types of prints (including "actors," alleged to be satirical and subversive) were banned.

Print censorship was inextricably involved with government supervision of books, and illustrations for books formed Hokusai's main output throughout his life. He did the pictures and decorations in 267 books (some multivolume), plus five published posthumously.[29] Hokusai liked this work, particularly when he was in complete charge, but he was always keen on new experiences and pushing the frontiers. In 1804 he engaged publicly in what we would now call "performance art." Before a crowd of gawking citizens, he strode over 350 square meters of paper, painting with a bamboo broom dipped in a pail of ink. The result was erected, upright, in a bamboo frame and revealed to be a gigantic image of Daruma, patriarch of Zen Buddhism. The exploit won Hokusai the title *kigin*, "eccentric artist." Hokusai, like Turner, was not averse to being thought eccentric: it gave him greater freedom of action. Indeed, like Salvator Rosa before him, and Whistler, Dalí, and Warhol after him, he deliberately courted publicity and thrived on it. It enabled him to push forward into new territory.

In England, cheap published books of travel inspired by a search for the "picturesque," and illustrated with prints which could be hand-colored, had become a leading form of literature since the 1760s, providing well-paid work for writers and artists alike. As we have noted, Turner benefited from this long-sustained fashion, especially when it spread to European subject matter. Illustrated topographical books began to appear in France, then in Germany. The fashion infected Japan, too. Shortly after 1800 the first landscapes were integrated into illustrations for popular novels. Hokusai seized eagerly on this development. Indeed, he gradually created the language of the Japanese landscape, partly following or adapting western models, partly inventing the visual vocabulary himself. Up to his day, Japanese artists had never drawn clouds, only mists. Hokusai brought in cloud formations, following western patterns, and combined clouds and mists. He also learned from western prints how to convey perspective in depth, how to capitalize on shading, and how to draw shadows.

He also used western products, such as Prussian blue paint, which came as a godsend to him. He exercised extraordinary skill in adapting, rather than copying, western methods, and effected a synthesis of east and west that made his work attractive both to Europeans and to Americans, as well as to Japanese.[30]

Hokusai's efforts to create a Japanese taste for landscape began to take effect early in the 1830s when his *Thirty-Six Views of Mount Fuji* (actually forty-eight prints) was published to great success. These were the first large-scale landscapes in the history of Japanese prints. He followed them with *Going the Rounds of the Waterfalls in All Provinces* (1832), which was an original idea of his own, since his method of drawing waterfalls owed nothing to the west.[31] These topographic works were followed by *Large Flowers*, then *Small Flowers*, and then more topography: *Eight Views of the Ryukyu Islands* (1832) and *Remarkable Views of the Bridges of All Provinces* (1834). Hokusai had a lifelong passion for bridges and drew them with wonderful skill and from a stunning variety of angles. In 1835 came *One Hundred Views of Mount Fuji*. Hokusai also invented seascapes, and in 1833 produced *One Thousand Pictures of the Ocean*. His *Giant Wave*, which he produced in a variety of forms, became his most famous image, indeed one of the most famous in all art, alongside Dürer's *Rhinoceros*, Rembrandt's *Elephant*, and *The Scream* by Edvard Munch. It, too, was an amalgam of western and Japanese pictorial idioms.[32] Hokusai was also producing illustrated books of poems, and many of his works have poetic images, for instance the beautiful *Snow, Moon, and Flowers* of 1833. Like Turner, Hokusai saw landscape in terms of poetry, both classical and modern.

While these works were appearing, Hokusai was also engaged in a formidable undertaking: teaching ordinary middle-class or lower-middle-class Japanese to draw. His instructional drawings, of which fifteen volumes eventually appeared, are known as *Manga*, "random sketches." Volume 1 was printed in 1812, when Hokusai was fifty-two, and seems to have been put together from his sketches by his pupils, of whom we know the names of fifteen.[33] It averaged ten images per page, woodcuts printed in light and dark, shades of ink with pale rose tints. It concentrated on the human figure, was cheaply priced, and proved remarkably popular. So Hokusai, and

his assistants, worked hard on the series. Volumes 2 and 3 appeared in 1815; 4 and 5 in 1816; 6, 7, 8, and 9 in 1817; and 10 in 1819. Thereafter the pace slackened: Volumes 11 and 12 had to wait till 1834; Volume 13 came posthumously the year after Hokusai died; and 14 (1875) and 15 (1878) were probably not mainly or at all by Hokusai.[34]

The volumes contain not only human figures but animals, birds, insects, flowers, fish, landscapes, water views, ships, and rafts. Volume 5 is mainly concerned with shrine architecture, 6 with *kendo* (fighting with poles); and 7 with landscape, reflecting Hokusai's expanding interest in that subject. Volume 8 ranges from animals to looms and mountebanks, and includes the famous drawing *Blind Men Examining an Elephant*. Volume 10 is mainly devoted to ghost stories—it was one of Hokusai's obiter dicta that "ghosts are easy to draw, humans and animals hard." Volume 11 is on rivers. The *Manga* constitute one of the largest artistic compilations ever produced—well over 40,000 images in all, embracing a vast variety of subjects. It is not surprising that they proved even more popular in Japan than Hokusai's other works, and equally popular among Europeans when the volumes reached Paris during the Second Empire and were published by the Goncourts. (There is a good modern anthology, with excellent text and translations of all the prefaces.)[35]

The range of the subject matter is unique in art. There is a great deal about craftsmen.[36] Many studies of drunks make their appearance. There is a startling drawing of a man attacked by an octopus, and another of men carrying a sorceress across a stream. Much of the instruction is still useful today: for instance, how to draw waterfowl, irises (a favorite flower of Hokusai's, and of mine, and fiendishly difficult to get right in line and color), oxen, and horses—the last two using straight lines and circles. Japan was a largely vegetarian country then, and Hokusai's universe shows few cows, sheep, or pigs. But he enjoyed drawing horses, especially with fierce warriors riding them; these horses did not pull carts—that was the work of oxen. Hokusai also loved drawing woodsmen. One of the best things he ever did (not in the *Manga*) is a watercolor of an exhausted woodcutter, resting his head on a fagot, another at his back, his ax lying poetically by his

side—a glorious drawing, beautifully colored, as moving as Rembrandt's *Saskia Asleep*. The drawing of the woodcutter once belonged to Edmond de Goncourt. Of course, one has to distinguish between *Manga* drawings produced rapidly for instruction, and drawings done individually for Hokusai's own delight or for a collector. The *Manga* contain some notable drawings of rain, a specialty of Hokusai's—rain is the curse of Japan, as of England—and people, especially women with elaborate hairdos, coping with sudden showers. Hokusai drew showers and rainstorms more often than any other artist, in Japan or anywhere else.

Hokusai drew for the market. He catered to public taste and appetites. One type of print was *shunga*, erotica, which Hokusai produced throughout his working life, into his mid-sixties, though never thereafter. It varied greatly in quality. His best book of *shunga* is *Nami Chiduri*, chiefly remarkable for sensitivity in depicting limb positions, skin texture, garment folds, and gestures.[37] There is a theory that his best erotica was actually drawn by his favorite, gifted daughter, Oei, but no direct evidence has been produced. *Shungi* does not show Hokusai at his best. The genital organs, both male and female, are too large, though in other respects realistic. The postures are unconvincing, and the leg positions are often impossible, though cosmeticized by garments. Other Japanese artists also created *shunga*, though even less successfully than Hokusai. Western artists from Rowlandson and Fuseli to Turner himself tried their hand. Turner's erotic works are hopeless, painfully unstimulating and distressingly amateurish. By comparison, Hokusai's writhing couples—as always when we compare his figures with Turner's—are highly professional. But it is a fact that the only erotic print of Hokusai's which sticks in the mind is his notorious study of a woman pearl fisher being pleasured by two octopuses: a small one at her head and a large one at her genitals. It has undoubted imaginative power, and the master clearly relished creating it.[38] But in general he was ashamed of his *shunga*. He never signed one with any of his names.

Hokusai—like Turner—emerges from his work as an unforgettable creative personality. He was ever changing and always developing, yet always consistent in essentials—again like Turner.

A truly creative personality is always Janus-faced, revolving and evolving, yet always still too. Some of Hokusai's letters to publishers survive, often illustrated. "This month, I have no money, no clothing, no food. If this continues for another month, I will not live to see the Spring."[39] He tells how, in his seventies, he had some sort of seizure, and cured himself by taking a strong dose of lemon pulp mixed with "the best sake" (he gives the recipe). During another phase he says he has been drawing lions' heads every morning by way of exorcism (of bad luck). His *Book of Exorcism* was published. He went on working, like Turner, virtually to the end. There is a beautiful drawing (in the collection of the Victoria National Gallery, Melbourne) of him, as an old man, singing his heart out, with a girl accompanying him. At the age of eighty-seven, in 1847, he painted on paper a magnificent eagle in a blizzard. Another fine drawing survives from 1849, when he was eighty-nine; it shows a woodcutter smoking a pipe. From the same year we find a painting on silk, *Tiger Roaring in the Rain*; and *A Dragon in the Smoke Escaping from Mount Fuji*.[40] Only death stilled his active drawing hand, the year before Turner; stricken, he threw down his brush at last. So these two little men, giants of art, ended their long, fruitful lives.

7

Jane Austen: Shall We Join the Ladies?

*U*NTIL ALMOST OUR OWN TIME, and certainly until well into the twentieth century, women striving to reach the heights of creativity led isolated, lonely, and often desperate lives. Most gave up the struggle early, and we hear nothing more of them. A few succeeded, often because of a supportive family, but their success was always precarious because of their sex; and the way in which they scaled the mountain, usually alone, is obscured by family censorship of the record after their death: until recently a woman creator was always a source of embarrassment to her kin, even if they had helped her on her way. The outstanding case is Jane Austen (1775–1817), one of the world's greatest novelists. Her oeuvre is slender, because she was never able to become a full-time writer, having domestic and social duties to perform which took priority, and she died at the age of forty-one, of Addison's disease, then incurable. In effect her output consists of six "mature" novels: *Sense and Sensibility, Northanger Abbey, Pride and Prejudice, Mansfield Park, Emma,* and *Persuasion* (in order of composition). Her fame was beginning to establish itself at the time of her death, and it has continued to grow. She became a cult figure among upper-middle-class and upper-class intellectuals and then, more recently, a worldwide popular celebrity, deified by movies and television series. Her six novels have never been out of print for two centuries, and now more than a million copies a year are sold in paperback in the English-speaking world alone (another million copies are now produced in, for instance, Hindustani each year).

Unfortunately, we know comparatively little about Austen's

ascent to creativity because her family, beginning with her elder sister Cassandra, and continuing for two generations, suppressed or censored her letters (she was a constant and lively, at times inspired, correspondent). Cassandra admitted that she burned many of the letters, and we know she cut the survivors heavily. The family also altered and distorted the record in order to make Austen appear more genteel and socially law-abiding than she actually was.[1] In effect, they tried to turn her from essentially a Regency woman into a Victorian, and succeeded in taking in many of her twentieth-century biographers, such as Elizabeth Jenkins and Lord David Cecil. It is now impossible to use the altered evidence to reconstruct her life and character, though hints exist and surmises can be made: two words she used about herself, describing her states of mind, not her actions, were "wild" and "wicked."[2]

It helps to compare Austen with her contemporaries. She and Madame de Staël (Germaine Necker) died in the same year, 1817, though de Staël was nine years older. Among other works, de Staël wrote two novels—*Delphine* (1802) and *Corinne* (1807)—which Austen certainly knew about, though we have no positive evidence that she read either. *Delphine* is in tiresome letter-form, then a mark of an inexperienced or amateur writer of fiction, and *Corinne*, a much longer book, is weighed down with elaborate descriptions of Italian scenery and culture, so that neither is much read today. But when these novels appeared, they appealed strongly to intelligent women because their common theme is the isolation of such women in society, especially when they seek to express themselves creatively. Both heroines are forced to choose between an intellectual life and an emotional life—to follow the dictates of the head or of the heart—and both find death in consequence: Corinne dies of grief and Delphine poisons herself.[3] Women, de Staël argues, are faced with these impossible choices because, though both men and women are imprisoned by convention, the prison is much more rigorous and inflexible for women, and the chance of escape virtually nil. Women, in practice, cannot leave their family except to marry (a different form of imprisonment), and their chances of expressing themselves depend, therefore, on the kind of family they spring from.

There are three types of family the creative woman had (or has)

to contend with. The first type, almost universal in the early nineteenth century, and common until well into the twentieth, sets its face firmly against the idea of its female members embarking on any professional activity of a creative kind (or indeed of any other). We do not hear of many career women, because the gifted daughters never got started. This seems to have applied particularly to painting: the majority of men (and women, too, I suspect) found the idea of a woman artist abhorrent. Pliny, in Book 35 of his *Natural History*, lists six women artists of antiquity. Giorgio Vasari repeats their names in his *Lives of the Artists*, and in the 1568 edition of this book he adds the names of five Flemish women artists and ten Italians, including the admirable Sofonisba Anguisciola and her three talented sisters. But great women artists—like Artemisia Gentileschi, Caravaggio's disciple, or the Dutchwoman Judith Leyster—were scarcely mentioned until the late twentieth century.[4] Two women artists, Angelica Kaufman and Mary Moser, were among the founding members of the Royal Academy in 1768, but no woman member was elected for more than a century afterward; and I recall that, as recently as the 1960s, women Royal Academicians were not allowed to attend the annual Academy Banquet, but merely permitted, on sufferance, to join the men after the toast to the royal family.[5]

Joshua Reynolds, the first president of the Royal Academy, vetoed a proposal by his gifted sister to set up as a professional portrait painter, and did everything in his power to stop her from painting. Male creative giants were not at all eager to see female giants emerge in their families. Wordsworth never encouraged his wonderful sister, Dorothy, to write poetry, though he was often indebted, in his own verse, to her capacity for minute observation of nature. (His most famous poem, "The Daffodils," would have been impossible without her sight and insight, as recorded in her *Grasmere Diary*.) Rossetti never lifted a finger to help his sister Christina, a better poet than he was. Mary Cassatt, the greatest woman painter of modern times, whose superb paintings of mothers and daughters are as good as, and in some cases better than, Raphael's, was always pooh-poohed by the newspapers of Philadelphia as the "gifted daughter of a prominent local family whose interest is sketching," though in fact she was the most rigorously

trained, and self-trained, artist of her generation. I own a superb watercolor by Caroline St. John Mildmay (1834–1894), who was allowed by her family to acquire some training only after she threatened to starve herself to death unless they agreed, and then only on the condition that she would never sign her works or use the family name in any circumstances. The majority of women writers in England and France during the nineteenth century used pseudonyms so as not to offend their families.

By contrast, there were a few families for whom the pursuit of writing or art was their trade, and women members were expected or encouraged to participate. The outstanding example of such a family in the age of Jane Austen was William Godwin's. He had two wives and an extended, if chaotic, family. His first wife, Mary Woll-stonecraft, author of *Vindication of the Rights of Women*, died at the birth of her daughter, Mary, who subsequently eloped with and married Percy Bysshe Shelley. Godwin then married a widow, Mrs. Clairmont, who brought with her two children: a son and a daughter, Jane, who renamed herself Claire, and subsequently had a messy affair with Lord Byron and bore him a daughter, Allegra. According to Claire Clairmont, an assiduous diarist and a prolific letter writer, but not a creative artist, "You are accounted nothing in our family until you have written a novel." (Mary, her stepsister, wrote her first novel, *Frankenstein*, at the age of eighteen.) Mrs. Clairmont, a bossy, bullying woman, set up a publishing business turning out children's books. It is curious that she did not get Claire to write some of them. Instead, she became an embittered governess, the fate narrowly avoided by the beautiful but penniless Jane Fairfax in Austen's *Emma*.[6]

There was a third kind of family, which was not hostile to daughters (or even wives) exercising their talents, but did not go out of the way to assist a career in the arts. Such families expected girls to perform their household and social duties before anything else, yet nevertheless provided a cultured and appreciative background in which talent could flourish. That was precisely the kind of family to which Jane Austen belonged, and I would argue that it constituted the perfect setting for her particular genius. But there are mysteries about Austen; and because of the censorship imposed on information about her by her overanxious sister and family,

these mysteries are unlikely ever to be solved. The first concerns her appearance. Her elder sister Cassandra had a certain talent for drawing and drew Jane's likeness many times. But only two of her efforts have survived, and one does not show the face at all. The other does, and this is the portrait of Jane Austen that is endlessly reproduced in all the biographies and illustrated articles. It shows that she had large, luminous eyes, and this confirms other evidence but does not prove that she was either dazzlingly pretty or rather on the plain side. The fact is that as a portraitist Cassandra had no skill in conveying the essential visual truth about a subject's face. The literary evidence about Jane Austen's appearance is likewise inconclusive. Everyone agreed that she was a lively child and adolescent, eager, clever, talkative, and quick to learn. She was funny and loved laughter. She thought a good deal about handsome young men, and there is even a suggestion that she was a husband-hunter. Well, what normal girl was not, in those days? But no one ever suggested that she was a beauty. Had she been, the news would certainly have filtered through the censorship screens of the Austen family. If Jane had been "very handsome," like Elizabeth Elliot in *Persuasion*, or "handsome" like Emma, or even "a very pretty girl," like the young Anne Elliot, we would certainly have known it. The chances are that Jane Austen was no more than "a fine girl," the rather dismissive phrase that she uses to describe a young woman who has no claim to personal distinction in her looks.[7]

And that, hard as it may seem to say so, was to the advantage of all, certainly to Austen's readers. For the Austen family was very social, had some links to the gentry and aristocracy, was respectable and presentable, and had an enormous acquaintance. The Austens were much visited and did much visiting, attending balls regularly, and the girls had ample opportunities of meeting eligible young men. Cassandra, indeed, became engaged to an entirely suitable person who, alas, died suddenly before the marriage could take place, and she was evidently so stricken that she never formed another attachment. Jane herself got engaged, repented overnight, broke off the match the following day, and thereafter had no strong fancy or luck. Both sisters were particular. But Jane was strongly romantic, we know, and believed in love, and had she been a beauty the Darcys would no doubt have been forthcoming; she

would have married and produced children instead of novels. We would never have heard of her.

In the nineteenth century, the probability was very strong that a woman, however gifted she was, would never produce great works of art; were she a beauty, the probability was overwhelming. Take the case of de Staël. Her father, Jacques Necker, the great financier and finance minister of prerevolutionary France, was a millionaire and major landowner, the disposition of whose fortune put it beyond the powers of the sansculottes to confiscate; and Germaine was his only child and sole heiress. Had she been a beauty in addition, she would have made a grand marriage, into the ducal or princely class, and the life of a writer and den mother of a literary coterie would have been forbidden to her and probably not to her taste, either. As it was, she was plain, though not uninteresting in looks, as dozens of portraits and drawings testify; and the best that she could do, or that could be done for her, was marriage to the Swedish ambassador in Paris, Erik de Staël-Holstein, a man she never could or did love. Her marriage was thus the prolegomenon to her literary aspirations, her life at Coppet, and the amours which enlivened it and spurred on her works.

A similar point could be made about Aurore Dupin, the Baroness Dudevant (1804–1876)—or George Sand, the name with which she signed her writings.[8] Aurore, as she liked to be called, had a number of advantages in life. She was brought up on a beautiful property called Nohant, which she eventually inherited and which (like de Staël's Coppet) was the setting for some of her many liaisons and the place where she wrote the majority of her large oeuvre (106 volumes in the comprehensive edition). Her family, though difficult and quarrelsome, had some very grand connections on both sides; her father was an aide-de-camp to Prince Joachim Murat, Napoleon's brother-in-law and best cavalry commander. Her father, Maurice Dupin de Francevil (the name was shortened to Dupin during the Terror), was descended, illegitimately in some cases, from King Augustus III of Poland. Sand herself was related by blood to Louis XVI, Louis XVIII, and Charles X, all legitimate kings of France in their day. She aroused, and still seems to invite, extraordinary animosity and accolades. Chateaubriand thought her "destined to be the Lord Byron of

France." Baudelaire called her a "latrine," Nietzsche "a writing cow," V. S. Pritchett a "thinking bosom," and Virginia Woolf "France's Jane Austen." Saint-Beuve, who knew her well, thought she had much in common with Madame de Staël: each married to escape her mother, both were disappointed in marriage and treated it as a nullity, and both took lovers frequently younger—even much younger—than themselves. There is some mystery about George Sand. One of her lovers, Alfred de Musset, was not only younger than she but attractive and pleasing to women, as well as famous; another, "Freddie" Chopin, was also younger, handsome, and a European celebrity. They saw something in her. But what? Many portraits testify that she was plain, like de Staël, with a long, lugubrious face. Her figure was not boyish, as is erroneously supposed, but gross. Saint-Beuve testified: "She had a great soul and a perfectly enormous bottom." Gustave Flaubert, with whom she conducted a fascinating correspondence, also noticed it and, being a rude Norman, was not diffident about telling her so. When she asked: "Does my bum look big in this bombazine?" he replied: "Madame, your bum would look big in anything." Like de Staël, George Sand had connections and prospects that, if she had been given good looks too, would have enabled her to do well and move several steps up the social ladder. As it was she had to make do with a retired army officer, Baron Dudevant—a "washout," as she put it. So she lived her literary life, like de Staël, and the books flowed, a *roman-fleuve* indeed.

But the outstanding example of plainness fostering genius and leading to fulfillment is George Eliot (Mary Ann Evans, 1819–1880). She was almost grotesquely plain, while radiating intelligence, wit, and laughter, at any rate as a young woman; later she became more solemn.[9] But no man ever proposed to her until after she made herself rich and famous. Her father was an estate agent, like Wordsworth's, and was mean, especially to her: after she nursed him devotedly for years, all he left her was £2,000 in trust, enough to produce an income of £90 a year but not enough to live on even then. She faced what she called the "horrible disgrace of spinsterhood" and, in order to remain respectable, lived with the family of her unpleasant, disapproving elder brother, Isaac, and spent her time in plain sewing, playing the piano, and reading to

her nephews and nieces in a household of conventional religious and social observance which was to her stiffeningly narrow. Marian (as she called herself after about 1851) was not a forceful character, being shy and painfully conscious of her homely appearance, and still more of her powerlessness in a man's world. But she was not without courage and self-knowledge, and knew that, given the smallest chance, she could make a living in the world. Having acquired a good knowledge of German, French, and Italian, she chose translation as her best entry into the world of letters, broke with her father over religion, went to London, and set herself up in lodgings there. Her translations of important German books, such as David Friedrich Strauss's *Life of Jesus*, were warmly received, and she established herself at the *Westminster Review*, a well-regarded liberal publication, where she soon made herself indispensable. In effect, she became its editor, though the nominal title, and salary, naturally went to a man.[10]

Marian Evans was a highly emotional, not to say amorous woman, and if she could have married a man of anything approaching her own intelligence, she might have been perfectly happy, given birth to many children, and never written a novel. The trouble was that she was neither pretty nor handsome. Frederick Locker wrote: "Her countenance was equine. Her head had been intended for a much larger woman. Her garments concealed her outline, they gave her a waist like a milestone." Jane Carlyle observed: "She looks Propriety personified. Oh, so *slow*!" Evans fell in love repeatedly—for example with Herbert Spencer, to us a fusty, flyblown figure; founder of that pseudoscience sociology; writer of now unreadable books; and celebrated chiefly for his curious saying, "A proficiency at billiards is a sure sign of a misspent youth." Spencer, despite his personal faults, evidently attracted clever women; he also inspired a passion in Beatrix Potter (later Webb), who was not only brilliant in intellect but beautiful and rich. Evans worshipped him, and she wrote him a remarkable and shameless letter, in effect a proposal of marriage:

> I want to know if you can assure me that you will not forsake me, that you will always be with me as much as you can, and share your thoughts and feelings with me. If you become

attached to someone else, then I must die, but until then I could gather courage to make life valuable if only I had you near me. . . . Those who have known me best have always said, that if ever I loved one thoroughly my whole life must turn upon that feeling, and I find they say truly. You curse the destiny which has made the feeling concentrate itself on you—but if you will only have patience with me you shall not curse it long. You will find that I can be satisfied with very little, if I can be delivered from the dread of losing it.

It must have taken great courage to compose, and still more to send, this letter, which inspired great terror in the recipient. Evans went on:

I suppose no woman before wrote such a letter as this—but I am not ashamed of it, for I am conscious that in the light of reason and true refinement I am worthy of your respect and tenderness, whatever gross men or vulgar-minded women may think of me.[11]

However, Spencer was unresponsive, as he was to Beatrix Potter later. He never married, though he once shared a house with two maiden ladies, eventually quarreling with both of them.

If Marian Evans had induced Spencer to marry her, the likelihood is that she would not have become a writer of fiction, of which he strongly disapproved. Denied marriage, she moved in an overwhelmingly masculine society. She was often the only woman present at dinners and meetings for public intellectual or cultural purposes, for instance a gathering at 142 Strand in May 1852, presided over by Dickens, to protest against the booksellers' cartel. Given her ardent temperament, it was inevitable that she would sooner or later become the mistress of a literary man, and this happened in 1854 when her choice fell on G. H. Lewes, a miscellaneous writer of wide gifts but no genius. He had been married for many years, to a woman who took lovers and had children by them (one of her lovers was Thornton Hunt, Leigh Hunt's son), but for legal reasons could not divorce her. He and Evans lived together, and she then called herself Mrs. Lewes, until his death. Her brother Isaac

forbade her family to have any further contact with her, and for a time she felt spurned and isolated, though she was at home in the largely male society of literary-journalistic London.

Things changed radically when she became a successful novelist. In this regard, Lewes proved invaluable. He recognized her talent for fiction the moment he saw "Amos Barton," the first tale in what became *Scenes of Clerical Life*. In November 1856, he sent it to the publisher John Blackwood in Edinburgh; and the *Scenes* as a whole were published (in 1858) with sufficient success to encourage her to write a full-length novel. This was *Adam Bede*, published in 1859 and an immediate best seller, with 10,000 copies sold in the first year alone. Then and after, she benefited both from Blackwood's generosity and from Lewes's business acumen. The manuscript of *Adam Bede*, in the British Library, is headed by the words "To my dear Husband, George Henry Lewes, I give this MS of a work which could never have been written but for the happiness which his love has conferred on my life." In fact, though, she was experiencing depression at this time, brought on by Isaac's cruel behavior and by the death (from tuberculosis) of her sister Chrissey, whom she had not been allowed to see.

Still, she worked through the sadness by writing her superb autobiographical novel *The Mill on the Floss*, exorcising her grief by describing herself as the delightful but tragic Maggie Tulliver and Isaac as Tom Tulliver, though Tom is characterized by love and warmth which Isaac lacked, and which reflect the author's greatness of spirit. This beautiful and poignant tale, one of the finest novels ever written, became Queen Victoria's favorite, and that of many of her subjects. (It sold 4,600 copies on the first four days of publication.) There followed, in steady succession, *Silas Marner*, *Romola*, *Felix Holt*, and *Middlemarch* (1872), the last a commercial and critical success of a high order, bringing George Eliot acclaim as the successor to Charles Dickens, who had died in 1870. By now she was rich, and the tables were turned. She was increasingly recognized not only as a storyteller of extraordinary gifts but as a moral mentor of formidable power. Polite society, far from shunning, queued up at her door and was often refused admittance. By the 1870s the Leweses' drawing room was known as one of the most exclusive. Moreover, Eliot's fame was global. *Romola*, set in

Renaissance Italy, was overresearched and was not enthusiastically received in England, but it was read and revered throughout continental Europe. And *Daniel Deronda*, set in the Jewish diaspora, was enormously influential among emancipated Jews, then emerging from the ghettos and taking a leading part in intellectual and cultural life. Indeed this book became one of the formative documents of the new Zionism, which emerged in the 1890s in the wake of the Dreyfus case and was the first decisive step in the creation of Israel. There was a spirit of high seriousness about George Eliot to which Dickens and Thackeray never aspired. Among the Europeans, Balzac, Flaubert, Zola, even Hugo never managed to strike the same philosophical note of seerlike wisdom. (Eliot was well described, by Leslie Stephen, as the "Mercian Sybil.") Only Tolstoy is a comparable figure.[12]

It is a pity that Marian Evans had to go down in literary history saddled with a masculine pseudonym. However, her pen name was not so degrading as "George Sand," which dated from Aurore Dudevant's collaboration with Jules Sandeau; in fact, Dudevant wrote first as "Jules Sand." In Evans's case, the pseudonym was adopted because of the difficulties raised by her liaison with Lewes, and was a horrible burden to her, particularly since a nonentity called Joseph Jiggins was identified in the gossip columns as the real George Eliot and for many years obstinately refused to disavow the falsehood. By the time her work was published, in the 1850s, it was no longer necessary, as a rule, for a woman novelist to write under a man's name. Actually, Fanny Burney and Maria Edgeworth had written under their own names half a century earlier. Jane Austen, once she attached any name at all to her writings, insisted on her own. Mrs. Gaskell used her own name from the start, though before the passage of the Married Women's Property Act, her earnings were appropriated by the Rev. Mr. Gaskell ("'Look, my dear,' she told him, 'see what Mr Dickens [then editing *Household Words*] has sent me for my little story, a cheque for a hundred pounds!' 'So he has,' her husband replied, taking the cheque and complacently putting it into his waistcoat pocket.") It is true that the Brontës, whose work was first published in the 1840s, used the names Currer, Ellis, and Acton Bell, deliberately concealing their sex. But that tiresome practice was by then unusual and needless;

and George Eliot was a victim of prejudice rather than convention.[13]

It is instructive to compare Eliot with Jane Austen. Eliot achieved astonishing success and fame in her own lifetime, whereas Austen, though she did become known, was still comparatively obscure at the time of her death. Sales of Austen's books did not overtake Eliot's until the middle of the twentieth century, though they now far surpass Eliot's; indeed, today Austen is more widely read than even Dickens, at any rate in the English speaking world. Eliot was in every way a better-read and more fully educated woman than Austen, fluent in languages, knowledgeable in history, theology, and philosophy; a woman able to argue, on almost any serious subject, with any man in Europe. Austen, by contrast, was educated perhaps adequately (for her sex and station) but certainly not well; was well-read only in novels; was a poor speller; and professed the lowest possible opinion of her qualifications to launch herself in literature.

What Austen had, however, was a gift or characteristic more important than any other qualification: the creative spirit. The record shows that, from her earliest years, as soon as she could read properly and write fluently, she had an urge—it would not be too strong to say a compulsion—to create. It expressed itself in verse and prose, but in either form in the telling of stories on paper, stories that had almost certainly begun as fireside tales, told to her siblings or just to herself. It is hard to think of any author who had this compulsion in such a natural, strong, undiluted form.

Jane was the second-youngest child in a large family (originally ten) mainly of boys: she and her elder sister, Cassandra, were the only girls. Jane was small, dark, sparkling, always laughing, full of jokes and inventiveness, superbly observant from a very early age, and as she grew older increasingly sharp. The remark about herself most to be treasured, for it goes to the heart of her creative personality, is: "Follies and nonsense, whims and inconsistencies do divert me, I own, and I laugh at them whenever I can." Austen grasped, as a mere girl, that human beings and their daily behavior were a source of endless laughter, as they kept themselves afloat, bobbing on the waves of existence. As the daughter of a country rector, whose profession automatically designated him a gentleman, and

with family connections which, in a few cases, were almost grand, she was a member of England's social pride, its hugely extensive middle class, whose higher reaches merged imperceptibly with the gentry, with glimpses even of the nobility. This position gave her an admirable perch from which to observe a wide spectrum of society; and her connections gave her an occasional opportunity to stay at houses considerably more affluent than her own (and to attend dances not easy of admission). So, in her birdlike way, she was able to hop to twigs much higher up the tree, and take in the activities and twitter there too. Indeed, I calculate that her social position, both in its strengths and in its precariousness, was exactly such as to give her the best and most extensive materials for novels of gentle social satire.[14]

That apart, Jane's background was not such as to make a literary career easy. For one thing, she never had a room of her own. It is true that when her father was an active clergyman, with a vicarage, she and Cassandra were able, despite the large size of the family, to share a sitting room of their own—a sparsely furnished but spacious attic, where Cassandra, a budding artist, drew and made watercolors and Jane scribbled. This space was a rare privilege. It appears in *Mansfield Park*, when the young Fanny is given an unoccupied attic room by her kind cousin, Edmund, and allowed to make it her own, for reading and writing in all the comforts of privacy. To a sensitive and imaginative creature like Jane Austen, privacy was one of the keenest of blessings; and she shows it operating in Fanny's case, but then being cruelly withdrawn in the second half of the book: Fanny declines what seems to be a suitable marriage to Henry Crawford and then is sentenced to a term with her natural family in Portsmouth and has to endure the squalor, noise, narrowness, and, above all, total lack of privacy of a lower-middleclass home. The fact that Austen shared her own precious sitting room with her sister was no drawback. One of the greatest advantages she enjoyed, from early childhood, till her death, was the love and intimate friendship of Cassandra. Their mother said that Jane wanted to share everything with her elder sister, "So that if Cassandra were to have her head taken off Jane would want to lose hers too." Their closeness and their ability to share secrets and ideas was probably the single most important factor in Jane's life, and the

one most helpful to the development of her skills. She knew it: hence the contrast she draws, in the most personal of her novels, *Persuasion*, between her own good fortune and the sadness of poor Anne Elliot, who can share nothing with her sisters—the haughty, unfeeling Elizabeth and the petty, selfish Mary. The shared upstairs room at the rectory, with Cassandra always available to consult, help, share jokes, and judge childish writings, was the real nursery of one of the finest talents in English literature.

Alas, it did not last. The decision of the Reverend George Austen to retire to Bath meant the end of the shared sitting room, and Jane was never again fortunate enough to have a private place in which to write. She was obliged to use communal rooms in comparatively small houses. When staying with her brother Edward, after he inherited Godmersham, a fine country house, she was able to use its library for writing; but even there she was liable to interruptions. During most of her life as a writer she had to use a little corridor, convenient when the house was silent, but a passageway at other times, so that Jane had to cover up her manuscript and put it away when she heard someone approach. Being inclined to ribaldry, I was fascinated to hear, when the amorous proclivities of President Clinton were made public, in considerable detail, that his couplings (such being the public nature and geography of the White House) also had to take place in a corridor, similarly subject to interruption; and that, hearing noises, the president was forced to zip up his trousers just as Jane Austen had to conceal the pages of her current novel. *Ceteris paribus*, and allowing for the standards of different epochs, Clinton's awkward interruptions were precisely the "follies and nonsense" that would have made Austen laugh. But she had no sex life of her own: and there are only sixteen kisses in her novels, none between lovers.

The lack of a private, secure place in which to write was not the only disadvantage from which Austen suffered. Girls of her class did not have careers. It was already well established that women could write books, especially novels, and in the first quarter of the nineteenth century the woman writer was already a familiar figure on the English scene—more so than in France. But an unmarried girl or woman had no rights or privileges in a genteel household (as opposed to the bohemian one of the Godwins); and even after

Austen was a published author, she was expected to put her family and social duties before her professional. Writing came at the end of the queue, after helping her mother, receiving and entertaining guests, and paying visits. Writing was not "serious," even when it began to earn money. In the family, Austen's creative passion, though always tolerated, was always seen as marginal. Ostensibly, even she saw it this way, though in her secret heart she must have recognized its centrality in her life.

Yet in important ways Jane Austen was lucky in her family. Except for her elder brother George, who was mentally handicapped, was farmed out, and disappeared permanently from the family circle, all the Austens liked to laugh. Her mother wrote comic verses for all occasions, with rapidity and some skill, and her brother Henry was the editor of, and a writer for, a comic Oxford University periodical. From the moment when she was old enough to make jokes and write squibs, verses, and tales, Austen never lacked a receptive audience at home, appreciative and critical. She was soon accorded an important place in the family's system of self-entertainment. The Austens were not only an educated family; they were clever. The father and two of the sons were, at one time or another, fellows of their Oxbridge colleges. There were always plenty of books in the house. Mr. Austen made all his children free of his library at all times and, so far as we know, no restrictions were ever imposed on Jane's choice of reading. They were a great family for amateur theatricals, which supplied Jane with some of the best chapters she ever wrote, in *Mansfield Park*. And there was no Sir Thomas Bertram to put a stop to them by his sudden return. Although Mr. Austen was a clergyman, he had no objection to performing plays for the family and neighbors; nor is there any hint that he, or anyone else, took a narrow view of what plays might be properly performed. The view of decorum at the vicarage was more liberal than at Mansfield.

Jane Austen thus grew up in an educated and literary circle at home that was broad-minded and tolerant; and her earliest efforts were offered to her elders, who could be guaranteed to laugh in the right places (provided the jokes were good enough) and to applaud literary merit. Later, her father, her brother Henry, and other members and friends of the family were generous and helpful in

enabling her to get published. It is true that, from first to last, Austen never met published authors or literary figures of any kind. She knew nothing of the salon atmosphere in which Madame de Staël spent her adolescence and early womanhood. Nor was Austen even tempted, like Marian Evans, to break away from the family and seek the competitiveness and stimulation of literary London. I suspect that Austen would have found such a course abhorrent—and, in practice, quite impossible. There is no evidence that her work suffered in the least from lack of contact with other literary people. After giving much thought to the matter, I conclude that her circumstances, with all their limitations, were highly conducive to helping her become a professional novelist of the highest quality. But that was only possible because, in addition to all her other gifts, she possessed one which is often quite lacking in creative people—the habit of self-criticism.

Austen was a superb judge of what she could do, and what was her best. I say "was"; it is more accurate to write "became." Her juvenile works, written between 1787, when she was twelve, and 1793, her eighteenth year, survive because as an adult, she went to the immense labor of copying them all out from the original manuscripts (which have disappeared) into three notebooks, as a record of her work and for the pleasure of reading them aloud to her family and friends. The lengths vary. Some of this work is fragmentary or unfinished. In the first manuscript volume are "Frederic and Elfrida," "Jack and Alice," "Edgar and Emma," "Mr. Harley," "Sir William Montague," "Mr Clifford," "The Beautiful Cassandra," "Amelia Webster," "The Visit," and "The Mystery." All were written when she was twelve to fourteen years old; "Love and Friendship," her earliest major story, was written in 1790, when she was fourteen. There followed "The History of England," dated November 1791. These, plus a story from 1792, "Lesley Castle," make up the second volume, together with "Scraps," as Austen calls them. The third manuscript volume contains "Evelyn" and "Catherine." In the first volume, though composed later, are "The Three Sisters," "Ode to Pity," and what Austen calls "Detached Pieces."[15]

These teenage works are remarkable for three qualities. The first two are the enormous self-confidence with which they were conceived and composed, and the direct, incisive, often elegant

manner in which they were written. Austen never had any difficulty with words, vocabulary, grammar, or syntax. Spelling was a different matter. She had difficulty with *i*'s, *e*'s, and *y*'s. Throughout "Love and Friendship," she has to correct the spelling of the title word, originally "freindship"; and she tended to write "Surrey," for instance, as "Surry." She also tended to spell by ear—geraniums thus became "jerraniums." However, no seasoned critic reading these teenage stories could have had any doubt about the author's narrative power; and any reader must marvel at Jane's economy of means, always one of her strongest gifts. Here, obviously, was a professional writer in the making.

The third remarkable quality might be called ebullience, enthusiasm, or recklessness of invention. The young Austen loved fierce, terrifying adventures; intense melodrama; shocking events; and abrupt deaths. Her characters love, revolt and fight, have babies with abandon, run away, marry in the most dashing manner, talk in superlatives and hyperbole, and then are written out of the script with ruthless enjoyment. Austen is writing fireside, nursery theater, or melodrama, to get the "oohs" and "aahs" of her audience, and she succeeds because the characters, though undergoing fantastic experiences, are recognizably the young people of her circle. As she grew older, she tended to vary bare narrative with that eighteenth-century fictional device, the exchange of letters. This was progress, because Austen, by using correspondence, was sharpening her wits to embark on dialogue, which she used in her maturity with increasing and soon brilliant skill, to carry on the story economically, to exercise her wit, and to add the huge new dimension of realism.

At this point in considering Austen's development, we must examine a fundamental change in her writing, which suddenly turned her from a juvenile of promise into a truly marvelous writer of stories about real life. The transformation, it seems to me, came when she was about eighteen or nineteen and began to see the melodramatic fiction in which women writers specialized in the mid-1790s, and which she read avidly, with critical eyes, and began to laugh. Laughter was the invariable precursor, in Austen's life, of creative action—the titter, the laugh, the giggle, or the guffaw was swiftly followed by the inventive thought. Once Austen began to

laugh, not with the melodramatic novels she read, but against them, she began to look into herself and say "I can do better than that." And, looking into herself, and what she did and thought, and her relations with Cassandra and her parents and brothers—and the relations, friends, and acquaintances in her small society—she began to see material for liveliness and laughter, which had no need of impossible events, death, or destruction to be interesting. Quite naturally, she perceived that real life, as she knew it from personal experience, was much more fun to write about than impossible adventures of which she knew nothing. Naturally, Jane put herself at the center of these new stories about the life she knew, for did she not know more about herself than about anyone or anything else? So in her first proper novel, written in 1794–1796 and called *Elinor and Marianne*, then rewritten 1787–1788 as *Sense and Sensibility*, she gives what she realized were the two sides of herself, the thoughtful Elinor and the impassioned Marianne, making the contrast between their natures the axis on which the story revolves. This is her first story in which the characters are all recognizable creatures from her own circle and knowledge and, in addition, behave fully in character and not as melodramatic puppets serving the interests of a sensational story.

But, not content with turning her own fictional back on melodrama, she also felt minded to express her satirical thoughts about it, by way of exorcism. So she wrote, in 1798–1799, a novel called *Susan*, which as revised became *Northanger Abbey*. Its teenage heroine, Catherine Morland, is in some ways the most interesting and touching of Austen's heroines, since Catherine evokes the author's earlier self, a gawky teenager with rough edges not yet smoothed off. All the Morland children were "very plain," and Catherine was "for many years of her life as plain as any." That proviso, "for many years," is the key to the novel, for its energy and delight is the transformation of a gawky teenager into a desirable young woman, and a lover of melodramatic novels (like Jane herself) into a highly emotional participant in real-life romance. So Austen introduces what is almost an antiheroine with "a thin, awkward figure, a sallow skin without color, dark lank hair, and strong features," "fond of all boys' plays," who "greatly preferred cricket to dolls." That is Catherine at ten. "At fifteen appearances were mending." She

became clean and tidy, and on some days "almost pretty." And from fifteen to seventeen "she was in training to be a heroine," though so far without an object of love. That is where the story begins, with Catherine's invitation to accompany the Allens to Bath.

Sense and Sensibility and *Northanger Abbey* are bridging works, from juvenilia to maturity. They are not great novels, though they contain passages of greatness, flashes of the power that now lay in her grasp. She had found what she could do best, and better than anyone else. As she later put it (in a letter to Anna Austen of 9 September 1814), "3 or 4 families in a Country Village is the very thing to work on." She began to narrow her scope strictly to what she had actually experienced by direct observation or hearing, thought about, and cared about deeply. This meant, as she put it to J. Edward Austen (in a letter of 16 December 1816), confining herself to "the little bit (two inches wide) of ivory on which I work with so fine a brush, as produces so little effect after so much labour." It became one of her rules, extremely rare among writers of fiction, never to describe an event or record a conversation that she did not see or hear, or could not have seen or heard, herself.[16] This means that there is no grandeur or squalor in her novels, and she never records, for instance, men talking among themselves—something which, by definition, she could not have known about. Her self-awareness and her careful nursing and restricting of her talent and subject matter are among the great secrets of her success. And here we come to a key point about Austen: she was not a genius. There was nothing mysterious about her work. In the work of the four supreme creative geniuses of English literature—Chaucer, Shakespeare, Dickens, and Kipling—there remain and will always remain inexplicable aspects—moments of creative achievement that seem to be plucked out of thin air, are pure imagination, and cannot be related to the author's known life. Each had his demon, and when this creature within flared up, the magic followed.

Now, Austen had no demon. There is no magic about her novels, even the four great ones. They can be explained. They are the discernible result of huge natural talent, honed, improved, and made superlative by "much labour" (as she put it), experience, and self-restraint. A good novelist feeds on direct experience—Austen

most of all, and nothing much happened in her life or in the lives of those close to her. Evelyn Waugh wrote that personal experiences are a novelist's capital, to be hoarded, and spent only with prudent avarice, because they are irreplaceable. Austen is an excellent illustration of this rule. She made use of key pieces of personal knowledge or direct experience with tremendous care, often using them again and again in ingeniously varied forms. One event that struck her for its imaginative possibilities was the good fortune of her brother Edward in finding favor with the rich and childless Knights, who took him from his natural family and educated him at considerable expense (he did the grand tour) to be their heir. Austen used this device again and again—from within, as it were, in *Mansfield Park*, where she, as little Fanny, enacts the touching business of being snatched from humble parents to be brought up amid ease and affluence—and fears—in the "big house" of her cousins. The device is used again, this time from without, in the character of Frank Churchill in *Emma*. Frank's experience is much closer to her brother's, and this character emerges in the novel as a wonderfully real person, a dashing amalgam of extravagance, superficial folly, and innate decency, making a splendid foil to the real, solid hero Mr. Knightley.

Austen uses the device a third time, again from within, in *The Watsons*, written in 1804–1805, a fragment unfortunately abandoned when her father died, which promised to become a great work. The book opens with Emma Watson, "who was very recently returned from the care of an Aunt who had brought her up," being taken to her first ball by her eldest sister, Elizabeth. Austen ingeniously uses Emma's long absence from her family to allow Elizabeth, in the course of their conversation, to give Emma, and so the readers, inside facts about the neighborhood and its inhabitants (and, in the process, about their own family—one of their sisters, Penelope, is presented as a selfish manipulator, almost a she-devil, and the reader looks forward to meeting her). This brilliant and wholly natural—though sophisticated—beginning to the novel shows that Austen was already, by 1804, at her self-confident best, putting in the background economically and easily while also driving forward the story. The first big episode, at the ball, where Emma accidentally makes the acquaintance of the great folks by

taking pity on a ten-year-old boy whose elder sister has reneged on giving him a dance, is another device clearly based on an actual incident in Austen's life. She uses it again and again, and I call it the "wallflower rescue." She had already used it in *Northanger Abbey*; it crops up in *Pride and Prejudice*; it is glanced at in *Mansfield Park*; and it plays an important role in *Emma*, where Mr. Knightley's pity in rescuing the slighted Harriet leads both Harriet and Emma to the dramatic conclusion that he is in love with the poor girl. Austen's economy of means, her husbanding of her fictional capital, and the skill with which she uses and varies it, are among the aspects of her art I most admire. But art it is, not genius. There was no need for the demon or the magic: Austen's entirely rational and profession-al methods of using her skill, and experience, were enough in them-selves to create four works of art that have never been bettered in their class.

By the time *The Watsons* was written, Austen had already drafted *First Impressions*, an early version (1797) of what became *Pride and Prejudice* (1809). This wonderful work—to many, though not to the most discerning, her greatest achievement—she recog-nized as a masterpiece of its kind, and she thought it the most "brilliant" and "witty" of her novels. But Austen, though con-fined in self-imposed narrow limits that made repetition easy, had all the great artist's distaste for formula. So she went to the opposite side of her creative territory and wrote *Mansfield Park* (1812–1813), her most "serious" novel, constructed with immense skill to achieve the formidable moral purpose of show-ing fragile, powerless virtue triumphing over brains, wealth, and position. Little Fanny emerges at the end as mistress of the entire Mansfield universe, in a way that is not only wholly plausible but enjoyable too. But the author, who easily tired of virtue (she once said it always made her want to be "wicked"), had, by the end of this novel, as she publicly announces, tired of having to describe distress. So she wrote *Emma*, a sunshine novel in which the only shades are caused by misunderstanding. Many readers find this their favorite, and with good reason. All of Austen's novels repay rereading because they contain hidden felicities not always apparent on the first perusal. But none has so many hidden treasures as *Emma*, or can be read so often with genuine pleasure.

It is constructed with infinite art and has been rightly compared to a detective story, with cunning clues half-hidden in the text to adumbrate the denouement. But, like *Mansfield Park*, it left Jane anxious for novelty; and in *Persuasion*—a tale about what happened when the great war against Bonaparte ended and naval officers found themselves ashore, where girls were waiting—she wrote her finest tale influenced by the new, strong currents of romanticism, generated by Scott, Byron, and other spirits of the age. Anne is a romantic heroine in a way Elizabeth Bennett and Emma Woodhouse decidedly are not—a figure of pathos and resignation most tenderly presented, rescued from the disaster of becoming an old maid (as, by then, Austen was herself) by her own steadfast heroism and the good fortune that Captain Wentworth is of similar nobility. The work is not without serious faults—unlike *Emma*, which is faultless—but yet has an emotional power that *Emma* cannot generate. Once again, however, Austen—as a great artist should—reacted against her creation, and the unfinished *Sanditon* is obviously intended to be a witty, funny satire on the new craze for the seaside: a return, though with a difference, to the glitter of *Pride and Prejudice*.

Thus Austen's creative life ended, in the pain and distress of Addison's disease. The knowledge that today this fatal complaint can easily be cured by modern medication heightens our sense of loss at her death at age forty-one. She left behind three admirable prayers, which contain not a hint of her satirical spirit but are of the strictest orthodoxy and conventional, if noble, expression—they might have been written by one of her heroes, Dr. Johnson—and demonstrate the high seriousness that was an essential part of her character. Her early death, like that of so many creative people of her era—Keats, Shelley, Mozart, Weber, Girtin, Géricault, Bonington—leaves us with a fierce longing for the works she would undoubtedly have produced to delight us. There is no other writer I know of who inspires this feeling so poignantly. That is testimony to her greatness as a creator.

8

A. W. N. Pugin
and Viollet-le-Duc:
Goths for All Seasons

*T*HE ENGLISH-SPEAKING WORLD has produced five archi-
tects of outstanding accomplishment: Sir Christopher
Wren, A. W. N. Pugin, Louis Sullivan, Sir Edwin Lutyens, and
Frank Lloyd Wright. Each was prodigiously creative; each left
behind a huge body of work of the highest quality. But I am
inclined to argue that, in this distinguished galaxy, Pugin was the
brightest star, burning with an intense creative radiance the
whole of his short life.

Pugin was born in 1812, the year when Bonaparte, the titan
of Europe, met his nemesis in the snows of Russia, and England
and the United States blundered into one of the most senseless
wars in history, leading to the destruction by fire of the world's
first planned modern city, Washington. A grand year in which to
be born, which he shared with Charles Dickens and Robert
Browning.

However, while Dickens was a miserable child working at a
Thames-side blacking factory, and Browning was a dreamy
schoolboy learning to write Greek verse, Pugin was already giving
full rein to his dazzling creative talents. He was an only child of
adoring parents who recognized those talents from his infancy
on and cosseted and nurtured them with devoted care. His
father, Augustus-Charles Pugin (1762–1832), was a Parisian
artist who came to London to escape the Terror, entered the

Royal Academy Schools, and then became assistant to the busy and superbly gifted architect John Nash. The father, strictly speaking, was not a professional architect (though he designed Kensal Green Cemetery, that fascinating city of the dead). But he was a superlative draftsman, especially of architectural subjects; a painter, illustrator, and designer; and above all a teacher of art.[1] His house, in Great Russell Street, was only 50 yards from the British Museum, with its magnificent Print Room where artists like Turner and Girtin came to study its drawings, and which A. W. N. Pugin knew from the age of five. His father conducted, from his house, a school of architectural draftsmanship, and the child Pugin mingled with the pupils, some of notable talent. The father was a highly successful illustrator (and writer) of books for the great Rudolph Ackermann, often collaborating with other artists. In 1808 he and Rowlandson produced the highly successful Microcosm of London, Pugin Senior doing the topographical settings and "Rowly" the figures. Both men were watercolorists of the highest accomplishment, specializing in pure, luminous washes. Pugin's gifts can be seen at their best in his brilliant watercolor of Westminster Abbey, at the Royal Institute of British Architects, done in the year of A. W. N. Pugin's birth.[2]

The child Pugin, then, grew up in a household that buzzed with activity—artists, publishers, engravers, and writers, all passionately determined to raise the banner of art, especially architectural art, high in an age when industry and commerce were transforming the most beautiful countryside in Europe, and overwhelming ancient towns, and the coal smoke from millions of chimneys, domestic and industrial, was tinting everything charcoal gray. The house was a fortress of cultural resistance, a defiant temple of beauty, and presiding over it was Pugin's mother, Catherine Welby, daughter of a famous barrister, whose enchanting looks won her the title "Belle of Islington." Her devotion to her gifted son helps to explain why he liked women so much, especially beautiful ones, and got on with them so well.[3]

Pugin began drawing, like Dürer and Turner, at the age of three. He quickly progressed to watercolors, and he continued to use pencils and brushes every day of his life. Every summer his parents took him on tours of the continent, where father and son set-

tled down each morning to draw churches and other Gothic build-
ings. As anyone who takes topographical drawing seriously will tell
you, the way to understand architecture thoroughly is to draw
buildings, with care and in great detail. You are obliged to look at a
building closely, repeatedly, and for long periods. Only thus do you
learn what the architect was doing in a particular case, and as a rule
you are also able to identify the contributions of the masons, car-
penters, and other craftsmen. Pugin, throughout his life, did a
huge number of drawings of Gothic buildings, in Britain and on
his annual continental tours. His close study and reproduction on
paper of actual medieval creations were the key to designing his
own, and helped him to enter the minds of medieval builders and
decorators: they formed, as it were, his apprenticeship under
experts who had lived hundreds of years before him, until he
became a master mason himself.[4]

Pugin drew not just buildings but the objects within them, of
every kind and material. To him, from a very early age, art was
ubiquitous; the world was, or could be, a continuum of beautiful
artifacts; and craftsmen-artists were a collegial body of experts
joining hands and skills to make everything that met the eye
graceful and fitting. At eight he designed his first work, a chair.
Thereafter there were few things in daily use, in the home or any
other kind of building, that he did not re-create according to his
own vision. In 1827, at age fifteen, he got his first professional
commission—to design Gothic furniture for George IV at Wind-
sor Castle; some of the furniture is still there, and in use.[5] At the
same time he began to be employed by the royal goldsmiths,
Rundell and Bridge, to design a variety of precious objects for the
king. At seventeen he set up his own business, designing furni-
ture, and the firm remained in continuous production from
1829 until his death in 1852. In his teens he was a passionate the-
atergoer, and by age nineteen he was creating scenery for Covent
Garden theater, alongside such professional scene painters and
designers as Clarkson Stanfield and David Roberts, both future
Royal Academicians and outstanding landscapists, for in the
nineteenth century set design and landscape were closely linked.
Pugin was soon designing theatrical costumes too. Indeed, what
did he not design? His creative attention turned in every direc-

tion. The Victoria and Albert Museum, later founded as a depository and study center for the astonishing inventiveness of nineteenth-century designers and craftsmen, contains more objects by Pugin than by anyone else (though William Morris, who in some respects modeled himself on Pugin, comes close). These include countless wall tiles, a variety of materials, floor coverings of every kind, plates, trays, dessert dishes, stove tiles, flowerpots, tables, straight chairs, armchairs, cabinets, candlesticks, saltcellars, spoons, candelabras, dishes in metal, chalices, reliquaries, crosses, a chimneypiece, a roller blind, printed linen and cottons, curtains, and other textiles—and the collection at the Victoria and Albert represents only part of his output.[6]

From his teens, too, Pugin was a prolific writer of art books, which he also illustrated profusely. The 1820s were for Pugin a decade of boyish enthusiasm and joie de vivre, marked by exuberant sporting activities, especially rowing and sailing small boats, of which he always possessed and constantly used at least one. His life oscillated between intense artistic activity at the design table, at the workbench, or in his studio; and ferocious exercise outdoors, often in stormy weather. With the 1830s, however, came increasing high seriousness, as the scene darkened. His father died in 1832, and Pugin's first major literary activity was to complete his large-scale work *Examples of Gothic Architecture*. The same year Pugin, who had married young, lost his first wife, Anne Carnet, who died giving birth to a daughter. Seeking comfort and reassurance, Pugin moved toward Roman Catholicism, and in 1835 he was received into the church. Thereafter, his artistic principles and his spiritual beliefs were one, and he saw medieval Gothic style and culture not only as the natural, normative expression for Catholics and indeed all Christians in England but as the right moral aesthetic for all of northern Europe (and its overseas dependencies). He dismissed the classical revival—which was powerful, even dominant in the England of his childhood and youth—as an anomaly, an inappropriate input from the Mediterranean, suitable only for blue skies and hot sun. To him "Gothic north" was tautological: the north *was* Gothic, and Gothic stood for the north.[7]

Pugin was thus one of the very few English architects, and the

only outstanding one, with a firm, at times ferocious, ideological posture. He not only despised but positively loathed the neoclassical architects of the previous generation, especially Decimus Burton. Writing to his greatest patron, the Catholic earl of Shrewsbury, from the North Euston Hotel at Fleetwood, which Burton had designed, Pugin gave full vent to his rage and disgust:

> The abomination of desolation, a modern Greek town is insupportable. I am sitting in a Grecian coffee room, in the Grecian hotel, with a Grecian mahogany table close to a Grecian marble chimneypiece, surrounded by a Grecian scroll pierglass, and to increase my horror the waiter has brought in breakfast on a Grecian sort of tray with a pat of butter stamped with the infernal Greek scroll! Not a pointed arch within miles![8]

In his anxiety to rout the classicists (and others) and to make Gothic the dominant style, especially for all religious and public buildings, Pugin used the literary and illustrative skill he had inherited from his father—and had improved on by perpetual observation and studio exercises—to launch a series of propaganda works unique in the art history of the Anglo-Saxon world. They put a case, vehemently, but they were also practical manuals for followers and disciples, and wonderful works of artistry in their own right. In 1835 came *Gothic Furniture in the Style of the Fifteenth Century, Designed and Etched by A. W. N. Pugin*. The next year came his masterpiece, *Contrasts; or A Parallel between the Noble Edifices of the Fourteenth and Fifteenth Centuries, and Similar Buildings of the Present Day, Showing the Present Decay of Taste* (a second volume appeared in 1841). Also in 1836 appeared two design books, one for goldsmiths and silversmiths, the other for iron and brasswork. In 1837 he published *Details of Ancient Timber Houses of the Fifteenth and Sixteenth Centuries . . . Drawn on the Spot and Etched by A. Welby Pugin*. The title speaks for itself: these were the fruits of his constant continental travels. In 1841 and 1843 he set out his aesthetic ideology in two magisterial volumes: *The True Principles of Pointed or Christian Architecture* and *An Apology for the Revival of Christian Architecture in England*. He followed these key works with

his most complex and painstaking contribution to the revival, his *Glossary of Ecclesiastical Ornament and Costume,* later supplemented by *Floriated Ornament* and *Chancel Screens and Rood Lofts.*[9]

This enormous output of aesthetic theory and practical guidance, based on on-the-spot studies, massive reading and research, uncannily exact observation, and tens of thousands of drawings, was without precedent in England (and has had no successor). Even in Italy, one would have to go back to Alberti to find anything remotely comparable. But unlike Alberti, Pugin was a practical architect and rapidly becoming a highly experienced one, who not only drew his own detailed plans but spent much time on-site to ensure that they were carried out exactly as he wished. He began by designing imaginary buildings and interiors; got two key commissions, one to remake an enormous Gothic house from Scarisbrick Hall in Lancashire and another to fit out a Catholic school and seminary at St. Mary's Oscott in Warwickshire in the Gothic manner; and at the same time gave striking public lectures on what he was doing. These works won him the enthusiastic approval of the English Catholic community, especially its old recusant gentry and aristocracy, who were beginning to lift their heads from the obscurity of the "penal years," following the Act of Catholic Emancipation of 1829. Catholics were now free to spend their own wealth, or to collect funds by subscription, to endow churches and cathedrals, and Pugin became their master builder.

His first cathedral was St. Chad's, Birmingham (1839–1841), built of brick to withstand the smoke and acid corrosion of the Black Country. He used motifs from the Baltic, where brick had been the basic material for Gothic architecture throughout the Middle Ages. St. Chad's was a highly successful design, put up at great speed and minimum cost to suit the liturgical needs of the mother church in a vast industrial center. Pugin, in fact, was a functionalist, the first modern one, following two basic rules that he set down in his *True Principles*: first, that there "should be no features about a building which are not necessary, for convenience, construction, or propriety"; and, second, that "all ornament should consist of enrichment of the essential construction of the building." He followed St. Chad's with major cathedrals in

Southwark in southeast London, Nottingham, and Newcastle upon Tyne; and many minor ones in the United Kingdom, Ireland, and the empire, built under his direct supervision or according to his ideas. Indeed, no man in history was responsible for so many cathedrals. In addition there were dozens of churches— only Wren, with his total of seventy, built more.[10] Some churches by Pugin were comparatively simple, for he served poor communities, who could not afford big spaces or elaborate ornaments. In this respect he was at a grave disadvantage compared with his Anglican followers such as William Butterfield and George Gilbert Scott, who could draw on the almost bottomless resources of the Anglican church, often backed by money voted in Parliament. But, just occasionally, he was able to let himself go, as in the church of St. Giles, Cheadle, in Staffordshire, paid for by Lord Shrewsbury, and entirely built, decorated, and furnished to Pugin's exacting standards. This must rank as the finest church built in England in the entire nineteenth century, and the brightest jewel in the Gothic revival. In the last decade of his life, Pugin also devoted a vast amount of time and trouble to designing, building, and decorating his own house in Ramsgate, and its accompanying church, both masterpieces of their kind, and now being properly looked after following decades of neglect. At the same time as these independent activities, Pugin was collaborating with Sir Charles Barry on the new Houses of Parliament, built following the fire of 1834. The role played by Pugin in this immense enterprise was for a long time minimized or even suppressed, because of his militant Catholicism. It is now acknowledged, however, that Pugin supplied many of the drawings for the building itself, since Barry was ignorant of important aspects of the Gothic style; and that Pugin was entirely responsible for all the best and innovative features of the interiors, including all the decoration, especially the superbly presented House of Lords, the central jewel in the entire structure. Only now, since it has had all its grime removed, is this great building, outside and in, being recognized as a masterpiece of European art (though, alas, thanks to terrorists and the demands of security, the public has only limited access to the interior); and we still have not developed the habit of crediting it to Barry *and* Pugin.[11]

Two questions arise about Pugin as a creator. First, how did he manage to get through this enormous volume of work in his short life? There are many answers. First, owing to his precocity, his full working life began in his mid-teens, and his learning curve as a Gothic enthusiast started even earlier. He did not waste time at Oxbridge or art schools or trying to learn from people who knew less than he did. Second, his dislike of time-wasting extended to every aspect of his life. He was a very decisive man and never dithered. He made decisions quickly and stuck to them. He was extremely businesslike, with a sharp eye for costs and an acute nose for smelling out waste and incompetent workmen. He knew exactly how everything was done. As a scene painter he had learned carpentry, and he kept his hand in. He could carve, mix paint, lay bricks, tile a roof, and operate a forge or furnace for metalwork. Early in his career he formed close links with a succession of expert craftsmen whose quality and taste he could trust and who ran their own businesses. They included John Hardman, a metalworker who originally specialized in brass buttons and medals but whom Pugin encouraged to branch out into every kind of ironwork, into ecclesiastical jewelry and fittings, and even into stained glass, though for the last Pugin also employed the master craftsman William Wailes, especially at Cheadle. For structures, Pugin used George Myers, a gifted carver of wood and stone who was also an enterprising, reliable, fast-working builder. For every kind of ceramic work, especially the encaustic tiles so prominent in his interiors, Pugin used Herbert Minton, and for textiles of every kind, from carpets to chair bottoms, and superb wallpapers (one of the most important features of the Parliament building), he had the help of John Gregory Crace, another outstanding craftsman-artist.[12]

All these men ran sound businesses and could be relied on absolutely to deliver on time and to meet the highest standards. And since Pugin knew almost as much about their work as they did themselves, their collaboration was a union of equals. They worked as a team. From his first teenage business, which foundered in bankruptcy when he was twenty, Pugin had learned a great deal, and thereafter he paid the closest attention to costs, kept impeccable accounts, and eliminated expensive administra-

tive overhead almost completely. While Pugin at his perfectionist best was inevitably expensive, and his efforts at Cheadle drew groans from Shrewsbury's agent, Pugin gave tremendous value for money. He worked at a great pace and made his subcontractors keep pace too—the best way of keeping down costs on a project—and his decisiveness meant that his work never had to be redone. Unlike most architects, he never wasted time or creative energy on having rows with clients. His lifelong association with trusted expert craftsmen meant he never had rows with them either. Pugin never ran an office crowded with expensive draftsmen and assistants. His office was his own mind, and his workroom. A snatch of dialogue survives: "I will send this to your clerk, Mr. Pugin." "Clerk, sir? I never employ one. I should kill him in a week."[13] Though he reduced costs to a minimum, he carried all his accounts around with him, down to the minutest detail, "in a five-inch pocket book, kept in minute writing, like his diary." Hence he could answer clients' inquiries on the spot. He was an intensely practical man, "a serious sailor all his life," who could do remarkable things with his huge, bare hands, including sewing his clothes.

His clothes and appearance tell a lot about him. Though only five feet four inches tall, he was immensely strong and formidable. He could easily "deck a man," as he put it, and sometimes did, if he met with impertinence. He often wore a sailor's jacket, pilot trousers, jackboots, and a windjammer hat. Once, thus dressed, he descended from the Calais boat and got into his usual first-class carriage at Dover. Another snatch of conversation is preserved: "Halloa, my man [said a fellow passenger], you have mistaken, I think, your carriage." "I believe you are right. I thought I was in the company of gentlemen."[14] (That fellow passenger was lucky to escape decking.) Pugin had a broad chest; a massive forehead; restless, penetrating gray eyes; a loud voice; a tremendous laugh; long, thick straight hair; rapid movements; astonishing mental and physical energy; highly strung nerves; and a choleric, passionate temperament. He occasionally gave way to "honest rages with no malice in them," and discerning people recognized "genius and enthusiasm in every line of his face."

He must have been a curious, unforgettable figure to meet in

the street. He wore a wide-skirted black dress coat, a regency style he kept to the end of his life; loose trousers; shapeless shoes for endless tramping while he looked at buildings; and a black silk handkerchief wrapped round his neck. His overcoat was specially made with enormous pockets, to contain all his necessities—shaving things, change of linen, etc.—on his continental rambles, without the bother of luggage. On the return leg, he often threw away his dirty linen and instead stuffed his giant pockets with crucifixes, pieces of medieval stained glass or ornaments, and even on one occasion a monstrance. In contrast to this rough outdoor garb—which made him "look like a dissenting minister with a touch of the sailor"—when he was actually designing, at his Gothic desk he wore a black velvet gown like that of a medieval magus, though this too had giant pockets, inside and out. And for church, he wore black silk knee-breeches and silver-buckled shoes. Indeed, he even donned a surplice at his house in Ramsgate, in order to read vespers and compline in the attached church. As he put it, "I dress upon True Principles!"

This gives a clue to the second question that arises about Pugin. Since he was entirely devoted to reviving Gothic, can he really be called an original creative artist? Was he not a mere revivalist? The answer is an emphatic no. It must be borne in mind that in architecture there are, in practice, only three or four different ways of designing buildings. All were discovered not just centuries but millennia ago, and all subsequent building styles have been revivals, conscious or not. Egyptian architects of the Middle Kingdom and New Kingdom were revivalists. So were the Greeks and Romans. Romanesque architecture was a revival, and so was the classicism of the Italian Renaissance. Pointed-arch Gothic, which made its appearance in the late twelfth century, can be described as a new decorative style, though the buildings on which it was imposed had revivalist ground plans. Pugin believed that Gothic had grown up, pari passu, with civilized English society and was natural to England. He also believed, with more justice, that Gothic, once fully established in England, had never died out there. Indeed it is possible to point to Gothic forms used in every decade of the seventeenth century. Even St. Paul's has, essentially, the ground plan of a Gothic

cathedral. If we look for the origins of the "Gothick revival," we have to go far back into the eighteenth century. In England, Gothic is as much a tradition, reflecting a mood and a culture, as a style. Horace Walpole, in promoting "Strawberry Hill Gothick," was working in that tradition. It is possible, as Kenneth Clark argued in his book on the Gothic revival, to cite direct links between Strawberry Hill and the "specimens" provided in the works of both Pugins, father and son. But they also, and especially the son, established historical accuracy based on observation and study; and their books, as Clark points out, mark the point at which "Walpole's dream of correct Gothic was realisable."[15]

Pugin assimilated Gothic to the point where it became part of his being. His passionate identification with it was so intense and complete that his imagination gothicized not just scenes but people. His second wife died in 1844, and eventually—after much searching and soul-searching—he was married again, to a delightful woman called Jane Knill, exclaiming, "I have got a first-rate Gothic woman at last." He had eight children, all of them with Gothic credentials and all engaged in artistic activities. His life at Ramsgate was Gothic. He rose at six, to pray, like a Benedictine monk. Then he worked. There were family prayers at eight. He allowed only seven minutes for breakfast and fifteen for lunch. Compline in the church was invariably at eight, followed by supper at nine, then bed at ten. He did not smoke or drink, and he ate plain medieval food. He was excellent company, however—a superb conversationalist and particularly attractive to women, whether Gothic, classical, or baroque beauties. He was so immersed in Gothic that he was frightened of the dark and terrified of haunted rooms. Like Macbeth, he believed in ghosts. Also, he was so immersed in Gothic that he could let his artistic instincts roam freely through all its variations and, more important, its possibilities. This had a bearing on his creativity. He was just as innovative and unconstrained as a fourteenth- or fifteenth-century master mason asked to produce a new cathedral or add to an old one. Thus most of Pugin's Gothic designs, for buildings, furniture, or anything else, are entirely original. Only occasionally are they conscious replicas, and then always for a particular reason. What is so remarkable about his work is that it is "correct" Gothic, being designed in that

spirit while having no precise precedent in the Middle Ages. Indeed he designed many Gothic objects that medieval people had never thought of, including an ingenious Gothic umbrella he used for sketching in the rain. From first to last he was a creative artist of extraordinary sensibility and on an enormous scale. He worked, in short, in the same way as the men who designed and built Chartres, Notre Dame, Canterbury, Wells, and Ely, except that he was supervised not by bishops and canons but by his own artistic conscience.

Pugin was not a Victorian but a romantic, who came to aesthetic consciousness in the Regency, and whose affinities were with Keats, Shelley, Byron, and Wordsworth rather than with Tennyson, Carlyle, or Ruskin. Oddly enough, though, he achieved his apotheosis as a designer in a quintessential Victorian event, the Great Exhibition of 1851. In general, the quality of design among the thousands of objects shown was deplorable and incoherent. The outstanding exception was the "Medieval Court," in which all the craftsmen he had used and encouraged, especially Crace, Hardman, Minton, and Myers, got together to produce a glittering array of beautiful things, all in the Gothic manner, from tiles and wallpapers to lecterns, tabernacles, chairs, flower stands, brassware, and precious objects, tables, cabinets, textiles, and carpets, virtually all designed by Pugin. It was generally voted the centerpiece of the entire display; and designers, aesthetes, intellectuals, and opinion formers from all over the world turned it into a cult meeting place as long as the exhibition lasted. Afterward, many of its contents went into museums and collections. This was the event that turned Gothic revival into the normative style for ecclesiastical, state, and public buildings, not only in England but throughout the empire, and also in much of Europe and America. Scores of cathedrals and thousands of churches were built as Pugin would have wished—though not often so "correctly"—as were enormous edifices like Bombay's principal railway station and London's Law Courts. It was Pugin's moment of triumph, and had he lived longer he would certainly have gone on to become one of the great Victorians, perhaps the greatest of them all. But by the end of 1851 he fell seriously ill, and the next year he died, mad. His architectural enemies (he had no others) said that his disorder

was "general paralysis of the insane," the climax of syphilis, but the only evidence is that he was treated, at one point, with mercury. Though he was making little sense in his final days, he kept his creative spirit. His last recorded words were: "There is nothing worth living for but Christian architecture and a boat."[16] Just before he died, in September 1852, he designed a floriated cross for St. Mary's Beverley. The drawing survives, and the cross was made—and very fine it is. Thus passed one of the most continuously, persistently, and intensely creative artists of all time.

If there were world enough and time I would like to devote myself to tracing the influence of Pugin, and his interaction with three other great nineteenth-century men of art: John Ruskin (1819–1900), William Morris (1834–1896), and the French Gothic revivalist Eugène Viollet-le-Duc (1814–1879). Ruskin was seven years younger than Pugin, and by the time he went to Christ Church, Oxford (soon to have its riverfront gothicized in exactly the way Pugin urged), much of Pugin's written work was available, and he eagerly studied it. Indeed Ruskin's first important writing, "The Poetry of Architecture," published in the *Architectural Magazine* in 1837–1838, was the direct result of Pugin's teaching. Ruskin went on, in *The Seven Lamps of Architecture* (1849) and *The Stones of Venice* (1851–1853), to carry further Pugin's essential message that the way men build reflects the spiritual as well as the material value of their culture. Indeed Ruskin's central demand, for moral principles in architecture, was essentially a recapitulation of Pugin's teaching. Ruskin was immensely influential among clever young men, especially at Oxford, just as Pugin was among craftsmen; and one of Ruskin's followers was Morris, twenty-two years younger than Pugin and thus a true Victorian. Morris decided to become an architect after seeing the Medieval Court in 1851 and reading Ruskin and Pugin at Oxford. After visiting the cathedrals of Chartres, Amiens, and Rouen, Morris, following Ruskin, came to believe that medieval craftsmen had enjoyed much greater freedom in their work and art than their modern equivalents, who were enslaved by an industrial system which demanded uniformity, mass production, and above all large profits to make an adequate return on capital, and so used cheap materials and shoddy methods. Mor-

ris, as a youthful craftsman, learning tapestry weaving, carpentry, sewing, painting, and sculpture as well as building, agreed with Pugin and Ruskin that Gothic was the supreme mode; he called Ruskin's *On the Nature of Gothic*, which he reprinted sumptuously when he created the Kelmscott Press, "One of the few necessary meritable utterances of the century." But what Morris learned from the medieval world was not so much the inevitability of Gothic, except in so far as it sprang from nature, the source of all art, as the importance of individual craftsmanship. Art was the superlative form of craft, the foundation of all creative activity. Instead of using a group of firms, as Pugin did, Morris, who inherited capital from his family and had a shrewd (even harsh) business sense, formed what artists came to call "the Firm," known as "Morris, Marshall, Faulkner, and Company, Fine Art Workmen in Painting, Carving, Furniture, and the Metals." It listed on its first circular Ford Madox Brown, Arthur Hughes, Dante Gabriel Rossetti, Edward Burne-Jones, Philip Webb, P. P. Marshall, and Morris himself. This alliance, which included six major artists, naturally did not last, any more than the Pre-Raphaelite Brotherhood, one of its precursors, lasted. But Morris continued his firm throughout his life, in one form or another, and made it profitable and productive.[17]

Morris himself failed as a painter and an architect. His socialism, too, was defective in that he ran his firm, supposedly a cooperative in which workers shared the profits, as a standard commercial enterprise, even a ruthless one, since he did not believe ordinary workingmen could be trusted to spend money sensibly. As a furniture maker too, he was often accused, with justice, of making uncomfortable chairs and impractical articles generally. But he produced magnificent stained glass. And as a designer, especially of patterned textiles and wallpapers, he has never been surpassed. Many of his designs—especially Trellis, Pomegranate, Chrysanthemum, Jasmine, Tulip and Willow, Larkspur, Acanthus, Honeysuckle, Marigold and Willow Boughs, to give some of the most notable in chronological order—have been in use (chiefly for wallpaper, but also for cotton prints, rugs, runners, and tiles) for 150 years and are still popular today.[18] Moreover, Morris's work and example became, almost

imperceptibly, the "arts and crafts movement," whose objective was to design beautiful, well-made things; place them in every household; and so elevate the taste and morals of society. This movement spread to America, to the British empire, and all over Europe, leading to the foundation of thousands of craft firms in every branch of the arts, which not only produced high-quality goods in prodigious quantities but in many cases survive into the twenty-first century and have permanently changed the way we see everyday objects. Thus Pugin and Morris, starting from the same premise but working in different ways and modes, created a worldwide resistance to the aesthetic weaknesses of the industrial age; and it would be hard to say which of them made the larger and more lasting contribution to making the world a more beautiful place. Morris's taste as a designer was uniquely pure—it can be said with truth that he never produced a bad or even a mediocre design. On the other hand the creative spirit in Pugin burned with a more intense, gemlike flame (to quote Walter Pater, one of his admirers), and as an artist, producer, and entrepreneur, as well as an architect of genius, he was a much better example than Morris of moral principles in art. But these are all matters of opinion. Together they transformed taste, all over the world, in ways that have had permanent consequences.

By contrast, Viollet-le-Duc, though learned, gifted, immensely industrious, and highly sensitive, was not primarily a creator. Although he has often been called the "French Pugin," and although he was responsible, following Pugin and hugely influenced by Pugin's work, for making Gothic respectable and even popular in France, he was a different kind of artist, and the differences between him and Pugin are illuminating. Viollet-le-Duc was two years younger, born in 1814, and he took many years to find his niche in France's teeming artistic world. His father was curator of rural residences under Louis-Philippe; his uncle was a pupil of David and later art critic of the *Journal des Débats*. Viollet-le-Duc, following his father (like Pugin), became a superb architectural draftsman and topographical artist in watercolor. For many years he assisted a remarkable publishing entrepreneur, Baron Taylor, in illustrating a series (modeled on English examples that went back to the 1780s) called *Voyages Pittoresques et*

Romantique dans l'Ancienne France (1820 and following years). It eventually encompassed 740 volumes and 2,950 illustrative folios, each of four plates. It aimed to include every "old" building in France and employed artists such as Eugène Isabey, Horace Vernet, and R. P. Bonington (who lived mostly in France) as well as Viollet-le-Duc, though he was the most important contributor, drawing beautiful *entourages*, as they were called— lithographic drawings surrounding the texts. At the Salon of 1838 he won a gold medal for his superb drawings of Raphael's loggia at the Vatican, and the next year he became an inspector in France's National Council of Civic Buildings (he was to remain in the state sector for the rest of his life).[19]

His work was overwhelmingly in restoration. Victor Hugo, as a young man, had raised his powerful voice in protest at the way France's medieval architectural heritage, the largest by far in the world, was being allowed to deteriorate—indeed was being pulled down. Hugo's protests and those of others were effective, and Viollet-le-Duc was the key figure in the national response. He is identified with three projects in particular—the restoration of Notre Dame in Paris, the rescue of the enormous and unique medieval town-cathedral-palace-fortress of Carcassone, and the rebuilding of the magnificent castle of Pierrefonds. But he was also involved in scores of other important restoration projects, of churches, cathedrals, abbeys, and public buildings, all over the country. Despite bitter twentieth-century criticism, similar to that leveled at Gilbert Scott in Britain, Viollet-le-Duc's work was generally of the highest quality and based on profound knowledge. He was sensitive in deciding what had to be rebuilt, what could simply be restored, and how restoration should be done. He provided, too, a unique record of his work in his magnificent "before" and "after" watercolors, which are among the best topographical drawings ever made. Like Pugin, he was responsible for a series of immense books, which are works of architectural and historical philosophy as well as deeply researched records. They include his *Dictionnaire Raisonné de l'Architecture Française du XIème au XVIème siècles* (9 vols., Paris, 1854–1868) and his *Dictionnaire Raisonné du Mobilier Français de l'Époque Caroligienne à la Renaissance* (6 vols., 1858–1874), which revolutionized the study of medieval art and architecture in France

and throughout Europe. Viollet-le-Duc became an expert not only on how medieval artists and artisans worked but on many arcane subjects—locks and locksmiths, wood-casters, joiners, clothes, armor, weapons, and siege engines—illustrating all these topics with stunning watercolors and etchings. He entered into the spirit of medieval craftsmanship as thoroughly as Pugin. But though he could reproduce medieval designs of great utility to nineteenth-century builders who wanted to work or decorate in the Gothic manner, he lacked Pugin's extraordinary skill in producing new expressions of the art. His *Habitations Modernes* (2 vols., Paris, 1877) shows a disappointing lack of originality; and his own country house, La Vedette (near Lausanne, now destroyed), makes a poverty-stricken contrast to Pugin's work at Ramsgate.[20]

Both Pugin and Viollet-le-Duc acquired a knowledge and feeling for medieval art that have never been equaled. But a comparison of their work shows that knowledge and skill in reproducing it in word and line are not enough. Creative power must be there too, as it was superabundantly in Pugin's case, and as it conspicuously was not in Viollet-le-Duc's. Carcassone and Pierrefonds can be admired and enjoyed as medieval entities, brought back to artificial life by a restorer of spectacular energy.[21] But Pugin's church at Cheadle is a genuine masterpiece of nineteenth-century art and architecture, which could have been created in no other age and by no other man.

9

Victor Hugo:
The Genius Without a Brain

VICTOR HUGO (1802–1885) was a creative artist on the grandest possible scale, with the widest scope and the highest productivity. In all four great divisions of literature—poetry, drama, the novel, and the essay—he was equally productive and remarkable. At thirteen he was writing classical tragedies and stories, and three years later he received public recognition with a prize from the Académie de Toulouse. Thereafter his output was incessant (except for one period of depression in the mid-1840s when he turned from writing to drawing) until he suffered a stroke in 1878, at age seventy-six, and slowed down. Even then he continued to write sporadically until his death at age eighty-three. He published in all about 10 million words, of which 3 million were edited from his manuscripts and published posthumously.

Hugo wrote something almost every day of his life, be it only a love letter to Adèle, his wife, or to his principal mistress, Juliette Drouet. Usually it was one or more poems, or several thousand words of prose—perhaps both. Poetry punctuated his life, like his heartbeats, and seems always to have been spontaneous, effortless, and fluent. He often wrote poetry first thing in the morning, as soon as he got up and before breakfast. He was twenty when he published his first volume of verse, *Odes et Poésies Diverse* (1822). Other collections followed every two or three years. The most important are *Les Orientales* (1829), *Leo Feuilles d'Automne* (1831), *Les Chants de Crépuscule* (1835), *Les Châtiments* (1853),

L'Année Terrible (1872), and *La Légende des Siècles*, collections of poems commenting on all ages of history, which he published in four separate volumes in the years 1859–1883. All in all there are twenty-four books of poetry, and these do not include important *pièces d'occasion*, printed immediately after he wrote them in newspapers. There are probably over 3,000 poems by Hugo, a few very long, most short, some never published.[1]

Hugo wrote nine novels. The first, published in 1823, when Hugo was twenty-one, is *Han d'Islande*, set in seventeenth-century Norway. It is a romance containing the first of the great set-piece descriptions for which his novels became famous, a prolonged fight to the death with the bandit from which the novel takes its name. *Bug-Jargal* (1826), the story of the Negro revolution in San Domingo in 1791, features a horrific execution, as does *Le Dernier Jour d'un Condamné* (1829), a fictional manifesto against capital punishment. *Notre-Dame de Paris* (1831), the first of Hugo's "great" novels, is set in fifteenth-century Paris. It contains spectacular crowd scenes involving the underworld and a mob attacking the cathedral and being repulsed by the powerful hunchback Quasimodo, who lives in the belfry. *Claude Gueux* (1834), about convict life, is a failure; this was really a preparatory sketch for Hugo's next novel, *Les Misérables* (1862), an examination and indictment of the entire criminal justice system. It features Jean Valjean, an escaped convict—Hugo's most memorable creation—and Javert, the policeman who tracks him down. There are some spectacular scenes of pursuit including one in the great sewer of Paris; a description of the battle of Waterloo; and scenes from the barricades in the July Revolution of 1830. *Les Travailleurs de la Mer* (1866) is about the ocean and the fisheries, and has a magnificent fight between a mariner and a giant octopus. *L'Homme Qui Rit* (1869) is set in late-seventeenth-century England and is full of absurdities and unintentional jokes, featuring characters with names like Lord Gwynplaine; Lord David Dirry-More; the Duchess Josiane de Clancharlie; Tom Jim-Jack; and Barkiphedro, receiver of jetsam at the Admiralty—plus officials from "the Wapentake." Hugo's last novel, *Quatre-Vingt-Treize* (1873), concerns the Vendée rising against the French revolutionary tyranny and contains marvelous scenes set in the swamps and secret forests of west France.

The plays began with *Cromwell* (1827), in verse, with a striking introduction setting out Hugo's views of the new romantic movement in France, of which he became the leader. *Amy Robsart*, in prose, was followed in 1830 by the verse play *Hernani*, whose production at the Comédie Française marked the point at which romanticism drove classicism from the stage. *Marion de Lorme* (1829), in verse, is unimportant, as are *Marie Tudor* (1833); *Lucrèce Borgia*, in prose (also 1833); and *Angel*, in prose (1835). But *Le Roi s'Amuse* (1832), in verse, is memorable, not least because it became the libretto for Verdi's *Rigoletto*; and *Ruy Blas* (1838), in verse, is Hugo's best play. In 1843 Hugo wrote a bad play, *Les Burgraves*, which was ill-received, and thereafter he left the stage alone, except for his feeble *Torquemada* (1882) and a collection of one-acters, *Le Théâtre en Liberté* (1886).

Hugo's essays and nonfiction include *Le Rhin* (1842), a travel book also setting out Hugo's strident patriotic views; *Napoléon le Petit* (1862), his assault on the imperial regime of Napoléon III; *William Shakespeare* (1864), setting out Hugo's theory of genius; and a continuing series called *Actes et Paroles* (1841–1900, posthumous), taken from his journals. This list does not include vast numbers of articles, scores of pamphlets, and political ephemera.

Hugo dominated French literature in the nineteenth century, from the 1820s to the 1880s, and he is the nearest equivalent to Shakespeare in France. Yet despite his importance, there is no scholarly complete edition of his works, his vast correspondence has never been systematically edited, and critical works on his oeuvre are almost invariably vitiated by vehement partisanship.[2] There is only one really good biography, and that by an Englishman, Graham Robb.[3] It is hard to think of a writer whose popularity is so enormous but who has received so little objective study as a whole. Toward the end of Hugo's life, his works were selling well over 1 million copies a year in France. He was immensely widely read abroad. *Les Misérables* was published simultaneously in eight major capital cities. In Britain, for instance, just before World War I, there were over 3 million copies of Hugo's novels in print. One measure of his international popularity is that at least fifty-five operas have been based on his works, and others have been projected or sketched by a diverse a group of composers. Bizet, Wagner, Mous-

sourgsky, Honegger, Franc, Massenet, Delibes, Saint-Saens, Auric, Mendelssohn, Berlioz, Liszt, Rachmaninoff, Fauré, Gounod, Widor, and Donizetti have found musical inspiration in his texts.[4] And Hugo has been a godsend to writers of contemporary musicals, and to Disney. He still attracts comment: Graham Robb calculates that, on average, every day sees the publication of 3,000 words about Hugo, somewhere. Yet something is lacking: a true summation, a definitive placing of Hugo in the context of French, indeed world, literature. A century and a quarter after his death, he is still a loose cannon, crashing about the deck. Why is this?

One collateral reason is the continuing lack of a scholarly edition of his works (and essentially his letters), which compounds the inherent difficulty of mastering their sheer extent. But the real explanation lies much deeper and concerns the nature of creativity and its roots in other aspects of the human mind. That Hugo was phenomenally creative is unarguable: in sheer quantity and often in quality too, he is in the highest class of artists. But he forces one to ask the question: is it possible for someone of high creative gifts to be possessed of mediocre, banal, even low intelligence?

The same question has also been asked of Charles Dickens. But it must be said that, with Hugo, the query was raised at the beginning of his literary career; it was repeated at intervals, often with great vehemence; and it remains suspended and unanswered over his posthumous reputation. Chateaubriand, godfather of French romanticism, who regarded Hugo as his prize pupil, referred to him as the "sublime infant." The words "childish" and "infantile" crop up often in comment on Hugo by his peers. So do "insane" and "madness." Certainly madness ran in the family. Hugo's brother Eugène ended his sad, unfulfilled life in a padded cell; and Hugo's daughter Adèle, after teetering on the brink of insanity for many years, finally fell over it. Balzac seized on this: "Hugo has the skull of a madman, and his brother, the great, unknown poet, died insane." People referred to Hugo's popularity as *l'ivresse de Victor Hugo*. Moreover, he not only was mad himself but infected others. Still, the most common criticism was lack of intelligence. Lecomte de Lisle called him as stupid as the Himalayas (to which Hugo rejoined that de Lisle was "just stupid"). Léon Bloy used the phrase

"an imbecile lama" and went on to a more general indictment, written shortly before Hugo died: "No one is unaware of his pitiful intellectual senility, his sordid avarice, his monstrous egotism, and his complete hypocrisy." Tristan Legay argued (1922) that Hugo, master of the poetic antithesis, had missed the one about himself, his "splendor of manner and absence of thought," a point anticipated by Paul Stapfer (in 1887): "greatest of French poets but also a crude rhetorician, eloquent spokesman, and talker of trivia, a diverse author but an imperfect man." Emile Fagnet did not dispute Hugo's genius but rated him as "an average and ordinary character. . . . His ideas were always those of everybody else at a certain period, but always a little behind the times . . . a magnificent stage-manager of commonplaces." Jules Lemaître (1889) put it more cruelly: "This man may have genius. You may be sure he has nothing else."

The case against Hugo, as a mind and a human being, takes away nothing from his creative powers, and therefore can be put in some detail. He was born in Besançon, the son of a professional army officer who flourished mightily under Bonaparte, becoming a full general and ennobled as Comte Sigisbut Hugo. Some of the child Victor's life was spent traveling, in Italy and Spain, while his father was campaigning; and he saw and took in terrible sights on the roads—wounded men and corpses, dead horses, shattered villages. The parents were unhappy together; and Madame Hugo took her three sons (Victor was the youngest) away in 1812 and settled in Paris at 12 Impasse des Feuillantines, formerly a convent of nuns founded by Anne of Austria. It had an immense garden, with a ruined chapel and a dense wilderness, and these features imprinted ineffaceable memories on Hugo's young mind. The ruined chapel may well have been the ultimate progenitor of *Notre-Dame de Paris*, then in a state of some dilapidation, and the wilderness certainly reappeared in the dense woods and thickets of *Quatre-Vingt-Treize*. Hugo was always an intensely visual writer; this was his strength and his weakness. He would seize on an image—for a poem naturally but also for a novel or the key scene in a play—and would then expand the image in all directions to create a story, a plot, a scenario.

Hugo's education was scrappy and unsystematic. In many

respects he was an autodidact. Throughout his life he read vora-
ciously but sporadically, in a wild and undisciplined manner,
absorbing or half-absorbing vast quantities of facts, images, and
the sounds of words as much as their orthography. He had a
wonderful ear for words, which made him love them, and this
gift above all others made him a poet. He loved music itself, too,
especially Mozart and Beethoven, and he became a friend, in so
far as he was ever capable of friendship, of Liszt and Berlioz. But
it was the music of words, from first to last, that entranced and
empowered him. No Frenchman ever used the language with
more caressing affection or at times more brutal strength. Hugo
played with it like a young panther, and charged into it like a rhi-
noceros.

Hugo always thought of bringing himself fame through liter-
ature. But he also always (if at some times more directly than at
others) sought power through politics. He worked the two in
tandem when he could. However, in his long career, sometimes
close to the center, at other times on the periphery of politics, it
is impossible to find any thread of consistency or any basis of
moral principle or intellectual logic. There were always noisy
ideals; but they were words. Behind this rhetorical facade was a
love of power, normally blind and pursued with such clumsy
incompetence that, even when office was within his grasp, he
dashed it to the ground from impatience or vacillation.

Heredity should have made him a Bonapartist and a republi-
can. He never repudiated his father's record as a faithful follower
of Napoleon, and in particular quietly made use of the title his
father's sword had earned, calling himself virtually all his life—
except at brief moments when republican egalitarianism was in
vogue—"le vicomte Hugo," and always treating his brothers and
his wife as members of the *noblesse*. Yet when Bonaparte fell, and
even before then, Hugo was a legitimist and fervent royalist, a
teenage Bourbon fanatic and Catholic ultra. The intellectual
inspiration for the monarchist-papist revival in France was
Chateaubriand's great work *Le Génie du Christianisme* (1802), but
it is doubtful that Hugo read this. What he absorbed, rather,
were the symbols of the resurrected creed—the fleur-de-lis, the
Gothic visual vocabulary, and the apparatus of medieval chivalry

and crusading zeal he feasted on greedily, then regurgitated in poetry. When he was seventeen, he and his brother Abel founded the *Conservateur Littéraire* (1819), which flourished for eighteen months or so, Hugo writing in every issue, especially reviews of current poetry in which he castigated the authors for the smallest infraction of the strict rules of grammar, meter, and prosody—all the rules he was later to break with the most reckless abandon, and successfully.

At age twenty he married a childhood friend, Adèle Foucher, in a spirit of Catholic sacramentalism. Both were virgins, and he insisted that she preserve the strictest modesty, rebuking her for lifting her dress when she crossed a muddy street and so exposing her ankle. The same year as his marriage (1822), he published his first volume of poetry, receiving a donation from the king, Louis XVIII, of 500 francs from the privy purse. The next year Hugo's first novel, *Han d'Islande*, was again rewarded with a royal bounty, a regular pension; it also got Hugo invited to the gatherings that Charles Nodier, the protoromantic novelist, held at the Bibliothèque de l'Arsenal, where he was librarian—the first *cénacle* (coterie) of the romantic movement. Within two years, however, Hugo set up a *cénacle* of his own, taking most of the young writers with him. Then followed a cunning period of backing both sides. Still a royalist, and a sufficiently vocal one to be invited to the coronation of Charles X—and to write a poem about the royal birth describing the baby as a "royal like Jésu" and "a sublime infant" (another!)—he was also working up a band of his own followers to assist him to the center of events. His play *Cromwell* (1827) struck an ominous note for the Bourbons, for it was ambivalent about the choice between monarchy and republic. The preface he wrote to this drama is a kind of political manifesto, but about what? That is hard to say. It has the air of a mystery or a vacuity. Charles X offered to increase his pension. Hugo let it be known he had turned the offer down. But he kept the original pension, an early example of what became a habit—having it both ways. By 1830 he had a sufficiently large and fanatical band of followers to arrange a bellicose demonstration in his favor at the opening night of his play *Hernani* at the Comèdie Française. This was the official, historic triumph of the

romantics, led by Hugo, over the classicists. His 300 warriors were dispersed strategically throughout the theater and carefully trained and rehearsed. In the riot that ensued, several classicists were badly beaten up and the rest fled, leaving romanticism triumphant. It was a characteristic operation by Hugo, well planned and carried through with brio—he was not a general's son for nothing—but the fruit of cunning, not intelligence, let alone idealism.

The first night of *Hernani* is usually presented as the dramatic prelude to the overthrow of the Bourbons later in the year. This overthrow, though foreseeable—the winter was exceptionally bad, and there were many hungry—came as a surprise to Hugo, who after a week of bewildered hesitation dropped all his links with the Bourbons and proclaimed himself a republican. The triumph of the duc d'Orléans—who was elected not "king of France" but "king of the French," dropped the fleur-de-lis and took up the republican tricolor, with an Orléanist coat of arms on it (another example of having it both ways)—likewise surprised Hugo, though he was quick to endorse the new "popular monarchy." In return, King Louis-Philippe made him a "peer of France," with all the special privileges attached to the title, including a seat in the upper house of parliament. This proved convenient, as we shall see. Hugo's relations with the kindhearted pear-shaped monarch were good, and on one occasion a tête-à-tête conversation they had at the Tuileries Palace prolonged itself so late into the night that the servants, thinking everyone was in bed, extinguished the lights, and the king had to find and light a candle, then unlock the street door and let Hugo out.

Hugo always supported the state, and its grandeur, when it was advantageous to himself. Having originally upheld the strictest rules of French prosody and vocabulary, insisting that literary discipline was of the essence of French culture, he then broke them at will, especially in his verse. He invented new rhythms. He manipulated the alexandrine in the most audacious way. He used cunning, hitherto forbidden *enjambements*, carrying one line on to another. His placing of the caesura was idiosyncratic, and his use of the French silent *e* arbitrary. But all these devices were adopted or exploited by young poets, and Hugo's poetic revolution quickly

became orthodox or standard. In prose he used "natural" speech and plebeian words, and described situations and events hitherto beneath the notice of literature. He also bared his soul and made huge use of *moi* and *moi-même*. Coleridge and Wordsworth had done much the same a generation before (*Lyrical Ballads* had been published in 1798), in England, and Wordsworth had made a literary virtue of self-centeredness. But these things were new in France, and seemed fresh and exciting. Together with his literary antinomianism, they made Hugo a hero to educated youth.

At the same time, to counter charges that he was assaulting the temple of French culture, and importing destructive foreign practices, Hugo always took care to beat the patriotic drum and sound the French cultural trumpet at the charge. In 1840, on the tenth anniversary of the revolution of 1830, the choirs from the Paris opera sang a poem by Hugo during the celebrations in the Place de la Bastille:

Gloire à notre France éternelle!
Gloire à ceux qui sont mort pour elle!

And much else in the same vein.

Two years later Hugo published his travel book *Le Rhin*, whose theme was: "Give back to France what God gave her"—the Rhine frontier. The book presents France and Germany as the essence of Europe: "Germany is the heart, France the head." If the two powers act together, with France doing the directing, they can beat Britain and Russia out of Europe. But the "Rhine frontier" was the essential preliminary to this alliance of head and heart. Hugo said it would be democratic, too: the Rhinelanders, although German-speaking, wanted to live under "the finest, the most noble, the most popular flag in the world, the *Tricouleur.*" They would soon adopt French, the true language of culture, the speaking mind—a theme he reiterated throughout his career. Thus: "How does one recognize intelligence in a nation? By its ability to speak French."[5] Hugo always, and often, presented France as a nation that had the destiny of ruling others. It was *une nation conquérante.*[6] In a poem written in 1830 he presents Paris as the "mother city of Europe," a "spider in whose huge web entire nations are caught."[7] He presented

French nationalism, of the strident kind Napoleon Bonaparte had personified, as an unmixed boon to the world.[8] What he did not see was that nationalism inevitably spread to other countries, such as Italy and Germany, and as such worked to France's disadvantage. In the nineteenth century, the populations of both a united Germany and a united Italy each grew by 250 percent, whereas France grew by a mere 45 percent. But even in 1871, when the disastrous consequences of France's ignition of the nationalist bonfire were apparent, and France's own relative weakness was fully revealed, Hugo continued to pour forth nationalist froth. He told the National Assembly, of which he was a member, when it debated the peace terms laid down by the victorious Bismarck, that the lost provinces of Alsace and Lorraine would "soon be recaptured," adding, in a loud voice: "Is that all? No. France will again seize Trèves, Mainz, Coblenz, Cologne—the entire left bank of the Rhine!" This empty bombast was received in embarrassed silence.[9] Hugo's views on politics and international affairs appear here and there in his writings, often at considerable length. But it is impossible to point to any passages that show unusual knowledge, genuine insight, or even routine intelligence. All are vacuous expressions of popular platitudes—the republic, the people, France, destiny, and so forth. There is no evidence that Hugo ever thought deeply about these issues.

Indeed, had he thought deeply, he would have become uncomfortably aware of the logical insecurity of his own position. He was both the beneficiary and the victim of his own double standard. In youth a legitimist, he became a republican in 1830, briefly, then an Orléanist; but when Napoleon's ashes were returned to France, all the veterans of the wars turned out in the streets of Paris, and Hugo wrote, in *Retour des Cendres*, "It was as if the whole of Paris formed to one side of the city, like liquid in a vase that was being tilted." He became so excited that he found himself, without any rational process of thought, a Bonapartist, before reverting to Orléanism, which suited his personal convenience. With the revolution of 1848, which took him completely by surprise, he found himself a republican again. He wrote in exultation: "Paris is the present capital of the civilized world. . . . It is the thinkers of Paris who prepare the way for great things,

and for the workers of Paris who carry them out." Three days later, on 23 June 1848, those same workers sacked and burned Hugo's house in what is now the Place des Vosges, understandably placing him in the ranks of the existing regime, since he was a member of the House of Peers in the parliament.[10]

This confusion on the part of the revolutionaries was the inevitable result of Hugo's trying to have things both ways, to be both a man of the people and a peer of the Orléanist realm. This led to a ludicrous incident in 1845, which in various respects was characteristic of Hugo's entire life, public and private. From being puritanical as a young man, he had graduated to promiscuous bohemianism by 1830. He had a regular mistress—Juliette Druet, an actress—and was involved in many other affairs, usually casual, with chambermaids and their kind. In 1844 he began an affair with Léonie Biard, the discontented wife of a mediocre painter, Auguste Biard, who was her senior by twenty years. She was in the process of obtaining a legal separation when she met Hugo. Léonie was only four years older than Hugo's daughter Léopoldine. When she became his mistress, he began to write her frequent love letters. She loved them. What she did not know was that many of the most ardent passages in them were copied from love letters Hugo had written to Juliette, and from Juliette to him (he also used bits in his novels).[11] He also wrote for Madame Biard eleven poems about sexual love, again much cannibalized from other poems. It is worth noting that Hugo's love letters, whether original or derivative (and many hundreds survive), always follow a pattern, as Verlaine sharply noted. "I like you. You yield to me. I love you. You resist me. Push off." They were, said Verlaine, "the joy of the cock and then its full-throated cry."[12] Hugo found a love nest for his meetings with Léonie in the discreet Passage Saint-Roch, off the Rue Saint-Honoré. What he did not know was that Léonie's husband was having her followed. On 4 July 1845, Hugo (under the name of "Monsieur Apollo") and Léonie, both naked, were wakened up in bed by two police detectives. For a married woman to engage in "criminal conversation" was a serious offense, and Léonie, caught in the act, was hauled off immediately to the women's prison at Saint-Lazare, where prostitutes and adulteresses were incarcerated. She

served six months. Hugo, on the other hand, produced a gold medal, which he wore on a chain around his neck at all times, certifying that he was a peer of France, immune to arrest on such matters except by command of the House of Peers. He was accordingly released and returned at four in the morning to his house, where he woke up his wife and confessed. She, interestingly enough, was not disturbed to find that Juliette, whom she hated, had a rival. On the contrary she took Léonie under her wing, visited her in prison, gave her refuge when she was released, allowed Hugo to resume his affair with her, and took good care to let Juliette know all about it. Hugo, meanwhile, outraged at this display of French justice, of which he felt himself to be the victim (he was not much concerned about Léonie's sufferings), began work on *Les Misérables*, his great fictional epic about the workings of the law. Hugo did not get away with this episode completely, however. Though the scandal was not reported in the censored Parisian press, word of it got around. It brought the system of aristocratic privilege into disrepute, and the king was very angry. The husband, who might have gone public about his wife and Hugo, was bought off by being given a commission to do some wall painting at Versailles. The king also authorized Léonie's transfer from prison to the Convent of Dames de Sainte-Michèle, fearing that she, too, might publicly complain about the inequality of treatment. At the convent, Léonie helped the nuns to make a selection of Victor Hugo's poems for the edification of teenage schoolgirls, before moving into Hugo's home under Adèle's supervision. It was Hugo who eventually threw her out, complaining to Adèle: "Must you always boss me about? Cannot you even allow me to choose my own mistress?" The episode cast Hugo in a comic and disreputable light, and he never quite got over it. Balzac, in his *Cousine Bette*, written the next year (1846), made fun of Hugo's arrest and the circumstances, and other writers continued to make covert allusions to it. Mallarmé claimed to have been born in the house where Hugo was arrested.

All the same, Hugo's embarrassment did not last long, even if it may have played a part in the sacking of his house. He continued to have affairs, to seduce servants whenever possible, and to frequent prostitutes for the rest of his long life. His diaries con-

tain a symbol for copulation, which appears eight times in the spring of 1885. The final one is on 5 April, thirty-eight days after his eighty-third birthday, and six weeks before his death on 22 May 1885. When I was a young man living in Paris in the early 1950s, I was given an unforgettable picture of the elderly Hugo's sexuality by an old society gentleman who, as a small boy, had been a visitor at a château, along with Hugo, in 1884. In those days, children and women servants had rooms on the attic floor, which was uncarpeted and spartan (the male servants slept in the basement). He said he got up very early one summer morning, being bored, and went out into the corridor, the unvarnished boards under his feet, the strong sunlight slanting through the windows at a low angle, picking out the motes of dust. He was, perhaps, four. Suddenly an old man hove into sight, striding purposefully along, white-bearded, eyes penetrating and fierce, wearing a nightshirt. The boy did not know at the time, but surmised later, thinking of the episode, that Victor Hugo had risen early too, having noted a pretty serving girl handing plates at dinner the night before; had, possibly, made an assignation with her; and anyway was now in search of her bedroom. The old man, whom the boy thought was possibly God, paused in his stride, seized the boy's hand, and, lifting his nightshirt, placed the hand on his large, rampant member and said: "Tiens, mon petit. Il paraît que c'est tres rare à mon age. Alors, en temps d'avenir tu auras le droit à dire à tes petits-enfants, que tu a tenu en ton p'tit main, *le machin de Victor Hugo, poète!*" Then he lowered his nightshirt and strode off down the corridor, in search of his prey.[13]

The events of 1848–1851 were the pivot of Hugo's life, though they were in control of him, rather than the other way around. There were appalling scenes of radical violence in Paris during 1848, which shook Hugo's newfound radicalism; and when Louis-Napoléon came to the fore, Hugo supported him and entered the new legislature as a Bonapartist. But though Louis-Napoléon, on forming a government, offered Hugo an office, it was not the senior office he felt he deserved, and he declined it in disgust. Thereafter, he became increasingly hostile, and when Louis-Napoléon staged a coup d'état in 1851, which as usual took him by surprise, he passed into open and violent

opposition, taking refuge first in Belgium, then in the British Channel Islands—Jersey in 1853, Guernsey from 1855 on. Both his wife, Adèle, and his mistress Juliette shared this self-imposed exile for two decades. In some ways exile suited Hugo. He created a medieval universe of his own at Hauteville House, as he called his mansion, writing and surveying the world from his top-story aerie; writing poems and pamphlets denouncing "Napoléon le Petit," as he called the emperor; and enjoying the wild coast and sea, which he drew endlessly in pen and wash and portrayed in his great novel *Les Travailleurs de la Mer*. He always predicted that Louis-Napoléon's regime would end in a debacle, as indeed it did in 1870. But then everyone could see that, and the end came as a result of the emperor's pursuing precisely the vainglorious nationalist courses which Hugo himself had periodically urged, and which were now beyond France's power. Nonetheless, Hugo was able to return to Paris in 1871 vindicated, a national hero, and was again elected to the parliament, though his speeches made no sense. His books continued to sell in vast numbers, promoted by a huge publicity machine in which Hugo took the closest interest, and he effortlessly assumed what he (and others) took to be his natural position as *doyen de la littérature française*.

Moreover, after all his oscillations around the monarchical traditions in France, he ended up as the embodiment of republicanism, so that his death in 1885 was a national event and his funeral a public ceremony recalling *le retour des cendres*. Hugo had planned it well in advance, and it was (in a sense) the final statement of his philosophy of a double standard and having things both ways. In his will, he appointed the president of the republic, Jules Grévy; the president of the senate, Léon Soy; and the president of the chamber of deputies, Léon Gambetta, as his three executors. His deathbed was a long-drawn-out drama. He let it be known that he believed in God. The archbishop of Paris foolishly offered to give him the last rites. Hugo, having toyed with the idea for a few days, finally declared himself a secular figure, and arranged to be buried in the Panthéon, a reconsecrated church which had to be specially deconsecrated again, by a hastily passed parliamentary statute, in order to receive his secular coffin. On the night of 19–20 May 1885, Hugo

gave a virtuoso performance as a dying cultural giant, speaking phrases in French, translating them into Latin, then into Spanish. He uttered alexandrines such as "C'est ici le combat du jour et de la nuit"—grand but empty of meaning. He had accepted the government's offer of a state funeral on the grandest possible scale but insisted that the actual coffin and hearse should be of the type provided for paupers—a peculiar proviso, since Hugo had been a millionaire for a long time and had guarded his money with anxious care. The turnout for the funeral was enormous, a million or more, and Edmond de Goncourt recorded that the police told him that all the brothels were closed and draped in black crepe as a mark of respect (appropriately, since Hugo had been one of their best customers), though the night before, while Hugo's body lay in state under the Arc de Triomphe, the girls had been hard at work in the surrounding crowds. The pauper's hearse raised some eyebrows even among those long inured to Hugo's double standard. Ford Madox Ford, an eyewitness, wrote that it was "like a blackened packing case drawn by two spavined horses . . . an inconceivable shock effect of grinning hypocrisy." There followed eleven carriages full of flowers. Several people were killed during the funeral, and a woman gave birth. People remembered it as a later generation would remember the day Kennedy was assassinated.[14]

Ford's remarks were typical of the mixed feelings with which the English reacted to Hugo as a phenomenon. Tennyson, almost as famous in England as Hugo was in France, called him a "weird titan." He was "an unequal genius [and] reminds one that there is only one step between the sublime and the ridiculous." (This, oddly, recalled Bonaparte's comment on the retreat from Moscow.) In 1877 Tennyson wrote a sonnet in Hugo's honor ("Victor in Poesy, Victor in Romance"), and sent it to the old man, who replied: "How could I not love England, when she produces men like yourself." Thackeray read Hugo's book on the Rhine and noted: "He is very great and writes like God almighty." But later, seeing Hugo in a Parisian church, Thackeray dismissed him as a "queer heathen."[16]

Dickens was impressed both by Hugo himself and by Hugo's apartment in the Place Royale: "the most fantastic apartment and

stood in the midst of it, a little, fine-featured, fiery-eyed fellow." It was

> a most extraordinary place, looking like an old curiosity shop or the Property Room of some gloomy, vast old theatre. I was much struck by Hugo himself, who looked a genius, as he certainly is, and is very interesting from head to foot. His wife is a handsome woman with flashing black eyes, who looks as if she might poison his breakfast any morning when the humor seized her. There is also a ditto daughter of fifteen or sixteen, with ditto eyes and hardly any drapery above the waist who I should suspect of carrying a sharp poignard in her stays, but for not appearing to wear any. Sitting among old armours, and old tapestry, and old coffers, a grim old chair and tables, and old canopies of state from old palaces, and old golden lions going to play at skittles with ponderous old golden balls, they make a most romantic show, and looked like a chapter out of one of his books.[16]

It is illuminating to compare Dickens with Hugo. Dickens is the English equivalent, as close as one can get: a tireless romantic, fertile in invention, loving strange tales and brilliant at telling them; a descriptive writer of pure genius, never at a loss for words; a lover of mysteries, ancient nooks and corners, and human peculiarities. Yet what a difference! It is the difference between France and England. The marvelous Pilgrim edition of Dickens's letters, in a dozen volumes and profusely annotated, allows us at last to see the man, fully and in all his activities (save one: his relations with Ellen Ternan, still, and perhaps forever, shrouded in mystery). Both men were creators on the largest possible scale. But in all else they differed. Where Hugo was a bombastic orator and noisy politician who sat in parliament under three regimes, Dickens flatly refused repeated invitations to enter the House of Commons, and confined his public activities to practical projects such as running a hostel for fallen women and shipping them out to Australia. Where Hugo was mean and miserly, Dickens was profuse and generous. Where Hugo was a thunderous nationalist and noisy jingo, Dickens deplored the

Crimean War, loathed politicians like Palmerston, and always sought peaceful ways out of international disputes. Hugo shouted about injustice in general, but Dickens actually worked hard to remedy it in particular instances. His letters show a hardworking life of dedication and courage and are punctuated by endless kindnesses to all. Hugo, by contrast, appears vainglorious, selfish, and totally absorbed in his own egotism. He is also unconsciously comic, with a sinister twist to his buffoonery. Both men treated their wives badly, and both had salient weaknesses of character, together with much strength of will. But whereas greater knowledge of Dickens's works and life makes one warm to him, with Hugo the same process repels one more and more. Which was the greater creative artist? Impossible to judge.

10

Mark Twain: How to Tell a Joke

M ARK TWAIN, or, to give him his real name, Samuel Langhorne Clemens (1835–1910), stands at the center of American literature. Indeed he may be said to have invented it. All earlier writers who achieved prominence in the United States, such as Washington Irving (1783–1859), Ralph Waldo Emerson (1803–1882), Nathaniel Hawthorne (1804–1864), and Henry Wadsworth Longfellow (1807–1882), to name the quartet who dominated transatlantic letters in the first half of the nineteenth century, were very much part of the English tradition and suffered in varying degrees from what was later to be called "cultural cringe." It is true that James Fenimore Cooper (1789–1851) used an American background, from 1826 on, in his celebrated Leatherstocking stories of backwoods Indians and the scout Natty Bumppo. These stories were read all over the world and had a perceptible effect on European migration to the United States. But Cooper was, in all essentials, a follower of Sir Walter Scott, writing traditional romantic adventures in an American vernacular, and in all his voluminous works he was always looking over his shoulder at English models. Moreover, Cooper was a writer of such grotesque ineptitude, as Twain himself pointed out in his essays "Fenimore Cooper's Literary Offenses" and "Further Literary Offenses of Fenimore Cooper," that he scarcely merits membership in any artistic canon, however meager.[1]

By contrast, Twain was not only a great creative artist but a quintessential American artist from first to last. His material was

American, even though he garnered or stole much of it from all over the world; his style (if that is the right word) was American, as were his vocabulary, verbal accent, ideological humor, comedy, indignation real or stimulated, self-presentation, methods of literary commerce, and journalistic flair. He was an American opportunist, an American plagiarist, an American braggart and egoist, and an American literary phenomenon. Once and for all he liberated American letters from its slavelike cringe and taught American writers, and public performers of all kinds, a completely new set of tricks, which have been in use ever since. His creativity was often crude and nearly always shameless. But it was huge and genuine, overpowering indeed, a kind of vulgar magic, making something out of nothing, then transforming that mere something into entire books, which in turn hardened into traditions and cultural certitudes. He was the greatest of all literary con men, and the joy he derived from conning his audience—a joy which was greedy, bitter, contemptuous, and exultant all at once—was an essential part of his creative spirit.[2]

America was a big new country, initially inhabited chiefly by people who came from a small old one. As they penetrated America's vastness and discovered something about its amazing characteristics, they began to relate and embroider what they had seen, for each other and for those who had not gotten quite so far. They did so sitting around campfires and primitive stoves in tents, wooden cabins, and the stores that served instead of the inns and coffeehouses of their country of origin. They had genuine tales to tell which became taller in the telling and retelling, and the relish of these tales lay not so much in their veracity and verisimilitude but in the audacity with which they were told, and the gravitas and sincerity of the tellers. It was a new art form, or rather a revival of the ancient art of the sagas and Nibelungenlied the Germans and Nordic races had created before they became literate. But it was a revival with a difference, because it grew up alongside or on the frontiers of a sophisticated, literate, modern society, and it called for a modern Homer to set it down. Twain was that man.

Twain was born in Florida, Missouri, and grew up in Hannibal in the same state, on the immense, complex, muddy river that provided so much material for the tales he heard as a boy.[3] He

became in time a journeyman printer, a steamboat pilot, a volunteer soldier, a miner in the Nevada silver rush, and eventually a journalist. These activities took him all over the American midwest and west, where pioneering was still the norm and the moving frontier a fact of life. In much of this semi-tamed country there was nothing to do at night, so the storyteller was king. In his childhood by the Mississippi, his adolescence, and his early manhood, Twain was exposed to the art of rustic or pioneering narrators and yearned to emulate them, just as he longed to be a river pilot (as he tells us in *Life on the Mississippi*). And, just as he eventually became a pilot, so he became, by stages, a master storyteller, and remained one for the rest of his life.

Twain not only heard stories and told them in turn but also thought deeply on the matter. In time, he wrote an essay, "How to Tell a Story," the lead item in a collection he published in 1896. It begins:

> I do not claim that I can tell a story as it ought to be told. I only claim to know how a story ought to be told, for I have been almost daily in the company of the most expert storytellers for many years.

He adds that only one kind of story is difficult, the humorous story; and that the humorous story is American, the comic story is English, and the witty story is French. Crime stories and witty stories depend for their effect on the matter. But the humorous story succeeds or fails by the manner of its telling.[4]

Here we begin to come close to the essence of Mark Twain, and the hub of his creativity. He learned how to tell a story by listening to verbal masters of the art, around campfires, in wooden huts, and in stores and bars. Then he transformed this knowledge into print. Twain was not, strictly speaking, a novelist, philosopher, seer, or travel writer, though he was a bit of all of these. Essentially he was a teller of stories. And he was a great storyteller—a teller of genius—because he was ruthless. Twain grasped, even as a child, the essential immorality of storytelling. A man telling a tale is not under oath. He may insist, indeed he must insist, that his story is true. But this does not mean that it

is true, or that it needs to be. The storyteller's audience may expect him to proclaim his veracity because that is one of the conventions of the art. But what the readers or listeners actually want from him is not verisimilitude or authenticity but entertainment and laughter. They know it. He knows it. When he says, "What I am going to tell you is strictly true," he is merely pronouncing a formula of the genre like "Once upon a time." A storyteller is a licensed liar, though he must never say so. When Twain was presented with Thomas Carlyle's assertion: "The truth will always out at last," he replied: "That's because he did not know how to lie properly." The word "properly" is important. There are conventions in the lying of storytelling. Twain was sensitive on the point. Indeed that is why he adopted a pseudonym. As Sam Clemens he was bound to the truth by his conscience, like every other well-brought-up American who believed (or pretended to believe) the story about Washington and the cherry tree—which itself was a lie, invented by Parson Weems (who was himself not a parson but a Bible salesman). But as Mark Twain he was a licensed storyteller, and so could lie in the cause of art. Actually, there was a double dishonesty in the pseudonym. The river call "Mark Twain," meaning a depth of two fathoms, was not the invented nom de plume of Sam Clemens. He pinched it from another former pilot turned writer called Isaiah Sellers, who had used it in the *New Orleans Picayune*. Clemens savaged this man so severely in a rival paper, the *New Orleans True Delta*, that Sellers gave up writing in disgust, and Clemens took over his moniker.[5]

This was in 1863, and two years later Twain (as he now was) published a sketch in the *New York Saturday Press*, "The Celebrated Jumping Frog of Calaveras County." This tale (which became the lead item of Twain's first book in 1867) was momentous in attracting nationwide attention to the teller, and thereafter Twain never lacked celebrity or an audience. "The Celebrated Jumping Frog" is the absolute essence of Twain as a writer and an operator—nothing else in his career is so quintessential. To begin with, he did not hear it, as he originally claimed, told by an old pioneer by a campfire in California. It was an old folktale (so he later said) with distant origins in ancient Greece, and had

been around a long time even in the United States. Indeed, in California it had reached print at least as early as 1853, when Clemens was eighteen—and long before he got to the west coast. How he first really heard (or read) the tale is undiscoverable. He presumably invented the names of the frog, Dan'l Webster, and the frog's owner, Jim Smiley. He later insisted that the episode occurred in Calaveras County in spring 1849, during the gold rush, Smiley being a "forty-niner." He also insisted: "I heard the story told by a man who was not telling it to his hearers as a thing new to them, but as a thing they had witnessed and would remember." This may be true. But Twain added: "The miner who told the story in my hearing that day in the fall of 1865 . . . saw no humor in his tale, neither did his listeners; neither he nor they even smiled or laughed; in my time I have not attended a more solemn conference." Twain said they were interested in only two facts: "One was the smartness of its hero, Jim Smiley, in taking the stranger in with a loaded frog; and the other was Smiley's deep knowledge of a frog's nature—for he knew (as the narrator asserted and the listener conceded) that a frog likes shot and is always ready to eat it." Now here Twain is embarking on an inverted form of the story. Smiley did not take in the stranger. The stranger took in Smiley. And Smiley did not know the frog liked shot—the stranger fed it with shot. Indeed there is no evidence from the original story that frogs like shot; on the contrary, Dan'l Webster must have disliked shot intensely after his horrible experience of being unable to jump.[6]

The truth is, Twain was making his story serve a second, a third, and even a fourth turn. Having first sold the story several times in the 1860s, he tells it again in the 1890s, first giving the Greek version, "The Athenian and the Frog," from Sidgwick's *Greek Prose Composition,* then repeating the Californian version about Smiley, which he had invented or plagiarized. Then he has the nerve to give a third version, a retranslation of a French version translated from his own original text by "Madame Blanc" and published in *Revue des Deux Mondes.* As his retranslation was literal, it is very funny, and it gives Twain the opportunity to give the reader a lecture on the chaotic confusion of the French language. I suspect he did this trick with a German version too, for

Twain was very critical of the German propensity to put together huge words, and got a lot of laughs on this score in his travel books. Later, Twain admitted that the Greek original of the story was an invention itself. Sidgwick, with Twain's permission, had simply translated Twain's Californian story into classical Greek, changing quail shot to stones, making Jim a Boethian, turning the stranger into an Athenian, and calling the result "The Athenian and the Frog." So all Twain's huffing and puffing about the amazing coincidence was just showmanship.

What all this proves is that Twain was a canny professional humorist. He understood the economics of humor, and how, once you have a funny idea—a champion jumping frog that cannot move because it is loaded with shot—you can use it, with suitable variation, again and again. Twain told a version of the frog story in private conversation among admiring friends. And he often told it from the platform during his many lecture tours—for another of his professional gifts was his ability to recognize a story that could be told as well as read. And it is hard to say when this story is funniest: read or told, or in French, German, English, or Greek. In Twain's written version the language is mining-camp Californian of the 1840s. But the tale can equally well be told in Mississippi "darky" or Missouri "Doric," or, for that matter, New England demotic.[7]

With the frog story Twain stumbled, almost by chance, on what twentieth-century comedians called the running gag—that is, a joke which can be made to work again and again in the course of a long story, a book, or a lecture, and actually—if well told and well timed—gets funnier when repeated. Once he realized what a humorous treasure he had found, Twain used the device again and again. The classic example occurs in *Roughing It*, when he takes a dull anecdote about Horace Greeley riding a coach, which is told on a coach and repeated at intervals by everyone who joins the coach. There were a lot of anecdotes told about Greeley, and Twain, with his low cunning, killed them all dead, and in doing so gave himself an easy, funny chapter for his book—another example of the economics of humor.

Running gags are a feature of Twain's first big success, *The Innocents Abroad*, which describes his first tour of Europe with a

group of Americans. The first edition sold over 100,000 copies and made Twain rich. He subsequently lost most of his money in an ill-starred business manufacturing a patent typesetter, was declared bankrupt, and then redeemed his fortune by a world speaking tour. That tour was recorded in a reprise of *The Innocents Abroad* called *Following the Equator*, the profits from which allowed Twain to repay his creditors in full—another example of his mastery of the economics of writing, since the idea behind both books is essentially the same but the variations are sufficiently numerous and inventive to keep the readers happy.

Twain took to public speaking, both for money and to publicize his books, early in his career as a writer, and his lectures quickly became a major source of income and fame. Indeed it is hard to say whether, in his lifetime, Twain was better known as a writer or a speaker—the two roles were inextricably mingled.[8] His lectures were essentially humorous performances; they were dramatic, and he was acting. He came to this life on the coattails of Charles Dickens's readings, which were attracting enormous audiences all over the United States in the late 1860s, just as Twain was getting going. Dickens read from his books, and so did Twain. But whereas Dickens aimed to draw tears (with his "Death of Little Nell") or gasps of horror and excitement (with "The End of Bill Sykes"), Twain wanted laughs. He was essentially a stand-up comedian. Raising a laugh was at the heart of his art and his creativity. Twain liked money. He liked the good things in life. He lived well and built two expensive houses, one of which survives and is, in effect, a museum to his genius. But his real reward was laughs. He was a supreme egoist, as great a demander of attention and hero worship, in his own pseudo-modest way, as Victor Hugo or Richard Wagner. And the form of worship he found most congenial—it was the breath of life to him, in private company and in public performance—was the titter, rising to a continuous hooting roar of laughter and reaching a crescendo of uncontrolled mirth, with people "stomping their feet and throwing chairs about," as he put it. Twain's entrance, early on, went as follows. He would be behind a curtain, playing the piano. (He did this with some skill; and he was the originator of the western saloon joke, later purloined by Oscar Wilde during

his American tour in the 1880s, "Please do not shoot the pianist. He is doing his best.") When the curtain went up, Twain would be engrossed in his music; then, slowly, he would realize that an audience was awaiting his attention and would stand up and walk to the center of the stage. There would be a long pause, then he would begin to speak.[9]

Twain dressed the part, or his part, as did Dickens and Oscar Wilde. But whereas Dickens used the male evening attire of early Victorian England, suitably embellished, and Wilde the velvet pantaloons, golden buckles, and greenery-yallery of the aesthetic movement, Twain devised his own attire. His black tailcoat gave place to an all-white suit, of linen or wool, according to the season, with a white silk tie and white shoes. At the time he became a favorite on the lecture circuit, his flaming red hair turned grayish, then a glorious white, or rather the color of foaming champagne, as did his bushy mustache. This white appearance became celebrated, and Twain was recognized wherever he went, in Europe as well as the United States. He basked in this glory and wore his white outfit everywhere, not just onstage. For special occasions he acquired a new trick, after Oxford University, to his delight, awarded him an honorary doctorate. He loved the splendid full-length black gown, with gold lace trim and red silk hood, crowned with a mortarboard, that went with the degree. He sported this rig, especially at dinners given in his honor, and on any other formal occasion when he felt he owed it to his public to draw special attention to himself.

Being a performer, and a teller of humorous anecdotes, Twain realized that his act had to be varied by modulations in his voice, and that the best way to do this was to clothe his stories, when appropriate, in different accents. Now as we have seen, accents, as instruments of humor, go back at least (in the English language) as far as Chaucer, and were much used by Shakespeare. Dickens used accents to great effect and was a master of Cockney in its many Home Counties variations. But accents, especially in generating humor, are essentially a spoken device. The problem for a writer who uses them on the page is how to transliterate standard English into an accent both authentic and funny. It is not easy to do. Indeed it is very difficult to do. Dickens often suc-

ceeded, his accents being reinforced by a brilliant facility in mis-
using words and forming malapropisms; Mrs. Gamp is a prime
example. But Dickens sometimes failed; Thackeray often failed;
and even Kipling, who was superb at transcribing Indian accents
on to the page, failed when it came to Irish, Yorkshire, and Cock-
ney. Twain never failed. As a raconteur of genius, he could always
get his accents right on stage; and he is the only writer I know
who successfully transcribed them in his written work. The out-
standing example of his skill is *The Adventures of Huckleberry Finn*.
Twain says, in a note headed "Explanatory," just before the table
of contents in the original edition (1885):

> In this book a number of dialects are used, to wit: the Mis-
> souri Negro dialect; the extreme form of the backwoods
> South-western dialect; the ordinary "Pike County" dialect;
> and four modified varieties of this last. The shadings have
> not been done in a haphazard fashion, or by guess-work;
> but painstakingly and with the trustworthy guidance and
> support of personal familiarity with these several forms of
> speech.
>
> I make this explanation for the reason that without it
> many readers would suppose that all those characters were
> trying to talk alike and not succeeding.

The dialect used in *Huckleberry Finn* is a virtuoso exercise for
which there is no parallel in English literature, and is the greatest
single charm in this book of many charms. But Twain's accents
are true and vivid throughout his work, and they were even better
onstage or in the lecture hall, where he could introduce
emphases and purely verbal descants which are impossible to
reproduce in type.[10]
 In the hall, telling a tale to a live audience, Twain could
indulge in verbal acrobatics, like a violinist playing a cadenza. The
outstanding example is "The Golden Arm," one of his lecture-
hall anecdotes, which he prints in "How to Tell a Story." He calls
this "a negro ghost story that had a pause before the snapper at
the end." The pause "was the most important thing in the whole
story." Like most professional stand-up comedians, he directed

his attention to a particular person in the audience, depending on the story. For this one he needed an "impressionable girl." He adds, "If I got [the pause] the right length precisely, I could spring the finishing ejaculation with effect enough to make [the girl] give a startled little yelp and jump out of her seat." I give "The Golden Arm" in full, as there is no other means of showing what a shocking tale it is.

The Golden Arm

Once 'pon a time dey wuz a monsus mean man, en he live 'way out in de prairie all 'lone by hisself, 'cep'n he had a wife. En bimeby she died, en he tuck en toted her way out dah in de prairie en buried her. Well, she had a golden arm—all solid gold, fum de shoulder down. He wuz pow'ful mean—pow'ful; en dat night he couldn't sleep, caze he want dat golden arm so bad.

When it come midnight he couldn't stan' it no mo'; so he git up, he did, en tuck his lantern en shoved out thoo de storm en dug her up en got de golden arm; en he bent his head down 'gin de win', en plowed en plowed en plowed thoo de snow. Den all on a sudden he stop (make a considerable pause here, and look startled, and take a listening attitude) en say: "My *lan'*, what's dat?"

En he listen—en listen—en de win' say (set your teeth together and imitate the wailing and wheezing singsong of the wind), "Bzzz-z-zzz"—en den, way back yonder whah de grave is, he hear a *voice*! he hear a voice all mix' up in de win'—can't hardly tell 'em 'part—"bzzz-zzz—W-h-o-g-o-t—m-y—g-o-l-d-e-n *arm?*—zzz—zzz—W-h-o-g-o-t—m-y—g-o-l-d-e-n *arm?*" (You must begin to shiver violently now.)

En he begin to shiver en shake, en say, "Oh, my! *Oh*, my lan'!" en de win' blow de lantern out, en de snow en sleet blow in his face en mos' choke him, en he start a-plowin' knee-deep towards home mos' dead, he so sk'yerd—en pooty soon he hear de voice agin, en (pause) it 'us comin' *after* him! "Bzzz—zzz—zzz—W-h-o-g-o-t—m-y—g-o-l-d-e-n *arm?*"

When he git to de pasture he hear it agin—closter now, en a-*comin'*!—a-comin' back dah in de dark en de storm— (repeat the wind and the voice). When he git to de house he rush up-stairs en jump in de bed en kiver up, head and

years, en lay dah shiverin' en shakin'—en den way out dah he hear it *agin*!—en a-comin'! En bimeby he hear (pause—awed, listening attitude)—pat-pat—pat—*hit's a-comin' up-stairs!* Den he hear de latch, en he know it's in de room!

Den pooty soon he knows it's a-*stannin' by de bed!* (Pause.) Den—he know it's a-*bendin' down over him*—en he cain't skasely git his breath! Den—den—he seem to feel someth'n *c-o-l-d*, right down 'most agin his head! (Pause.)

Den de voice say, *right at his year*—"W-h-o—g-o-t—m-y—g-o-l-d-e-n—*arm?*" (You must wail it out very plaintively and accusingly; then you stare steadily and impressively into the face of the farthest-gone auditor—a girl, preferably—and let that awe-inspiring pause begin to build itself in the deep hush. When it has reached exactly the right length, jump suddenly at the girl and yell, *"You've* got it!"

If you've got the *pause* right, she'll fetch a dear little yelp and spring right out of her shoes. But you *must* get the pause right; and you will find it the most troublesome and aggravating and uncertain thing you ever undertook.)

Most of Twain's best humorous stories can be used, and were used, both on the platform and in print. But they diverged significantly in detail. One of the most characteristic concerns Jim Blaine and his grandfather's champion ram. The narrator has to be "liquored up when he tells it," and the point of the story is that he gets so diverted onto sidelines and other issues and characters that he never reaches the point. This is a very dangerous anecdote to tell, as it is easy to bore the listeners and lose them; and it is still more dangerous to put into print, as the bored readers have merely to turn the page and pass on. Transforming a rambling, pointless, stream-of-consciousness bore into something funny requires great art, and not many writers possess the skill. Shakespeare uses the device successfully with Polonius in *Hamlet*; and so does Jane Austen with Miss Bates in *Emma*; whether James Joyce does it with Molly Bloom in *Ulysses* is a matter of opinion. Twain could and did do it, because of the fertility of his irrelevant narrative items and characters, but it is significant that in delivering the story of the champion goat, which originally appeared in print, on the platform he gradually intro-

duced significant variations, to get laughs and sustain interest. When the spoken version was written down and he compared it with the original, he was amazed at the differences (or so he says; one is never sure when Twain is being frank).

Some of Twain's funny devices simply do not work on the platform, as he discovered. For instance, there is his brilliant little work "The Diary of Adam and Eve." This, like the running gag, is a prime example of another Twain comic invention—the war between the sexes. Earlier authors, such as Molière and Sheridan, had hinted at the topic, and Shakespeare had devoted an entire play to it, *The Taming of the Shrew*. But Twain stood the perpetual joke on its own feet; made it into an independent, entire, complete comic turn on its own; and did this with such skill that the show has run and run ever since. But *Adam and Eve* is not a platform show. It depends for its effects on quiet irony and must be read. Here is Adam's diary on the subject of Eve and fish in the river:

> This made her sorry for the creatures which live in there, which she calls fish, for she continues to fasten names on to things that don't need them and don't come when they are called by them, which is a matter of no consequence to her, she is such a numskull, anyway; so she got a lot of them out and brought them in last night and put them in my bed to keep warm, but I have noticed them now and then all day, and don't see that they are any happier there than they were before, only quieter.

Irony and ironies within ironies were used constantly by Twain in virtually all his works, often with a delicate sleight of hand that escapes all but the most attentive readers. With irony went the one-line joke, for which Twain had a genius. The one-liner has become the pivot of American humor, and it would be nice and convenient to argue that Twain invented this device. But that would not be true. Benjamin Franklin has some claim to being the inventor: "In this world nothing can be said to be certain except death and taxes"; and his remark on signing the Declaration of Independence: "We must all hang together, or

assuredly we shall all hang separately." And the one-liner became a feature of American politics in the generation after Franklin, Henry Clay being a notable exponent of the art, as was his enemy Andrew Jackson, who said on his deathbed: "The only thing I regret is that I didn't shoot Clay and hang Calhoun." When Twain was a young man, Lincoln was also dealing wholesale in the one-liner. But Twain was the man who made the one-line joke universally popular and respected, as a prime feature of American life. He used it as an eye-opener in short stories—the first sentence in "A Dog's Tale" is "My father was a St. Bernard, my mother was a collie, but I am a Presbyterian." He used it with enormous success for chapter-head quotations in his "dark novel," *Pudd'nhead Wilson*. (These are allegedly from Wilson's "Calender.") If possible Twain liked to begin and end a story with a one-liner. I have counted over 100 one-liners scattered through his works. The true total is probably nearer to 1,000. Characteristic examples—both as to sentiment and as to construction (syntax, etc.)—are: "Truth is the most valuable thing we have. Let us economize it." "Man is the Only Animal that blushes. Or needs to." "Familiarity breeds contempt—and children." "Cauliflower is nothing but cabbage with a college education." There is also his comment on the appearance of his obituary in a New York paper: "The reports of my death are greatly exaggerated." Twain used one-liners in his books and on the platform. Some he made up as he went along. Others he sweated over.[11]

Twain was in some ways a serious man, and he wanted to leave the world a better place than he found it. So he held opinions and espoused causes. He thought, for instance, that Chinese immigrants and blacks got a raw deal, and said so, often. But he was not an idealist or an ideologue. When the Civil War came and gave him the chance to behave nobly, he hoofed it west after a mere fortnight in the Confederate army. Twain was essentially an entertainer. He felt that getting people interested and making them laugh were what he was best at, the surest way to make money, and his best contribution to the health, wealth, and happiness of mankind. As I noted earlier, he was not a novelist, poet, playwright, writer of philosophy and history, or travel writer, though he posed as such. His books are all entertainment.

For example, his autobiographical account of his youth in Nevada and his early journalism, *Roughing It*, is not a structured book, and its supposedly chronological order is misleading. My analysis of its contents shows that it consists of twenty-seven major anecdotes, and many other minor ones, plus a certain amount of topographical ballast or padding. The stories are as follows: virtues and vices of the Allen pistol; the talkative heifter (woman); the camel that ate overcoats; slumgullion; the coyote and the dog; Bemis and the buffalo; the Pony Express; Slade and his murders; Digger Indians; Mormon beds; Horace Greeley and Hank Monk; the escape of the tarantulas; the adventure on Lake Tahoe; the Mexican plug (horse); silver fever; getting lost in the snow; the great landslide case; horrors of the alkaline lake; Buck Fanshaw's death; running your own private graveyard; important hangings; Jim Blaine and his grandfather's ram; Chinese virtues; a dueling editor; the delights of California; being in an earthquake; the wisdom of Tom Quartz the cat. Then, in Chapter LXII, Twain takes off for the Pacific and remains there, the business of roughing it disappears, and the book ends not with a bang but with a series of exotic whimpers. The work, in short, is thrown together with no regard for shape or cause and effect—or truth, for that matter. It stands or falls simply by being readable or not. I find it one of the best books I know and have read it, or dipped into it, many times.

If we analyze Twain's other great piece of autobiography, *Life on the Mississippi*, we find essentially the same pattern: a score or so of major anecdotes; many minor ones; some padding. It is entertainment and most of it could have been delivered onstage. (Though as Twain himself noted, with books you may skip, but with lectures "you must hear the fellow out or leave altogether. I do not recommend mounting the platform.") Twain's two best-known books, *The Adventures of Tom Sawyer* and *Adventures of Huckleberry Finn*, his masterpiece, are also, when inspected closely, compilations of anecdotes. Each has more in common with *The Pickwick Papers* than with, say, *Bleak House*, *Middlemarch*, *Vanity Fair*, or *Portrait of a Lady*. It is true that Huck Finn's relationship with the escaped slave Jim gives the book unity and a purpose, rather as Pickwick's refusal to truckle to the lawyers who involve

him in *Bardell v. Pickwick* gives his adventures a plot and a climax. But the enjoyment, both in *Pickwick* and in *Huckleberry Finn*, consists essentially in the anecdotal episodes. Both are great works of art: unplanned, rambling, artistically irresponsible, and chaotic. They work, and work superbly, because of the authors' inventive genius and sheer creativity.

In the end, creativity is what matters in art. Because of his central position in American literature, Twain has been much studied, not to much effect. There is a large Twain industry in academia. Much of it, in recent decades, has revolved around the question "Is *Huckleberry Finn* a racist book?" It is certainly not a politically correct book. After looking carefully into Twain's views on blacks, their rights and wrongs, their place in society and how it could be improved, I came to the conclusion that, in all essentials, he had the same views as his older contemporary Abraham Lincoln. Like Lincoln, he was not obsessed with race (as we are supposed to be, and as a bossy minority actually is); rather, he was obsessed with justice. But, like Lincoln, he liked to laugh and make others laugh, and in Twain's case laughter had priority even over justice, as a rule. That is all one can say about it. Huck's Jim is the first penetrating and sympathetic portrait of a black in American literature (if we except the doubtful case of *Uncle Tom's Cabin*). There are faults in the book—there are faults, often grievous, in all Twain's books—but they are outweighed by its astonishing beauty, authenticity, and (despite all Twain's efforts) truth. In 1885 the library board of Concord, Massachusetts, voted not to buy *Huckleberry Finn*, on the grounds not that it was "racist" but that it was "the veriest trash." But as Ernest Hemingway noted, two generations later, "It's the best book we've had. All American writing comes from that. There was nothing before. There's been nothing so good since." An exaggeration, no doubt. But not by much. Every American writer has read it. It has influenced each, one way or another.[12] The whole of Twain's vast, sprawling, dog-eared, careless, infuriating, delightful, and inspired output forms a great mountain of detritus which straddles the high road of American writing and forces those involved in it to pick their way over or through it. It is the basic fact of American literature. Hemingway learned from it. What American writer of his times, or since, has not? It is impossible to imagine

the American musical without Twain's influence, often at second or third hand—or such institutions as Disney, *Time* magazine, *Reader's Digest*, or the *New Yorker*. James Thurber's *The Night the Bed Fell* is a literary grandchild of Twain's. Indeed all of Thurber's work springs from the fields Twain first tilled. It was the same with Dorothy Parker, who honed and polished the one-liner till it shone brightly, even in Hollywood. There was an element of Twain in the Marx Brothers and Raymond Chandler. Twain's tricks made an entry into the White House, taking up themes Lincoln had left behind, in the age of Theodore Roosevelt, whose "Speak softly and carry a big stick" is pure Twain. (So, for that matter, is his distant cousin Franklin Delano Roosevelt's "The only thing we have to fear is fear itself.") Even the priapic John F. Kennedy at his (very rare) best has a twang of Twain. And the great Ronald Reagan occupied the White House for eight memorable years almost entirely in the Twain spirit. He communicated, he governed, by jokes, nearly all of them one-liners, of which he had, literally, thousands, graded and stored in his capacious showman's memory. A typical one, with its powerful element of truth (as with Twain's), was: "I'm not too worried about the deficit. It's big enough to take care of itself." If Twain was the stand-up comedian of literature, Reagan was the stand-up comedian of the cold war, finally bringing down the curtain on that long historical episode.

Some years ago the Oxford University Press had the inspired idea of reprinting by photocopy all of Twain's books in their original format and type, together with their old illustrations, and with perceptive introductions added. I secured a copy of this twenty-seven-volume set at an amazingly low price, and it has been more frequently used, ever since, than any comparable series in my library. The way this audacious, vain, unscrupulous, untruthful, appalling man has survived into the twenty-first century is a wonder. It shows that, in the written and spoken word, you can't beat the ability to create out of thin air.

11

Tiffany:
Through a Glass Darkly

*L*OUIS COMFORT TIFFANY (1848–1933) is an artist worth looking at not only because he was the greatest creator of glassware of modern times, perhaps of all time, but because he takes us into the mysterious and arcane world of glassmaking, the least understood of the crafts. Making fine glass is an extraordinary mixture of creative skill, science, and accident. Humans have been making glass for over 5,000 years; but only quite recently did they discover the chemistry of what they were doing, and there is still a large element of unpredictability in some of the processes. Few people in the art world fully understand glassmaking, be they collectors, dealers, art historians, or curators of museums, even those with large glass collections. Many people go on guided tours of Murano but gawk and pass on none the wiser. The few people who do understand glass, and even write about it, tend to be fanatics, and their accounts are often incoherent, dotted with the strange vocabulary of the craft— slumping, marvering, claw beakers, tweaking, pontils, pucellas, parisous, prunts, lehr, glory hole, annealing, and trailing. Some of the terms are thousands of years old.[1]

Tiffany's own story, and its aftermath, is a bizarre tale of artistic fashion—a poor man who collected Tiffany's stuff sixty years ago would be a multimillionaire today. One reason for the enormous prices now paid for these works is that art nouveau, the prevailing mode for most of Tiffany's career, was totally eclipsed for over a generation, vast quantities of it being destroyed, often delib-

erately. Both of his palatial homes, containing the best of his art, were sold off and demolished. No other modern style has had such a low survival rate, and Tiffany's work suffered more than that of any other designer working in it. Of course glassware, being fragile, suffers more from time and chance than any other artifact, except gold work, which is melted down during hard times. Thus of Benvenuto Cellini's output, the only major work that has come down to us is the salt of Francis I (and even that has now been stolen, from the Vienna Kunsthistorisches Museum). Tiffany has not suffered quite so much, but it is likely that only about 10 percent of his ware has been preserved, and many of his unique pieces have vanished forever.

Glass is made from sand or silicon dioxide or silica, with various additives to make it workable. The most common composition is 75 percent silica, 15 percent soda, and 10 percent lime. It defies exact definition, and scientists refuse to recognize it as a material. They write, rather, of "the glassy state" and explain it as a substance, regardless of its chemical composition, which has solidified from the liquid state without forming any crystals. Thus at the atomic level it has none of the regular structure of normal crystalline solids, being instead a random network of atomic bonds in the liquid state, which is preserved in the solid state. Therefore glass has been defined, by Keith Cummings, perhaps the greatest contemporary expert, as "a mobile supercooled liquid whose precise viscosity can be controlled by heat." The artistic consequence of its indeterminate and indefinable chemistry is that glass can be, and always has been, made and colored from a vast range of different materials and worked in countless different ways at widely separated places all over the globe. It is therefore possible for an ingenious glassmaker to create his own new kind of glass, and this is what Tiffany did when he invented favrile.

New kinds of glass are related to the two basic ways of working it: hot and cold. The hot process is analogous to iron-making, the glass or iron being molded when it is still liquid or viscous; the cold derives from jewelry making, and is akin to a combination of sculpture and etching. The Romans, who united the varying glass technologies of the ancient world and pushed glassmaking forward almost to the point of mass production,

called hot-glass workers *vitrearii* and cold-glass workers *diatriarii*, so distinct were the methods. Susan Frank, whose book *Glass and Archaeology* is a window into how antiquity made glass, warns that all generalizations about glass run into trouble: "Glass is one of the most complex of substances [and] its scientific study as a disordered, multi-component system is in many ways still in its infancy."[2] Most glass technology and products evolved by accident and were then imitated by craftsmen who did not understand the process. Take drinking glass. Originally people drank from horns, which could not be put down till empty. The earliest drinking glasses were imitative cones—hence the term "tumbler." The design of the bowl with foot and stem was originally a piece of inspired improvisation, which became classic in the eighteenth century and is still with us today.

Heat is required to melt and stabilize the materials (silica, stabilizer, and flux) into glass. It is solid once cool, or rather supercooled into frozen liquid. The greater the heat, the more liquid it becomes. As it cools it creates an elastic boundary or skin at the point where it meets the air. This allows weird procedures like shearing of a liquid or toughening when the interior mass is under compression and the skin in tension (for instance, dropping in water makes "tough drops" or "Prince Rupert drops"). There are countless methods of working. Inflation, to create a bubble, makes use of the fact that glass hardens as it cools but can be softened by reheating. This involves constant rotation by hand and body movements and is the basis of the ancient skill of glass blowing. In modern times skilled human movements are replaced by complicated machinery. Then there is static pressing, or squeezing between two metal surfaces, to impress patterns, shapes, dates, names, and other devices on blobs of hot glass; this technique is used with buttons and buckles, for instance. It involves the same methods as small-scale metalwork and was a cottage industry in Bohemia. Molds were developed for complicated objects. Sheet glass, following steel technology, is produced between rollers fed by a continuous stream of molten glass. Then there is spinning, the use of centrifugal force, which, at 3,000 revolutions a minute, pushes liquid glass upward into a mold, and is splendid for individual

pieces designed by artists. In primary casting, the original material is pushed into the sand and then removed, leaving a designed void; hot glass is then poured into it direct from the furnace, using a ladle—this is obviously a good way of producing glass sculpture. The ladle can be replaced by an overhead casting machine, which melts the glass mixture and then pours it in a controlled stream. At this point we see an analogy with cooking, to join the analogies with iron founding and jewelry. The more mobile the mass of liquid glass is kept during its founding, the cleaner it becomes. So mobility is essential for clear glass (especially optical glass), and this entails continuous stirring, as in many cooking processes. The cleaner the glass, the stronger it is. Without continuous stirring, striation results, and that makes the glass ugly and fragile. Machines can be made to stir continuously in a way that is beyond the strength of a mere craftsman.[3]

All these are primary methods of glassmaking. Secondary methods, using reheated solid glass, do not need high temperatures, so no foundry is necessary and many forms of handworking are possible. These include lamp working, involving a small but intense heating source, and tremendous dexterity of hands and fingers, producing rods and tubes twisted into a vast variety of shapes. This kind of decorative glass, which goes back to Mesopotamia 5,000 years ago, calls for simple technology but enormous skill and dexterity, and is still in use. For paperweights and similar pieces, there is cone forming—coating a pliable cone with homogeneous layers, then removing the cone and fusing. It was first developed in ancient Egypt and is still in use for high-quality objects, employing similar methods for forms of sweet making such as Blackpool rock. It looks magic, and is typical of the way in which artistic glassmaking is miraculously more than the sum of its parts. Bending, which exploits the intermediate stage between solid and liquid glass, is still used after 4,000 years. Secondary casting creates a much wider range of qualities than the primary kind. *Pâte-de-verre*, for instance, uses finely crushed glass grains and powders and is now applied for ceramic tiles in spacecraft. Another form of secondary casting is the *cire perdu* method, used from antiquity in casting bronze.[4]

It is vital to remember that glass is a solution, not a com-

pound, and therefore a vast range of ingredients are possible. For instance, opaque white glass can be made by crystals, formed by putting in, say, fluorine; blue glass is made by adding cobalt or copper oxide; you add iron to produce green glass, or chromium, or a mixture of both; uranium oxide, tiny colloidal particles of silver or iron manganese, will produce varieties of yellow glass; cadmium sulphide is used for orange glass; various mixtures—cadmium sulphide plus selenium, antimony sulphide, or copper, gold, or lead—can be used for red glass.[5]

Over the last 200 years artists and manufacturers have acquired continuously growing knowledge of how different constituents of glass function, and what is the best way of securing this interaction and working the result. Control and predictability have replaced mystery and empirical rituals. Sometimes science is used to produce major improvements in technology. Thus in 1959 Pilkingtons discovered the flat process in which molten glass is floated on a bed of molten tin to produce polished, even sheets; this ended the traditional method of flat glassmaking. In the last fifty years and especially the last twenty-five, glass of enormous strength has increasingly been used as a building material, to create the amazingly light, ethereal appearance of new railway stations and airports.[6]

Tiffany came to glassmaking through jewelry. His father, Charles Lewis Tiffany, born in 1812, set up a shop in New York in 1837 selling stationery and fancy ware. He seems to have possessed extraordinary acumen in business, plus impeccable taste in choosing his merchandise, a form of creativity insufficiently acknowledged in the history of art, though the growth of studio-workshops in medieval Florence illustrates it perfectly. He had a strategy: to link the burgeoning wealth of the United States to the ancient fine arts and crafts of Europe. His progress from simple homemade stock to imported silverware from England and Germany; Swiss watches; jewelry from France; and glassware, porcelain, and bronze statuary from Italy is a classic example of entrepreneurial growth.[7] He then reinvested his profits from selling luxurious imports into creating his own workshops and training and employing American craftsmen. He started making his own jewelry in 1848, and by the 1860s he was running the

biggest business of its kind in America, with a busy branch in Paris. In 1851 he went into silverware and soon dominated the market. During the Civil War in the early 1860s his firm supplied the Union armies with swords, cap badges, buttons, and insignia. He used the enormous profits to expand his luxury business once peace returned, and a vast American plutocracy became his customers. In 1871, for example, his designer Edward Chandler Moore created "Audubon" flatware, silver services using bird motifs from the famous Elephant Folios of *Birds of America*, which Tiffany's is still making and selling today nearly 140 years later.[8] Tiffany was the first American silversmith to adopt the top sterling standard of 925 parts of 1,000 pure silver, and he made the most of the huge Nevada silver boom—so strikingly depicted by Mark Twain—to encourage rich Americans to go in for enormous silver presentation pieces. The William Cullen Bryant vase, for instance, is thirty-four inches high. Even more opulent was a gold vase presented to Edward Dean Adams, designed by the Tiffany artist Paulding Farnham, combining jewelry and silver- and goldsmithing. It is decorated with pearls, rock crystal, amethysts, tourmalines, and spesartites and is now in the Metropolitan Museum of Art in New York. Tiffany used the new resources of Nevada, California, New Mexico, and Arizona, supplying silver, gold, and precious and semiprecious stones, in bewildering quantities to make all-American artifacts of the highest quality, which won first prizes at the top European exhibitions.[9] He also took advantage of Europe's political instability to buy up the jewels of royal and aristocratic families that had fallen from power. Thus in 1848 his agents bought up cheap jewel collections in Paris, Vienna, Berlin, and Italy; sold them at a princely profit to the new court of Napoléon III in Paris, especially to Empress Eugénie; then bought much of the spoils back again in 1870, when Napoléon III fell and he and his court had to run for it. Grand Europeans also bought Tiffany's originals: by 1900, two years before he died, Tiffany was selling jewels and silver to twenty-three royal families (including Queen Victoria), as well as 100 millionaires of America's "gilded age."

Louis Comfort Tiffany, his son and heir, was primarily an artist rather than a businessman, studying painting first in the

studio of George Inness, then in Paris under the orientalist land-scape artist Léon Bailly.[10] The younger Tiffany was also much impressed by the works of William Morris and his workshop, and by the way artists and craftsmen worked together in the early stages of the arts and crafts movement. All his life Tiffany was an artist and a primary creator. But he was also, by nature, an orga-nizer, a leader, and a businessman—a lavish spender and collector to be sure, but also a man who handled money circumspectly. He always paid his bills by return mail, a rare habit in his world; and he knew exactly how to create a viable business and cater to pub-lic taste, as well as improve it. He copied from Morris the idea of artists cooperating in firms. He first formed, in 1877–1878, the Society of American Artists (with John La Farge and Augustus Saint-Gaudens) to improve the quality of American painting and market it successfully. Then, in 1879, he set up, following Mor-ris's example, the interior decorating firm of Louis C. Tiffany and Associated Artists (the latter including Candice Wheeler, an embroiderer and textile designer). Interior design was the rage, thanks to Whistler, whose Peacock Room was a harbinger, and Oscar Wilde, whose notorious lecture tour of America carried the message of "living for art," especially in the home. Tiffany's firm carried out some notable schemes—in the Veterans' Room in the Seventh Regiment Armory in New York City; at Mark Twain's house in Hartford, Connecticut; and, not least, at the White House, which under Chester Arthur, president from 1881 to 1885, received its first large-scale makeover since it was built. Arthur got rid of twenty-six wagonloads of "old junk," as he called it, and brought in Tiffany's team.[11]

It is a matter of definition whether Tiffany was primarily an artist and creator himself or a "creator facilitator," a man who made it possible by his vision and organizing ability for others to create and produce. He was certainly both: but which came first in his order of priorities? One might ask the same question of Verroc-chio, a painter and sculptor of genius in his own right, who also ran the largest shop in Florence, training young men like Leonardo da Vinci, who became great masters in their turn. Creators like Pugin, Morris, and Tiffany—designers themselves but also businessmen competing in the open market and employing craftsmen, some-

times in large numbers, to undertake big projects—ran the modern equivalents of the Italian Renaissance studio. But though Tiffany had a great deal in common with Pugin and Morris, including an imperious nature which made it impossible for him to continue for long as part of a team, he also had the background of his father's business, conducted on a large global scale, and emerging at a time when America was transforming itself from a largely farming economy into the world's biggest industrial power. In 1883, while he was still redecorating the White House, he dissolved his art partnership, and thereafter he operated through a series of personal businesses: the Tiffany Glass Company of Brooklyn (1885) and Tiffany Studios of New York (1889), which was integrated with the original Tiffany and Company in 1902 when his father died and he inherited the firm. In 1892 Tiffany established the Tiffany Glass and Decorating Company in Corona, Long Island, to make art glass on a huge scale. His object, conscious or unconscious, was to unite the forms and methods of Morris and the arts and crafts movement with the new style which sprang from it, especially in Belgium and France. This embodied Tiffany's own aesthetic ideology, that all art forms should evolve directly from the forms of nature, whether trees, flowers, rocks, birds, and animals or phenomena such as sunsets and moonlight. Although the style was English at birth, it was baptized *l'art nouveau*, after a shop opened by the entrepreneur Samuel Bing in Paris in December 1895. By then, as it happens, the style was already a decade and a half old, and Tiffany was right at the center of it. But Bing put his finger on the distinguishing mark of Tiffany as a "creator facilitator" when he wrote: "Tiffany saw only one means of effecting the perfect bridge between the various branches of industry: the establishment of a large factory, a vast central workshop that would consolidate under one roof an army of craftsmen representing every relevant technique . . . all working to give shape to the careful planned concepts of a group of directing artists, themselves united by a common current of ideas."[12]

Tiffany was thus updating the Renaissance studio in an industrial age, but one that centerd around glass rather than on bronze, marble, and paint. He came to glass, however, through his work as a landscape artist, his first love. He wanted to infuse

his landscapes with light, in a way never before achieved. In Paris he had watched artists try to do this using the techniques (derived from Turner) of what was soon called impressionism. He decided to do it by painting on, or increasingly with, glass. He was much impressed by the stained glass produced by William Morris and Morris's chief designer, Edward Burne-Jones, which he rightly saw was infinitely superior to anything being produced in America, despite the enormous demand: in the 1870s about 4,000 churches were being built in the United States, each of which required colored glass. Tiffany first worked with John La Farge, who had similar ideas; but gradually they became rivals, then enemies.

Tiffany's approach to colored window glass was based on two main ideas. First, he grew to dislike painted or stained glass and came to believe that the patterns and pictures must be composed of glass whose color was inherent and acquired in the foundry. By going into the chemistry of glassmaking he realized that virtually any color of glass could be produced; and by producing his own "palette" of glass, he could compose windows exactly as he wished, with all the intensity and purity of color of the best medieval glass. Second, he thought that colored glass should not be confined to churches but also used in the modern home. From the start, and using his new industrial methods of glass production, he made windows for large numbers of churches using the lead line to reproduce his draftsmanship and color choice and with virtually no painted detail (he also tended to ignore the pointed Gothic design of windows or other architectural features; this disregard would have infuriated Pugin).[13] Tiffany continued to produce religious window glass. One of his masterworks was *Tree in the Marsh* (1905) for the Russell Sage Memorial Window in the First Presbyterian Church in Far Rockaway. Another was a vast landscape window (1924) in the Pilgrim Congregational Church in Duluth, Minnesota. This use of landscape glasswork in churches was at first regarded as sacrilegious by critics, but is now accepted as a distinctive and marvelous form of the art and features prominently in the Metropolitan Museum's great Tiffany display.[14] But Tiffany's secular glass windows were naturally more adventurous, though he was not the

only artist making them: there were also Charles Rennie Mackintosh in Scotland, Victor Horta in Belgium, Antonio Gaudi in Barcelona, and Hector Guimard in Paris. But Tiffany was the only one who produced highly adventurous landscape designs from nature that he executed himself. As early as 1883 he produced an immense screen for Chester Arthur's White House, dividing the dining room from the main corridor axis. In 1890 he exhibited, in Paris and London, his vast *Four Seasons*, four symbolic landscapes, perhaps his greatest work in colored window glass. He used opalescent and iridescent glass as well as transparent colored glass, and some of the effects he achieved were mesmerizing, though with one or two exceptions all his best windows have been destroyed. For designs he favored flowers and birds, especially peacocks (as Whistler also did). Tiffany's great *Peacock Window*, now in a villa on Long Island, was designed for a New York house (1912), built in the Pompeiian style. When, today, his glass windows are shown in museums, like the Metropolitan, it has to be remembered that he designed them for specific rooms where their motifs and colors were integrated with other elements which Tiffany designed or supplied—carpets, curtains, furniture, and ornaments.[15]

As a by product of his window work, Tiffany began to produce lamps, taking another turn in his effort to use intensified light in designs from nature. Here was another case of art and industry advancing together. John D. Rockefeller, by creating Standard Oil and achieving enormous economies of scale, had reduced the price of paraffin by over 90 percent, the greatest single boon ever bestowed on the housewife, making both stove heat and lamplight cheap, and leading to a vast increase in the number of lamps manufactured. This was quickly followed, in the closing decades of the century, by the introduction of electric light in the home, replacing both paraffin and gas lighting with a source of light that was odorless and far less risky. Tiffany's venture into luxury lamps, distinct from the mass-produced articles, thus highlighted a sensational technological change in the way homes were lit. Originally he designed lamps to use up bits of colored glass left over from his windows. Then, as the idea took off, lamps became a key part of his production and favorites with

the public, who paid as much as $500 for one of the more complex lamps, with 1,000 separate pieces of glass in its shade. Tiffany also realized that glass lamps (and vases), if well designed and superbly crafted, were the best method of fulfilling his aim of bringing beauty into the home.

All his lamps were inspired by nature. The Wisteria lamp introduced the uneven edge of the shade, a Tiffany hallmark. The magnificent Zinnia was a virtuoso piece of clever metalwork. The Dragonfly had a twisted base in the shape of a water lily. The most spectacular lamp was the Pond Lily, which had twelve lights of iridescent glass sprouting from a base of metal. It vied as a favorite with the Apple Blossom, designed to "light up like an Orchard in Spring"; and the Magnolia, which produced the precise off-white shades of this fascinating tree. All the later lamps were designed to use electricity; Tiffany recognized that this new source of power could be used to produce spectacular light effects. He joined forces with Thomas Edison to design New York's first all-electric theater. Tiffany had been mesmerized in Paris by the Folies Bergères, where the dancer Loie Fuller of Chicago had a spectacular season. She was the first to use a team of skilled electricians, and colored glass, to illuminate her gyrations with long veils mounted on arm sticks, producing effects that drew artists and sculptors from all over Europe to capture her poses. Among these artists was Toulouse-Lautrec. Tiffany, who greatly admired him, used him and other artists, such as Degas and Whistler, to design glass windows and screens for Samuel Bing's shop in Paris. But as a rule Tiffany preferred his own designs or designs prepared under his immediate supervision. He wrote: "God has given us our talents not to copy the talent of others but rather to use our own brains and imagination." Individualism, even when the artist was working in a team, was "the road to True Beauty."[16]

Although Tiffany understood glass technology thoroughly and was always introducing innovations at his works, he did not blow glass himself, or even cast it. In 1892 he brought from Stourbridge, England, the manager of the White House Glassworks, Arthur J. Nash, to create a new division, called Tiffany Furnaces, to produce a special new kind of multilayered glass,

the chemistry of which Tiffany had already discovered. It was iridescent, with a nacreous surface, very luxurious to the touch, and produced by treating hot glass with a secret combination of oxides, which Tiffany registered in 1894, calling the project favrile (not after a French term but from an Old English word meaning made by hand). As was typical of Tiffany's love of sensual effects, the touch of this new material was as important as its visual properties and its receptivity to rare colors. It could be used for all kinds of objects, and became a fin de siècle symbol of *décadence*, but it was best suited to the magnificent vases that Tiffany created in the 1890s. These included the Peacock Feather, in which favrile produced, as if by magic, a distinct shimmer; and the Double Gourd, which blended ideas from antiquity with art nouveau. Tiffany was fascinated by an American flower called jack-in-the-pulpit, in which the stamens appeared to be preaching from out of a delicate hole formed by the petals. He designed various vases based on this theme, using new technical devices, including a superb gold-colored-glass, velvety to the touch. The rare colors and textures had to be achieved while the glass was hot, so they required superb craftsmanship. Even more care was required for the Paperweight vases, using an ancient technique Tiffany improved and updated, in which flowers appeared to be trapped between outer and inner layers of glass.[17]

Tiffany was a true creator in that he was never content, was always experimenting, and delighted in setting himself and his assistants impossible tasks. By the turn of the twentieth century he was employing 100 of the world's best glassworkers, paying them the highest wages, and encouraging them to produce any of their own ideas that he could research with his chemistry division, make using Nash's experience, and market—he had an immense personal flair for marketing. He used the resources of his Tiffany jewelry workshops to produce special metal effects at his foundry, and these, combined with rare colored glass, led to "jewel vases," which extended his range of vases based purely on nature. He was constantly studying ancient pieces of glass that he had picked up on his travels or had examined in museums, to find effects, originally produced by accident, which he could chemically analyze and produce artificially. This is how he and Nash hit on a superb new class

he called Cypriote, opaque and delightfully pitted, found in its original form in diggings at Famagusta. He also developed a ravishingly rich glass with a rough surface that he called Lava, inspired by fragments he found near Vesuvius. His studies of antiquity led him to make delicate encaustic tiles that could be used in modern bathrooms, or in the surround for a new type of fireplace he designed (incorporating shelves for books or objets d'art), the first radical innovation since Count Romford produced a smokeless grate in Jane Austen's day. Tiffany found that tiles buried for 2,000 years in ashes (as at Pompeii) underwent chemical changes, producing lusters which he could reproduce in his factory, and he was soon selling more tile sets than vases. He experimented with pottery, producing some amazing pieces, especially vases such as the Fern Frond, in yellow, with seven scrolled openwork stems joined at the top, or pots modeled on cabbages, corn stumps, pussy willows, artichokes, and other common plants and vegetables. His clay was thrown on a wheel or sculptured from lumps, molded in plaster for duplicates, hand-finished, and fired in a coal-burning kiln. The colors—ivory, beige, ochre, and rare browns and greens—were sumptuous, and each object was produced only ten times. His metal objects, especially vases, became more adventurous, especially after 1898, when he used special metal furnaces and recruited an enamels department. In 1902 he made a startling enamel-on-copper vase, with repoussé work of orange branches and green foliage. It gave an effect of opacity in reverse: rays of light, passing through translucent layers of enamel on the vase, rebounded off a layer of mirror foil with great iridescence and brilliance, an effect achieved by spangles and small sheets of thin gold or silver embedded in the transparent enamel. It would be hard to decide which was more remarkable: Tiffany's conception, entirely original, or the skill of the three enamelers who carried it out.

Tiffany's best times were the 1880s and 1890s, the opening years of the twentieth century, and the height of the art nouveau period. Then came a series of blows. His father died in 1902, leaving him all the responsibility for the vast jewelry business; and his friend and partner Samuel Bing, in Paris, retired the same year. In 1904, Tiffany's great rival Émile Gallé died, and Tiffany missed him. He had already experienced a brutal attack on his art. In 1901,

Theodore Roosevelt became president, as a result of McKinley's assassination, and moved into the White House. Roosevelt, like Tiffany, had an estate on Long Island at Oyster Bay, and was a sworn enemy as well as a jealous neighbor. He saw Tiffany as an immoral bohemian, who had brought to New York the adulterous habits of the Parisian Latin Quarter. "That man," he roared to anyone who would listen, "lays his hands on other men's wives." (There was some truth in this.) Chester Arthur had said he found the White House "like a secondhand junk shop"—hence the expensive remake by Tiffany. But Roosevelt declared that the changes "made it look like a whorehouse." He refused Tiffany's offer to buy back all the objects, including the great screen that had been installed. Regarding the screen, he commanded his workmen: "Break that thing into small pieces." Everything Tiffany had put into the White House was destroyed.[18]

There were other developments that also made Tiffany uneasy. He loathed the fauves. He hated the cubists still more. He was deeply upset in 1913, when the Armory Show introduced modern art from Paris to America, especially as half a million people went to see it. Tiffany responded by using his wealth to embellish his houses and entertain lavishly. At his home on Seventy-second Street, the principal theme was ancient Egypt, with decor by Joseph Lindon Smith. Delmonico did the catering for Tiffany's dinner parties, at which Tiffany often wore Turkish clothes and donned a turban. To compensate for the pain caused him by the Armory Show, he staged a masque at his Madison Avenue showroom. On the stage were some of his most magnificent favrile vases, beautifully spotlighted. The New York Philharmonic Orchestra played, and one of his girlfriends, the dancer Ruth St. Denis, wearing a microskirt, did an Indian hatchet dance to music specially written by Thomas Steinway. The *New York Times* called it "The most lavish costume *fête* ever seen in New York."

In Oyster Bay, Tiffany took over an estate of 580 acres, with a long shoreline facing Cold Spring Harbor, demolished an old hotel there, and built Laurelton Hall, a vast steel-frame mansion, probably the most elaborate house ever conceived in America. A stream ran through its central court, feeding an immense bronze fountain in the shape of a Japanese dragon. Water bubbled through a vast

Greek amphora that changed color electrically and gave the effect of sunlight on a lake. There was a campanile, and the entrance lay between granite columns flanked by ceramic mosaics, using many of his finest iridescent blue tiles. The house rose above a yacht basin—like many other millionaires in the gilded age, Tiffany commuted to his New York office by steam yacht—and contained eighty-four rooms and twenty bathrooms. The roofing was of copper, and the building as a whole, conforming to his art nouveau principles, had the appearance of a magic mushroom. Gaudi, the outstanding architect of the age, had a hand in it, though Tiffany himself was the master designer. There were "dark rooms," lit mainly by electricity; and "light rooms," where sunlight was the chief source of illumination. The living room (dark) contained his five masterpieces in colored glass—*Four Seasons*, cut into separate panels; *Feeding the Flamingos*, which had won the prize at the 1894 Chicago World Fair; *Flowers, Fish, and Fruit* (1885); *Eggplants* (1880); and *The Bathers*, specially designed for the house. There was a room for his collection of Native American artifacts, as well as a Chinese Room, various tearooms, a music room, and an elaborate conservatory with palm trees.

This was by far the most publicized house in America, but it was not a happy home. Tiffany squabbled with other neighbors besides Theodore Roosevelt. His second wife, much loved, died in 1908. His three daughters—Julia, Comfort, and Dorothy—grew up and left home; all were gone by 1914. Tiffany was lonely and entertained frantically, with one mistress after another as his resident hostess. In 1911 he invited 150 "gentlemen intellectuals," as he called them, to Laurelton Hall "to inspect the Spring Flowers," and consume a "feast of peacocks" served by floozies dressed as ancient Greek maidens, with real peacocks perched on their shoulders. An orchestra played Bach and Beethoven.[19]

By this point, Tiffany could feel public taste slipping away from him, as the jazz age and the society described by F. Scott Fitzgerald in *The Great Gatsby* took over. In 1916 Tiffany published—through Doubleday, but not for sale—a sumptuous volume, printed on parchment, called *The Artwork of Louis C. Tiffany*. Just 502 copies were made, 300 of them given to friends. The text consisted of a series of interviews with Tiffany, conducted by

Charles de Kay. (The book is now very scarce and a prime collector's piece.) The same year he gave a new masque at Laurelton, "The Quest for Beauty," which used a revolutionary system of dome lighting. The forty-five-member cast included "Beauty" herself, who emerged from an iridescent bubble of blown glass, a minor miracle of new technology. The cost was $15,000. All was to no avail. Tiffany could still get important commissions overseas—in 1925 he decorated the presidential palace in Havana, with twenty-three of his special rugs and fifteen lamps. Also in 1925, Robert de Forest, the farsighted director of the Metropolitan Museum, bought Tiffany's tremendous landscape window, now the center of a vast display. But by then Tiffany's art was decidedly out of fashion, and yearly becoming more so, as art deco ousted the last vestiges of art nouveau. He shut down his favrile production center in the early 1920s and sold off the stock. Other bits of his empire were disposed of. He had a red-haired Irish girl, Sarah Hamley, to look after him, as a nurse and mistress—he remained sexually active to the end—but died on 17 January 1933, at age eighty-four.

There followed one of the most ruthless artistic massacres in history. By the mid-1930s, during the Great Depression, about the last thing Americans wanted was art nouveau, even its finest flowering, Tiffany ware. In 1938 the house on Seventy-second Street was dismantled and razed to the ground. Its contents fetched virtually nothing. The same year 1,000 precious items of Tiffany stock, including twenty large colored-glass windows, were sold off at low prices. Unsold items were thrown away. In his old age, Tiffany had tried to turn Laurelton Hall into a home for artists, but the scheme did not flourish. In 1946 its wonderful contents were auctioned for tiny sums; one large, signed favrile vase fetched only $20. The house and its surrounding acres, once valued at $20 million, were sold for $10,000, and the house itself burned down.

Fashion is a flirtatious mistress and a savage master. It is impossible now to convey the contempt, amounting to hatred, with which art nouveau was regarded during and just after World War II. By then much of this art had been deliberately destroyed. One important collection, however, emerged unscathed. In the

1880s, Joseph Briggs, a lad from Accrington in Lancashire, went to America to better himself. After working on the railroads, he got employment with Tiffany at the Long Island works. He rose through the ranks to become general manager, and each time he was involved in a new product he kept a copy of it. After Tiffany's death, Briggs retired and returned to Accrington, bringing his collection with him, and when he himself died he bequeathed it all to the local museum. It consists of 120 pieces, including sixty-seven vases and forty-five tiles, and many of these items are unique. The museum was urged, just after the war, to "get rid of the rubbish," but refused. As late as the 1950s the entire collection was valued at only £1,200. But at about that time, collectors started to look again at art nouveau, and auction prices rose. The museum was again advised to sell "and buy something decent" but again refused. It now has the third largest collection of Tiffany in the world, after the splendid holdings at the Metropolitan Museum in New York and the Gallery in Winter Park, Florida, which has over 4,000 pieces as well as Tiffany's Byzantine ceramic chapel, originally created for a New York Episcopal cathedral.

The Tiffany revival began with Robert Koch's book *Louis C. Tiffany: Rebel in Glass* (1964) and continued with Mario Amaya's *Tiffany Glass* (1967). At the same time auction prices of Tiffany vases and, still more, lamps began to skyrocket. The immense destruction carried out from 1935 to 1955 made for rarity and high prices. By the early twenty-first century good pieces were fetching over $1 million each.[20] More important was the regard now felt for objects involving brilliant design and invention and superb craftsmanship, noble to look at, exciting to touch, and, when illuminated, singular tributes to the first age of electricity. Tiffany lived at a time when American art and craftsmanship first came of age and took their place with the other great creative civilizations of Europe and Asia. After splendid but meretricious fame in his youth and neglect and contempt in his old age, followed by near-oblivion, Tiffany stands in the top rank of transatlantic craftsmen, a creative artist alongside Benvenuto Cellini, Grinling Gibbons, Thomas Chippendale, and Paul de Lamerie.

12

T. S. Eliot:
The Last Poet to
Wear Spats

\mathcal{T}HE CASE OF **T. S. ELIOT** (**1888–1965**), the Anglo-American magus, who launched modern poetry in the English-speaking world in 1922 with the publication of *The Waste Land*, is a strange one, perhaps unique in world literature. As a rule, the great creative innovators in the arts, those who effect revolutionary changes in the way we see, feel, and express ourselves, are also radical human personalities, at any rate at the time when they overthrow the existing creative order. Thus Wordsworth and Coleridge, the creators of romantic poetry, who achieved a similar revolution with their publication of *Lyrical Ballads* in 1798, were then doctrinaire utopians, who had applauded the extinction of legitimacy in France; Coleridge planned to establish an egalitarian community in America. T. S. Eliot, however, both at the time he wrote *The Waste Land* and before it—and after it, and throughout his life—was a conservative, a traditionalist, a legitimist, and, in many respects, a reactionary. He came from a deeply conventional, sober, stable background; received a long, thorough, exhaustive education of a kind calculated to reinforce these factors; and, most important, was of a temperament that venerated the riches of the past and regarded their disturbance with abhorrence. His very appearance reflected this orthodox inner man, who declared himself "a classicist in literature, a royalist in politics, and an Anglo-Catholic in religion." Whereas Byron, Keats, and Shelley, all poetical innovators in their day, abhorred starched, buttoned-up collars and favored loose,

unrestrictive garments, Eliot was never once (except on holiday) pho-
tographed without a tie, wore three-piece suits on all occasions, kept
his hair trimmed, and was the last intellectual on either side of the
Atlantic to wear spats. Yet there can be absolutely no doubt that he
deliberately marshaled his immense creative powers to shatter the
existing mold of poetical form and context, and to create a new ortho-
doxy born of chaos, incoherence, and dissonance.

There is nothing in Eliot's background except inhibition,
repression of emotions, and strong cultural continuity. He was
born in St. Louis, where his father became a successful brick
manufacturer, but his family origins were Boston Brahmin. One
forebear had been part of the initial Massachusetts settlement of
1620—Puritan, strict, and individualistic. Another had been a
Salem witch-hunter. But the family members were not, by the
nineteenth century, Calvinists. They were Unitarians, living on
that last staging post which links Christianity to outright disbe-
lief in God. They denied the divinity of Jesus but recognized his
virtue, seeing him as a superior Emerson. They were extremely
careful, in discussing their religious beliefs, to use words meticu-
lously and sparingly, preferring ambiguity to assertion. Later,
Eliot himself wrote an ironic poem holding up to ridicule the
temperament and habits he inherited from this Unitarian past:

> How unpleasant to meet Mr. Eliot!
> With his features of clerical cut,
> And his brow so grim
> And his mouth so prim
> And his conversation, so nicely
> Restricted to What Precisely
> And If and Perhaps and But. . . .

Eliot was brought up in a family enjoying affluence but with-
out ostentation of any kind, and to privilege mitigated by strong
concepts of duty and service, to God, country, community, and
culture. His inheritance was virtue, probity, and righteousness. It
was softened, however, by circumstance. He was by far the
youngest of a large family, the delightful afterthought child of
an adoring mother who wrote poetry and cultivated the best

taste; and he was attended by an angelic quartet of sisters, much older than he was, so that in effect he had five careful mothers. They did not spoil but concentrated on him, ensuring that he was taught to be good, conscientious, hardworking, well-mannered, civilized, and pure. Having learned to read early under their careful tuition, he absorbed books voraciously all his life, reading richly and thoughtfully, rereading and analyzing, storing lines and passages of poetry—and prose too—in his heart, so that the habit of quotation and reference became second nature and habitual.[1]

The range of Eliot's reading was wide from the start, and continued to widen and deepen throughout his childhood and adolescence. If ever there was a creative genius nourished by reading the classics of all nations, it was Eliot. In this respect he was like Milton and Browning, the best-educated—and self-educated—of English poets. At a very early age his mother put before him Macaulay's *History of England*, which he read with delight. The family oscillated between St. Louis, on the enormous Mississippi River, and Gloucester, a New England fishing port where they also had a house; and Eliot devoured books on rivers and the sea—and birds. There survives his annotated copy of the *Handbook of Birds of Eastern North America*, given to him on his fourteenth birthday. He loved studying tiny things in great detail over long hours—a bird's wing, small sea urchins in rock pools. At Mrs. Lockwood's school in St. Louis he was plunged into Shakespeare, Dickens, and the romantic poets, especially Shelley and Keats. At Smith Academy, the preparatory school for the local university, Washington, funded by his grandfather, he learned Latin, Greek, French, and German and read the literatures of these languages. He loved Aeschylus and Euripides in Greek, Horace and Ovid in Latin. The "set books" on which he was examined in his final year at Smith included Molière's *Le Misanthrope*, Racine's *Andromache*, Virgil's *Aeneid* (Books III and IV), Homer's *Iliad*, Ovid's *Selected Poems*, Horace's *Odes and Epodes*, Shakespeare's *Othello*, Burke's *Writings on America*, Milton's *Paradise Lost*, Macaulay's *Essays*, Hill's *Principles of Rhetoric*, Addison's *Cato*, and La Fontaine's *Fables*. He learned masses of poetry by heart—at twelve he could recite Kipling's relentlessly tragic *Danny Deaver*, at thirteen Omar Khayyam. Thence he moved to

Edgar Allan Poe, and on to Byron's *Childe Harold*. He later said that
his adolescent "drowning" in verse was akin to "daemon's posses-
sion." He wrote poetry himself, and as all good budding poets do,
he became a master of pastiche and parody, so much so that his
mature poetry is in a sense an epitome or anthology of all poetry.

At Harvard, he lived on the fashionable "Gold Coast" and
belonged to good clubs, associating superficially with the rich
and wellborn but in essence leading a life of study, meditation, and
sheer hard work on texts and languages. His learning spread wider
and wider, "like a benevolent pool of water" (to use one of his simi-
les) "on the parched earth of his ignorance." Eliot always worked
hard at whatever he was doing, being conscientious, and consumed
with guilt if he was "lazy" (a rare state), and having moreover the
priceless gift of concentrating. He could set to work immediately,
first thing in the morning, without any time-consuming prelimi-
nary fiddling or rituals. If interrupted, he could refocus immedi-
ately and resume work. The intensity with which he worked was
almost frightening. He saw time as a precious commodity, never to
be wasted. The word "time" occurs very often in his best, mature
poems: the sense of time provokes a continual chronic punctua-
tion of his verse, varying in volume and intimacy from tickings and
heartbeats to the rhythmic throbbing of drums. (It was Ezra Pound
who first spotted the "insistent drum-beats" that gave "unity and
power" to Eliot's work).[2]

This fear of time passing inexorably and permanently—"time
lost"—made Eliot greedy for knowledge. If he had been English
and gone to, say, Balliol College at Oxford, or King's at Cam-
bridge, he would have been obliged by the rigidity of the curricu-
lum to concentrate on ancient texts and Greek history and
philosophy. At Harvard, however, the multiplicity of learned
courses, and the right of the student to pick and choose, was of
inestimable benefit to him. He spread his net as wide as possible,
and although this often leads to superficiality and shallow epi-
cureanism, Eliot brought up a goodly harvest from the oceans of
knowledge, and feasted on it, digesting and retaining much. In
his first year at Harvard, 1906, he took courses in Greek litera-
ture, German language, medieval history, English literature, and
the art of constitutional government. He followed these with

courses in French literature, ancient and modern philosophy, comparative world literature, and forms of religion. He got himself tutored in English composition and made a special study, himself designing the parameters, of the life and work of Baudelaire—regarded as very daring in 1908. He memorized much of James Thomson's unsettling poem *The City of Dreadful Night*; and he read widely in the English poets of the 1890s, especially Wilde, Dowson, and Davidson. He read not only Symonds's poetry but also Symonds's *Symbolic Movement in Literature,* and Symbolism, the first advanced movement he absorbed, became a permanent element in his work. (Indeed it can be argued that Eliot was a Symbolist, though he was also much else.) By the end of 1908, he was beginning to plunge deeply into philosophy, to the point where he thought seriously of becoming a professional student of the mind and its empire.

Here we come to an important feature of Eliot's life, which was central to his achievement—the absence from it of sports (including almost every form of strenuous physical activity) and sex. As a child, he suffered from what was called a double hernia, was fitted with a truss, and wore one virtually all his life. He was thus excused from games, and later declared unfit for military service. The period 1850 to 1914 was, for young men from wealthy families, the age of games. Eliot's inability to participate in this vital and time-consuming dimension of life left a huge hole to be filled by academic work, pursued all the more furiously because of his feelings of guilt that he was not drudging away and distinguishing himself on the playing field. His physical weakness, then, was a priceless gift of time, to be spent worthily on his books.

In the mysterious area of sex, that greedy consumer of a young man's time and energy, less is known of Eliot's activities or inactivity. He said he was a virgin until his marriage, and there is no reason to doubt his word. Indeed the only question is whether he remained a virgin all his life. A childhood dominated by a mother and four elder sisters can produce an adult male who is thoroughly at home with women and familiar with their ways, so that he has no difficulty in forming close attachments to the other sex at all times of his life. On the other hand, if the mother

is fond but frigid, and the sisters are loving but dowdy and fear-
ful of men, the opposite effect can be produced—and that was
precisely Eliot's misfortune as a man, and (perhaps) his creative
destiny as a poet. It is doubtful that he ever achieved full sexual
congress with his difficult and mentally disturbed first wife; and
by the time he found happiness in the motherly arms of his sec-
ond, he was in his late sixties. What is certain, however, is that as
a young man Eliot found no woman to provide him with sensual
gratification, and was too inhibited and fearful to turn to prosti-
tutes, though he evidently often thought about them: the image
of a beckoning woman in a lighted doorway on a dark or foggy
street is a recurrent one in his poetry.[3]

With no sports or sex, the reading and cerebral exploration
went on relentlessly. Eliot conforms perfectly to my definition of
an intellectual: "a person who thinks ideas are more important
than people." It is not clear that Eliot ever thought a particular
person important, though he perceived that some people were
useful, at least to him. Not that he was selfish. Self-centered, of
course: what intellectual isn't? But there was no doubt about the
importance—perhaps "import" would be a better word—he
attached to ideas. The first major adult spinner of ideas for the
maturing Eliot was Jules Laforgue (1860–1887), a Symbolist
poet, now nearly forgotten, who was born in Latin America, came
to Paris in 1876, starved, wrote poetry, went to Berlin, wrote
more poetry, married an English governess, returned to Paris to
starve, and died of tuberculosis at age twenty-seven. You have
only to read his three-volume *Oeuvres Complètes*, which Eliot
bought in 1909, to realize his importance to the poetry to come.
Irony, allusion, quotation, apparent incoherence masking unity
of mood, music rather than rhythms and prosody, impersonality,
emotional detachment concealing (or rather emphasizing)
intense pessimism—these are all there. Laforgue was a proto-
Eliot, without much talent. Eliot observed him completely,
digested him, then excreted and forgot about him.

Next came a host of "idea figures." Eliot earned his bachelor's
degree in 1909, then earned a master's degree in English litera-
ture. His tutors included Irving Babbit, who took him through a
course in French literary criticism. Babbit insisted on "stan-

dards" and "discipline"—attractive words (often used later) and powerfully attractive concepts to Eliot's conservative mind. Under Babbit's influence (it is said), Eliot took up the East—specifically Sanskrit and Buddhism, and acquired a certain knowledge of both, mainly superficial, though one can never be quite sure with Eliot. He saw them as ideas, and they did not run deep into his psyche, but he found them very useful as background noises (and rhythms).

In 1910 Eliot persuaded his father to let him visit Europe, and to finance the trip, and off he trundled in search of more ideas and mentors. (He ate both to fill hungers deprived of other sustenance.) I have a feeling that, in mid-Atlantic, as he watched the sea furrows of the vessel widening—another favorite image—he became aware for the first time of his statelessness. Earlier, the fact that he had been born in St Louis, and to its vast, rolling, muddy river, but had roots in New England Puritanism and spent summers in Gloucester with its fierce, sparkling sea, made him, when he thought about it, and he often did think about it, a divided American, a hyphenated southerner or southwesterner and Yankee New Englander, or rather neither, a kind of American specter. He seemed, already, a visitor in the land of his birth. This is, or at any rate was, not uncommon among Americans, especially in the nineteenth century and in the years just before World War I, when the country was expanding and reinventing itself with every generation, almost with every decade. Dickens recalled traveling by train across the American vastness in the 1860s, in one of the new dining cars, and committing some solecism. He apologized to the waiter for his ignorance, pleading, "You see, I'm a stranger here." The waiter replied: "Mister, in this country we are all strangers." Eliot was a stranger at home and felt himself a stranger, or at any rate strange. But was he more at home on the other side of the Atlantic? Paris, Berlin, and London were cultural centers rather than homes. Since Eliot did not leave the United States until he was twenty-six, he might be considered entirely an American. But he was not. Indeed he gradually lost his American accent completely—something few American expatriates do. In Paris he learned to speak French, fluently and correctly though not idiomatically—he was not a man for vernaculars

except in pastiche. In Paris (he said later), he knew "nobody," adding that the best way to profit from the city was to remain isolated, since the people there he was likely to meet were "futile and time-wasting." He was fascinated by its red-light district and brothel doorways, and by the brasseries where the buxom waitresses serving bock were to be had, but never penetrated one or the other. However, he read about such horrifying delights, especially in a novel called *Bubu de Montparnasse*, by Charles-Louis Philippe, describing the brothel culture of the Left Bank, which Eliot said was symbolic of Paris in 1910 to 1914 to him. In Paris, too, he went to the lectures of Henri Bergson, another man interested in time, who discoursed humorlessly on *le rire*; and he became fascinated by Charles Maurras, a revolutionary conservative who believed in violence, especially against Jews, atheists, and anyone who criticized national symbols such as Saint Louis and Jeanne d'Arc. Eliot enjoyed watching the riots Maurras organized with his rabid student groups.

Returning to Harvard, Eliot drifted toward philosophy, by way of F. H. Bradley's *Appearance and Reality*, an attractive cul-de-sac much visited by clever young men at the time. He took a course with a visiting professor, Bertrand Russell, who described him accurately as "altogether impeccable in his tastes but has no vigour or life, or enthusiasm."[4] Harvard offered him a traveling fellowship, to complete his Bradley studies, in the form of a doctoral thesis in Europe. He traveled to England via Germany, barely getting out before he would have been trapped by the outbreak of World War I in August 1914. He settled in Bloomsbury, already a center of upper-middle-class writers and intellectuals with a touch of bohemianism (and sexual deviation)—the kind of English people with whom Eliot was to feel most at home, insofar as he felt at home with anyone.

For some time he had been writing poetry or, as he always called it, "verse." This early work, commencing in 1909 and eventually published as *Prufrock* (1917) and *Poems* (1919), consists all together of twenty-four items, of which only "Gerontion," in the second collection, adumbrates the power of his maturity. Some are clever, sophisticated, even witty in a dull way; the kind of things a well-educated but shy and diffident Harvard man might

be expected to produce in private but would not venture to publish or even perhaps show to his friends. That there was a deft, humorous side to Eliot's verse is clear. Friends of his youth testify to his capacity to make sly, ironic jokes, often surprisingly funny. This talent, under the warming nourishment of fame, eventually blossomed into his remarkable collection *Old Possum's Book of Practical Cats*, published in 1939; it eventually formed the libretto to an astoundingly successful musical, *Cats*. However, it is fair to say that if Eliot had never written and published *The Waste Land* and *Four Quartets*, this early work would by now have been forgotten; as it is, "Gerontion" and "Mr. Appolinax," for instance, are studied and anthologized entirely because of their supposed relationship to Eliot's two masterpieces, and are parasitical on them. His instinct not to publish was in a sense sound. In fact many verses he wrote remained unpublished, not least of them a comic epic, "King Bolo and His Great Black Queen," on which he worked, spasmodically, for some years. This work has been described by Peter Ackroyd in his biography of Eliot as "consistently pornographic in content, with allusions to buggery, penises, sphincters and other less delicate matters."[5] It is likely that Eliot wrote pornography on and off all his life, as a form of sexual satisfaction, to compensate for his virginal existence (and his horror of masturbation, which he believed might make him insane), and later destroyed most of it. Then and later, Eliot was obsessed by the futility and pointlessness of human affairs, especially his own. Life was empty of significance. How was it to be filled? Religion was one way, but Eliot was not yet ready for that. Philosophy, in particular Bradley's so-called idealism, was another; but Eliot quickly discovered this to be a stony path leading nowhere, as others have found since. A third way was sexual excess, but Eliot was much too puritanical and fastidious—and nervous—to travel that road; creating pornographic verses was a substitute, albeit a dispiriting one.

Then, in September 1914, Eliot's rather feeble and purposeless existence was transformed, forever, by a meeting. Such meetings, the human equivalent of the transformation effected by blending chemicals, are of tremendous importance in the history of creation. An outstanding example is the meeting of Coleridge

and Wordsworth at Bristol in August 1795, an encounter which inflamed both and led directly to their collaboration in 1797 in the creation of *Lyrical Ballads*, its publication the following year, and the birth of romantic poetry. The meeting of Eliot and Ezra Pound was of comparable importance, since, again, it led eventually to a poetic revolution, the birth of modern poetry, with the publication of Eliot's *The Waste Land* in 1922.[6]

Pound was three years older than Eliot and a much more positive character, a man of enthusiasms, sometimes violent ones, and huge ambitions. He also had, in some ways, a grand generosity of spirit. Whereas Eliot was diffident about poetry, Pound was a crusader, a fierce pioneer and propagandist, to the point of bombast. Like Eliot, he had an academic side and considerable scholarship. He had taught at Wabash College, from which, characteristically, he was dismissed for his impatience and exasperation with academic methods. He then roamed Europe, living in London from 1908 to 1920. Between 1908 and 1912 he published several volumes of poetry including translations from Chinese, Provençal, and Italian, and made subtle and sometimes esoteric experiments in meter and language. Pound came from Idaho, so, like Eliot, he was technically a midwesterner, and their scholarly leanings also gave them common ground. In temperament, however, they were opposites—Eliot bloodless, Pound ebullient and bursting with ferocious energy.[7]

When, at Pound's request, Eliot showed him "Prufrock" and "Portrait of a Lady," there was an explosion of enthusiasm: "This is as good as anything I have ever seen." Pound at once wrote to Harriet Monroe, editor of the magazine *Poetry* in Chicago, and told her that he had found a new master. He also introduced Eliot to Wyndham Lewis, a writer and painter who soon produced by far the best portrait of Eliot (now in the National Gallery of South Africa, Durban) and who described him at the time as a "sleek, tall, attractive, transatlantic apparition, with a sort of Gioconda smile, moqueur to the marrow [with] a ponderous, exactly articulated drawl." Pound introduced Eliot to many other literary figures, American and English, and Eliot soon found himself treated not as an academic philosopher but as a "young poet," a member of the avant-garde. This brought about

a faint stirring of the blood. He found himself being bullied into publication, both in magazines and in books. Pound brought pressure on him to make up his mind about other things as well: to settle in Europe, preferably England (Pound argued strongly that this was the place most congenial to a literary life); to give up sterile academic philosophy in favor of literature; to empower this process of settling down and concentration by marrying. The decisions were connected, since they involved cutting himself off from his family. Indeed, from this point on Eliot saw very little of his parents (though his mother visited him) and received little financial support from them, despite his father's wealth. He also began to assimilate to Europe—not, like Henry James (who became British in 1915), for social reasons but because Pound persuaded him that America was culturally conservative, and that Europe was the place where the future of art and literature was being shaped.

"Prufrock" appeared in *Poetry* in June 1915, and the same month Eliot married Vivien Haigh Haigh-Wood, an English gentlewoman, slightly older, who aspired to write and paint. The marriage was, in one sense, a personal disaster; in another sense, it was a cultural spur to produce and a tone-setting event. It was contracted in haste and without the consent of Eliot's parents; in fact they were not even informed until afterward. Whether it was ever consummated is doubtful. Vivien was not uncomely but of fragile health, both physical and mental. She was always about to be ill, actually ill, or recovering from an illness. Some of her complaints were real, others imaginary. Her impact on Eliot was considerable in one respect. He had never been robust, as we have already noted, and his truss was an impediment not only to sex but to any kind of normal life. Vivien sharply increased his awareness of his physical disabilities, and his proneness to minor ailments such as colds and migraines. From the early days of their marriage they engaged in competitive hypochondria. Both became valetudinarians and were always dosing themselves, complaining of drafts, and comparing symptoms. (It is a curious fact that Eliot's only successful appearance on the amateur stage was as Mr. Woodhouse, the outstanding valetudinarian in English literature, in a production of *Emma.*) When Vivien recovered

from a bout of neurasthenia, Eliot was sure to sicken, and a kind of medical ping-pong persisted throughout their marriage. Their bathroom medicine chest overflowed into the dining-room sideboard. All this first occurred during the war, but afterward, as travel became possible and the impact of Freudianism first powerfully asserted itself, both became addicts of psychology, psychiatry, and psychoanalysis. All this can be studied in the first volume of Eliot's *Collected Letters*, where his anxieties about his own mental state, and hers, were emphatically canvassed, and his efforts to find expert help described in detail.

There is no need to go into the marriage here, or for that matter to apportion blame for its unhappiness and eventual failure. It has been much commented upon: about as much as the tragic union of Sylvia Plath and Ted Hughes, and to equally little effect. As Tom Stoppard has truly noted, "No one, no matter how well informed, can possibly know what goes on inside a marriage except the two principals themselves." What we do know is that Eliot was unhappy. But then he had not been notably happy before his marriage. (He later said he had never been happy in his life except as a child, embosomed by his mother and sisters; and in his second marriage, a similar experience.) However, the study of the creative process, especially in the arts, suggests that unhappiness is rarely if ever an obstacle to production and may, indeed, be a positive incentive. The case of Thackeray, whose wife went mad and left him lonely and desperately miserable, indicates that his plight was directly related to the writing of his masterpiece, *Vanity Fair*, one of the greatest of all novels.

In Eliot's case, the transformation of a diffident versifier into a great creative artist was impelled by a ferocious counterpoint of personal and public misery. On the one hand there was the daily sadness of his marriage, punctuated by bitter disputes and medical crises; on the other there was the truly appalling destruction and agony of World War I, with its daily casualty lists of daunting length—a conflict that seemed to prolong itself indefinitely and to become more hopeless and seemingly interminable with every dreadful week that passed. It was a war without hope or heroic adventure—just a dull misery of loss and pain—which induced in the participants, serving in the trenches or suffering

vicariously at home, an overwhelming sense of heartache. The times seemed to have no redeeming feature; mankind appeared to be undergoing the agony of the war with no compensating gain in virtue but merely the additional degradation that the infliction of death and cruelty brings. It was unmitigated waste. So, equally, was Eliot's marriage, both parties to it enduring suffering without a mitigating sense of redemption, just two wasted lives joined in sorrow. This public and private mortification was the genesis of both the substance and the title of *The Waste Land*.

There was a third factor of some weight. Eliot had always worked hard. There was no element of idleness in his mind or his body. He was self-disciplined. But he lacked the external discipline of regular work. His father's meanness in refusing to finance his son's dilettante existence (as he saw it) in Europe obliged Eliot, now a married man, to earn a living. He tried being a schoolmaster, as did so many literary men in those days: first at High Wycombe Grammar School, then at Highgate Junior. Like some of his contemporaries, notably Aldous Huxley and Evelyn Waugh, he found the experience exhausting, numbing, and deleterious to his creative instincts.

Then, in March 1917, at the lowest point of the war, a happy chance pushed Eliot into a position in the City, in the colonial and foreign department of Lloyd's Bank. He was there eight years, till November 1925, and his job became a position of some responsibility: from the end of the war onward he was put in sole charge of debts to and from the bank arising out of the war with Germany. This was a very complex matter, and Eliot later claimed that he never properly understood it. But that is belied by the confidence he evidently inspired in his superiors. In 1923 a member of the bank's board asked a literary person at a reception: "You may know of one of our employees who is, I understand, a poet. Mr. Eliot." "Indeed I do. He is a very remarkable poet." "I am glad to hear it. He is also most proficient in banking. Indeed, I don't mind telling you that, if he goes on in his present way, he will one day be a *senior bank manager*!" Eliot had never looked or dressed like a bohemian. On the contrary he had always looked and dressed like a banker, and he continued to do so for the rest of his life. In 1946 he was invited to Buckingham

Palace to read poetry for the king, the queen, and the two princesses. Unlike many poets, he did not read his own verses well, and the occasion was not inspiring. Many years later, the queen mother recalled the event: "He did not seem like a poet to us. The girls laughed at him afterwards, and I said: 'Well, he gives the impression that he is some kind of dignified official, rather buttoned up. Or that he works in a bank—of course, we didn't know then that he *did*!'"

Eliot took to the initially difficult but increasingly satisfying routine of foreign-exchange banking, and worked at his poetry in the evenings. The contrast between his ledger work and his versification was sharp and salutary. There is an illuminating parallel here with Charles Lamb's work in the accounts department of the East India House. The distaste that Lamb felt for his account books made his essay writing in his scant leisure hours doubly welcome and delightful. So, too, Eliot found an immense benefit in the relief from figures and double-entry bookkeeping which his evening poetry brought: for the first time in his life he discovered the power and depth of creative pleasure. This discovery in turn led him to think about, and plunge into, the business of writing poetry in a way he had never before experienced, so that his work broadened and deepened but also became more sharp and merciless, more ruthless in expression and effect.

These three factors, then—the counterpoint of public and private misery, and the work in the bank—were crucial elements in the creation of Eliot's first masterpiece. But there were two others. The first was alcohol. Even with the encouragement of powerful personalities like Pound, Eliot was always diffident about writing poetry. In prose, there is reason to believe, he was fluent and unhesitating. He also found no problems with dialogue; that is one reason why he turned increasingly, later in life, to drama (to our and poetry's loss). But with verse he was always strongly inhibited, incapable without stimulation, of releasing the deeper feelings poetry requires. For him to begin a poem induced the fear that many people feel on entering a crowded room, in mingling with its occupants. Just as alcohol helps such people, it enabled Eliot to plunge into verse and into all that verse implied. Eliot always enjoyed drinking, especially gin. He

liked strong cocktails. (And called them that: hence the title of his play *The Cocktail Party*; a born Englishman of his class would have called it *The Drinks Party*.) In 1953 (I think) I first met Eliot standing just inside the entrance to the drawing room at 50 Albemarle Street, headquarters of the famous publishing firm of John Murray for over 200 years. In that room Byron's letters from exile had been read to the London social literati, and in its grate the sole copy of Byron's memoirs had been burned, before witnesses. The then head of the firm, "Jock" Murray, was celebrated for the strength of his dry martinis, and that was one reason why Eliot delighted to be present at the Murray parties, even though he worked for a rival firm, Faber and Faber. The sole remark he addressed to me, before we were interrupted, was: "There is nothing in this world quite so stimulating as a strong dry martini cocktail."

The word "stimulating" was, and is, instructive. Many years later, after Eliot's death, I had a long talk with his second wife and widow. She gave an instance of the role alcohol played in his poetry: "Tom's poem 'The Journey of the Magi' was of great importance to me. He wrote it in 1927, and when I was fourteen, I heard a recording of him reading it. It made a huge impression on me, physically, intellectually, and spiritually, and I remember saying to myself, 'That is the man for me.' In due course I succeeded in becoming his secretary, and eventually his wife. After we were married, I asked him about the composition of that poem, and he told me: 'I wrote it one Sunday after matins. I had been thinking about it in church and when I got home, I opened a half-bottle of Booth's Gin [a powerfully flavored drink with a faint yellow tinge], poured myself a drink, and began to write. By lunchtime, the poem, and the half-bottle of gin, were both finished.'"

The fifth factor in the creation of *The Waste Land* was Pound. Eliot began this medium-length work, which in its published form is 434 lines but was originally much longer, late in 1919. What it is about is not clear; indeed it is not necessarily about anything. It has often been subjected to detailed exegesis, which can illuminate particular sections. Eliot himself supplied notes, a kind of confidence trick, which he later regretted as dishonest and pretentious, and these help with references, though they no

more explain what the poem is about than the sideheads that Robert Browning reluctantly supplied for his incomprehensible poem *Sordello*. *The Waste Land* is not a narrative but a poem about moods, predominantly despair and desolation, reflecting the ruin and waste of Eliot's private life and the defeat World War I had pointlessly inflicted on civilization. Eliot continued to work on it throughout 1920 and early 1921, but by the summer of 1921 he was so downcast that he was advised, by what was then still called a neurologist, to take three months' sick leave from the bank. Lloyd's agreed, and Eliot went in November to Lausanne to see a leading psychiatrist. While in Switzerland he finished the poem, which was thus essentially brought to completion under the stress of mental breakdown.

Though Eliot was a conservative by intellectual conviction and instinct, he had a passion for cultural innovation. He strongly approved of cubism, for instance; he said that when he first heard Stravinsky's *Rite of Spring* he burst into cheers; *Ulysses* struck him as the best novel he had ever read. He wished to bring about the same kind of revolution in poetry as these phenomena had achieved in painting, music, and the novel. Eliot had much admired Conrad's tale *Heart of Darkness*, and in particular Kurtz's death cry "The horror, the horror!" which, to Eliot, summarized dismay at the utter meaninglessness of the world—to understand what the world is "about" is to comprehend emptiness. Siegfried Sassoon later claimed that Eliot, while working on *The Waste Land*, said that "all great art is based upon a condition of fundamental boredom: passionate boredom." The original text of the poem contained large elements of parody, stylistic cleverness, and wit—witless wittiness perhaps—in the manner of Eliot's early verse, illustrating the boredom induced by cultural satiation, and in so doing boring the reader. However, Eliot had the sense to submit the original, full text to Pound, or perhaps he agreed to Pound's insistence on being appointed editor; he had the further good sense to accept Pound's changes, which essentially consisted in cutting away the pretentious parodying and witty superstructure with which Eliot had decorated the poem's hard despair. The extent of the work Pound performed on *The Waste Land* can be judged from the original manuscript, which came to

light in 1971, after Eliot's death, and was published by his widow.[8]

In effect, Pound dug out from the version Eliot gave him the fundamental bones of the poem of despair so that its music and rhythms can be heard and felt. The changes transformed the work into a masterpiece, and one which was perceived as such the moment it was made public. *The Waste Land* was beautifully timed to appeal to young men who had come to the universities shortly after the war ended. They, like Eliot, felt empty, bored, disgusted with the world, and with themselves; overeducated in the classics, especially in Greek and Latin and often in German and French, as well as familiar with the English classics; and unsure, now, what all their education had been for. The poem was allusive (and elusive), sophisticated, catchy, rhythmic, full of incoherence, and meaningless anecdotes. It ranged from the plebeian and demotic to the ultra-academic, and it contained snatches of jazz and popular songs. It was carefully loaded with sexual innuendo of a kind calculated to stimulate and tease male virgins or near-virgins, reflecting Eliot's own appetites and frustrations. It was perverse, decadent, sly, outrageous, provocative, but also unquestionably poetic in its careful, musical choice of words, its strong beat in places, its skillful repetitions, and its rhymes, or pseudo rhymes. It is marvelous to recite and easy to memorize despite its obscurity. Most of all, it invites participation. The greatest strength and appeal of the poem is that it asks to be interpreted not so much as the poet insists but as the reader wishes. It makes the reader a cocreator.

This ability of an author to entice the reader into collaborating with him in expanding, interpreting, and transforming what he has written is a rare gift, and an extremely attractive one. Jane Austen notably possessed it. Many of the most strongly emotional episodes in her novels are merely suggestive or indicative. She supplies characters but sometimes only hints about how they behave in a given situation—we, the readers, are left to fill in the gaps in her narrative, and delight in doing so. The books are full of lacunae, and we are to supply them. As Virginia Woolf put it, "Jane Austen stimulates us to supply what is not there." The reader is thus, as it were, drawn up by her graciously inviting

hand to her own creative level and becomes an honored collaborator in her work. Eliot does the same in *The Waste Land*. The poet gives the readers the mood, and certain episodes or elements are clearly presented, though others less markedly. The readers, having caught the mood, are then invited to exercise their imagination—they are told (in effect) to clarify, add, expand, prolong, correct, emphasize, and intensify. They are cocreators in a major exercise in brilliant deception.

It is hard to imagine, now, how intoxicating this must have been to clever young people in 1922–1923. The poem's reception on both sides of the Atlantic was mixed, to put it gently. The professional critics were angered, puzzled, outraged, occasionally intrigued and fascinated, disapproving or dismissive. Some were slow to make up their minds and waited for others to speak first. But the young were dazzled. It is hard to think of any other occasion when a new writer has been taken so rapidly to the hearts of the student elite. Oxford was first to become enthusiastic; Cambridge was not far behind, followed rapidly by Yale, Princeton, Harvard, and Columbia. Printed copies were initially hard to find, and the text was often copied out by hand or typewritten, then circulated and read aloud at undergraduate parties. Shortly after its appearance in the Hogarth Press edition of 1923, Cyril Connolly, who was then an undergraduate at Oxford, wrote to a contemporary at Cambridge: "Whatever happens, read *The Waste Land* by T. S. Eliot—only read it twice. It's quite short and has the most marvellous things in it—though the 'message' is almost unintelligible and is a very Alexandrian poem—sterility disguised by superb use of quotation and obscure symbolism—thoroughly decadent. It will ruin your style!" Connolly's reaction was typical albeit heightened, since he was the sharpest, most knowing critic of his age group. As he later put it, nothing could convey "the veritable brainwashing, the total preoccupation, the drugged and haunted condition which this new poet induced in some of us."[9] The young Harold Acton read it out loud, through a megaphone, from his Gothic rooms in Christ Church Meadow Buildings to the hearties trudging down to their eights boats on the river, provoking rage because "that poem" was already a symbol of antagonistic modernity. No poet has ever had a reception more

gratifying, especially among the audience that matters most—the opinion makers, the younger generation. The poem's success more or less instantly placed Eliot at the head of the profession of poetry, a position he occupied until his death more than forty years later.

Eliot was in his mid-thirties when *The Waste Land* brought him fame. It occupies in his oeuvre the same position that *In Memoriam* held in Tennyson's. *In Memoriam* was written in 1833–1850; was published in 1850, when Tennyson was forty-one; and was followed almost immediately by his appointment as poet laureate. Thereafter he never quite hit top form again except with his *Idylls of the King*, a fragment of which was written and published in 1842 and the rest spread out between 1859 and 1885. Yet Tennyson (who made a great deal of money from his poetry) was prolific. Eliot was not. He remained diffident and, despite constant and growing praise in the 1920s and 1930s, unsure of his genius. The celebrity he won with *The Waste Land* made it possible for him to cofound, with Lady Rothermere, the literary review *Criterion* (1922). This gave him additional influence. In 1925 he left the bank (which was very sorry to lose "a valuable employee") and joined the publishing firm of Faber and Faber. He served there as chief editor of the firm's volumes of poetry, in which it specialized. That confirmed his position as by far the most powerful poet and editor in the English-speaking world.

Some might argue that it was Eliot's power which kept him to the fore as the greatest living poet. But that would be unjust to the sparse but intense gift he possessed. In 1925 he published "The Hollow Men," a ninety-eight-line poem which reprised the emptiness, despair, and horror of *The Waste Land*, and proved extraordinarily memorable, from its opening line "We are the hollow men" to its shocking last couplet,

> This is the way the world ends
> Not with a bang but a whimper.

"The Hollow Men" was followed by two other successes: "Journey of the Magi" (1927) and "Ash-Wednesday" (1930). These punctuated his progression into the austere but glowing

form of Christianity then known as Anglo-Catholicism. Indeed in 1927 he was ritually confirmed and became a British subject (not "citizen," as he liked to point out). However, it was with his grand poem or poems, *Four Quartets*, that he finally proved, beyond possibility of argument, that he was the world's greatest poet. Their chronology is complex, since the first, "Burnt Norton," dates from 1935 and the other three date from 1940–1942. Effectively, however, the *Quartets* are a mid-war publication, appearing as a whole in various editions toward its end. They led to the repeated assertion, which became almost a truism, that Eliot was dispersing the wartime darkness with his solitary gleam of civilization.[10]

The *Quartets* were self-edited, without Pound's assistance, for Eliot had learned the lessons Pound had taught. Together, these poems are longer and fuller than *The Waste Land*, more pictorial, full of luminous images and catchy themes, with more rhymes, and with a great deal more music. Whether they are more "accessible" (a term just coming into vogue in 1942–1943) is a matter of opinion. They echo all sorts of incidents, themes, and places in Eliot's life, but they are not about anything. Like *The Waste Land*, they are poems of mood. But if we take these two major works together, we see how Eliot creates, sustains, or changes mood. He harps continually on certain abstracts and certain concretes or substances. Among the abstractions the most important is time. (Time is sometimes contrasted or linked with distance—a reminder that Einstein's general theory of relativity of 1915 was demonstrated to be true, empirically, in 1919, while *The Waste Land* was being written, and that this theory was a key element in Eliot's cosmology.) Time is a word that occurs frequently in the *Four Quartets*, notably in the opening of "Burnt Norton" ("Time present and time past," itself a Proustian echo) and in the introduction to "East Coker" ("In my beginning is my end"). Another principal abstract theme is desiccation. The word "dry" is very often used, for instance in the title of the third of the *Quartets*, "The Dry Salvages" (though this was actually the name of a group of rocks near Eliot's childhood vacation home in New England). Desiccation is not really abstract, since it is a quality Eliot associates with bones (he is fond of bones, especially dry ones), sand, earth, and rock. The world is a desert, a

lunar or Martian landscape, sometimes menacingly hot, sometimes piercingly cold. Its images, such as rocks, dry riverbeds, and cracks in the earth's surface, reproach the human who strays there. Eliot also traffics in the undersea world, with its dim or impenetrable recesses, and its transformations over time ("Those are pearls which were his eyes"). Then there is fire, the subject of "The Fire Sermon," one of the five parts of *The Waste Land*. Fire recurs repeatedly in *Four Quartets*. Eliot's landscape is fiery when it is not desiccated or frozen, but though the fire scorches ("Burnt Norton"), it consumes not. It leaves ashes, though—and "ashes" is another favorite word. Then there is death; the word "death"occurs nearly as often as "time" in Eliot's work. As Eliot puts it in "Little Gidding," last of the *Quartets*:

> We die with the dying;
> See, they depart, and we go with them.
> We are born with the dead;
> See, they return, and bring us with them.

The *Four Quartets* were much discussed when I was a freshman at Oxford in 1946, and they, too, were still fresh from the presses. I recall a puzzled and inconclusive discussion, after dinner on a foggy November evening, in which C. S. Lewis played the exegete on "Little Gidding," with a mumbled descant from Professor Tolkien and expostulations from Hugo Dyson, a third don from the English faculty, who repeated at intervals, "It means anything or nothing, probably the latter." But, like *The Waste Land*, it required input from the reader, and each reader's contribution was and is different. Therein lay the charm and the power of Eliot's poetry.[11]

With *Four Quartets*, Eliot's active life as a poet was essentially complete. He had created one of the most penetrating and memorable moods in the history of the art, and that was his contribution to western culture. It exactly suited a dreadful century, the twentieth, and in a sense said all that could be said, or hinted, about it. As the old rabbi observed, "All the rest is commentary." Eliot had been dabbling in poetic drama most of his life, and with his fame as a poet firmly established, he felt he could

indulge his foible. So we were given the five plays: *Murder in the Cathedral*, *The Family Reunion*, *The Cocktail Party*, *The Confidential Clerk*, and *The Elder Statesman*. It is a habit of poets to write plays, and a custom of the public to dislike or neglect them. There are exceptions, but most of these works fall by the wayside. Who has seen the plays of Byron or Shelley? Eliot's repute was sufficient to get his plays staged, and they are revived from time to time, briefly and unmemorably. But he was pre-Beckett and pre-Pinter, and believed a play must tell a story; and his gift lay not in telling stories but in setting moods. So we pass over his plays.

In 1947 his first wife, from whom he had long been separated, died. The next year Eliot received the Nobel Prize; and shortly afterward he received England's highest award, the Order of Merit. He received eighteen honorary degrees from universities throughout the world, and was an honorary fellow of colleges in both Oxford and Cambridge. His second marriage, in 1957, brought him happiness, and a faithful future custodian of his oeuvre. He died in 1965 in an odor of sanctity, literary distinction, and high social repute, a model celebrity and a writer *sans peur et sans reproche*. My favorite line of his is still "There is nothing quite so stimulating as a strong dry martini cocktail."

13

Balenciaga and Dior: The Aesthetics of a Buttonhole

O F ALL THE CREATIVE PEOPLE I have come across, Cristóbal Balenciaga (1895–1972) was easily the most dedicated to the business of making beautiful things. His work absorbed him totally, and there was no room in his life for anything or anyone else. When the cultural revolution of the 1960s, that disastrous decade, made it impossible (as he saw it) to produce work of the highest quality, he retired and quickly died of a broken heart.

Making elegant clothes is one of the most ephemeral but oldest forms of art. The oldest of all, and by its nature even more transient, was body painting, which antedated the art of painting in caves and on stones (itself 40,000 years old) by many centuries. Nothing whatever survives of that, and the clothes worn by our distant ancestors are found only in minute fragments. Indeed, until the sixteenth century complete outfits are the rarest of all artifacts to survive; and until quite modern times museums were lacking in even rudimentary collections of historic clothes. With historians and archivists fighting shy of the subject, one of the most important of human needs and interests was ill recorded. When H. G. Wells began his history of the world (1920s), purporting to put in the subjects conventional historians neglected, he asked the question: "Who did the dressmaking for the Carolingian court?" But he did not provide the answer.

Until the twentieth century only the rich dressed well and fashionably. From earliest times there was an international trade in wool and other textiles but made-up clothes (as opposed to fashions) rarely crossed frontiers until the eighteenth century. Wealthy men in the American colonies began to order clothes from London tailors, and in the 1790s Beau Brummell established standards in male attire that became international at the highest levels of society and made the London tailors, centered on Savile Row in Mayfair, the world focus of the trade. Slowly, Paris began to achieve a comparable supremacy in female fashions, but it was a precarious position until the late 1850s, when Charles Frederick Worth (1825–1895) set up shop in Paris, dressing the very rich. Worth was an Englishman, trained at Swan & Edgars in Piccadilly Circus, the shop said to have introduced the cage (hoopskirt), a sprung steel lightweight frame that could be used to increase the size of skirts to amazing dimensions. Britain was the world center of the textile trade (except for silk) and was the first country to establish large department stores, so it is curious that Worth, who was enormously inventive, methodical, and businesslike, did not choose to make London the center of high fashion. The reason was that Queen Victoria, though she reluctantly adopted the cage (and later, equally reluctantly, discarded it), was a plain, dowdy woman, not interested in dress even before the death of the prince consort in 1861 turned her into a widow weed woman. By contrast, Empress Eugénie was passionate about clothes and turned her court into a manequin parade. In 1860 she appointed Worth her official dressmaker and, for the first time, he began to make for her entire multi-dress outfits, one set in January for the spring and summer, and another in July for the autumn and winter. This determined the cycle of the Parisian dress year; and since the empress rarely if ever wore the same dress twice, and certainly never wore a dress from the year before (and since all the Parisian rich followed her example), Worth greatly expanded the volume of what he called haute couture.[1]

The system demanded seasonal change to make clothes from the previous season look out of date and therefore unwearable. Worth responded with astonishing ingenuity and ruthlessness.

He invented "planned obsolescence" a century before the term was coined. Among his novelties were: the antique over-tunic (1860); the shorter, ankle-clearing walking skirt (1862–1863); the flat-fronted cage (1864); light-colored spotted and striped summer dresses (1865); and fur trimmings (1867). In 1868 he abolished cages completely and with them the long-lived crinoline—a dramatic step that achieved the first real coup in fashion history. In 1869 he brought back the bustle, another audacious step that paid off. Worth survived the Franco-Prussian War and the siege of Paris, shutting his *maison* but reopening it in the autumn of 1871, catering especially for a new range of American customers who now began to come to Paris to be dressed. In 1874 he created the "cuirass line," giving the upper part of the body the sheathed shape beloved of late Victorian women, and in 1881 the "princess line," after Alexandra, princess of Wales. In 1890, he introduced the cut against the bias (i.e., against the natural line of the textile), an innovation later credited to other designers. In 1893–1895 he made leg-of-mutton sleeves the main feature of his silhouettes.[2]

By the time he retired and handed the business over to his son, Gaston, Worth had explored virtually every shape open to the designer and proved what all dressmakers learn in time: there are only half a dozen basic ways of sculpting a dress, using the focii of hemline, waist, bust, neckline, and sleeves. If fashion is to change regularly, repetition is inevitable—Worth reintroduced the bustle three times and the leg-of-mutton sleeve twice—and the art of the skillful designer is to conceal it. Under Gaston Worth, the Parisian fashion world took its classic organizational shape: concentration around Avenue Montaigne; biannual shows coordinated in the first fortnight in January and the last two in July (six weeks before the autumn salon); and membership in the Chambre Syndicale de la Haute Couture, which fought piracy, disciplined the fashion press, and upheld standards, including the manner in which original designs could be sold to large ready-to-wear firms in Britain and America. To qualify for membership, a *maison* had to employ at least twenty people in its atelier and produce a minimum of fifty new designs in each collection. Both Worth and his son pioneered close links between

the Parisian fashion industry and the textile trade, especially the silk makers of Lyon, to produce materials of the highest quality. Gaston Worth's organizational work was complete by 1910. The number of houses then rose slowly (and allowing for wartime interruptions) to a peak of about 100 to 110 in 1946–1956; and their primary aim—to produce women's clothes of the highest quality, in materials, design, cutting, sewing, fitting, and finish—was maintained until the end of the 1960s.[3]

There is, however, an interesting historical point, which is not sufficiently grasped by those who study fashion. There was no intrinsic reason why women's high fashion should be centered in Paris rather than London. Paris became the center essentially because Empress Eugénie provided client-leadership and Worth responded with designer leadership. If Victoria had died in, say, 1870, and Alexandra, an unusually handsome woman with a fine figure, had become queen and offered client leadership, Worth would have responded by transferring his house to Mayfair, and the whole story would have been different. Design was, and is, international, and a good dressmaker can operate anywhere if the market is encouraging. Not only was Worth English; so was John Redfern. Redfern, a linen dealer from the Isle of Wight, was the first to design (in the 1870s and 1880s) lightweight leisure and sports clothes for women, the kind of outfits a fashionable lady could wear playing croquet or indulging in the new craze for bicycling. Between the wars some of the best Parisian designers were foreigners. For example, an Englishman, Captain Molyneux, set up his house in Paris in the 1920s and again in 1946. He would have preferred to work in London, and did so for a time (as did his ablest disciple, Hardy Amies), but he had to follow the custom. The French could always produce original designers, such as the brilliant, fierce Gabrielle (Coco) Chanel, who invented a form of elegant simplicity that she produced, with tiny variations, for nearly half a century. But of the greatest designers during the years between the wars, one was Mainbocher, an American; and another was Elsa Schiaparelli, an Italian. These two set up shop in Paris in 1930 and 1929 respectively. It is interesting to speculate about what would have happened if Wallis Simpson, who captivated the heart of King

Edward VIII, had become queen. Even as the duchess of Windsor, she became the finest client leader of the twentieth century, having an exceptionally slender, fine-boned figure that designers loved to work for, fit, and adorn; an intense interest in fine clothes; and a superb eye for the kind of fashion novelty that works. She quickly established herself in 1937–1938 as a pillar of the Paris industry. As queen of England, with virtually unlimited money and an immense natural following of society ladies, she would surely have made London the focus—or so Molyneux and Amies believed. As things happened, however, Queen Elizabeth, a Scotswoman with a natural predilection for tweeds and tartans, pursued a homely upper-class native dowdyism for her entire long life (her daughter, Queen Elizabeth II, following her), attended by a suitably homegrown couturier, Norman Hartnell. Hartnell laid down his philosophy of dressing royalty as follows, making it clear why his clients could never be called smart: "One of the essential elements of a majestic wardrobe is visibility. As a rule, ladies of the royal family wear light-colored clothes because such colors are more discernible against a great crowd, most of which will be wearing dark, everyday clothes." It is hard to imagine the duchess of Windsor accepting such a principle.

So the fashionable world went to Paris, and all the great designers were to be found there. Among the foreign-born masters of Parisian fashion, Balenciaga was the greatest.[4] Indeed many would rate him the most original and creative couturier in history. And he was a true couturier, not just a designer: that is, he could design, cut, sew, fit, and finish, and some of his finest dresses were entirely his own work.

He was born on 21 January 1895 in Guetavia, a Basque fishing village. Balenciaga's father was a sailor and mayor of the village but died young, leaving his wife, Eisa, badly off. There were three children: Augustina, Juan Martin, and Cristóbal, the youngest. Eisa set up as a dressmaker and also taught the village women to sew. Cristóbal, age three and a half, joined the class and showed astonishing skill with a needle. For the next seventy-four years he could, and did, sew superbly, and kept his hand in by doing a piece of sewing (be it only darning) every day of his life. His first original work was a collar set with pearls for his cat.

The collar was noticed by a grand lady of the neighborhood, Marquesa de Casa Torres (the great-grandmother of Queen Fabiola), who became his first patron, getting him to copy one of her best dresses. At twelve he was apprenticed to a San Sebastián tailor to learn cutting (an art few dress designers really possess). At seventeen he went to Biarritz, across the border, to acquire French. By 1913, at age eighteen, he was learning the women's-wear trade in San Sebastián, in a luxury shop, Louvre, where he became adept at fitting ladies and finding gowns for their personal requirements. Later, experts as well as customers marveled at the speed with which he went about his work, especially the difficult business of fitting models with scores of garments just before a collection (he could do 180 in a day). The explanation is that from the age of three to his mid-twenties he learned thoroughly every aspect of his trade, building on his immense natural gifts—he had, for instance, strong, powerful, but also delicate hands and was ambidextrous; he could cut and sew with either hand. The one thing he was deficient in was draftsmanship: he could draw, in a way, and certainly got his ideas down on paper clearly, but as he progressed he employed skilled artists to interpret and embellish his designs.

In 1919 Balenciaga opened his first shop in San Sebastián, on a coast more frequented by high society than it is now—Chanel had been operating at Biarritz since 1915. His first major commission was a bridal gown (as was his last, done in retirement and depression for the duchess of Cádiz in 1972). He was soon in demand at court, in the last phase of the Spanish monarchy before its suspension in 1931, working for Queen Victoria Eúgenie and Queen Mother Maria Cristina. He opened a second house in Madrid and a third in Barcelona, all three called Eisa, after his mother. His Spanish business was run with the help of his sister, his brother, and other relatives, and was from first to last very much a family firm, though on a substantial scale: 250 people worked in the Madrid house alone, and a further 100 in Barcelona. These three houses showed his own clothes; but he also imported clothes from Paris, going there frequently to choose them, from Worth, Molyneux, Chérait, Paquin, and Lanvin. Madame Vionnet, the most beloved of designers, was his

inspiration. When the Spanish Civil War broke out, he had to shut up shop, and it was natural for him to transfer to Paris (the third floor of number 10 on the new Avenue George V) in 1937. When the war ended in 1939, he reopened in Spain and was soon dressing General Franco's wife. But Paris thereafter remained his chief base, though it had to be financed from Spain. Clearly his French profits (if any) probably never matched his Spanish ones.

In Paris, Balenciaga had a partner, Vladzio d'Attainville-Gaborowski, who designed hats, while Nicholas Biscarondo looked after the business side (as well as Balenciaga's sexual needs). Balenciaga presented his first collection in August 1937, charging about 3,500 francs for a dress, and earning 193,200 francs in a month—a good start. For his second collection in January 1938 he secured the duchess of Windsor as a client; and for his third, in August 1938, Saks Fifth Avenue placed a big order. He was launched, and thereafter, until his retirement at the end of the 1960s, his was one of the major Parisian houses and he himself was regarded by the cognoscenti as the top dressmaker. In 1938 King George VI and Queen Elizabeth visited Paris, and the dressmaking industry there celebrated the fact that England had a jolly and delightful but dowdy queen, no threat to their interests, by giving the two princesses, Elizabeth and Margaret Rose, a collection of dolls with a 300-piece wardrobe designed by Paton, Lanvin, Paquin, Vionnet, and Worth, with hats by Agnès, furs by Weil, and jewels by Cartier. The fact that Balenciaga was invited to contribute underlined his membership in the Parisian elite. But he declined, not wishing—then as evermore—to take part in mere publicity stunts, a characteristic assertion of his high seriousness.

Balenciaga soon had to contend with a new war, in September 1939, and shut down his Paris house for a time. When France surrendered to the Nazis and Paris was occupied, the fashion industry was in a dilemma: to carry on or not? To risk being accused of collaborating, or to fire all their employees? In France the fashion industry was regarded as a vital exporter. In 1938–1939, one exported couture dress would pay for ten tons of imported coal, and a liter of exported perfume would pay for two tons of imported gasoline. The Germans were jealous of the

French fashion industry, and both Hitler and Goebbels believed that under the Nazis' "new order" for Europe, Berlin would usurp the role of Paris as the world center of fashion (and of art generally). When the Nazis seized Paris, German agents ransacked the offices of the Chambre Syndicale de la Haute Couture and carried off all its archives to Berlin. The idea was to recruit all the top cutters, sewers, and designers as forced labor and set up dress houses in Berlin. Some people in the industry resisted: Michel de Brunhoff, head of the Paris *Vogue*, shut it down rather than work under Nazi supervision. Some collaborated. Chanel sucked up to the Nazis, lived openly with a young Nazi lover at the Ritz in Paris, and flourished mightily, accumulating vast sums in hard currency so that she was later able to flee to Switzerland when the Allies retook Paris, and gradually buy her way back to respectability by bribery.[5] Lucien Lelong, head of the Chambre Syndicale, steered a middle course. He negotiated with the Nazis; defeated the attempt to transfer Parisian fashion to Berlin; operated a two-city base, with Lyon, in unoccupied France, sharing the leadership with Paris; and by these means saved 97 percent of the industry and 112,000 jobs. The price was to hand over the industry's Jews to the S.S., who deported them to death camps. That done, the industry flourished during the war. Balenciaga did well, thanks to his connections with Hitler's ally Franco. Reopening his house in September 1940, he was one of sixty firms that the Germans allowed to function. He produced ingenious outfits suited to wartime conditions—smart cycling outfits, for instance, consisting of short skirts, worn over tight purple jersey bloomers, with blazers and thick red stockings. His three Spanish shops, all successful and with access to materials unobtainable in France, reinforced the Parisian business, so he was in a strong position when the war ended.

At that point, France was devastated, bitterly divided, and impoverished. All we have left, said André Malraux, "are our brains and our artistic skills"—that is, intellectuals and designers. On 29 October 1945, Jean-Paul Sartre, on behalf of the first group, gave a public lecture in the Salles des Centraux, 8 Rue Jean Goujon, which launched his new philosophy, existentialism. Almost instantly it became world famous. For a time, at least,

Paris became the center of the intellectual avant-garde. The fashion industry took advantage of this recovery in prestige to launch its own program on 10 December 1946 at the "Théâtre de la Mode." It showed 237 figures designed by Jean Cocteau and Christian Bérard, two clever, artistic jacks-of-all-trades closely connected to the dress industry. There was a spectacular display of evening gowns called "Les Robes Blanches," in which established houses like Patou, Ricci, Desses, and Balenciaga joined with ambitious newcomers like Balmain.

All this was a preparation for the first proper postwar collection, in January 1947, when a sensation was caused by an unknown designer, Christian Dior. He produced long, full-skirted dresses, with emphatic hips, narrow waists, and rounded bosoms, using prodigious quantities of precious materials and thumbing his nose at wartime austerity. He himself called this style the "Corolla line," but American fashion editors, coming to Paris in force for the first time since the 1930s, called it the "new look." It electrified rich, fashion-conscious ladies of all nations, and infuriated the radicals as a symbol that the ruling class was back in the saddle. Nancy Mitford, who had recently published her bestseller *The Pursuit of Love*, wrote home from Paris: "Have you heard about the New Look? You pad your hips and squeeze your waist and skirts are to the ankle. It is bliss! People shout *ordures* at you from vans because for some reason it creates class feeling in a way no sables could."[6]

Who was Christian Dior? And what was his relationship with Balenciaga? He was a Norman from Granville, born on 21 January 1905 and thus ten years younger than the Basque. His mother, Marie-Madeleine Juliette, had upper-class pretensions and wanted to move in "good society." Young Dior, plump, pink-cheeked, with a receding chin and popping eyes, had his mother's physique and her longing to move up the social ladder, though his inclinations were toward smart bohemia rather than *le gratin*. His father was a successful businessman who ran a fertilizer factory specializing in liquid manure. This, oddly enough, was also the trade of the father of Kenneth Widmerpool, the fictional antihero of Anthony Powell's roman-fleuve, *A Dance to the Music of Time*, which began to appear in 1951. I asked Powell, who

was almost exactly the same age as Dior, by then world famous, if that is where he got the idea, but he denied it vehemently. The profits of liquid manure allowed Dior *père* to maintain a house in Paris, as well as in Normandy, and young Dior took full advantage of it. He could draw; he loved dressing up, with the help of his adoring mother; and he enjoyed designing fancy frocks for his sisters. He flatly refused to go into his father's business. But his father vetoed the École des Beaux Arts, forcing young Dior to study for a career in diplomacy. In Paris he quickly became a member of the elite artistic set, which included Picasso, Poulenc, Breton, Cocteau, Dérain, Radiguet, Bérard, Aragon, Milhaud, Léger, and the painter Marie Laurencin. The group buzzed around a nightspot called Le Boeuf sur le Toit. Dior never became a diplomat, though he dressed *à l'Anglais* with a bowler hat, tightly furled umbrella, and spats. He designed clothes for his female friends; attended masked balls; was at the opening of the Exposition des Arts-Décoratifs of September 1925, which finally buried art nouveau and launched art deco; and attended Shrovetide parties for homosexuals at the Magic City Music Hall. In 1927 he was conscripted into the Fifth Engineer Corps, where he had to carry railway girders. He met the designer Paul Poiret, who declined to take him on. Instead he became a partner in an art business, the Galérie Jacques Bonjeau, his father putting up the money. The name was his partner's, for Dior's mother would not allow his own to be used: that was "trade." The years 1928–1929, culmination of the boom of the 1920s, were good years for selling contemporary art, and as an art dealer Dior traded in the works of his friends "Bébé" Bérard, Raoul Dufy, Giorgio de Chirico, Joan Miró, and Alberto Giacometti. Then troubles came, and Dior later told me: "I never really got over them." His brother was locked up in an insane asylum. His mother died. In 1931, in the Depression, his father went bankrupt. Virtually all the galleries, including Dior's, failed.[7]

Without this financial disaster, Dior would probably have spent his life as a middle-ranking art dealer, and died unknown. As it was, penniless, he kept up a brave front with an apartment at 10 Rue Royale, and hawked his designs as a freelancer to big-name houses like Nina Ricci, Schiaparelli, Molyneux, and Patou.

Dior was lanky for a Frenchman in the 1930s (5 feet 10 inches). He wore shiny, well-pressed suits and frayed spats. He had success with a design called Café Anglais, a houndstooth dress with petticoat edging, and he was offered a full-time though humble job with Robert Pignet in 1938; but he preferred to design the costumes for a production of *The School for Scandal* in 1939. He effected introductions to important figures at the Parisian end of the American fashion trade, like Marie-Louise Bousquet and Carmel Snow. In September 1939 he was conscripted for "farming duty"; a dim photo shows him wearing clogs and performing some rural job. Demobilized, and in the unoccupied zone, he worked in Cannes, where a rudimentary fashion trade had sprung up, again selling designs. Peace found him back in Paris, hovering on the fringes of the fashion industry.

Then came a unique stroke of fortune that transformed his life. In this book I do not, perhaps, pay enough attention to the role of luck in the creative process, especially to the way it sometimes allows a frustrated would-be creator to fulfill his destiny. Dior certainly believed in luck. He kept lucky charms in his pockets and fingered them constantly. He often visited fortune-tellers. To the end of his life, he regularly consulted an astrologer, Madame Delahaye, who cast his horoscope. A "wise woman" (as he said) had told him during the war, "Women will be very lucky for you. You will earn much money from them and travel widely." As of July 1946, however, Dior was a nobody in his forties, with nothing in his design career to suggest genius. Then, that month, he met Marcel Boussac, a textile magnate who was called "King Cotton." Boussac wanted to own a big Paris fashion house to give prestige to his booming but humdrum business; and he had a crumbling house called Philippe et Gaston. Someone told him that Dior might be able to produce ideas—hence their meeting. Dior told him: "I am not interested in managing a clothing factory. What you need, and I would like to run, is a craftsman's workshop, in which we would recruit the very best people in the trade, to reestablish in Paris a salon for the greatest luxury and the highest standards of workmanship. It will cost a great deal of money and entail much risk." This was, looking back on it, an amazing speech to make to a hard-nosed businessman, for Dior

was extraordinarily shy, and his plump pink cheeks gave him a babyish look that put many people off, as did his protruding Bing Crosby ears. But Boussac liked the idea and offered to set Dior up immediately with an investment of 10 million francs (this was later increased to 100 million). At the last minute Dior, frightened, almost turned down the offer, but he was persuaded into it by his fortune-teller.

Dior doubled the risk of opening a new house with his revolutionary "new look" (12 February 1947), a deliberate and defiant return to the most extravagant use of material since the grand old days of Worth before World War I. He spat in the face of postwar egalitarian democracy and said, in so many words, "I want to make the rich feel rich again." His first collection, which purposefully sought to put the clock back and defy the conventional wisdom of the time—that luxury and privilege had gone for good—turned out to be, to the delight of Boussac, the most successful in fashion history. People who looked carefully at Dior garments were amazed that such brilliant craftsmanship and superlative materials were still to be had: Dior's new shapes and gambits were merely, as it were, the artistic icing on a cake made with solid skill, with no expense spared and endless trouble taken. Dior recruited and continued to employ in his atelier the best people to be found in France, men and women who would die rather than turn out an article which was, in the tiniest degree, below the best in the world. The sewing was perfect, the cutting impeccable, the fitting infinitely patient and exact. The success of the house was immediate and prolonged, and the volume of business continued to grow steadily in the ten years up to Dior's death in 1957, by which time the house employed 1,000 of the finest experts ever gathered together under one roof. During this decade Dior sold over 100,000 dresses made from 16,000 design sketches and using 1,000 miles of fabric.[8]

How did Dior's sudden, enormous, continuing success strike Balenciaga? We do not know. As Dior realized, and often remarked, there is a great deal of unpredictable chance in fashion. He thought himself spectacularly fortunate with his success in 1947. It has to be understood that couturiers never present just one line. They produce a variety of styles in each collection, and though for publicity purposes they stress a particular favorite, they know that in

the end the magazine writers, the big buyers, and, above all, the individual customers will decide which is dominant. That certainly happened in February 1947. Just as, the year before, the media and elite intellectual society had saddled Sartre with "existentialism," a word he himself had never hitherto used—and always disliked, or so he told me. So it was with Dior's first collection—the "Corolla line" was singled out from a number of lines he presented and re-baptized by journalists (chiefly Carmel Snow) the "new look." As it happened, long, full skirts with padded hips—the essence of the new look—had been made by Molyneux just before the war, and by Balenciaga himself just after it. As Dior acknowledged, what told was the fact that his house was new and was funded by Boussac (who was seen as a significant and rather alarming figure at the time). But another factor, undoubtedly to his credit, was the unabashed joy with which he presented this return to luxury, the panache of his *épater les travailleurs*, and the fun of his well-rehearsed presentation. Once he could get away from his own shyness, Dior could be a mesmerizing symbol of good times ahead. That is what everyone, not least rich women, needed after seven years of austerity and horror.

Balenciaga, so far as I know, never said a word about the "new look," or Dior's triumph. He never commented on other designers. He certainly approved of the high standards of workmanship which Dior insisted on, and which matched his own. That, in Balenciaga's view, was what haute couture was all about. He did say, once, that he envied Dior's skill as an artist. Dior was stunningly quick with pen and brush—"I often do several hundred drawings in two or three days," he said—and some of the results were striking. By contrast, Balenciaga had to rely on the draftsmanship of his assistant Fernando Martinez. But draftsmanship must have been the only skill of Dior's that he wished he possessed. In every other way he was immeasurably superior. On the question of quality, indeed, Balenciaga sometimes felt that Dior was unrealistic, going too far, precisely because he could not (like Balenciaga) sew, cut, and make a dress himself and was not fully aware of the sheer effort involved in superlative sewing. A curious episode, related to me at the time, illustrates this. Balenciaga hardly ever dined out, except with one or two old friends. One

evening he was the guest of Madame Hérnon and her husband. She was one of his customers, though she also patronized Dior, and on this occasion she wore a Dior dress that buttoned down the back—or should have. Her maid was on vacation; she herself could not button the dress alone; and her husband, summoned to help, flatly refused: "I won't get involved in that absurd garment—get your friend Monsieur Cristóbal to do it when he comes." So that is what happened. The dress had no fewer than thirty-six tiny buttons at the back, each covered with brilliant Lyon silk. Balenciaga, with his wonderful fingers, succeeded in doing it up, but with some difficulty. Somewhat exasperated, he said, "Twenty-four buttons would have been quite enough to preserve the fit of the dress perfectly. But thirty-six! He is a madman! *C'est de la folie furieuse!*" There followed other remarks in demotic Basque, the purport of which Madame Hérnon could only surmise.

Balenciaga may have felt that Dior did not take the craft seriously enough. By his reckoning, Dior, who could not actually make a dress, was not a couturier, merely a designer. (That was true of virtually all the others, then and since. Chanel claimed that she could sew beautifully. But then she had no respect for truth.) Balenciaga possibly thought that Dior got too much sheer pleasure out of high fashion, which in his own view was an art on a par with painting, sculpture, and architecture, to be taken with the utmost seriousness. It was not something in which you could *faire le ponchinelle*, "do a Picasso" (in those days Picasso often called himself the "clown of art"). But Balenciaga certainly did not regret the success of the new look. He was a businessman, and a very astute one, and he recognized that it had done wonders for the Parisian fashion industry and that everyone involved in it, himself perhaps most of all, had benefited from the publicity. He certainly did not see Dior as a rival, and he had no fear that his own claims to excellence would be overlooked. Dior dressed the rich, Balenciaga the very rich. During the 1950s, a woman "graduated" from Dior to Balenciaga. And equally, Dior was never jealous of Balenciaga's superior skills. He recognized them and revered the man who possessed them. He always called Balenciaga *maître*. In December 1948, Balenciaga's partner, Vladzio, died at age forty-nine. The master

was so upset that he seriously considered retiring and returning to Spain. The word got around, and Dior went to see him on Avenue George V and begged him to stay: "We need your example in all that is best in our trade." Dior suggested, instead, that Balenciaga should buy Mainbocher's old premises next door, which were up for sale, and expand. Balenciaga, touched, did exactly as Dior recommended.

Balenciaga's best days were in the 1950s, before the "cultural revolution" of the 1960s. He regarded making dresses as a vocation, like the priesthood, and an act of worship. He felt that he served God by suitably adorning the female form, which God had made beautiful. His approach was reverential, indeed sacerdotal. His premises reflected his own vocational tone. In those days, haute couture shops varied in atmosphere greatly. Molyneux tried to make his like an aristocratic London town house. You rang a bell and an English butler answered the door and ushered you in. Dior's premises were grand but busy, with much *va-et-vient*, like a big salon on one of the hostess's "days." Dior himself, affable and gregarious, could be seen roaming about, wearing a white overall over his well-cut Savile Row suit. *Bonjour, patron!* sang out his women workers, always pleased to see him. By contrast, Maison Balenciaga was like a church, indeed a monastery. Marie-Louise Bousquet said, "It was like entering a convent of nuns drawn from the aristocracy." Courrèges, who worked there, described the atmosphere as "monastic in both an architectural and a spiritual sense." Emanuel Ungaro remembered: "Nobody spoke." If it was absolutely necessary to speak, the voice had to be hushed or reduced to a whisper. Security was intense. It was difficult not just to get in at all but to move from one room to another, for all entrances were guarded by fierce females. There was a porter in blue, but the real keeper of the gate was a dragon called Véra. Indeed, it was a place of women—like a convent vowed to silence (as is usual in Spain)— but any women who were not models or seamstresses were dragons. Madame Renée was the head dragon, who ensured that patrons came only by appointment. Her saying was: *Les dames curieuses ne sont pas bienvenue ici.* Unwelcome—that was putting it mildly. The only *dame curieuse* who ever got past Véra and Renée was Greta Garbo. (She was dressed by the despised Hollywood

couturier Adrien.) The impression should not be given that the place was drab. In fact the decorations in the window done by Janine Janet were the best in Paris, though they had nothing to do with women's fashions, featuring birch sculptures of fauns, unicorns, and similar figures. Inside were tiled floors, Spanish-style; oriental rugs; damascene curtains; ironwork fittings; and a great deal of red Cordoba leather, varied with brown, black, and white leather in the showrooms. The elevator was lined with leather, too, and contained a sedan chair. Balenciaga did a limited trade in scarves, gloves, and stockings; but he sold only two (very expensive) perfumes: Le Dix and La Fuite des Heures. He gave the impression that he thought such things vulgar and irrelevant to his main work, and permitted them reluctantly, since they were highly profitable. He never did anything to court popularity. He never gave interviews (except once, to the London *Times*, when he had decided to retire). He never went out in society. There are virtually no photographs of him and none at work, though we know he wore black trousers and sweater and used a curious curved table on which to sew or cut material, with rulers and a square as aids. All the rooms in his atelier, as noted above, were closely guarded, and his own room was totally inaccessible except to the most senior staff. At one time it was widely believed he did not actually exist and that Balenciaga was a pseudonym.

His remoteness was not a pose but part of his dedication to his art. He worked fanatically hard when he was actually in Paris. Each collection had between 200 and 250 designs, all of which he completed himself, since he had few trusted assistants and often turned down promising juniors, such as the seventeen-year-old Hubert de Givenchy. He had the manners of an old-fashioned cardinal under Pius XII. He was sometimes angry, but his anger expressed itself in irritable foot movements, never in violence of any kind. He never raised his voice. Indeed silence was his norm. Ungaro said: "There was something noble about him." When he was satisfied with his designs, and the clothes were made up, each outfit had four fittings: one for materials, and three for shape, using models. In just one day he could get through fitting sessions for 180 outfits by dint of intense concentration and by working with a team who knew exactly what his gestures signi-

fied, for few words were spoken. It was said that he disliked women, but there was no evidence that he disliked them more than men. He saw them as racehorses: "We must dress only thoroughbreds." He used to quote Salvador Dalí: "A truly distinguished woman often has a disagreeable air."

Yet he was a woman's designer, through and through. His fundamental principle as a dressmaker was to make women happy. "He liked to make a duchess of sixty look forty, and the wife of a millionaire tradesman look like a duchess." His clothes were, above all, comfortable to wear, an amazing fact—and it was a fact—considering their grandeur, their complexity, and the magnificence of their materials. His designs accommodated a well-rounded stomach, a short neck, and overly plump arms and shoulders, and left space for ropes of pearls and for bracelets. Comfort was achieved by great ingenuity of design and attention to what the duke of Windsor called the "underpinnings." (But of course Balenciaga never used pins or extraneous stiffening of any kind.) Balenciaga argued that if a woman was comfortable in her clothes, she was confident; and if she was confident, she was at her best and wore her clothes with style. He said that some designers put a strain on the client so that she was glad to get the dress off at the end of an evening. He wanted his clients to be reluctant to part with their clothes, which had become an integral part of the body, a second skin.

His second principle was permanence. While Dior made changes twice a year, Balenciaga was always fundamentally the same, especially in his splendid evening dresses, which were his specialty. A woman could buy one of them as an investment because properly looked after, it would last forever. In 2003, I saw a young woman of eighteen wearing a superb dress. "Is that not a Balenciaga?" "Yes. It belonged to my grandmother." He wanted his dresses to be bequeathed, as they were in imperial Spain. In a sense he was antifashion. He was impressed by the way dresses, hats, and even accessories in certain old masters remained elegant after hundreds of years, and he constantly got ideas from them. From Velázquez's *Queen Marianna of Austria* (in the Louvre) he stole the idea of a stiff bodice sliding out of the skirt. Another Louvre picture, *La Solana*, gave him the inspiration for an entire

outfit: black dress, white lace mantilla, masses of dark hair with a huge pink satin rose planted in or on it. His favorite source was Zurbarán's saints. He used the *Santa Ursula* in Strasbourg, the *Santa Casilda* in the Prado, and especially the enchanting *Santa Maria* (there are versions in Seville and in the National Gallery in London), seen by the painter as a rich bourgeoise, wearing her hat and dress with flair and carrying an enchanting straw shopping bag. That bag became, and remains, a classic. He borrowed the full-length pinkish satin twice from Manet's *Femme au Perroquet* at the Metropolitan Museum in New York, and he was not above raiding paintings by more vulgar artists, such as Monet's *Les femmes au Jardin* at the Musée d'Orsay. But he was never a plagiarist: he transformed touches of the old masters into contemporary clothes, and women often did not "get" the reference until it was pointed out to them. One leading customer, who not only bought a dress but faithfully followed Balenciaga's strict advice on how to wear it (or "present it," as he said), was surprised to be told by a society magazine that she looked like Goya's *Narcissa Baranana* at the Metropolitan Museum. I recall some critics in the 1950s who argued that Balenciaga, a "great artist," was "above" his clients. They included Hollywood figures like Ginger Rogers, Carole Lombard, Marlene Dietrich, Mrs. Ray Milland, and Mrs. Alfred Hitchcock, as well as the superrich like Doris Duke, Margaret Biddle, Marella Agnelli, Mrs. Paul Mellon, Barbara Hutton, and Mrs. Harvey Firestone, as well as (of course) the duchess of Windsor and paragons of *le gratin*. But it was Balenciaga's view that his clothes, properly put on (and it was rare for a customer not to follow his rules), raised the wearer into a classless, ageless empyrean, a superculture where a woman's body, even if old and defective in places, entered into what he called a "mystic marriage" with his clothes. For this reason he did not, like some designers, expect a client to suppress her personality; he expected her to emphasize it—he rejoiced when a woman "added to" his work. Strict and implacable in many ways, he had a certain creative modesty which allowed him to see that his dresses only became alive when worn, and that the wearer was needed to complete the creative act.

Balenciaga's third principle was the central importance of

material in his designs. Textile and lace manufacturers, embroiderers, and specialists in gauze and dyes lined up for appointments to see him and often collaborated with him to produce completely new, complex materials. He could dye himself, and often did. His skill at embroidery enabled him to pick out the occasional genius. He dealt with large firms and tiny Lyon or Como workshops alike, and to him a first-class textile creator was an equal. Gustave Zumsteg created for him in 1958 "Gazar" and in 1964 "Zagar," a refinement, which miraculously combined fine texture, thickness, and stiffening so that Balenciaga could sculpture dresses made of it without artificial support. Lida and Zika Ascher from Prague made for him special materials, notably a mohair and chenille, ravishing and of incomparable luxury. But Balenciaga never allowed his sensuality to ignore practicalities. When Zika Ascher showed him a new blend of mohair and nylon thread, thick and spongy, Balenciaga admired it but asked, "Will it take a buttonhole?" "Oh, yes!" "We shall see." He took the sample away into his sanctum and returned a few moments later, with a superbly sewn buttonhole—one of the most difficult tasks a seamstress faces, especially with intractable material. Gérard Pipart, inspecting it, exclaimed, "A buttonhole by Balenciaga! It should be framed." The master gave his wan Spanish smile. He often sewed to keep his hand in, and for every collection he designed, cut out, sewed, and finished, entirely himself, a "little black dress," usually of silk, sold like the others but never identified as his.

Balenciaga used a variety of lace: chantilly, guipine, the heavy chenilles, and the so-called blond. Occasionally he reinforced the thread with horsehair. He patronized the best embroiderers in the world. In 1966 Lizbeth, head of her profession, made for him a pair of bolero pants with flowers of pearl and mother-of-pearl. The garment to which it belonged might last a millennium, if worn "with discretion" (a key couturier's phrase). He discovered and often used an artist called Judith Barbier to create with him a fishnet cloak of knotted white velvet, using parachute silk to make pink-and-white flowers for the entire outfit. The finest of his creations were essentially cooperative efforts using textile creators and specialists like Barbier to bring to life his conceptions.

Happily, many of these marvelous dresses are preserved (some were shown at a retrospective mounted in Lyon in 1985), so we can still see what marvels Balenciaga could create, with thick faille ribbed with velvet, lacquered satin sewn with tiny gemstones, organza sewn with Barbier flowers, Ottoman silk with gold embroidery, ostrich feathers on figured tulle, or a gold lamé sari he made for Elizabeth Taylor. Using such sensational materials Balenciaga also did many daring things, such as bunching a skirt or yoking sleeves so as to dominate both the front and the back of the garment.

The essence of his creations was the work of human hands, bringing into existence the images projected on paper from his powerful and inventive brain. The archives of his firm survive intact, and they reveal the extent to which everything was done by hand: the exact sums paid by his celebrated clients; dates for fittings and deliveries, all entered in fine pen-and-ink; materials supplied in detail, and prices paid; and countless pieces of paper showing the process whereby each garment was created, in ink and pencil and crayon, with pieces of the material used pinned on by the master sketcher—a lost world of agile, tireless fingers, before the computer or even the typewriter took over.

That world was disappearing even in Balenciaga's lifetime. The death of Dior in 1957 was the final fatal blow. Dior was a man who loved rich food, he had fought a constant but losing battle against surplus flesh, and his heart inevitably failed. His funeral was a historic gathering of high fashion: only Chanel, who had returned from her exile in Switzerland and brazenly reopened her shop four years before, failed to pay tribute. On prie-deux, in front of the congregation, knelt two striking figures, symbols of a passing era: Jean Cocteau and the duchess of Windsor.

After Dior's death, Balenciaga seemed an increasingly lonely figure, working backward rather than forward. He was rich, with houses and apartments in Paris, at La Reynerie near Orléans, in Madrid, in Barcelona, and in Iguelda in his own Basque country. This last house was as near as he ever came to making a home. He designed beautiful dresses for the maidservants, sometimes sewing them himself. The centerpiece of the house was a vast

antique wall table with his mother's old Singer sewing machine in solitary state, beneath a vast and fearsomely realistic crucifix. His apartment in Avenue Marceau displayed his halfhearted collections: Spanish keys in gilded bronze, ivory cups and balls. There were eighteenth-century chairs in satin upholstery, dyed a certain dark green by the master himself. Balenciaga was seventy in 1965, and he found the 1960s increasingly unsympathetic as horrors of taste and behavior were unveiled. In the 1950s he had been generally regarded as the greatest dressmaker in the world. But he worked in fashion; he was fashion; and it is of the nature of fashion to turn every one of its heroes, sooner or later, into a museum piece. In the 1960s he was increasingly criticized. His dresses were said to be so overwhelming that they "dwarfed the woman." He was "not for the young." He refused to go into the pret-à-porter trade—"I will not prostitute my talent." He hated miniskirts. He felt that "youth has no time for grand couture and the craftsmanship on which it rests." He never commented, but he looked down his nose at designers like Yves St. Laurent, taking over at Dior, who was "trendy" (a new Anglo-Saxon expression that Balenciaga found abhorrent). In 1966, to defy the trend, he lengthened skirts, but the big New York buyers would not take his wares. In 1967 he appeared to capitulate by making short tutu dresses and trouser suits, and did good business. But in 1968 he was uncompromising again and sold nothing wholesale. His individual clientele flourished as ever, but he was himself an increasingly disillusioned and melancholy figure. The *événements* of 1968—the student revolt hailed everywhere as a new dawn—he saw as a display of savagery and an assault on civilization, a view which he shared with the perceptive philosopher Raymond Aron and which proved to be right. Balenciaga continued designing for a time, and it is significant that his dresses of the late 1960s—against the trend; "cut against the bias," as he put it—are now the ones most admired, collected, and copied. But his heart was no longer in the game, and he found that the new tax rules and labor regulations made it increasingly disagreeable to run his business. Abruptly, like de Gaulle, he retired, shut down his Paris house completely (there was no possible successor), and returned to Spain. He died in 1972, sad and lonely, a great artist

broken by the years, one of the many casualties of the lunacy of the 1960s—along with institutions such as the Society of Jesus, the old-style university of scholars and gentlemen, the traditional rules of sexual decorum, artistic reticence, and much else.

High fashion, begun by Worth, essentially ended with Balenciaga's retirement, and with it went a tradition not only of civilized, and occasionally inspired, design, but of craftsmanship of the highest possible standards. The fashion industry continues, polycentric and multicultural, and on an enormous scale as the world becomes wealthier and travel easier. But it is most improbable that the kind of dresses Balenciaga created in the 1950s and 1960s will ever be made again. They are, indeed, museum pieces to inspire women or, among the fortunate descendants of his clients, heirlooms to be treasured and, on grand occasions, flaunted.

14

Picasso and Walt Disney: Room for Nature in a Modern World?

\mathcal{T}HE TWENTIETH CENTURY saw a transformation of our visual experiences comparable to the blossoming of the Renaissance in the fifteenth century. We saw many more things and saw them differently, both because they were different and because events and artists accustomed us to look with different eyes. Whether this process was benign or malevolent, creative or destructive—or a mixture of both—only the long evolving judgment of history will determine. It was certainly both exciting and disturbing. Much of the altered vision was due to technological change, especially the coming of cinema, television, videos, and digital cameras, and the rapidity with which all were made accessible to humanity everywhere. But these visual revolutions were compounded by artists who destroyed the tradition of naturalism, which had hitherto dominated the visual arts, and replaced it—as the prime source of beauty—with the expression of what was going on in their own minds. The interplay between the new technologies and the new individualism created a third element of visual change. In the twentieth century, then, new experiences for our eyes were the product both of relentless impersonal forces frog-marching humanity forward and of powerful creative individuals striving to wrest control of change in order to realize their personal ways of seeing things. Among this last group none were more successful than Pablo Picasso (1881–1973) and Walt Disney (1901–1966).

A comparison of the two is instructive. Picasso was born two

decades before Disney and outlived him by a few years, but both
were essentially men of the twentieth century, outstanding cre-
ative individuals first and foremost but also representative fig-
ures. Each embraced novelty with shattering enthusiasm. But
there were essential differences. Picasso came from Andalusia, on
the periphery of the culture of old Europe, and he progressed
first to Barcelona, Spain's cultural capital, and then to Paris, for
over 200 years the capital of the arts of Europe. Paris gave his
ideas the resonance and the critical and commercial success that
enabled him to carry through his revolution in art. No other cen-
ter could have done this. And it should be added that Picasso's
successful charge against representative art was the last absolute
victory Paris enjoyed in leading cultural fashion. If Picasso creat-
ed shocking novelties, he did so in a traditional old-world
manner—in an artist's studio and in the familiar capital of art.
Disney, on the other hand, was of the New World—a midwestern-
er from an agricultural background, who eagerly embraced both
America's entrepreneurial effervescence and the new technolo-
gies leaping ahead of popular taste. He went from the open
spaces to Hollywood, not so much a place as a concept. When he
was born, it did not yet exist. During his lifetime it became the
global capital of the popular arts, thanks in part to his creativity.
He made use of the new technologies throughout his creative
life, just as Picasso exploited the old artistic disciplines of paint,
pencil, modeling, and printing to produce the new. Paris and
Hollywood: no two places could be more unlike; yet no two are so
similar in the mixture of eagerness and cynicism with which they
nurtured creativity, both vulgar and sublime. It is also notable
that both men played roles in the tremendous and horrific ideo-
logical battles which characterized the twentieth century, at
opposite poles of the axis of ideas. And the influence of both
continues, in the twenty-first century, powerfully and persistent-
ly, raising a question: which has been, and is, more potent?

Picasso was born in Málaga on the Mediterranean coast of
Andalusia, where his father was an art teacher and artist, special-
izing in birds but fascinated by bullfighting. The family moved
first to La Coruña, in the northeast, then to Barcelona, capital of
the most economically advanced and culturally enterprising

province of Spain, Catalonia. His father continued to teach him until he was fourteen, and then he put in some time at La Lonja, Barcelona's excellent fine arts school, before setting up on his own as a teenage artist.[1] He was essentially self-taught, self-directed, self-promoted, emotionally educated in the teeming brothels of the city, a small but powerfully built monster of assured egoism. He lacked the benefit—though also the inhibitions—of full academic training, and if his drawing is sometimes weak in consequence (one of the myths most consistently spread about Picasso is that he was a superb draftsman), he was exceptionally skillful, from an early age, at exploiting his many and ingenious artistic ideas. He always kept a sharp eye on the market and always knew what would sell. He disposed of drawings from the age of nine on; and though his output became and remained prodigious throughout his long life, he never had any difficulty in marketing.[2]

Picasso seems to have grasped, quite early on, that he would not get to the top in the field of conventional painting from nature. In Barcelona the competition was severe. In particular, he was up against perhaps the greatest of modern Spanish painters, Ramon Casas i Carbo, fifteen years his senior and far more accomplished in traditional skills.[3] Taught in Carolus-Duran's atelier, Casas oscillated between Barcelona and Paris, sharing for a time the famous studio above the dance hall of the Moulin de la Galette. In 1890, following in the footsteps of Renoir and Toulouse-Lautrec but excelling both, he painted a superb, sombre picture of this hall. His most important pictures were striking pieces of social realism, such as *The Garroting* and a painting of a street riot, *The Charge*. At one time the young Picasso thought of entering this field, but Casas had preempted it. Casas was also a draftsman on the level of Ingres, and a portraitist of uncommon ability. He not only befriended Picasso but produced, in 1901, the most beautiful and accurate drawing of him.[4] Casas's superb full-length charcoal portraits of people in Barcelona inspired Picasso, at age eighteen, to do a similar series, which he exhibited in his first one-man show at the place where "advanced" artists, known as *modernistas*, gathered: El Quatro Gats. There were 135 other drawings and paintings in the show.

But it was not a success.[5] Indeed it was a foolish move, one of the few in Picasso's career, for his portraits invited comparison with Casas's and are manifestly inferior (both can be seen in Barcelona). Picasso had already been in Paris, and in 1900 he challenged Casas again by painting his own version of *The Moulin de la Galette*, a spectacular piece of updated Renoir but again inferior to Casas's restrained study in light and gloom. It was, however, calculated to make a splash.[6] Picasso visited Paris twice more and found that he had no difficulty in staging shows there or in selling his work. In 1904 he effectively left Spain for good, partly to escape conscription, but chiefly to get away from life under Casas's shadow, and from endless disparaging comparisons with Casas. Picasso also saw that Paris, with its preoccupation with novelty and fashion, was the place where he could shine and rise to the top.

Picasso was perhaps the most restless, experimental, and productive artist who ever lived. But everything had to be done at top speed. He was incapable of lavishing care, time, or sustained effort on a work of art. By 1900 he was turning out a painting every morning, and doing other things in the afternoon. He tried sculpture, facial masks, and symbolism, among other forms of expression, and from then until his death, at age ninety-two, he remained a master of spectacular output, working on paper and canvas; in stone, ceramics, and metal; in every possible variety of mixed media. He also designed posters, advertisements, theater sets and costumes, dresses, logos, and almost every kind of object from ashtrays to headdresses. The number of his creations exceeds 30,000, and although there is a thirty-three-volume *catalogue raisonné* (1932–1978), it is far from complete and has to be supplemented by ten other catalogs. The literature on Picasso is enormous and continually growing.[7] It includes an ongoing, detailed multivolume biography by John Richardson, comprehensive and essential though hagiographic, and hundreds of specialist studies covering every aspect of his activities, as well as a few critical efforts, such as A. S. Huffington's *Picasso: Creator and Destroyer*.[8] In the twentieth century, more words, often contradictory, were written about Picasso than about any other artist. Picasso was a millionaire by 1914 and a multimillionaire by the

end of World War I; and his wealth continued to grow, so that by the time of his death he was by far the richest artist who had ever lived. He made a deal with the French government over inheritance taxes, and as a result, in 1985 the Musée Picasso opened in Paris. There, his work of all periods can be studied, supplemented by the Musée Picasso in Barcelona, which specializes in his earlier portraits and his drawings.[9]

Picasso's work can be divided into eight chronological periods. First was his early work up to the end of 1901. Then came the "blue period," with a predominantly blue palette, figurative in style and focusing on stage characters, prostitutes, outcasts, prisoners, and beggars. This lasted until 1904 (autumn) and also included sculpture and etching.[10] Then came the "rose period," with much use of pink and flesh tints, again with figures (chiefly clowns) but dislocated from surrounding objects and space. In 1906 Picasso changed again: he was experimenting with primitive shapes and figures and moving away from representative art.[11] By 1907 he was able to produce *Les Demoiselles d'Avignon*, perhaps the most important and influential of all his works, in which he disengaged from nature and representation and adopted linear analysis.[12] This led directly to his fourth phase, cubism, in 1907–1908. He and Braque used the late work of Cézanne to dismantle objects and reassemble them in blocks and lines. The object was, or was said to be, to achieve greater solidity and thus greater realism than mere representation. Cubism in this original, so-called "analytical" phase was the most sensational of Picasso's revolutions, since it broke the umbilical cord that linked art to the world of nature and the human body.[13] This raises a logical problem about Picasso. If cubism was his greatest invention, since it sounded the death knell of representation in art (or so the majority of art historians claim), why do collectors, museums, and the art market place a much higher value on works from his earlier periods, especially the blue period, when he was still a representational artist? In 1912, Picasso reinvented an old trick of sticking bits of paper onto his canvases (especially bits of newspaper, to introduce an element of literary-political comment), and building on it by inserting solid objects, such as bits of guitars, wire, and metal. This work, known as synthetic

cubism, was a further step in his fourth phase. It lasted until World War I, and it raises another logical problem. If cubism was a way of introducing a new degree of solidity and realism into the depiction of objects on a flat surface, surely the introduction of solid (three-dimensional) objects into the work of art defeated the whole purpose of the cubist method?[14] This problem, like the earlier one, has never been satisfactorily answered by writers on Picasso. Indeed such writers refuse to recognize that they are problems, denouncing people who pose them as Philistines.

After synthetic cubism, Picasso spent the war years and post-war years working in theater, designing costumes and sets and painting backdrops. But he also, in the 1920s, entered and left a fifth phase, classicism, using images from antiquity. In 1925–1935 he was in a sixth phase, surrealism, though he was never a surrealist as such. During the Spanish Civil War he took up political subjects, his seventh phase. At the request of the embattled Republican government, he painted a large canvas, *Guernica*, for the Spanish pavilion at the Paris World Fair of 1937.[15] This joined *Les Demoiselles* as his best-known picture. His later years constitute the eighth phase. His works now featured particular models; minotaurs; variations on the old masters, such as Velázquez and Goya; bullfights; and crucifixions. All these themes overlapped and are difficult to distinguish. And each phase of Picasso's two-dimensional work overlapped with sculpture, pottery, and constructions, as well as exercises in lithography, prints and etchings, book illustration, and costume design—and more work in theater. Even among his admirers there seems to be some agreement that his work deteriorated from the 1940s on, but this, like every other aspect of his professional career, is a matter of sharply differing opinions.

The extraordinary success Picasso enjoyed from quite early in his career and then in growing measure until his death is explained by a number of factors. He took a long time even to become literate and was middle-aged before he could communicate in French. Very few of his letters survive, for the simple reason that to him writing a letter was more difficult, and took more time and effort, than doing a painting. Matisse wrote him many letters, which we have, but got only one in return, in which his name was misspelled ("Mattisse"). But if Picasso's brain was

not academic, it was nonetheless powerful, reinforcing his ability to think visually with sharp clarity and cunning. He was essentially a fashion designer (like two other Spaniards imported to Paris, Fortuny and Balenciaga), at his best working on costumes and drop curtains, designing logos and symbols, creating arresting images of women tortured out of shape into distortions that etch themselves into the mind like acid. In the first decade of the twentieth century, French painting finally moved from art to fashion, and, in a world tired of figurative skill, Picasso was a man whose time had come. He replaced fine art—that is, paintings composed 10 percent of novelty and 90 percent of skill—with fashion art: images where the proportions were reversed.[16]

This was the new game in art. There was intense competition, but Picasso became the champion player, and held the title till his death, because he was extraordinarily judicious in getting the proportions of skill and fashion exactly right at any one time. He also had brilliant timing in guessing when the moment had arrived for pushing on to a new fashion. Although his own appetite for novelty was insatiable, he was uncannily adept at deciding exactly how much the vanguard of the art world would take. This cunning was closely linked to an overwhelming personality and a peculiar sense of moral values. His ability to over-awe and exploit both men and women—some of them highly intelligent and uneasily aware of what he was doing to them—was by far the most remarkable thing about him. His sexual appeal, when young, was mesmeric, both to women and to homosexuals. He later claimed to have first slept with a woman when he was ten, and he attracted women long before his fame and money became their object. His appeal to homosexuals, especially those who enjoyed the passive role, was even stronger; he seemed a small, fierce, thrusting tiger of virility. Picasso himself was overwhelmingly heterosexual by inclination. But in the culture from which he sprang there was no disgrace to his manhood in taking the active role to satisfy a needy "queen," to use his expression. It was homosexuals who adored him—the dealer Pere Manyac; the publicist Max Jacob; and Jean Cocteau, the Andy Warhol of his day, who first made Picasso famous and reinforced his success.[17] His most passionate admirers have always

been homosexuals, such as the Australian collector and publicist Douglas Cooper, and Cooper's lover John Richardson, who became Picasso's biographer. Curiously enough, one homosexual who was not taken in by Picasso's personality and who even pushed him around was Diaghilev. Diaghilev used to call Picasso by the contemptuous diminutive "Pica." But most homosexuals in the art world did, and do, regard Picasso as almost beyond criticism—an opinion which, granted their power in that narrow enclave, was decisive. Picasso's own attitude toward men was ambivalent, and he was shrewd at detecting passivity. He referred to Braque, with whom he created cubism, as "my wife" (a term of contempt) and said: "[He] is the woman who has loved me the most." Picasso also appealed, aesthetically, to lesbians, and it is significant that he called the masculine Gertrude Stein "my only woman friend."[18]

In this game of exploitation Picasso benefited from a sort of moral blindness. He had gifts that the vast majority of human beings would give anything to possess. But apparently innately, he lacked two things that ordinary people take for granted: the ability to distinguish between truth and falsehood, and the ability to distinguish between right and wrong. This lack was one source of his power. At the center of his universe there was room only for Picasso—his needs, interests, and ambitions. Nobody else had to be considered. He began by exploiting his penurious father. He soon developed an imperious eye for wealthy women. Once he acquired a reputation, he proved a harder businessman than any of his dealers, whom he hired or fired on a strictly commercial basis. He boasted: "I do not give. I take." To his harsh mind, kindness, generosity, and consideration for feelings were all weaknesses, to be taken advantage of by master figures like himself. Those who helped him, such as Stein and Guillaume Apollinaire, and countless others, were dropped, betrayed, or lashed by his venomous tongue. His ingratitude was compounded by jealousy, especially of other painters, which may have sprung from insecurity about the merits of his own work and a feeling it was all a con. It is curious that he always subscribed to a press-cutting agency and could be litigious with critics, especially those who quoted his periodic admission, "I am nothing but a

clown." He grew to hate Braque and put anyone who befriended Braque on his enemies list. He said odious things about Matisse, who thought him a friend. ("What is a Matisse? A balcony with a big red flower-pot falling over it.")[19] He was particularly vicious toward his fellow Spaniard, the modest and likable Juan Gris, persuading patrons to drop him, intriguing to prevent him from getting commissions, and then, when Gris died at age forty, pretending to be grief-stricken.[20] By the end of World War I, in which Picasso evaded conscription while many of his contemporaries were killed or maimed, he was a major power in the Parisian art world, since he carefully controlled the release of his paintings and dealers groveled to do his bidding. He could effectively stop any painter he disliked, below the top rank, from getting a show: that is what happened to one of his mistresses, Françoise Gilot, when she left him.[21]

Gilot was one of the few who dared to tell the truth about Picasso while he was still alive, despite the tribe of lawyers he employed to get her book suppressed. Picasso's attitude toward women was terrifying. He needed and of course used them for his work and pleasure, but one does not need to look long at his enormous iconography of women to realize that he despised, hated, and even feared them. He said that, for him, women were divided into "goddesses and doormats," and that his object was to turn the goddess into the doormat. One of his long-term mistresses said of him: "He first raped the woman, . . . then he worked. Whether it was me, or someone else, it was always like that." He was predatory and intensely possessive. He discarded women at will, but for a woman to desert him was treason. He told one mistress: "Nobody leaves a man like me." He would steal a friend's wife, then tell the man that he was honoring him by sleeping with her. He told Gilot: "I would rather see a woman die than see her happy with someone else." Was he a schizophrenic, as Jung, on the basis of his paintings, believed? At times he appeared a monomaniac. He told Giacometti: "I have reached a point when I don't want any criticism from anyone." He was overheard saying to himself, over and over: "I am God, I am God." A pagan who regarded himself as an artistic deity, he believed he had an unfettered right to inflict injustice on those

around him—family, friends, admirers. As he put it, "being unfair is god-like."[22]

His distorted paintings of women are closely linked to the pleasure he got from hurting them, both physically and in other ways. He abused them not only in rage but on purpose. Dora Maar, probably his most beautiful and gifted mistress, was beaten and left unconscious on the floor. Another mistress said: "You got hit on the head." His favorite, almost his only, reading was de Sade. Marie-Thérèse Walter, whom he seduced when she was seventeen, was persuaded by him to read Sade, and later initiated into Sade's practices. Picasso loved to rule over a seraglio but avoided the risk of harem conspiracies by setting one woman against another. His delight was to see his victims turning their rage on each other instead of on himself. He would create situations in which one mistress angrily confronted another in his presence, and then both rolled on the floor, biting and scratching. On one occasion Dora Maar and Marie-Thérèse Walter pounded each other with their fists while Picasso, having set up the fight, calmly went on painting. The canvas he was working on was *Guernica*.[23] He was mean to his women, liking to keep them dependent on him. Most parted from him poorer than when they met. It is true that he sometimes gave them paintings or drawings. But he never signed these works. If, after a rupture, a woman attempted to sell such a gift, dealers would not handle it without Picasso's authentication, which was refused. This, of course, raises another logical problem about Picasso's art. Without both a signature and Picasso's personal authentication, such works were commercially valueless. In short, they had no intrinsic value. Few leading painters have ever been so easy to copy or imitate. Because of his abuse of his power of authentication, and the fear in which dealers held him, some works rejected as forgeries are undoubtedly by him, and it is likely that many authenticated works are fraudulent. Indeed, despite the attention lavished on his oeuvre by hagiographers and scholars, it remains in some confusion.

Many people find it hard to accept that a great writer, painter, or musician can be evil. But the historical evidence shows, again and again, that evil and creative genius can exist side by side in the

same person. It is rare indeed for the evil side of a creator to be so all-pervasive as it was in Picasso, who seems to have been without redeeming qualities of any kind. In my judgment his monumental selfishness and malignity were inextricably linked to his achievement. His creativity involved a certain contempt for the past, which demanded ruthlessness in discarding it. He was all-powerful as an originator and aesthetic entrepreneur precisely because he was so passionately devoted to what he was doing, to the exclusion of any other feelings whatever. He had no sense of duty except to himself, and this gave him his overwhelming self-promoting energy. Equally, his egoism enabled him to turn away from nature and into himself with a concentration which is awe-inspiring. It is notable that, from about 1910, he ceased to be interested in nature at all. He never traveled, except to a few Mediterranean resorts. He never explored Africa, Asia, or Latin America. Leaving aside his women models (and a few quasi portraits), he never drew or painted the world outside his mind. By excluding nature he increased his self-obsessed strength, but it cost him peace of mind and probably much else that we cannot know about. The all-powerful machinery of the Picasso industry—his regiments of women, his châteaux, his gold ingots, his unlimited fame, his vast wealth, the sycophancy that surrounded him—none of these brought him serenity as he aged. It seems to me that his personal cruelty and the evident savagery of much of his work (so different from the indignant savagery of Goya) sprang from a deep unease of spirit, which grew steadily worse and terminated in despair. When he realized that his sexual potency had gone, he said bitterly to his son Claude. "I am old and you are young. I wish you were dead." His last years were punctuated by family quarrels over his money. His demise was followed by many years of ferocious litigation. Marie-Thérèse hanged herself. His widow shot herself. His eldest child died of alcoholism. Some of his mistresses died in want. Picasso, an atheist transfixed by primitive superstitions, who had his own barber so that no one could collect clippings of his hair and so "get control" of him by magic, lived in moral chaos and left more chaos behind.[24] It is an appalling tale, though edifying in its own way—it shows painfully how even vast creative achievement and unparalleled worldly success can fail to bring happiness.

Leaving morality and happiness aside, however, and concentrating on Picasso's creative impact, it has to be said that, if you subtract him from the history of art in the twentieth century, you leave an immense hole. It is impossible to know what direction art would have taken if Picasso had never existed. Would fine art have been submerged so completely and for so long? Would fashion art have enjoyed so many decades of such complete supremacy? These questions, being hypothetical, cannot be answered. Would our vision of the world be any different? Probably not. But then would it be different if Walt Disney had not lived and worked? That is harder to answer.

Walt Disney, like Picasso, began his working life early, but he had a much harder struggle to earn a living or achieve recognition and success. Much of his childhood was spent on a farm in rural Missouri, and he delighted all his life in observing and drawing animals. Their movements and idiosyncrasies gave him great pleasure, as they did Dürer; and Disney—like one of his mentors, Landseer—liked to pin the entire range of human emotions on them.[25] Whereas Picasso tended to dehumanize the women he drew or painted. Disney anthropomorphized his animal subjects; that was the essential source of his power and humor. His family was impecunious and his irascible father demanding, but despite this, or perhaps because of it, Disney always saw the family as the essential unit in society and the only source of lasting happiness. When the farm failed, the Disneys moved to Kansas City, where his father started a newspaper-distributing business (in effect, a glorified round) and made Disney work very hard at all hours. But he did get some art education, even if he never had the luxury, like Picasso, of cutting art classes in favor of visiting brothels. By the age of eighteen he was making his living as a newspaper cartoonist. But he developed two passions. First, he wanted to run his own business and be his own master—he had the American entrepreneurial spirit to an unusual degree, and by the age of twenty he had already run his own company, gone bankrupt, and set up again. Second, he wanted to get into the art or craft of animation.[26]

As an artist Disney sprang from a distinct nineteenth-century tradition that included Edward Lear and the great cartoonist Tenniel, who drew for *Punch* and first illustrated Lewis Carroll's

Alice in Wonderland, creating our image of the Mad Hatter, the March Hare, and Alice herself. Disney could also take from a huge repertoire of examples in the newspapers—strips known as "comics" in England but "funnies" in America. Disney believed that the first of the animated funnies drawn for the new motion-picture industry was made in 1906 by J. S. Blackburn and titled *Humorous Phases of Funny Faces,* updating a tradition of grotesque physiognomy which went back to Leonardo da Vinci and earlier. It was produced and marketed by the Vitagraph Company to accompany longer movies filmed with actors. Vitagraph also used series drawn by Winsor McKay, an artist for whom Disney had much respect, admiring especially his *Gertie the Dinosaur* of c. 1910. McKay took his animated cartoons on old-style vaudeville circuits, accompanying them with a humorous vocal commentary which he delivered himself.

Disney always felt that animation without sound was dead and that the nature and quality of the sound were the key to success. But initially the sound dimension baffled him. So did a lack of capital. The burgeoning movie circuits would buy cartoons only in series of ten, twelve, or twenty, believing that moviegoers had to become accustomed to them (the same belief dominates television in the early twenty-first century), and Disney lived from hand to mouth. Five dollars was a lot of money for him, and he often had to borrow cash. But he contrived to keep abreast of what was a rapidly evolving technology, both in animation and in moving photography. On the one hand there were companies like the Bud Fisher Films Corporation and International Features Syndicate, producing animated versions of comic-strip characters, such as *Mutt and Jeff* and *The Katzenjammer Kids,* both in 1917–1918. In 1917, too, Max Fleischer, famous for his *Felix the Cat* series, made the first movie combining moving photography of actors with animated cartoon characters. Disney used this combination himself in 1923, when he made *Alice in Cartoonland,* using an eight-year-old girl, Margie Gay. A photo survives showing Margie in the middle of Disney's production team of seven people. They included, besides Disney himself, his elder brother Roy Disney, who ran the finances (he also worked in a bank), and a clever artist and animator, Ubbe

("Ub") Iwerks. All the men are wearing plus fours, with ties and pullovers—the uniform of young entrepreneurs in the early 1920s, the era of Harding and "normalcy."[27]

Disney's original company, the Laugh-O-Gram Corporation, made short animation films, animation plus photography films, and advertising shorts using cartoon figures. But though Disney owned his own movie camera, bought on credit, and borrowed cash, he was forced into bankruptcy. All he kept was the camera and a print of *Alice* to use as a sample. He was forced to disband his team and use his camera for freelance news photography, making Kansas City his base and selling his footage to Pathé, Selznick News, and Universal News, all based in Hollywood. He completed his plus fours outfit with the badge of the newsreel cameraman, a cap turned backward. He did private jobs, too—filming weddings and funerals at $10 or $15 each. He did not starve, but he often lived off canned beans. His contacts with the news studios persuaded him that he had to establish himself, and a new production company, in Hollywood. So he sold his camera and, with the proceeds, bought himself a ticket there, with $40 as his capital, traveling on the famous train *California Limited*, in July 1923.[28]

The early 1920s, full of hope and daring, were a classic period for American free enterprise, and for anyone interested in the arts—acting, writing, filming, design, costumes, sets, music. Hollywood was a rapidly expanding focus of innovation. But Disney had a very hard time getting work of any description in the movie industry, trudging from studio to studio and borrowing money just to eat. He went back to making animated cartoons, drawing a head, mouth, and eyes, then a body of single lines—"they looked like white matchsticks on a black background." He also used his Alice sample to get a series going. He shot the live part against a white drop (the camera was hired at $5 a day), then drew the cartoons around her. He organized a group of local children, each paid 50 cents a day, to act skits around Alice, and he trained his great-uncle Robert's Alsatian dog to be part of the fun. Each reel consisted of 900 feet of film of real children and the dog, and 300 feet of animated cartoon. Disney wrote the script (or improvised it); built the sets in the open

air—his "studio" was a small back room in a real estate office rented for $5 a month—made any props he needed; produced, directed, and filmed it himself; and then sat down to draw the animation. The first movie cost him $750 in all, and he sold it "east" (i.e., to a New York syndicate) for $1,500, his first real profit.

He had a contract for a dozen movies, and the first six he made entirely by himself. These he sent to Ub Iwerks in Kansas City, and then he brought Iwerks out to help with the animation. There is a curious similarity between his work with Iwerks and Picasso's collaboration with Georges Braque in the invention of cubism nearly two decades earlier. So closely did Picasso and Braque share their ideas and techniques that a few years later it was sometimes impossible to tell which of them had produced a certain canvas, or if both of them had; neither painter could tell either. In some cases the mystery remains to this day. Equally, the precise roles of Walt and Ub in the early successful animations can no longer be determined with certainty. It is clear that the basic ideas came chiefly from Disney. But many of the most effective touches sprang out of the animation process itself, and here Iwerks was important. Disney also hired another draftsman, Tom Jackson. Disney did the initial outlines of the drawing himself, and his two assistants filled them in. Then, gradually, he gave his assistants entire scenes to do, but he insisted on a distinctive Disney style of drawing that became, and remains to this day, his hallmark. He made the maximum use of circles because they were easier to draw fast. Even so, each short movie took a month, "and was the hardest work I have ever done."[29]

It is impossible to exaggerate the need for a producer like Disney to respond quickly to changes in public taste and to the need for novelty. Just as Picasso, in Paris, went from one phase to another, to cater to the insatiable appetite for ideas of the art world, so Disney had to adapt and change his cartooning. "The east" reported that audiences were tiring of Alice, and indeed of animation plus photography. They wanted a "new character." Disney invented a rabbit called Oswald, who was all cartoon, with long ears, long feet, and a little knob of a tail. Live action and real people were eliminated, and Disney's output remained

homogeneous for a long time. *Oswald* was a success, but Disney found that once his shorts acquired a reputation, other studios, bigger and with more capital, tried to raid his staff and steal his animators by offering them more money. He could frustrate this process by inventing a new character, rather as, nearly a hundred years before, Charles Dickens defeated pirates, before the age of copyright, by conceiving a new story and writing it fast.

The result was a mouse. Disney said that in Kansas City a mouse had lived in or on his desk and he had become fond of it and recognized its possibilities for affectionate animation. Disney said he sometimes caught mice in his wastepaper basket, where they fed on bits of candy wrappers, and that he put them in a cage on his desk so he could study their movements. He became especially fond of one specimen, and when he left Kansas City for Hollywood he carried this mouse into a field and released him. He had called the mouse Mortimer, so when he decided to feature a mouse series, he chose the name Mortimer Mouse. But his wife, Lilly (he had just married on the strength of the profits from *Alice*), objected: "Too sissy." That was when Disney picked Mickey. The essence of Mickey Mouse was that he inspired affection, just as the mouse on Disney's desk had "won my stony heart," as he put it. Picasso had, in effect, turned the bodies and faces of his women and models into caricatures, cubist cartoon characters, animated (often enough) by contempt and even hatred. But Disney produced a mouse animated by admiration of its antics, and even by love. It is significant that Mickey Mouse, in the year of his greatest popularity, 1933, received over 800,000 fan letters, the largest ever recorded in show business, at any time in any century. (The next largest figure was the 730,000 letters Shirley Temple received in 1936.)[30]

But the mouse had first to inspire affection, just as Picasso had to inspire awe (and a sense of dread by his rejection of nature). Therein lay Disney's genius: he could make people, especially children, love his creations. The process was not simple—it was in fact extremely complex, as was Picasso's progress away from representation. The earliest Mickey was described as "functional. Not handsome. He had black dots for eyes, pencil legs, three fingers per hand, a string-bean body, and a jerky walk." It

was pointed out, however, that Mickey was a kind of self-portrait (as were some of Picasso's distorted heads in 1915–1925, and much later). The soulful eyes, when they emerged; the pointed face; the gift for pantomime were those of his creator. The earliest Mickey does not look lovable to our eyes, nearly a century later. His jerkiness was technical, rather than deliberate. With every month that passed, animation was becoming more complex, and Disney, to outpace his competitors, forced the pace. He used sixteen drawings to make Mickey move once. The team of animators had grades, with senior members drawing the key moves, following Disney's own sketches, and juniors filling in. About 14,400 drawings went into a ten-minute cartoon short.

While Mickey was in his awkward infancy, backed by music provided, in the usual way, by the movie theaters, Warner Brothers released (1927) the integrated sound picture *The Jazz Singer*, starring Al Jolson. Disney had made three Mickey shorts, but he jumped for joy at the idea of talkies because he had always believed sound to be the true third dimension of movie cartooning. Disney had no sound equipment and proceeded on a do-it-yourself basis, which is a model of entrepreneurial improvisation. He got Jackson to play a harmonica; he bought nightclub noisemakers, cowbells, tin pans, and washboards for scrubbing noises. The problem, as Disney saw it, was tempo and mathematics. Sound film ran through the projector at the rate of twenty-four frames a second. If his sound tempo for a mouse movie was two beats each second, he had to beat every dozen frames. He introduced a metronome, then drew the noises on blank music sheets to produce a sound score. The cartoon animation and the sound effects could thus be devised to synchronize. But it was one thing to produce a sound score and quite another to record the score, mixing noises with orchestral accompaniment—and yet a third to integrate the sound into an animated film. New York, not Hollywood, was then the headquarters of the recording and music industries. In the rush to embrace talkies by all movie producers in 1927, not only was equipment in short supply, but the whole business was bedeviled by copyright restrictions imposed by big recorders such as RCA, who wanted $3,500 from Disney to sound-back his Mickey, and insisted on doing it their way

instead of his. He refused and devised his own method, often sidestepping copyright barriers by ingenious dodges. He hired an orchestra leader, Carl Edwards, and thirty players. They were packed into a tiny studio, and eventually were reduced to sixteen to save on wages.

To make the recording, Disney's method was as follows. Sound required 90 feet of film a minute. Individual pictures were projected on a screen at the rate of twenty-four a second. The musical tempo was two beats a second, giving a beat every twelve frames. All this, including sound effects—bells, gongs, etc.—had to be marked on the score. The film was marked with India ink every twelve frames. When it was projected in the recording studio, the mark made a white flash on the screen, becoming a visual substitute for the ticking of the metronome and keeping the music director (or sound effects chief) on the beat. It took a great deal of effort, time, and rerecording to get the system working smoothly; and by the time the composite print was made, with fully synchronized sound, the Disney brothers had run out of cash and had even had to sell their father's car.[31]

This first sound movie using the mouse was called *Steamboat Willie* and shown early in 1928. It was a huge success, not only because of Disney's technical triumph of synchronized animation, but because of the ingenuity of what Disney got the mouse to do in producing noises. Therein lay his extraordinary gift, the imagination to enter into the head of a half-mouse, half-man, and devise weird and hilarious things to do as the mouse steered a boat down the river.[32] The possibilities opened up were limitless, a new kind of anthropomorphized animal art that would have fascinated Dürer. The cartoon movie came of age with this enchanting little picture. Like Dürer, who effectively invented the art of illustrated printed books, Disney had invented the sound cartoon, a combination of imaginative drawing, scripting, and engineering science. It was, and remains, a wonderful example of creativity—the birth of a new art form. Disney could now borrow money from the banks, and he quickly delivered a series, the importance attached to the sound track being reflected in the name, *Silly Symphonies*. The first, *The Skeleton Dance*, was backed by Grieg's *The Hall of the Mountain King*, Saint-Saën's *Danse Macabre*, and bone-rattling. This worked too

with audiences. But the clamor was for "more mice." By the end of the decade Mickey Mouse was the best-known figure in movies. Mickey's voice was originally done by Disney himself, then became a standard sound track. Other characters devised by Disney soon appeared: Minnie Mouse, Figaro the Kitten, Chip the Chipmunk, Pluto the Pup, Goofy the Dog, and Donald Duck. The way in which Disney devised the infuriated animation of Donald to synchronize with irascible quacking noises was another triumph of imagination. This was the first time in the history of art that drawing had been not merely animated but vocalized. Disney's stress on the importance of sound and song in animated drawing was finally vindicated by his cartoon *The Three Little Pigs*, made in 1932. The movie originally got a cool reception from distributors because, they claimed, it had only four characters. three pigs and their enemy, the wolf. It was said, "Walt is cutting down on characters to save money." The movie was saved when Disney decided that it needed a theme song, and it was produced by the entire studio. An animation scriptwriter, Ted Wears, wrote a series of couplets with the chorus "Who's afraid of the big bad wolf?" and a young studio musician, Frank Churchill, who had never composed before, devised the marvelous tune. The result turned out to be one of the greatest song hits of the twentieth century, and a catchphrase that resonated throughout the world. This song not only launched the pigs in their film life but gave Disney's animated image of them a global life long after the cartoon itself faded.[33]

The year 1932, perhaps the worst year of the Depression, also saw Disney release for exhibition his first cartoon in color, *Flowers and Trees*. This underlined his emphasis on the study of nature for inspiration in depicting movement in cartoons. Though Disney and his animators stylized their subjects—such as Mickey Mouse and Donald Duck, with their strongly individual features and characteristic movements—the studio regarded nature as the one and only true source of Disney art. Animators, led by Disney himself, constantly watched movies of animals, and live animals were brought into the studio for study. It was Disney's view that nature was a richer source of humor than the human imagination. What he and his team supplied was anthropomorphism. In 1934 Webb Smith devised and Norm Ferguson animated a

sequence in which Pluto the puppy dog tries to shake off a strip of flypaper. This superb little movie had an enormous influence on the cartoon trade. It delighted audiences because the dog remains a dog while being endowed with human resources—obstinate determination and fury.[34] Disney could only anthropomorphize successfully if he kept his animal movements highly realistic, and set them against plausible backgrounds. He regarded color as a godsend, almost as crucial as sound, because it enormously increased realism. He experimented widely with color systems before he adopted Technicolor, and signed an exclusive contract with its manufacturer to use the three-strip system needed to produce the full chromatic range. *Flowers and Trees* was not only an eye-opener, displaying the huge leap that color made possible in the depiction of nature. It also set completely new standards for future realistic backgrounds for animated characters.[35] Disney was now moving toward cartoon fires, waves, winds, and storms, as well as anthropomorphized trees, flowers, and man-made objects.

He spent money freely as fast as it came in. Like Turner as a teenager, Disney always bought the best paint, film, and other materials. He insisted on reanimation, however time-consuming and expensive, until the results were right. In the early 1930s, Disney's production costs for an eight-minute movie were $13,000 and over, at a time when rival studios spent a maximum of $2,500. Like Dürer and Rubens, Disney put excellence before any other consideration, and the studio barely made a profit despite its huge bookings, since the incoming cash instantly went for investment in new technology and better artists. In many ways, the studio Disney ran in the 1930s was not totally unlike the big European studios of the seventeenth century. Disney hired the best artists he could get, and gave them tasks to the limits of their capacities if they proved good enough—just as Rubens pushed the career of Van Dyck, his greatest assistant. In addition to Iwerks's work on Mickey Mouse, Carl Stalling designed *The Skeleton Dance* in the first of the *Silly Symphonies*, Albert Hurter did the settings and characters for *The Three Little Pigs*, Art Babbitt was responsible for Goofy, and Clarence Nash provided Donald Duck with a voice (and was henceforth known as Ducky Nash). The studio was a highly creative, interactive place,

tense and sometimes hysterical as new ideas were presented, debated, boosted, and discarded. There were arguments, and animators sometimes left after disputes; Iwerks and Stalling were two examples. In some ways the studio resembled the organization Guido Reni ran in the second quarter of the seventeenth century, when he was the most successful painter in Europe, with seventy assistants (at one point over 200). In Reni's studio, too, there were clashes of personalities, quarrels, and abrupt departures. In the early 1930s, Disney's studio was about the same size as Reni's. But it continued to expand and later employed over 1,000 animators, artists, and other draftsmen. During the period 1930 to 1937, Disney and his studio, by trial and error and prodigies of industry and skill, acquired the art of animating figures, making them seem as "real" as human comedians on the stage, in essentially the same way as the Siennese and Florentine painters, from Duccio to Giotto, learned to reproduce people, in fresco, on walls, or in gesso on panels. What took the early Renaissance painters two centuries, the Disney studio did in a decade; but then Disney's animators had the whole tradition of western art on which to build, just as the countless animators of today are inspired by Disney's work of the 1930s.

The arrival of satisfactory color; the improvement of background technique; the perfection of the sound track, allowing high-quality orchestral music and singing; and financial factors persuaded Disney to break out of the limitations of the funny cartoon and make a feature-length fairy tale. The result was *Snow White and the Seven Dwarfs*, conceived in 1934 and shown in cinemas all over the world in 1938.[36] The idea was Disney's, of course. He had been preparing for human animation for some time by holding life classes at the studio under Don Graham; and to create Snow White herself he appointed his best human anatomy draftsman, Jim Natwick, assisted by Ham Luske, who specialized in character development. The Queen, who is transformed into a witch, was also a joint work of two of his best animators: Art Babbitt did her as queen, Norm Ferguson as witch. The dwarfs were the work of four senior animators—Bill Tytler, Fred Moore, Frank Thomas, and Fred Spencer—heading a team of twenty-nine involved in the personalities of the seven sharply differentiated dwarfs. In today's climate of political correctness, the movie

could never have been made. Snow White would have been vetoed as racist; the dwarfs would have been transformed into "vertically challenged people"; one of them, Dopey (the most popular with audiences), would have been attacked as making fun of a mental defective; two others—Sleepy and Sneezy—would have been seen as a cynical exploitation of medical conditions; and even Grumpy and Bashful might have been classed as objectionable. Only Happy and Doc are politically correct, by today's criteria. As it was, in the climate of freedom in the 1930s, the movie introduced numerous artistic and technical innovations that transformed the art of movie cartooning. It involved over 2 million drawings and formed the largest single project in the history of draftsmanship, which had begun 40,000 years before in the caves of France and Spain. It was a huge critical and commercial success and marked the point at which animation achieved maturity as an art form. The impact on every form of commercial art, fashion art, and indeed fine art was incalculable. Snow White's appearance even altered the way women, from teenagers to professional actresses and models, wanted to look, smile, and behave. Among children, the movie was the biggest instant success in juvenile entertainment ever recorded, as indicated by the exceptional numbers who missed classes to see afternoon showings; and art teaching in schools testified to its effect on the way pupils tried to draw. The storm scene and the flight through the forest were particularly dramatic in their effects on visual consciousness, and not just among the young.[37]

Disney's art compounded and intensified the impact of cinema on the way humanity saw things. The movie houses themselves were part of this process. The years 1927 to 1929 (at the height of the pre-Depression boom) brought the architectural products of cinematic triumphalism. New York's Roxy (1927), created by the designer Walter W. Aschlager, and financed by Samuel L. "Roxy" Rothapfel, was a blazing temple of light, seating 5,800 people. The Fox in San Francisco (1929), financed by William Fox (of Fox Studios) and designed by Thomas W. Laint, seated 5,000 and was even more visually lavish. In Berlin the Universum Luxor Palast (1926–1929) summoned up all the arrogant pride of ancient Egyptian architecture at the time of the New

Kingdom, and lit it with hundreds of thousands of lightbulbs. A new kind of visual experience, known as "night architecture," came into being, thanks to the Odeon theaters.[38] These prototypes were imitated throughout the new decade, in vast buildings in London, like the Carlton in Islington and the Astoria in Finsbury (both 1930); and in a variety of styles, chiefly Egyptian, Persian, Moorish, Spanish, and Italian, though the Granada, Tooting, was a Gothic fantasy. Most of these giant movie houses, physical tributes to the dominance of cinema in the 1930s, have been demolished. In their day, however, they filled the eyes of the public with monumental and exotic visions, inside and out, for the lavish lobbies and halls of these palaces, staffed by usherettes trying to look like Snow White, were even more luxurious than the exteriors.

Disney, however, never liked the artificial side of the Hollywood "picture palace" industry. He was really a product of the arts and crafts movement and of art nouveau, which had formed the aesthetic background to his first attempts to draw. Hollywood was art deco, quite a different visual influence. Disney's instinct was always to get back to nature (whereas Picasso's was to get away from it). The success of *Snow White* financed a series of four big feature movies, all made between 1938 and 1944: *Pinocchio, Fantasia, Dumbo,* and *Bambi.* All these successful movies explored natural phenomena, whether living, vegetable, or climatic, in new visual ways. Disney insisted on turning Pinocchio from a puppet into a little boy; *Fantasia* not only used his animals, including Mickey as *The Sorcerer's Apprentice,* but made astonishing use of sea, swamp, mountain, and forest backgrounds, using classical music compositions as the sound. The dinosaur sequence in the prehistoric swamp used to illustrate Stravinsky's *Rite of Spring* was the first modern exploration of the age of reptiles for the benefit of children, a harbinger of countless images to come. The *Pastoral Symphony* in the movie inspired Disney to resurrect the nature portrayed by the Symbolist movement of the 1890s, and some of the preproduction studies made by the Disney studio for this section (done in pastel) are of great beauty. The dances in this movie are often extraordinary exercises in anthropomorphic animation, but the movements of

the animals are based on nature. So are the atmospheric effects of the final section, *Night on Bald Mountain*. *Dumbo*, the circus movie, and *Bambi*, essentially a nature film, show the immense distance Disney and his studio had traveled in the art of animation since he first made his mouse movie.

The logic of Disney's invention meant that he eventually turned to filming nature itself, living but unanimated. The result was a series of movies like *Seal Island*, filmed in Alaska; *The Vanishing Prairie*, filmed in the midwest; and *The Living Desert*. These were not the first nature documentaries by any means, but their high professional quality and Disney's name gave an impetus to the genre, which continued for the rest of the twentieth century and into the twenty-first, especially on television. Disney's love of nature, of course, always jostled with fantasy, and this combination is reflected in his later feature-length movies, such as *Alice in Wonderland* (1957); *Peter Pan* (1953); *The Lady and the Tramp* (1955), made in the new CinemaScope; and *Sleeping Beauty* (1959). Disney was always experimenting with novel ideas and new technology—rather, it must be said, like Picasso—and *One Hundred and One Dalmatians* (1961) used the new Xerox camera, which greatly influenced both background and animation. His *Jungle Book*, Disney's last animated film, released in 1967, the year after his death (from lung cancer; Disney was a heavy smoker), used new recording techniques to transform animal voices spoken by leading actors. Disney also resurrected his old technique (dating from *Alice*) of combining animation with real actors on film, in *Mary Poppins* (1964). This film exploited the new technologies that had become available—allowing Dick Van Dyke to dance with animated penguins, for instance—and made the studio more money than any other movie shown in Disney's lifetime.

In Disney's last years, and after his death, the studio continued to make major all-animated movies, following his prescription of heightening but never forgetting nature. In the 1990s the studio presented *The Lion King*. This had an original story, but—more important—it followed the direction pointed by *Bambi* in showing the animals in a vividly realistic environment, drawn and colored expertly by the artists, after countless studies of the

real thing but with the sequence movements assisted by comput-
ers. It produced, among other spectacular sequences, a musical
turn by the evil hyenas and a cattle stampede of terrifying ebul-
lience.[39]

However, long before the turn of the twenty-first century,
Disney's business had expanded from cartooning into complete-
ly new forms of entertainment. Disney wanted to retain nature
and surrealize it (to coin a phrase), but he also wanted to com-
bine it with a fantasy world. In a sense, this is exactly what Wat-
teau had done with his paintings of fêtes and arcadia in the early
eighteenth century. *Fantasia* had been an exercise in such juxta-
position, but during World War II Disney had brooded on the
possibility of creating these worlds not in the studio, of paint
and celluloid, but in real life. He thus produced the idea of a Dis-
ney park, constructed around a theme. He re-created his scenery
in three dimensions, in the open air; peopled it with his animals,
real and acted; and invited the public to enter. His first Disney-
land opened in 1955 in Anaheim, California. Re-creating his own
versions of Ludwig II's Bavarian castles, or William Randolph
Hearst's San Simeon, he revealed again his creative genius for
satisfying the human demand for popular art as entertainment.
Not content with this concept, which spread over the world, he
hinted in 1954, when he introduced Disneyland on television,
that he had a further project, called Experimental Prototype
Communities of Tomorrow, or EPCOT.[40] This revived the vision
of experimental architects during Disney's boyhood before
World War I, in which ideal communities would be planted,
using the latest technology, in "controlled environments," a
phrase minted in Disney's youthful heyday in the 1920s. This
project was not fulfilled until after Disney's death, when Disney
World, covering 27,000 acres of Florida, came into being in 1971.
This, besides being a vacation destination on an unprecedented
scale, was an experiment in urban design, with nonpolluting
vehicles, a monorail system, the first pedestrian malls, novel uses
of prefabrication, and a vertical takeoff and landing to eliminate
aircraft noise. The first test center, at Orlando, Florida, complet-
ed in 1992, had three areas: Port Orleans, a simulation of a typi-
cal *quartier* of old New Orleans; Magnolia Bend, resurrecting a

plantation of the deep south; and Alligator Bayou, a way of mov-
ing tourists through Louisiana swamps without discomfort or
danger. Large raised gardens, and all the facilities of resorts from
golf to swimming pools, were grouped around these theme cen-
ters. So the work of Disney continued after his death, and the
first decade of the twenty-first century was marked by various
innovations in his tradition, including what was voted the
world's perfect concert hall in Los Angeles (2005).

Clearly, the influence of Disney on the presentation of visual
images in the twentieth century and beyond was immense,
almost past computation. Even directly, for instance, his *Snow
White* was the ur-document of a school that had branched out
with over 200 systems of animated cartooning by the end of the
twentieth century. Disney himself trained over 1,000 artists,
almost as many as the Académie Julien, the most successful art
school in history. Cartoons were the basis of most fashion art
during the second half of the twentieth century, and they also
had a direct influence on clothes, hairstyles, interior decoration,
furniture, and architecture. Postmodernism was part of cartoon-
land. And the influence of cartoons was reinforced by Disney's
parks, worlds, and physical experiments in landscape and urban
planning.

Picasso's influence was also immense, since he abolished all
the parameters of representational art and largely replaced it by
fashion art. He made it possible for Warhol to coin the telling
phrase "Art is what you can get away with." By the beginning of
the twenty-first century artists, or rather operators in the art
world, were getting away with anything. Since the influence of
both Picasso and Disney was so vast, is any purpose served in try-
ing to decide which was the greater and more enduring? Yes, and
for two reasons. The first reason is that the essence of Picasso's
art was to move away from nature and into the interior of his
mind. The essence of Disney's art was to reinforce, transform,
and reanimate nature, to surrealize it. Hence, in deciding which
was more extensive and permanent we are pronouncing a verdict
on the power, or weakness, of nature.

Second, both artists were involved, not always by their own
choice, in the politics of the twentieth century. Disney was an

entrepreneur, and a highly successful one, the founder of a business which in his own day employed thousands of people and which, in the first decade of the twenty-first century, survives and flourishes and is measured in terms of billions of dollars. Disney was, in the highly charged ideological atmosphere of the 1930s, his most creative period, a strong supporter of what would now be called family values and traditionalism, who primly and obstinately (though silently) refused to allow his organization to promote collectivism or socialist values. As he employed a good many intellectuals, artists, and writers who at that period leaned overwhelmingly toward the left, this produced tension at Disney Studios and, in 1940, led to a strike aimed either at forcing Disney to make pro-Communist propaganda cartoons or at shutting the studio down. Disney defeated the strike, with some help from J. Edgar Hoover's FBI, and pursued his own individual way until his death. As a result, left-wing writers tried to demonize him, both during his lifetime and later.[41]

By contrast, the left deified Picasso, who identified his interests with those of communism from the mid-1930s. Before that he had vaguely supported "progressive causes," as did most avant-garde artists. However the showing of *Guernica* as the centerpiece of the Spanish Republican government's pavilion at the 1937 fair in Paris brought him a degree of world fame he had never before possessed, and was an important step in turning him into the art god of the left. That apart, however, he never lifted a finger to help the desperate Republic. Though happy to protest with his brush against the Nazis' atrocities, he never, to the end of his days, acknowledged the torture and execution, by the Stalinists and the Spanish Communist Party, of thousands of Catalonian anarchists, including people he had known. He was a great signer of collective letters of protest—signing cost nothing—but appeals to him to help individual Spanish refugees, including old friends, fell on deaf ears. So did the anguished appeal of his old patron Max Jacob, whose help had been central to Picasso's first successes. When Jacob was arrested by the Nazis and asked for succor, Picasso joked: "It's not worth doing anything at all. Max is a little devil. He doesn't need our help to escape from prison." Jacob died of cold in his cell.[42]

World War II and its aftermath produced many cases of per-
fidy. Picasso's is one of the worst. When the Nazis occupied Paris
in 1940, Picasso (who had sheltered from the fighting in the Bor-
deaux country) was able to return there, despite the fact that he
was a prominent left-wing figure whose works had featured in
the Nazis exhibition "Degenerate Art." He lived in Paris through-
out the occupation, undisturbed and able to carry on painting
and selling his works. Indeed he was probably the only artist who
emerged from World War II (as from World War I) much richer
than he had entered it. He was undoubtedly protected by promi-
nent Nazis, one of them Hitler's favorite sculptor, and by the
coterie of Nazi homosexuals who gathered in Paris during the
occupation. Picasso rewarded his Nazi friends with gifts of his
own paintings, drawings, pottery, and other artifacts from his
collection. Needless to say, he had nothing to do with the Resis-
tance, for Picasso had a terror of violence (except when practicing
it himself on women); but he had many friends among the com-
munists who largely controlled the Resistance in 1944. Once the
Nazis had gone, Picasso was hailed as a heroic figure by the
French Communist Party, and he himself loudly denounced any
compassion or clemency for Frenchmen judged to have collabo-
rated. Indeed he held a meeting at his studio to demand the
arrest of such people, some of whom were on his list of personal
enemies. At the Salon d'Automne of 1944, largely controlled by
the communists, Picasso was selected for the honor of a gallery
entirely devoted to his work. On 5 October, on the eve of its
opening, the Parisian press announced that Picasso had joined
the Communist Party the day before.[43] He believed, like many
other people at that time, that the Communists would take over
France. Moreover, the French Communist Party was then, and
remained for many years, a strong power, controlling over 4,000
newspapers and magazines, including many arts journals. The
party was thus able to relaunch Picasso's career on a large scale
and arrange for his European tours under its auspices. He fig-
ured prominently at international communist conferences, espe-
cially those designed by Stalin (and his successors) to persuade
the west to disarm unilaterally; and he designed the dove of
peace that was the logo of the communist empire's propaganda

effort. Picasso also flatly refused to condemn the various suppressions of workers' revolts by Soviet tanks, first in Berlin in 1953, then in Budapest in 1956, and the savage destruction of the "Prague spring" in 1968. In fact he never criticized communist policy or the policies of the Soviet Union in even the smallest particular, and he died a member of the party. He also took care that his various country houses and châteaus in France were always in areas where the party controlled the local government, just in case he fell afoul of the law (e.g., by seducing a minor). Thus the support of the left was of immeasurable help to Picasso in establishing him, even in his lifetime, as the "greatest painter of the twentieth century"; and even though the communist empire has disappeared, and communism is dead, Picasso remains an unassailable hero of the left.

However, in the long run, political factors fade away. The popularity of the creative arts, and the influence they exert, will depend ultimately on their quality and allure, on the delight and excitement they generate, and on demotic choices. Picasso set his faith against nature, and burrowed within himself. Disney worked with nature, stylizing it, anthropomorphizing it, and surrealizing it, but ultimately reinforcing it. That is why his ideas form so many powerful palimpsests in the visual vocabulary of the world in the early twenty-first century, and will continue to shine through, while the ideas of Picasso, powerful though they were for much of the twentieth century, will gradually fade and seem outmoded, as representational art returns to favor. In the end nature is the strongest force of all.

15

Metaphors in a Laboratory

*I*N THIS BOOK I have dealt essentially with people of outstanding talent, or genius, who worked in the arts. But as I pointed out at the beginning, creativity can take innumerable forms. Why have I included nothing, for instance, about the sciences? I have no satisfactory answer to this question. It is true that some observers will not allow scientists to be called creative. Scientists are discoverers. You cannot create something that is already there. Making discoveries is a form of factual activity. There are two objections to this argument. First, throughout history, no real distinction was made between the exercise of skill or even genius in the arts and sciences. Imhotep was an example of a creator who operated in many spheres: architect, builder, engineer, doctor, surgeon, priest, politician. A typical seer of antiquity was Archimedes (c. 287–212 BC), the greatest mathematician of his age, perhaps of all time, but also an engineer, inventor, astronomer (like his father, Phidias), adviser of kings, and prolific writer. He was rather like Imhotep, in fact, and notable as the only prominent Greek writer who understood hieroglyphics (he had been to Egypt and hobnobbed with its priests). A stylist, he famously said of the lever, "Give me where to stand, and I will move the earth." Some of the machines he invented, such as the water screw, were exercises in creativity by any standards, and he was the kind of inventive, imaginative jack-of-all-trades who pops up from time to time in history to astonish us. Leonardo da Vinci, 1,600-odd years later, was another superlative example,

though Archimedes leaned rather more to the sciences and Leonardo to the arts.

Renaissance studios, especially in Florence, where metallurgy was so important, buzzed with artist-scientists. Verrocchio, who ran one of the largest and most successful of them, where Leonardo and Della Robbia (among others) were trained, could turn his hand to almost anything. Dürer, Bramante, Michelangelo, Cellini—these were artists who knew a lot about the physical world and how it worked. If you could handle a variety of materials, as they did, the likelihood is that you were well up in physics and chemistry too; and all those I have mentioned were versed in mathematics. In the seventeenth century, the tradition of multicultural creators continued. Thomas Hobbes, one of the most creative political philosophers (his *Leviathan* is uniquely powerful), was also a master of geometry, pursuing ingenious lines of inquiry. Christopher Wren, a many-sided scholar, was a leading astronomer before he took up architecture. The Royal Society, confirmed by Charles II in 1660, abounded with learned men who bridged the arts and sciences. The truth is that until the nineteenth century, there was a single culture of learning, and it could be embraced even by self-made men who came up from trade, like Benjamin Franklin, just as well as by those educated at Harvard or Oxford. It is comforting to read that, in the 1790s, Wordsworth and Coleridge, while creating romantic poetry in their *Lyrical Ballads* (1798), were also mixing with the young chemical pioneer Humphry Davy, in Bristol, writing and reading poetry together, and "attacking chemistry," as Coleridge put it, "like sharks." (They also experimented with drugs, including marijuana and "laughing gas.")[1]

Davy was a creator in the strictest sense. In May 1812 a gigantic firedamp explosion at the Falling Pit near Sunderland, in England, cost the lives of ninety-two men and boys. The country, which then had by far the largest coal industry in the world, demanded a safety lamp for its miners. Various lamps were produced but proved unsatisfactory for different reasons, usually weight. In 1815 the mine owners appealed to Davy, by then director of the Royal Institute in Albemarle Street in London, and regarded as England's leading scientist, for help. Davy visited

pits, talked to miners and managers, and designed a safety lamp. His brilliant assistant Michael Faraday, who later discovered electromagnetism, testified: "I was witness in our laboratory to the gradual and beautiful development of the train of thought and the experiments which produced the lamp." On 9 November 1816, Davy gave a famous lecture at the Royal Society, "On the Fire-Damp of Coal-Mines and on Methods of Lighting the Mine," announcing that he had solved the problem. In fact the great railway engineer George Stephenson, head of engineering at the Grand Allies coal pits, also produced a safety lamp, rather earlier than Davy's, and marginally more safe. There is no record that the Stephenson lamp ever caused an explosion, whereas in 1825 a Davy lamp ignited gas and cost twenty-four lives. But Davy got the credit for the lamp. He went down in history as the "miner's friend," but was handsomely rewarded at the time, receiving £2,000 from Parliament, a massive set of silver plate from the mine owners, the Rumford Medal from the Royal Society, and a baronetcy. The most illuminating aspect of the episode, to me, is Faraday's description of the train of thought leading to the creation of the lamp as "beautiful." It is as if the emergence of a clever piece of scientific engineering in a laboratory is similar to the making of a piece of sculpture in a studio. The tragedy of the time, however, is that Davy's trains of thought, albeit beautiful, had by the 1820s become incomprehensible to his old colleagues in discovery, Coleridge and Wordsworth. Davy met Wordsworth for the last time in 1827, at Lowther Castle in the Lake District. Wordsworth complained in a letter that it had no longer been a meeting of kindred spirits: "His scientific pursuits had hurried his mind into a course where I could not follow him, and had diverted it in proportion from objects with which I was best acquainted."[2] We can thus date, fairly precisely, the bifurcation of the arts and sciences, which, a century later, the scientist and novelist C. P. Snow was to call "the two cultures."

The bifurcation should not be exaggerated, however, as we can see from the careers of two outstandingly inventive spirits, the Scotsman Thomas Telford (1757–1834) and the American Thomas Edison (1847–1931). Telford began working life, at age ten, as a stonemason—his "mark" can still be seen in the bridge

and doorways of the New Town the duke of Buccleuch created at Langholm.[3] Telford went on to achieve a quantitative record in civil engineering—roads, bridges, canals, viaducts, ports, and docks—which has seldom been equaled in history, and never for quality. But he always loved to work with his hands, in iron as well as stone, and his singular virtue was to combine superb craftsmanship, by himself and others, with a passion for the latest technology and formidable powers of organization in the completion of immense projects. Telford transformed northern Scotland with his immense Caledonian Canal, from the Atlantic to the North Sea; his docks; his ports; and 1,117 bridges. He built the fast new road from London to Holyhead (and Ireland) with its amazing bridge over the Menai Strait, which reduced the time to get from the capital from forty-one to twenty-eight hours. He planned, and wished to build, a national system of fast roads, bypassing the ancient towns—a concept 150 years ahead of its time. He was a great reader and close to men of letters: he took with him, on a tour of his great works in Scotland, the poet laureate, Robert Southey, who wrote a fascinating book about it. Most of all, Telford ensured that all his constructions, from gigantic locks and dockyards to humble tollkeeper's houses and milestones, were designed with classical simplicity and occasional decorative features of the highest elegance—doing it himself or employing architects of genius.

Equally, Thomas Edison, the greatest inventor the world has ever known, with over 1,000 patents, scores of them of major significance, often worked closely with creators in the arts.[4] One of his objects, in producing the first recording machine or phonograph (1877), was to hand down to posterity the voices of great singers and instrumentalists; and his improvements in electric lighting were of immense help to dramatists. He produced, with Tiffany, New York's first electric theater, the Lyceum; and his spotlights made possible the career of the Chicago dancer Loie Fuller in the 1890s, who performed using son-et-lumière effects at the Paris Folies Bergères. Edison's research laboratories, first in Newark, then on a bigger scale at Menlo Park, were temples of creativity, often with a bohemian streak more characteristic of a painter's studio on Montmartre than a lab: Edison would sleep

on the floor in his clothes when in an inventive frenzy.

Scientific research can be not only "beautiful," as Faraday said, but highly imaginative in almost the same way as literature. Einstein used to say, "A scientist tells himself a story and then finds out by experiment whether it is true or not." A hypothesis is essentially an imaginative exercise, and without a hypothesis a scientist cannot move forward into new territory of knowledge. In scientific storytelling, in forming a hypothesis, there is much use of the literary device of metaphor, which has the primary purpose of conveying meaning more clearly and strikingly but the secondary aim of allowing thinkers (or writers) to loosen up their own mental processes in a variety of ways—broadening the topic under discussion, relating apparently disparate or distant ideas in a creative way, and jumping from the physical to the metaphysical and back again. The primary purpose was exploited brilliantly by Michael Faraday in his famous lectures at the Royal Institution (especially in his Christmas lectures to children, who love and need metaphors). He inaugurated a tradition, followed by Sir James Jeans, Lord Rutherford, Julian Huxley, and other leading communicators of scientific truth to the public. The second purpose can be illustrated by the work of many creative scientists, a notable example being Robert Burns Woodward (1917–1979), who has been called the greatest organic chemist of the twentieth century. In all advanced sciences where the matter under discussion is too minute to be seen, metaphor is essential; and all diagrams are metaphors. The three-dimensional "structures" (the word itself is a metaphor) used in organic chemistry are metaphorical lab apparatus and stimulate further metaphors in the worker. By introducing the word "bonding," with a range of metaphorical images flowing from it, Woodward was able to formulate the patterns governing the way electrons shifted in chemistry. What are now known as the orbital symmetry rules were a double product of metaphor, first in Woodward's mind, where bonding was a master metaphor, and then in his linked colored balls, which formed his chief metaphorical laboratory tools. But scientists also use metaphoric tools that have no apparent relationship with their subject. In childhood Einstein, for instance, developed the habit of building card houses, some-

times as high as fourteen storys, and he continued to build them throughout his life, explaining that they helped to develop the persistence, independence, and self-reliance essential for formulating and reformulating "stories" or hypotheses. When a house of cards collapsed, indicating that the hypothesis was weak, the scientist instantly had to begin to build another house, or formulate a different hypothesis, until the hypothesis is rendered secure by experimentation. The fragility of the card house was itself a virtue, akin to the falsifiability principle which (as Karl Popper argued) was the great merit of a useful scientific hypothesis, and of which Einstein's special and general theories of relativity were outstanding examples.

An example of the value of metaphors in both senses—explaining and thinking—is provided by the work of the great American philosopher and psychologist William James (1842–1910), who occupies a central place in the development of American (as opposed to European) thought, especially in educational theory and practice. He and Henry James were brothers, and William shared Henry's fastidious attitude toward language, used words with great care and precision, and (to tell the truth) wrote not only with elegance but with greater clarity than Henry. William James probably made more conscious use of metaphors than any other scientist because, as he said, they enabled him to think of deeply abstract matters in concrete terms. He believed that metaphors were particularly useful when used in teams or ensembles, where they became interactive. He drew a diagram, which he used in evolving his theory of mind in 1908, showing how four "families of metaphors"—stream, fringe, flight, and herdsman— by interacting, illuminated such concepts as change, selectivity, relations, continuity, and personal consciousness. His brilliant use of metaphor is illustrated by this passage from *The Principles of Psychology* (Vol. I, p. 243):

Our mental life, like a bird's life, seems to be made of an alternation of flight and perchings. The rhythms of languages expresses this, where every thought is expressed in a sentence, and every sentence closed by a period. The resting-places are usually occupied by sensorial imaginations of

some sort, whose peculiarity is that they can be held before the mind for an indefinite time, and contemplated without changing; the places of flight are filled with thoughts of relations, static or dynamic, that for the most part obtain between the matters contemplated in the periods of comparative rest. Let us call the resting-places the "substantive points," and the places of flight the "transitive parts," of the stream of thought.[5]

A modern research team took the trouble to examine the use of metaphor in psychological writing. Examining research papers from 1894 to 1975, they found that among psychologists of routine skills and limited creative imagination, the "metaphor score" was only three per article, whereas in William James's famous "President's Address: The Experience of Activity" (1905), there were twenty-nine metaphors.

That metaphors are useful to creative thinking becomes more certain and obvious the more you study specific instances. What is more difficult to ascertain is the part activities play. Einstein's card houses were an example more of character training than an actual aid to creative thought. But most scientists and many writers have on their desks implements, gewgaws, games, and puzzles, presumably because they find such things useful to thought. I have no difficulty in concentrating, and I get down to actual writing as soon as I sit at my desk (or at my easel or drawing table), so I cannot easily follow the reasoning behind such gimmicks. But in cases without number, it is clear that spasmodic or periodic activity helps imaginative thought. Thus Dickens, who would spring up from his writing table to make dreadful faces in the big mirrors in his study, is by no means unusual among writers. Some writers build up such resistance against writing, or against continuing to write, that physical means have to be applied to force them to concentrate. When I was an editor, I had, on occasion, particularly with one or two contributors, to lock them in a bare room with a typewriter, in order to get them to write or complete an article, not allowing them to emerge until it was done. But many writers cannot work out their creative thoughts in a writing room. It is well known that

Wordsworth usually composed his verses while walking in the open air, either around the lake at Grasmere or Rydal Water, or ascending and descending the fells. He memorized the lines thus imagined, and only wrote them down when he returned to the house. Sometimes a gap of days, even weeks, intervened between writing the lines in his head and getting them on paper. It is not clear whether Wordsworth needed walking for his poetry because he saw things outside that he could then transform into verse, or because the sheer movement of walking jogged his thoughts. The latter, I surmise, for Wordsworth was in some ways an unobservant man. It was his sister, Dorothy, who saw the works of nature, in astonishing detail, and noted them down. When both were at Gowbarrow Bay, on Ullswater, when the daffodils were dancing in the wind, it was Dorothy who observed them and noted them in her journal, passing on her visual experience to her brother, who some weeks later wrote the famous poem. Without Dorothy it would not have come into existence.

Yet experience is the mother, or rather a mother, of creativity, and by experience I mean the combination of observation and feeling that leads to a creative moment. Emily Dickinson did not just notice things in nature (as Dorothy Wordsworth did); she also felt strongly, or deeply, or perceptively, about them—and this is what makes her little poems so powerful and moving. Charlotte Brontë's strong feelings about her life, combined with an acute eye and ear, enabled her to transform experience, in the first half of *Jane Eyre*, so strikingly into art—an act of creation rare, for its passionate beauty, in the annals of literature. Writers, particularly of novels, are never so powerfully creative than when recording, albeit transformed into fiction, their own deeply felt experience. Dickens always felt *David Copperfield* was his best book, for this reason. The same could be said of *The Mill on the Floss*, for Maggie Tulliver is the young Mary Ann Evans, and all she lived and felt. In that wonderful novel, in the stories of *Scenes from Clerical Life*, in *Adam Bede*, and to some extent in *Middlemarch*, George Eliot is writing of things and people she knew from her own direct observation and feelings. Later, though more experienced as a writer, she was less convincing. For *Daniel Deronda*, her novel about the Jewish problem; and for *Romola*, set

in Renaissance Florence, she did much careful reading, intelligently digested. But these stories do not come to life in the same way. For the novelist, books cannot make up for the absence of direct knowledge and feeling. Flaubert wrote *Madame Bovary* from the heart, his later stories from books, and the difference shows. *Bouvard et Pécuchet* sprang from an entire library—stillborn. When I see a certain woman novelist I know, sitting behind an entrenchment of books in the reading room of the London Library, and scribbling industriously away at her next piece of fiction, I say to myself: "Oh, dear!"

Evelyn Waugh was very conscious of the creative capital based on the direct experience of deeply felt things in the childhood, youth, and early manhood with which a novelist begins his career, and the ease with which this precious capital can be spent—thrown away, as it were—in one profligate work. He said that it should be carefully conserved, doled out frugally. Alas, he added, by the time a novelist was old, and wise enough to realize this, his capital was gone. "Spent," as he put it, with a rueful expression on his fierce face. The only way it could be replenished was by undergoing fresh experience of a peculiarly taxing and intense kind. That is why he welcomed World War II, which came in his mid-thirties when his initial capital was well-nigh exhausted. He made good use of it, too: first as the framework for his rococo display of virtuoso romanticism, *Brideshead Revisited*; then as the substance of his three-volume masterpiece, *Sword of Honour*. It was the same for Waugh's contemporary Anthony Powell, in writing the twelve-volume roman-fleuve, *A Dance to the Music of Time*. It is true that this long work covered his entire life, from schooldays to middle age. But the war, when his life was richest and most exciting, and when he met people and experienced events quite out of his normal milieu and its habitual activities, provided the three best books of the dozen, and without them the entire work would have failed. Students of the creative process, especially in fiction, can learn a lot by comparing Waugh's and Powell's absorption and regurgitation of their respective military careers—the first intense, vivid, tragic, and noble; the second discursive, contemplative, and philosophical; both rich in the ironies that warfare inspires in artists. Without the war, both would have been far less creative or, to put it more accurately,

would have created far less. The same is true of a significant num-
ber of male novelists. Stendhal had published a good deal by the
end of the 1820s, by which time he was in his mid-forties. Had his
work ceased at that point there would be no reason whatever to
read it or remember him. But in 1830 he published *Le Rouge et le
Noir*, and nine years later *La Chartreuse de Parme*, both arising natu-
rally out of his experiences as a soldier and a military administrator
under Napoleon. It was these events, and no others, essentially,
which made him a major creative artist. The same could be said of
Ernest Hemingway. His experiences in Italy in World War I made it
possible for him to write *A Farewell to Arms*, which established him
as a novelist in the eyes of both himself and the public; and further
wars, in Spain and northwestern Europe, replenished his fictional
capital and kept him going as a creator. For women writers of fic-
tion, the essential capital is supplied by emotion and love affairs,
and children and divorces, and is not so easily replenished, as time
goes by. Jane Austen's novels were all rooted in her emotions, felt
while she was young or comparatively so. Had she lived into her six-
ties, say, instead of dying at forty-one, how and where would she
have found the replenishment for her depleted creative capital?

It is true that creative art or science does not necessarily spring
from, or even have any relation to, the work a creator performs for
a living. It is curious and interesting that both Einstein and the
poet A. E. Housman spent many years in national patent offices,
one in Bern, the other in London, before moving openly into cre-
ative work. And then there was T. S. Eliot's dignified and successful
career as an exchange-rate banker, before he moved into the more
appropriate world of publishing. Much of Stendhal's life was spent
as a consul; so was Nathaniel Hawthorne's; and Evelyn Waugh seri-
ously thought of doing the same in mid-career, and even took ten-
tative steps to securing a position. I have heard writers argue
fiercely that the best background to a productive life of poetry and
fiction is a humdrum, undemanding, regularly paid job which has
absolutely nothing to do with creation.

But other writers would hotly disagree; and, in any case, such
a job is not in practice an option open to many kinds of creators
at the highest level: composers, painters, and scientists, for
instance. They can all teach, to be sure, to make a living; and

many do. But teaching an art is too intimately related to its practice to constitute the contrasting world of the everyday which, the theory runs, stimulates production in the creative world. The truth is, all creators are highly individual and have different views about what helps or hinders their work. Often their views are confused, or are formed so slowly and tentatively—after setbacks and failures—as to come too late materially to influence their careers, when options have closed and energy flags. It is not easy to be a creator at the higher levels, and at the highest it is often agony. All creators agree that it is a painful and often a terrifying experience, to be endured rather than relished, and preferable only to not being a creator at all.

Notes

Chapter 1: The Anatomy of Creative Courage

1. There is surprisingly little about Imhotep in the historical literature. See, for instance, *The Cambridge Ancient History* (new series), i, part 2: *The Early History of the Middle East*, chapter XIV, i. See also my *The Civilisation of Ancient Egypt* (2nd edition, London, 1998), pp. 36-37, 53-54, 120, 133-138; and *Grove's Dictionary of Art*, XV, p. 146, with bibliography.
2. Emily Anderson (ed.), *The Letters of Beethoven*, 3 vols (London, 1961), *passim*.
3. Paul Ferris (ed.), *Dylan Thomas: The Collected Letters* (London, 1985), *passim*.
4. Ibid, p. 79.
5. Rudolph Sabor, *The Real Wagner* (London, 1987), chapter IV.
6. Some of Frau Goldweg's sketches survive, including one of the frilly lace underpants she designed for Wagner.
7. Letter to Louisine Havemeyer, 4 December 1913, quoted in Judith A. Barter (ed.), *Mary Cassatt: Modern Woman* (Chicago, 1998), p. 350.
8. Rene Gimpel, *Diary of an Art Dealer* (trans., New York, 1966), p. 9.
9. Julia Frey, *Toulouse-Lautrec: A Life* (London, 1994), based on family papers and over 1,000 unpublished letters, gives the first full account of Lautrec's medical background, especially pp. 58-9, 70-79, 87-95, 103-8, 202-3.
10. Bradford A. Booth and Ernest Mehew (eds.), *The Letters of Robert Louis Stevenson*, 8 vols. (Yale, 1994).

Chapter 2: Chaucer: The Man in the Fourteenth-Century Street

1. *Statutes of the Realm*, ii, p. 375; key extract in A. R. Myers (ed.), *English Historical Documents iv, 1327–1495* (London, 1969), pp. 483-484.
2. Claire Jones, "The Use of English in Medieval East Anglian Medicine," in Jacek Fisiak and Peter Trudgill, *East Anglian English* (Cambridge, 2001).
3. C. Paul Christianson, "Chancery Standard and the Records of Old London Bridge," in J. B. Trahern (ed.), *Standardizing English* (Knoxville, 1989).
4. T. K. Derry and Trevor I. Williams, *A Short History of Technology* (Oxford, 1979), p. 234.

5. L. D. Benson, "Chaucer: A Select Bibliography," in D. S. Brewer (ed.), *Geoffrey Chaucer* (London, 1974), pp. 352–372; C. F. E. Spurgeon, *Five Hundred Years of Chaucer Criticism and Allusion, 1357–1900*, 3 vols. (Cambridge, 1925).

6. Portraits of Chaucer are found in the Ellesmere mss of his *Works*, the basis of most modern editions, now in the Huntington Library; in the mss of *Troilus and Criseyde* in Corpus Christi College, Cambridge; and in the British Library Harley mss 4866.

7. For Clarence, see Dugdale, *Baronage*, i, p. 396, and T. F. Tout's entry in *Dictionary of National Biography*, standard series, XI, pp. 1214–1217.

8. M. M. Crow and C. C. Olson (eds.), *Chaucer Life Records* (Oxford, 1966).

9. See E. B. Graves (ed.), *Bibliography of English History to 1485* (Oxford, 1975), under "Chaucer," items 6999–7014, especially 7007.

10. D. R. Howard, *Chaucer and the Medieval World* (London, 1987), pp. 388–371; see also Gervase Matthew, *The Court of Richard II* (London, 1968), *passim*.

11. J. M. Marly, *Some New Light on Chaucer* (New York, 1926); see also Marly's edition of *The Canterbury Tales* (New York, 1928).

12. For Chaucer and Italian authors, see H. M. Cummings, *The Indebtedness of Chaucer's Works to the Italian Works of Boccaccio*, U. [University] of Cincinnati Studies, X, p. 1916; M. Praz, "Chaucer and the Great Italian Writers of the Trecento," in *Monthly Criterion*, VI, p. 1927; J. L. Lowes, "Chaucer and Dante," in *Modern Philology*, XIV, p. 1917.

13. See N. R. Havely, *Chaucer's Boccaccio* (London, 1980); A. C. Spearing, *Medieval Dream Poetry* (London, 1976).

14. H. S. Bennett, *Chaucer and the Fifteenth Century* (Oxford, 1948), p. 95; G. F. Cunningham, *The Divine Comedy in English*, 2 vols. (London, 1965–1966), introduction. Dante's name first occurs in English in Chaucer.

15. J. A. W. Bennett, *The Parliament of Fowls* (London, 1957); R. O. Payne, *The Key of Remembrance: A Study of Chaucer's Poetics* (London, 1963).

16. David Crystal, *The Stories of English* (London, 2004), pp. 182–183.

17. Quoted ibid., pp. 176–177.

18. Ibid., p. 177.

19. For a good edition see James Winny (ed.), *The Miller's Prologue and Tale* (Cambridge, 1994).

20. Crystal, 2004, pp. 163–168.

21. For an instructive comment, see John Speirs, "The Pardoner's Prologue and Tale" in B. Ford (ed.), *The Age of Chaucer* (London, 1963), pp. 109ff.

22. For Chaucer's use of words, see the excellent treatment in Bennett, 1957, pp. 81ff.

Chapter 3: Dürer: A Strong Smell of Printer's Ink

1. C. White, *Dürer: The Artist and His Drawings* (London, 1971).

2. F. Piel, *Albrecht Dürer: Aquarelle und Zeichnungen* (Cologne, 1983).

3. W. L. Strass, *The Complete Drawings of Albrecht Dürer*, 6 vols. (New York, 1974; with supplements 1977, 1982).

4. W. M. Conway (trans. and ed.), *The Writings of Albrecht Dürer* (New York, 1958).

5. G. Bott et al. (eds.), *Gothic and Renaissance Art in Nuremberg 1300–1550* (New York, 1986).

6. D. C. McMurtrie, *The Gutenberg Documents* (New York, 1941); E. P. Goldschmidt, *The Printed Books of the Renaissance* (Cambridge, 1950); C. H. Bühler, *The Fifteenth-Century Book* (Philadelphia, 1960).

7. R. Hirsch, *Printing, Selling, and Reading 1450–1550* (Wiesbaden, 1967).

8. R. Lightbown, *Medieval Jewellery in Western Europe* (London, 1991).

9. A. Shestack, *The Complete Engravings of Martin Schongauer* (New York, 1969); *Le Beau Martin: Gravures et Dessins de Martin Schongauer* (Colmar, 1991).

10. *From a Mighty Forest: Prints, Drawings, and Books in the Age of Luther* (Detroit, 1983).

11. A. M. Hind, *An Introduction to a History of Woodcut, with a Detailed Survey of Work Done in the Fifteenth Century*, 2 vols. (London, 1935).

12. W. L. Strauss (ed.), *Albrecht Dürer: Woodcuts and Woodblocks* (New York, 1980).

13. M. Geisberg, *The German Single Leaf Woodcut 1500–1550* (Washington, 1974); C. Dodgson, *Catalogue of Early German and Flemish Woodcuts . . . in the British Museum* (London, 1903), especially pp. 259–347.

14. C. Dodgson, *Albrecht Dürer: Engravings and Etchings* (New York, 1967) and *Albrecht Dürer: Master Printmaker* (Boston, 1971); W. L. Strauss, *Albrecht Dürer: Intaglio Prints, Engravings, Etchings, and Drypoints* (New York, 1975).

15. For Dürer's paintings see F. Anzelevosky, *Albrecht Dürer: Das Malerische Werk*, 2 vols. (Berlin, 1991).

16. See W. L. Strauss (ed.), *The Human Figure by Albrecht Dürer: The Complete Dresden Sketchbook* (New York, 1972).

17. Dürer's work is called *Etliche Underricht, zu Befestigung der Stett, Schosz und Flecken* (Nuremberg, 1527); see J. R. Hale, *Renaissance Fortifications: Art or Engineering* (London, 1977).

Chapter 4: Shakespeare: Glimpses of an Unknown Colossus

1. I am following the attribution in Stanley Wells and Gary Taylor (eds.), *The Oxford Shakespeare: The Complete Works* (compact paperback edition, Oxford, 1994).

2. F. W. Sternfield, "Shakespeare and Music," in K. Muir and S. Schoenbaum, *New Companion to Shakespeare Studies* (Cambridge, 1971), pp. 157ff; *Grove's New Dictionary of Music* (London, 1980), XVII, pp. 214–218.

3. S. Schoenbaum, *William Shakespeare: A Documentary Life* (London, 1975), which prints most of the texts.

4. Printed in Wells and Taylor, 1994, pp. xliii–xlix.

5. W. W. Greg, *The Shakespeare First Folio* (London, 1955); C. Hinman, *The Printing and Proofreading of the First Folio of Shakespeare* (London, 1963). The First Folio was printed in facsimile in 1968.

6. See Park Honan, *Shakespeare: A Life* (Oxford, 1998), chapters 5 and 6, pp. 60–94.

7. Meredith Anne Skura, *Shakespeare the Actor* (Chicago, 1993); for a list of Shakespeare's parts see Honan, 1998, pp. 204–205.

8. Peter Thomson, *Shakespeare's Professional Career* (Cambridge, 1992).

9. For Shakespeare's theater world, see E. K. Chambers, *The Elizabethan Stage*, 4 vols. (Oxford, 1923), especially II, pp. 1–246, for the companies; IV, and pp. 353–578, for the theaters.

10. On staging, see ibid., III, pp. 47–102.

11. See A. Gurr, *The Shakespearean Stage 1574–1642* (Cambridge, 1985); D. Bruster, *Drama and Market in the Age of Shakespeare* (Cambridge, 1992).

12. See G. Wilson Knight, "The Philosophy of Troilus and Cressida," in *The Wheel of Fire: Interpretations of Shakespearean Tragedy* (London, 1961).

13. See, for instance, William Hazlitt, "Characters in Shakespeare's Plays," in Duncan Wu, *Selected Writings of W. Hazlitt*, 9 vols. (London, 1998), I, pp. 85–266.

14. David Crystal, *The Stories of English* (London, 2004), pp. 309–333.

15. H. Neville Davis, "The Phoenix and Turtle: Requiem and Rite," in *Review of English Studies*, XLVI (1995).

16. J. H. Long, *Shakespeare's Use of Music* (Florida, 1977).

17. F. W. Sternfield, *Music in Shakespearean Tragedy* (London, 1967).

18. R. Savage, "The Shakespeare-Purcell 'Fairy Queen,'" *Early Music*, I (1973).

19. Kenneth Muir, *Shakespeare's Sources* (London, 1957); Keith Dockray, *William Shakespeare, the Wars of the Roses, and the Histories* (Stroud, U.K., 2002).

20. Leslie Hotson, *Shakespeare versus Shallow* (London, 1931).

21. See my *Elizabeth I: A Study in Power and Intellect* (London, 1988), pp. 377ff.

22. Sidney Lee, *A Life of William Shakespeare* (London, 1916), pp. 246ff.

23. See G. R. Hibbard (ed.), *Hamlet* (Oxford, 1987).

24. B. Everett, *Young Hamlet: Essays on Shakespeare's Tragedies* (Oxford, 1989).

Chapter 5: J. S. Bach: The Genetics of the Organ Loft

1. Stanley Sadie (ed.), *The New Grove Dictionary of Music and Musicians*, 20 vols. (London, 1995), I, pp. 774–779, with geneological tree; many of these Bachs have separate entries. This should be supplemented by the entry on Bach in H. C. Coller (ed.), *Grove's Dictionary of Music and Musicians*, 5 vols. (London, 1929), I, pp. 148ff, which is livelier and contains additional material.

2. The story about wife swapping is gossip. For the family see P. M. Young, *The Bachs 1500–1800* (London, 1970).

3. F. Walker, "Some Notes on the Scarlattis," *Musical Review*, XII (1951).

4. *New Grove*, 1995, XX, pp. 240–241.

5. R. Hughes (ed.), *A Mozart Pilgrimage: Being the Travel Diaries of Vincent and Mary Novello in the Year 1829* (London, 1975).

6. See the English translation (1978), of B. Schwendowins and W. Dömling (eds.), *J. S. Bach: Zeit, Leben, Werken* (Kassel, Germany, 1976).

7. For a popular account of this episode, see J. R. Gaines, *Evening in the Palace of Reason* (New York, 2004).

8. For a detailed list of works see *New Grove*, 1995, I, pp. 818–836.

9. *Grove*, 1929, III, pp. 765–767.

10. E. H. Geer, *Organ Registration in Theory and Practice* (Glen Rock, New Jersey, 1957); *New Grove*, 1995, XV, pp. 684–689.

Chapter 6: Turner and Hokusai: Apocalypse Now and Then

1. Quoted in Mary Lloyd, "A Memoir of J. M. W. Turner" (1880), in *Turner Studies*, IV, 1, summer 1984.

2. Lives of Turner include A. Wilton (1979), J. Gage (1987), and J. Lindsay (1986).

3. The catalogue raisonné of Turner's oil paintings is published by Yale University Press in 2 volumes (2001).

4. Quoted by Mary Lloyd in *Turner Studies*, IV, 1984.

5. A. J. Finberg, *Life of J. M. W. Turner RA* (Oxford, 1961), p. 198.

6. Ibid., pp. 201–202.

7. John Gage, *Color in Turner* (London, 1969), p. 35.

8. All four, plus three similar views of Lake Como done on the same trip, are reproduced in Lindsay Stainton, *Turner's Venice* (London, 1985), plates 1–5.

9. Gage, 1969, p. 35.

10. Quotations from Finberg, 1961, pp. 198ff.

11. Much of this appears in *Turner Studies*, 1982.

12. Gage, 1969, pp. 56ff.

13. Finberg, 1961, p. 289.

14. R. B. Bennett (ed.), *John Constable's Correspondence*, 6 vols. (Suffolk, UK, 1962–1968), letter to C. R. Leslie, 14 January 1832.

15. William S. Rodner, "Turner and Steamboats on the Seine," *Turner Studies*, VII, 2, winter 1987.

16. Judy Egerton, *The Fighting Temeraire* (London, 1995).

17. John Gage, *Turner: "Rain, Steam and Speed"* (London, 1972); John McCowbrey, "Turner's Railway: Turner and the Great Western," *Turner Studies*, VII, 1, summer 1986.

18. Twain's attack appeared in *A Tramp Abroad*, 2 vols. (New York, 1880), 1, p. 219; see also Jerrold Ziff, "Turner's Slave Ship: What a Red Rag Is to a Bull," *Turner Studies*, III, 2, winter 1984.

19. By, for instance, Jerrold Ziff; see his "J. M. W. Turner's Last Four Paintings," *Turner Studies*, IV, 1, summer 1984.

20. Quotation from *Turner Studies*, I, 1; and IV, 1, summer 1984.

21. See Joyce Townsend, *Turner's Painting Techniques* (London, 1996), chapter 2.

22. Quoted in Finberg, 1961. See also *Turner Studies*.

23. Quoted in Finberg, 1961, p. 169.

24. Ruskin, *Modern Painters*, 1, part II, chapter 7, note 249 (Library Edition).

25. Joyce H. Townsend, "The Changing Appearance of Turner's Paintings," *Turner Studies*, X, 2, winter 1990.

26. Ibid., p. 71.

27. The list of his principal names as an artist is given in *Hokusai*, edited by Matthu Forrer with text by Edmond de Goncourt (New York, 1988), pp. 370–371.

28. See Louis Gouse, *L'Art Japonais*, 2 vols. (Paris, 1883), 1, p. 286.

29. For a detailed chronological table see Forrer, 1988, pp. 384–388.

30. Jack Hillier, *The Art of Hokusai in Book Illustration* (London, 1980), gives an appendix with a chronological list of Hokusai's illustrated books, pp. 263–280.

31. See the chapter on waterfalls in Gian Carlo Calza (ed.), *Hokusai* (London, 2003), in which drawings by Hokusai are accompanied by photos of the actual waterfalls.

32. For the evolution of the *Great Wave*, see the chapter in ibid., pp. 23–32.

33. For pupils, see Forrer, 1988, pp. 372–373.

34. For contents and chronology of the *Manga* see Hillier, 1980, pp. 97–111.

35. J. A. Michener, *The Hokusai Sketchbooks: Selections from the Manga* (Rutland, Vermont, 1958).

36. For Hokusai on crafts, see Hillier, 1980, pp. 181–189.

37. For *Shungi*, see ibid., pp. 158–180; illustrations from *Nami Chiduri* are plates 149–153 .

38. *The Pearl Diver and Two Octopuses* is from the album *Young Pines* (1814), 3 vols., an erotic tale written and illustrated by Hokusai but published anonymously. The original of the famous drawing is in the Gerhard Pulverer Collection.

39. Quoted in Forrer, 1988, p. 32.

40. For these final works see Forrer, 1988, pp. 353ff.

Chapter 7: Jane Austen: Shall We Join the Ladies?

1. See Deirdre le Faye (ed.), *Jane Austen's Letters* (3rd edition, Oxford, 1995).

2. For the wild side of her character in her youth, reflected in her juvenilia, see David Nokes, *Jane Austen* (London, 1997), pp. 115, 126–127, 141.

3. The most recent life is Maria Fairweather, *Madame de Stael* (London, 2005); but see the review by Douglas Johnson, *Spectator*, 20 February 2005.

4. See Griselda Pollock, "Women and Art History," in *Grove's Dictionary of Art*, XXXIII, pp. 307-316, with an excellent bibliography.

5. I saw this myself in 1966; the women Royal Academicians were led by Dame Laura Knight.

6. See Marion Kingston Stocking (ed.), *The Clairmont Correspondence*, 2 vols. (Baltimore, 1995).

7. The best book about Jane Austen as a person is George Holbert Tucker, *Jane Austen the Woman* (London, 1994).

8. Of the many biographies of George Sand, the one I prefer, mercifully short, is Donna Dickenson, *George Sand: A Brave Man, the Most Womanly Woman* (London, 1989); for the latest research see the special edition on George Sand of *Magazine Littéraire* (Paris, 2004). There is a recent life by Elizabeth Harlan, *George Sand* (New Haven, Connecticut, 2004).

9. The standard life of George Eliot is Gordon S. Haight, *George Eliot* (Oxford, 1968); two recent lives, both good, are by Frederick Karl (1995) and Rosemary Ashton (1996).

10. For details of Eliot's writings, etc., see John Rignall (ed.), *A Reader's Companion to George Eliot* (Oxford, 2000).

11. Quoted ibid., pp. 412-413.

12. For the influence of *Daniel Deronda* in Europe, see my *History of the Jews* (London, 1987), pp. 378-379.

13. For Eliot and women, see Rignall, *A Reader's Companion to George Eliot*, pp. 466-471.

14. For the background to Austen's novels provided by her circumstances, see Mary Lascelles, *Jane Austen and Her Art* (Oxford, 1939), pp. 1-40. This is the best book on Austen as a novelist.

15. For the juvenilia, etc., see R. W. Chapman, *Minor Works* (Oxford, 1982), vol. IV of his *Works of Jane Austen*. This explains the various manuscripts.

16. Jane Austen's realism has often been challenged: why did she write so little about the great war that dominated so much of her life? I answer this in my annual address to the Jane Austen Society, 1996, "Jane Austen, Coleridge, and Geopolitics," in *Report of the Society* (1997). See also Brian Southam, *Jane Austen and the Navy* (London, 2000).

Chapter 8: A. W. N. Pugin and Viollet-le-Duc: Goths for All Seasons

1. There is no biography of the elder Pugin that I know of, though he figures in *Dictionary of National Biography*; Howard Colvin's *Dictionary of British Architecture*, pp. 667-668, and *Grove's Dictionary of Art*, XXV, pp. 710-711, with bibliography. There is an essay by F. G. Roe, "The Elder Pugin," *Journal of the Old Watercolour Society Club*, XXXI, 1956.

2. If you can get hold of it, the elder Pugin's fine illustrations are found in the book he did with J. Britton, *Illustrations of the Public Buildings of London*, 2 vols. (London, 1825, 1828).

3. For Pugin the man, see M. Trappes-Lomax, *Pugin: A Medieval Victorian* (London, 1932); and P. Stanton, *Pugin* (London, 1971).

4. For early work, see Paul Atterbury and Clive Wainwright, *Pugin: A Gothic Passion* (London, 1994).

5. *Gothic Furniture in the Style of the Fifteenth Century, Designed and Etched by A. W. N. Pugin* (London, 1835).

6. For items at the Victoria and Albert Museum see Atterbury and Wainwright, 1994.

7. See Michael McCarthy, *The Origins of the Gothic Revival* (Yale, 1987).

8. Quoted in Guy Williams, *Augustus Pugin v. Decimus Burton: A Victorian Architectural Duel* (London, 1990), p. 109.

9. A list of Pugin's writings is given in *Grove's Dictionary of Art*, XXV, p. 716.

10. For Pugin's work, see P. Waterhouse, "The Life and Work of Welby Pugin," *Architectural Review*, 1897–1898 (six parts).

11. See M. H. Port (ed.), *The Houses of Parliament* (London, 1976); see also *The History of the King's Works*, vol. 6 (London, 1973). E. W. Pugin, A. W. N. Pugin's son, wrote a pamphlet on the subject, published in 1867, to which A. Barry replied in 1868.

12. For Pugin's craftsmen see Alexander Wedgwood, *A. W. N. Pugin and the Pugin Family* (London, 1985).

13. Quoted ibid.

14. Quoted in Atterbury and Wainwright, 1994.

15. Kenneth Clark, *The Gothic Revival* (London, 1928), p. 95.

16. Quoted in Atterbury and Wainwright, 1994.

17. The best biography of Morris is Fiona MacCarthy, *William Morris* (London, 1994).

18. For an overview of Morris see L. Parry (ed.), *William Morris* (exhibition catalog, Victoria and Albert Museum, London, 1996).

19. Jean-Paul Midant, *Viollet-le-Duc and the French Gothic Revival* (Paris, 2002).

20. For Viollet-le-Duc's own houses see his *Habitations Modernes*, 2 vols. (Paris, 1877); there is a drawing in Midant, 2002, p. 161, of the villa at Lausanne.

21. For Carcassone and Pierrefonds, and Viollet-le-Duc's work there, see Midant, 2002, pp. 96ff, 110ff. See also *Grove's Dictionary of Art*, V, pp. 726–728, with diagrams and bibliography of Carcassone.

Chapter 9: Victor Hugo: The Genius Without a Brain

1. *The Distance, the Shadows*, a translation by Harry Guest of sixty-six important poems (London, 1981), is the fairest attempt to bring Hugo's poetry to an English-speaking audience.

2. The first complete edition is called *Édition d'Imprimerie Nationale*, 45 vols. (Paris 1904–1952); a better one is *Édition Chronologique*, 18 vols., Jean Massin (Club Français de Livre 1967–1971); a third, eds. Jacques Seebacher and Guy Rosa, was published by Laffont in 15 vols. of what it called its "Bonquins" (1985–1990). H. Guillemin edited three volumes of *Oeuvres Poétiques* for Pleiade (1964–1974). The so-called 45 vols. of the complete works contain 4 vols. of correspondence, and there are various other selections. See bibliography in Graham Robb, *Victor Hugo* (London, 1997), pp. 634–637.

3. Robb, 1997. There is no good French life—André Maurois, *Olympio* (1954), is the best. Herbert Juin, *Victor Hugo*, 3 vols. (Paris, 1980–1986), is the longest. Joanna Richardson, *Victor Hugo* (London, 1976), is also useful.

4. For an annotated list see Stanley Sadie (ed.), *New Grove Dictionary of Music* (London, 1980), VIII, pp. 769–770.

5. Honoré de Balzac, *Lettres à Madame Hauska*, 2 vols. (Paris, 1990), II, p.8.

6. See his poem "Ce qui se passient aux Feuillantines," from *Les Rayons et les Ombres, Oeuvres poetiques* (Pleiade edition, Paris), i, p. 1064.

7. *La Civilisation, Oeuvres complètes*, XII, p. 608.

8. *Les Misérables*, II, p. 362.

9. A. Lambert, *Le Siège de Paris* (Paris, 1965), p. 336.

10. Philip Mansel, *Paris between Empires, 1814–1852* (London, 2001), p. 294.

11. See Robb, 1997, p. 247. Robb gives a full account of the affair, pp. 241–272.

12. Verlaine, *Oeuvres en Prose Complètes* (Paris, 1972), p. 107.

13. This story may be *bien trouvé* rather than exact. When I lived in Paris, there were still people who had known acquaintances of Hugo and his family, and such stories abounded. I have forgotten the name of my informant, but he had held a high post in the administration of the former royal palaces of France. See Henri Guillemin, *Hugo et la Sexualité* (Paris, 1954), p. 134.

14. For the funeral, see Robb, 1997, pp. 527ff.

15. For Tennyson, see Robb, 1997, p. 515; for Thackeray, see Gordon N. Ray, *Letters and Private Papers of W. M. Thackeray*, 4 vols. (Oxford, 1945), I, p. 228; II, pp. 44, 139–154.

16. *Pilgrim Edition of the Letters of Charles Dickens*, 12 vols. (Oxford, 1965–2002), X, p. 155; V, p. 15; VI, pp. 334–335.

Chapter 10: Mark Twain: How to Tell a Joke

1. I have used for convenience the *Oxford Mark Twain*, ed. Shelley Fisher Fishkin, 27 vols. (1996), facsimile of the original editions. This is cheap, with (on the whole) excellent introductions by a variety of writers, and the original types and layouts give a flavor of the period. There is also, however,

a scholarly edition, *The Works of Mark Twain*, in process of publication for the Iowa Center for Textual Studies, by the University of California Press. This includes much previously uncollected work.

2. Twain is best presented, as a phenomenon, by his *Speeches*, originally collected with an introduction by William Dean Howells, reprinted in the *Oxford Mark Twain* (1996), with an introduction by the actor Hal Holbrook. Holbrook toured the United States in a one-man show as Twain and made a study of Twain's appearance and mannerisms.

3. J. H. and R. Hagood, *Hannibal: Mark Twain's Town* (Marcelline, Missouri, 1987). See also M. M. Brashear, *Mark Twain, Son of Missouri* (New York, 1964).

4. See Randall Knoper, *Acting Naturally: Mark Twain in the Culture of Performance* (Berkeley, 1995).

5. E. M. Branch, *The Literary Apprenticeship of Mark Twain* (Urbana, Illinois, 1950).

6. *The Celebrated Jumping Frog of Calaveras County and Other Sketches* forms a volume in the *Oxford Mark Twain* (1996), with an introduction by Roy Blount, Jr.

7. Twain's own voice was variously described as a "nasal twang," or "a little buzz inside a corpse." He was variously said to have a "Missouri drawl" or a "Down East" accent. See Paul Fatout, *Mark Twain on the Lecture Circuit* (Carbondale, Illinois, 1960).

8. There are many biographies of Twain. The one I like best is Andrew Hoffman, *Inventing Mark Twain* (London, 1997), which has a good chapter on Twain lecturing, pp. 162–167.

9. Fred W. Lorch, *The Trouble Begins at Eight: Mark Twain's Lecture Tours* (Ames, Iowa, 1960).

10. David R. Sewell, *Mark Twain's Languages: Discourse, Dialogue, and Linguistic Variety* (Berkeley, 1981).

11. It is important to note that *Pudd'nhead Wilson*, though dotted with one-liners and with each chapter headed by an aphorism, is in essence a story about the race problem.

12. The best edition of the book I know is *Mark Twain: Adventures of Huckleberry Finn: The Only Comprehensive Edition* (Mark Twain Foundation, U.S.A.; London, 1996), with an introduction by Justin Kaplan and textual addenda by Victor Doyno. This also includes a facsimile of the original mss., an eye-opener.

Chapter 11: Tiffany: Through a Glass Darkly

1. For an outstanding account of how glass is made, see Keith Cummings, *A History of Glassforming* (London, 2002).

2. Susan Frank, *Glass and Archaeology* (London, 1982).

3. For terms see H. Newman, *An Illustrated Dictionary of Glass* (London, 1977).

4. H. Tait (ed.), *5000 Years of Glass* (London, 1991).
5. D. Klein, *Glass: A Contemporary Art* (London, 1989); see also D. Klein and W. Lloyd, *The History of Glass* (London, 1984).
6. M. Wiggington, *Glass in Architecture* (London, 1990).
7. For the original firm of Tiffany, see J. Loring, *Tiffany's 150 Years* (New York, 1987).
8. For Tiffany silverware see W. P. Hood et al., *Tiffany Silver Flatware* (London, 1999).
9. See B. MacLean Ward and G. W. R. Ward, *Silver in American Life* (Yale, 1979–1982).
10. For the influence of Inness, see Adrienne Baxter Bell, *George Inness and the Visionary Landscape* (New York, 2003).
11. For Tiffany's firm see "Dictionary of Firms and Artists" in the exhibition catalog *In Pursuit of Beauty: Americans and the Aesthetic Movement* (Metropolitan Museum, New York, 1986).
12. Robert Koch, *Louis C. Tiffany: Rebel in Glass* (New York, 1964).
13. For Tiffany's stained-glass work, see Vivienne Couldrey, *The Art of Louis Comfort Tiffany* (London, 1989).
14. Sarah Brown, *Stained Glass: An Illustrated History* (London, 1994).
15. Catherine Brisac, *A Thousand Years of Stained Glass*, trans. (New Jersey, 1984).
16. For illustrations of outstanding Tiffany glassware, see Paul Greenhalgh (ed.), *Art Nouveau 1890–1914*, exhibition catalog (Victoria and Albert Museum, London, 2000); Tod M. Volpe and Beth Cathus, *Treasures of the American Arts and Crafts Movement 1890–1920* (London, 1988); Couldrey, 1989; and R. Koch, *Louis C. Tiffany: Glass, Bronzes, Lamps—A Complete Collector's Guide* (New York, 1971).
17. For the manufacture of favrile, see M. Amaya, *Tiffany Glass* (New York, 1967).
18. See H. McKean, *The Lost Treasures of Louis Comfort Tiffany* (New York, 1980).
19. For the house in Oyster Bay, see H. McKean, *Laurelton Hall: Tiffany's Art Nouveau Mansion* (Winter Park, Florida, 1977).
20. For the Tiffany revival, see A. Duncan, *Louis Comfort Tiffany* (New York, 1992).

Chapter 12: T. S. Eliot: The Last Poet to Wear Spats

1. Lyndall Gordon, *Eliot's Early Years* (Oxford, 1977).
2. Peter Ackroyd, *T. S. Eliot* (London, 1984), pp. 30–54.
3. See Gordon, 1977.
4. Bertrand Russell, *Autobiography* (London, 1968), vol. 2. Letter to Lady Ottoline Morrell, 27 March 1914.
5. Ackroyd, 1984, p. 54. Valerie Eliot (ed.), *The Letters of T. S. Eliot*, vol. 1, *1898–1922* (London, 1988), gives precious glimpses.

6. Richard Aldington, *Ezra Pound and T. S. Eliot* (Hurst, Berkshire, 1954).
7. For Pound, see Noel Stock, *The Life of Ezra Pound* (London, 1970); and D. D. Paige (ed.), *Letters of Ezra Pound* (London, 1951).
8. For *The Waste Land*, see Valerie Eliot (ed.), *The Waste Land: A Facsimile and Transcript of the Original Drafts* (London, 1971).
9. Cyril Connolly, *The Modern Movement*, 2 vols. (London, 2002), II, pp. 227ff.
10. Helen Gardner, *The Composition of the Four Quartets* (London, 1978).
11. Keith Alldritt, *Eliot's Four Quartets: Poetry as Chamber Music* (London, 1978).

Chapter 13: Balenciaga and Dior: The Aesthetics of a Buttonhole

1. D. de Marly, *The History of Haute Couture 1850–1950* (London, 1986).
2. D. de Marly, *Worth: Father of Haute Couture* (London, 1990).
3. R. Lynam (ed.), *Paris Fashion: The Great Designers and Their Creations* (London, 1972).
4. See the fine volume *Balenciaga*, by Marie-Andrée Jouve, text by Jacqueline Demorne (trans., London, 1989).
5. Edmonde Charles-Roux, *Le Temps Chanel* (Paris, 2004).
6. Colin McDowell, *Forties Fashion and the New Look* (London, 1997).
7. For Dior's early life, see his autobiography, *Dior on Dior* (trans., London, 1957).
8. Marie-France Pochna, *Christian Dior* (Paris, 2004).

Chapter 14: Picasso and Walt Disney: Room for Nature in a Modern World?

1. J. Palau i Fabre, *Picasso en Cataluna* (Barcelona, 1966).
2. For Picasso's works see C. Zervos, *Pablo Picasso*, 33 vols. (Paris, 1932–1978).
3. F. Fontbona, *Casas* (Barcelona, 1979).
4. For Casas's portrait drawings, see *Ramon Casas: Retrats al Carbo*, exhibition catalog, ed. C. Mendoza (Palacio Virreira, Barcelona, 1982).
5. For Picasso's portrait drawings, see John Richardson, *A Life of Picasso*, Vol. 1, *1881–1906* (London, 1991), pp. 146–147, where fourteen are illustrated; some drawings by Casas are shown on pp. 144–145.
6. For the Barcelona art world and its competitiveness, see *Homage to Barcelona: The City and its Art, 1888–1936*, exhibiton catalog (Arts Council, London, 1986), especially pp. 149ff.
7. R. A. Kibbey, *Picasso: A Comprehensive Bibliography* (London, 1977); there is a good bibliographical section at the end of Melissa McQuillan's article on Picasso in *Grove's Dictionary of Art* (London, 1996), 24, pp. 728–730.
8. London, 1988.
9. See M. Richet, *Musée Picasso: Catalogue Sommaire des Collections* (Paris, 1987);

Museu Picasso, *Catalog de Pintura i Dibiux* (Barcelona, 1984); J. L. Sicart, *Museu Picasso, Catalogo* (Barcelona, 1971).

10. For the blue period, see Richardson, I, 1991, pp. 211 307.

11. Ibid., pp. 334 349.

12. *Les Demoiselles d'Avignon*, 2 vols. (Musée Picasso, Paris, 1988).

13. See the excellent article on cubism by Christopher Green, *Grove's Dictionary of Art*, vol. 8, pp. 239-247; *Picasso and Braque: Pioneering Cubism* (Museum of Modern Art, New York, 1989).

14. C. Poggi, *In Defiance of Painting: Cubism, Futurism, and the Invention of Collage* (New Haven, Connecticut, 1992).

15. F. Opler (ed.), *Picasso Guernica* (New York, 1988); H. Chipp, *Picasso's Guernica: History, Transformation, Meanings* (London, 1989).

16. For this period, see, in general, Richardson, *A Life of Picasso*, Vol. 2, *1907–1917* (London, 1996).

17. For Picasso's early patrons, see A. S. Huffington, *Picasso: Creator and Destroyer* (London, 1988), pp. 74-131.

18. Huffington, 1988, pp. 83 (Stein), 98 (Braque).

19. For Picasso and Matisse, see *Matisse Picasso*, exhibition catalog (Tate Gallery, London, 2002).

20. Huffington, 1988, pp. 127, 134, 172, 190.

21. See F. Gilot and C. Lake, *Life with Picasso* (London, 1965).

22. Huffington, 1988, pp. 64, 194, 203.

23. Ibid., pp. 233-234.

24. Ibid., pp. 251, 424.

25. F. Thomas and O. Johnston, *Disney Animation: The Illusion of Life* (New York, 1981).

26. Michael Barrier, *Hollywood Cartoons. American Animation in Its Golden Age* (Oxford, 2003), pp. 35-48.

27. Diane Disney Miller, *Walt Disney: An Intimate Biography by His Daughter* (London, 1958), pp. 53-74.

28. Ibid., pp. 75ff.

29. Barrier, 2003, pp. 38ff.

30. Christopher Finch, *The Art of Walt Disney* (New York, 1999), pp. 20ff.

31. Barrier, 2003, pp. 63ff.

32. For Disney and sound, see Miller, 1958, pp. 93ff.

33. For *Steamboat Willie*, see Barrier, 2003, pp. 51-57.

34. Finch, 1999, pp. 28-31.

35. For still from *Flowers and Trees*, see ibid., p. 29.

36. Barrier, 2003, pp. 124-129, 193-233.

37. B. Thomas, *The Art of Animation: The Story of the Disney Studio Contribution to a New Art* (New York, 1966).

38. D. Atwell, *Cathedrals of the Movies* (London, 1980); D. Sharp, *The Picture Palace* (London, 1969).

39. Finch, 1999, p. 108.
40. R. B. Beard, *Walt Disney's EPCOT: Creating the New World of Tomorrow* (New York, 1982).
41. For an account of Disney's involvement with the unions, the FBI, and politics, see Marc Eliot, *Walt Disney: Hollywood's Dark Prince* (London, 1994).
42. P. Andreu, *Vie et Mort de Max Jacob* (Paris, 1982).
43. For an illuminating but uncritical account of Picasso's communism, see Gertje R. Utley, *Picasso: The Communist Years* (Yale, 2001); see also a review of it by James Lord, *Times Literary Supplement*, 30 March 2001; see also J. S. Boggs, "Picasso and Communism," *Artscanada* (1980).

Chapter 15: Metaphors in a Laboratory

1. For Coleridge and Davy, see Richard Holmes, *Coleridge: Early Visions* (London, 1989), pp. 245, 259, 303.
2. Wordsworth to Sir John Stoddart, 1831, quoted in Anne Treneer, *The Mercurial Chemist: A Life of Sir Humphry Davy* (London, 1963), p. 214.
3. For Telford, see Alastair Penfold (ed.), *Thomas Telford, Engineer* (London, 1980).
4. For Edison, see Robert Silverberg, *Light for the World: Edison and the Power Industry* (New York, 1967).
5. See Jeffrey V. Osowki, "Ensembles of Metaphor in the Psychology of William James," in D. B. Wallace and H. E. Gruber (eds.), *Creative People at Work* (New York, 1989).

Index

acting career, Shakespeare's, 51
Adventures of Huckleberry Finn, The
 (Twain), 178, 183–85
alcohol
 Chaucer and, 23
 T. S. Eliot and, 216–17
Alice in Cartoonland (Disney), 259–60
alliterations, Chaucer's, 32–33
American literature, Twain and,
 170–71
animation. *See* Disney, Walt
Archimedes, 276
architecture
 Imhotep's, 4–5
 movie houses, 268–69
 Pugin's (*see* Pugin, A. W. N.)
 Telford's, 278–79
 Viollet-le-Duc's, 150–52
art. *See* Dürer, Albrecht; Hokusai Kat-
 sushika; Picasso, Pablo; Turner,
 Joseph Mallord William
art nouveau, 186–87, 193, 198, 269
Art of Fugue, The (Bach), 89–90
arts and crafts movement, 148–50,
 269
Austen, Jane, 114–35
 Madame de Staël and, 115
 George Eliot and, 120–25
 family of, 114–15, 125–29
 productivity and methods of, 114,
 129–35, 285
 George Sand and, 119–20

women creators, families, and,
 114–19
awards, 5–11, 224. *See also* fame;
 financial status
Ayer, A. J. ("Freddie"), 6

Bach, Johann Sebastian, 77–93
 career of, 81–83
 Christian religion of, 83–84
 creativity of, 91–93
 death of, 85–86, 93
 family of, 77–81
 financial status of, 7, 93
 keyboard music of, 89–91
 orchestral music of, 91
 organs and, 86–89
 productivity of, 82–86
Balenciaga, Cristóbal, 225–46
 Dior and, 233–39, 244
 fame and decline of, 244–46
 family and early life of, 229–31
 fashion design as vocation of,
 239–41
 fashion design history and,
 225–29
 first Paris business of, 231–33
 principles of, 241–44
banking career, T. S. Eliot's, 215–16,
 285
bawdry, Chaucer's, 30–31. *See also*
 humor
begging letters, 7–11

book illustrations. *See also* literature
 Dürer's, 40–41
 Hokusai's, 109
 Pugin's, 139
 Viollet-le-Duc's, 150–51
Book of the Duchess, The (Chaucer),
 22–23
Brandenburg Concertos (Bach), 91
Briggs, Joseph, 201–2
Brontë sisters, 124, 283

Canterbury Tales, The (Chaucer),
 18–19, 23–34
Caravaggio, Michelangelo, 12
careers
 Bach's, 81–82
 Chaucer's, 19–22
 creativity and, 285–86
 T. S. Eliot's, 215–16, 285
 Shakespeare's, 51
 Twain's, 171–72
cartoons. *See* Disney, Walt
Casas i Carbo, Ramon, 249–50
Cassatt, Mary, 13–14, 116
cathedrals, Pugin's, 141–42, 147
"Celebrated Jumping Frog of Cala-
 veras County, The" (Twain),
 173–75
censorship, Hokusai and, 108–9
chamber music, Bach's, 85, 91
characters
 Chaucer's, 26–27
 Disney's, 262–65
 Hokusai's, 111–12
 Shakespeare's, 54–55
Chaucer, Geoffrey, 17–34
 The Canterbury Tales of, 24–34
 early poetry of, 22–24
 English literature and, 17–19
 family and career of, 19–22
Christianity. *See also* God
 Bach and, 83–84
 Pugin and, 139
churches, Pugin's, 141–42, 147

civil engineering, Telford's, 278–79
classical architecture, Pugin and,
 139–41
Clemens, Samuel Langhorne. *See*
 Twain, Mark
clothing
 fashion design (*see* Balenciaga,
 Cristóbal; Dior, Christian)
 Pugin's, 144–45
 Twain's, 177
 Wagner's, 9–10
coinage, word. *See* English language
collective creativity
 Disney's, 266–67
 Dürer and German, 37
 Edison's, 279–80
 Pugin's, 143
 Tiffany's, 192–94
color
 Disney and, 265–66
 Tiffany's colored window glass,
 194–95
 Turner and, 99–102, 103–4
comedy. *See* humor
commercial success. *See* financial sta-
 tus
communism, Picasso and, 273–75
concertos, Bach's, 91
counterpoint, Shakespeare's, 60–65
courage, creativity and, 12–16
craftmanship. *See* Pugin, A. W. N.;
 Morris, William; Viollet-le-Duc,
 Eugène)
creativity. *See also* productivity
 animation (*see* Disney, Walt)
 architecture (*see* Pugin, A. W. N.;
 Viollet-le-Duc, Eugène)
 art (*see* Dürer, Albrecht; Hokusai
 Katsushika; Picasso, Pablo; Turn-
 er, Joseph Mallord William)
 author's, and this book about, 1–2
 collective (*see* collective creativity)
 courage and, 12–16
 difficulty of, 11–12

fashion design (*see* Balenciaga, Cristóbal; Dior, Christian)
financial status and, 5–11 (*see also* financial status)
glassware (*see* Tiffany, Louis Comfort)
God and, 1–2 (*see also* God)
heredity, families, and (*see* families)
humor and, 2–3 (*see also* humor)
Imhotep and history of, 4–5
literature (*see* Austen, Jane; Chaucer, Geoffrey; Eliot, T. S.; Hugo, Victor; Shakespeare, William; Twain, Mark)
music (*see* Bach, Johann Sebastian)
science, metaphors, and, 276–86
women, families, and, 114–19 (*see also* women)
creator facilitators, 192. *See also* collective creativity
cubism, Picasso's, 251–52

da Vinci, Leonardo, 276–77
Davy, Sir Humphry, 106, 277–78
deaths
Austen, 135
Bach, 85–86, 93
Balenciaga, 245–46
Dior, 244
Disney, 270–71
Dürer, 48
T. S. Eliot, 224
Pugin, 147–48
Tiffany, 201
Demoiselles d'Avignon, Les (Picasso), 251–52
demotic vs. hieratic language, 25–31
de Staël, Madame (Germaine Necker), 115, 119
dialects
Chaucer's, 30
Shakespeare's, 30
Twain's, 177–80

dialogue
Austen's, 130
Chaucer's, 34
T. S. Eliot's, 216
Dickens, Charles, 9, 12, 13, 122–25, 136, 156, 167–69, 209, 283
Dickinson, Emily, 16, 283
difficulty, creativity and, 11–16
Dior, Christian, 233–44
Balenciaga and, 236–44 (*see also* Balenciaga, Cristóbal)
career of, 234–35
death of, 244
family of, 233–34
direct experience, 132–33, 283–85
Disney, Walt, 247–48, 258–75
first animations of, 260–62
methods of, 9, 258–59
Mickey Mouse character, sound effects, and color animation of, 262–68
movie houses and, 268–69
nature and, 269–71
Picasso vs., 247–48, 258, 272–75
theme parks of, 271–72
drawings
Balenciaga's and Dior's, 237
Dürer's, 35–36
Hokusai's, 108–13
Pugin's, 137–38
Turner's, 96–98, 106
Viollet-le-Duc's, 150–51
dressmaking. *See* Balenciaga, Cristóbal; Dior, Christian
Dupin, Aurore (George Sand), 119–20, 124
Dürer, Albrecht, 35–48
death and legacy of, 48
drawings and watercolors of, 35
engraving technique of, 41–42
fame and financial status of, 42–43, 46–47
individualism of, 36–37
instructional writings of, 44–45

Dürer, Albrecht (*cont.*)
 productivity of, 35–36, 47–48
 travels of, 42–44
 woodcuts, 38–41

economics. *See* financial status
Edison, Thomas, 279–80
Einstein, Albert, 280–81, 285
Eliot, George (Mary Ann Evans),
 120–25, 283–84
Eliot, T. S., 203–24
 alcohol and, 216–17
 banking career of, 215–16, 285
 fame and awards of, 220–21, 224
 family and early life of, 203–8
 Four Quartets of, 222–24
 intellectuality of, 208
 marriages of, 213–15, 224
 poetry of, 210–11
 Ezra Pound and, 211–13, 217–19
 sexuality of, 207–8
 travels and education of, 206–7,
 208–10
 The Waste Land of, 217–21
Emma (Austen), 134–35
English language
 Chaucer and, 17–19, 23–33
 lewd vs. learned language, 25–31
 Shakespeare and, 54–56, 76
 Twain and 181–82, 185
engravings, Dürer's, 38, 41–42
EPCOT (Experimental Prototype
 Communities of Tomorrow),
 271
erotica, Hokusai's and Turner's, 112
essays, Hugo's, 155
etchings, Dürer's, 41–42
Evans, Mary Ann (George Eliot),
 120–25, 283–84
evil, Picasso and, 256–57
experience, 132–33, 283–85

Falstaff character, Shakespeare's,
 59–67

fame
 Bach's, 83
 Dürer's, 43–44, 46–48
 George Eliot's, 123–24
 Hugo's, 155–56
 Picasso's, 250–51
 Tiffany's, 198–202
 Turner's, 95, 102–3
families
 Austen's, 114–15, 125–29
 Bach's, 77–81, 82
 Balenciaga's, 229–31
 Chaucer's, 19–20
 de Staël's, 119
 Dior's, 233–34
 Disney's, 258
 Dürer's, 38–39, 42
 George Eliot's, 120–21
 T. S. Eliot's, 203–4
 Hokusai's, 107
 Hugo's, 157–58
 Picasso's, 248–49
 Pugin's, 136–38, 139, 146
 Sand's, 119
 Shakespeare's, 49–50
 Turner's, 94–95
 Wagner's, 10
 women creators and, 114–19
Fantasia (Disney), 269–70
Faraday, Michael, 278, 280
fashion design. *See* Balenciaga,
 Cristóbal; Dior, Christian
favrile glass, Tiffany's, 187, 196–97,
 201
Fawkes family, 96, 101, 104
fear, creativity and, 13
Feast of the Rose Garland, The (Dürer),
 44
Fighting Téméraire, The (Turner), 102
films, Disney's, 267–71
financial status
 Bach's, 93
 creativity, begging letters, and,
 5–11

Dior's, 234
Dürer's, 42, 46–47
Hokusai's, 107, 113
Picasso's, 250–51
Pugin's, 143–44
Turner's, 95, 101
Flowers and Trees (Disney), 265–66
Four Quartets (T. S. Eliot), 222–24
Four Seasons (Tiffany), 195
Frankenstein (Shelley), 117
French culture
 Chaucer and, 17, 22, 32
 Hugo (*see* Hugo, Victor)
fugues, Bach's, 89–90
functionalism, Pugin's, 141
funerals. *See also* deaths
 Dior's, 244
 Hugo's, 166–67
furniture design
 Morris's, 149–50
 Pugin's, 138

genetics. *See* families
German culture
 Dürer and, 36–37, 45
 Bach and, 78
Giordano, Luca, 6, 101
glassmaking methods, 186–90,
 196–98. *See also* Tiffany, Louis
 Comfort
God
 Bach and, 83–84
 Balenciaga and, 239–41
 creativity and, 1–2
 T. S. Eliot and, 204, 211
 Picasso and, 255–56
 Pugin and, 139, 146
Goldberg Variations (Bach), 89
"Golden Arm, The" (Twain), 178–80
goldsmithing
 Dürer and, 37–38
 Pugin and, 138
Gothic architecture. *See* Pugin, A. W.
 N.; Viollet-le-Duc, Eugène

Guernica (Picasso), 252, 256, 273
Gutenberg, Johann, 37

Hals, Franz, 7
Hamlet (Shakespeare), 51, 67–76
harpsichord music, Bach's, 86, 89
haute couture. *See* Balenciaga,
 Cristóbal; Dior, Christian
Haydn, Franz Joseph and Michael, 80
Hemingway, Ernest, 285
Henry IV (Shakespeare), 57, 59–67
heredity. *See* families
Heroes (Johnson), 1
hieratic vs. demotic language, 25–31
Hobbes, Thomas, 23, 277
Hokusai Katsushika, 107–13
House of Fame (Chaucer), 22, 25–26
Houses of Parliament (Pugin), 142
Howerd, Frankie, 3, 6
Hugo, Victor, 153–69
 architecture and, 151
 death and funeral of, 166–67
 Dickens vs., 167–69
 family of, 157–59
 lack of intelligence of, 156–57
 music and, 58
 politics of, 158–63, 165–66
 productivity of, 153–56
 women and sexuality of, 153,
 163–65
humor
 Austen's, 128, 130–32
 Chaucer's, 28–31
 creativity and, 2–3
 Disney's (*see* Disney, Mark)
 T. S. Eliot's, 211
 Shakespeare's, 60–65
 Twain's (*see* Twain, Mark)
hypotheses as metaphors, 280–83

Ibsen, Henrik, 7
illustrations. *See* book illustrations;
 drawings
Imhotep, 4–5, 276

individualism
 creativity and, 247, 286
 Dürer's, 36–37
 Picasso, Disney, and, 247
Innocents Abroad, The (Twain), 175–76
instrumentation
 Bach's, 84
 Shakespeare's, 58–59
intellectuality
 T. S. Eliot's, 208
 Shakespeare's lack of, 53
 Turner's, 99
Intellectuals (Johnson), 1
intelligence, Hugo's lack of, 156–57
inventions, 277–80
Italian culture
 Chaucer and, 22, 32
 Dürer and, 43–44
 Turner and, 96–98
Iwerks, Ubbe, 259–61

James, William, 281–82
Japanese landscape painting, 107. *See
 also* Hokusai Katsushika
Jenkins, Roy, 6–7
jewelry, Tiffany's, 190–91
jokes. *See* humor
Jonson, Ben, 51, 53
jubiliee poems, 23

keyboard music, Bach's, 84–86,
 89–91
Knight, Death, and the Devil (Dürer),
 41
Kolberger, Anton, 38

lamps
 Davy's, 277–78
 Tiffany's, 195–96
landscapes. *See* Hokusai Katsushika;
 Tiffany, Louis Comfort; Turner,
 Joseph Mallord William
language. *See* dialects; dialogue; Eng-
 lish language

Laurelton Hall home, Tiffany's,
 199–201
letters, begging, 7–11
lewd vs. learned language, 25–31
Liber Studiorum (Turner), 96
light, Turner and, 99–100
literature, 1–2. *See also* Austen, Jane;
 Chaucer, Geoffrey; Eliot, T. S.;
 Hugo, Victor; nonfiction; Shake-
 speare, William; Twain, Mark
Lorrain, Claude, 96
luck, creativity and, 235–36
luxury, Wagner and, 9–10

Madonna with the Siskin, The (Dürer),
 44
Manga (Hokusai), 110–12
Mansfield Park (Austen), 126, 128,
 133, 134
Martin, Kingsley, 2
Mass in B Minor (Bach), 83, 91–92
material, Balenciaga's, 242–44
Melancholia (Dürer), 41–42
Merry Wives of Windsor, The (Shake-
 speare), 58, 67
metallurgy, 277. *See also* goldsmithing
metaphors, hypotheses as, 280–83
Mickey Mouse character, Disney's,
 262–65
morality, Picasso's, 253–58, 272–75.
 See also God
Morris, William, 139, 148–50, 191–92
movies, Disney's, 267–71
Mozart, Wolfgang Amadeus, 7, 11,
 80–81
music. *See also* operas
 Bach's (*see* Bach Johann Sebastian)
 Disney and, 259, 263–65
 Mozart's, 7, 11, 80–81
 Shakespeare and, 49, 56–59
 Wagner and, 8–11, 12

naturalism
 Disney's, 247, 269–72, 275

Dürer's, 36–37
 Picasso and, 257, 272, 275
Nazis, Picasso and, 274
Necker, Germaine (Madame de Staël,
 115, 119
Nobel prizes, 6, 224
nonfiction
 author's, 1–2
 Dürer's, 44–45
 Hugo's, 155
 Pugin's, 139–41
 Ruskin's, 148–49
 Viollet-le-Duc's, 151–52
Northanger Abbey (Austen), 131–32
novels
 Austen's (*see* Austen, Jane)
 Hugo's, 154
 Twain's (*see* Twain, Mark)

one-liners, Twain's, 181–83
operas. *See also* music
 Hugo's plays as, 155–56
 Shakespeare's plays as, 49, 58–59
 Wagner's, 11
orchestral music, Bach's, 91
organs, Bach and, 85–91
originality, 13. *See also* creativity
output. *See* productivity

painting. *See* Hokusai Katsushika;
 Picasso, Pablo; Turner, Joseph
 Mallord William
Paris, fashion design and, 225–29. *See
 also* Balenciaga, Cristóbal; Dior,
 Christian
Parliament of Fowls, The (Chaucer),
 22–23
Peacock Window (Tiffany), 195
performance art, Hokusai's, 109
permanence, Balenciaga and, 241–42
persiflage, Shakespeare's, 62, 65
personal experience, 132–33,
 283–85
Persuasion (Austen), 127, 135

Phoenix and the Turtle, The (Shake-
 speare), 56
physical debility, creativity and, 13,
 14–16, 207, 213–14
pianoforte music, Bach's, 86
Picasso, Pablo, 247–58, 272–75
 Disney vs., 247–48, 272–75
 fame and financial status of, 6,
 250–53
 family of, 248–49
 productivity of, 249–52
 sexuality and morality of, 253–58
plays
 Hugo's, 155
 T. S. Eliot's, 223–24
 Shakespeare's (*see* Shakespeare,
 William)
poetry
 Chaucer's (*see* Chaucer, Geoffrey)
 T. S. Eliot's (*see* Eliot, T. S.)
 Hugo's, 153–54
 Shakespeare's (*see* Shakespeare,
 William)
Pointed Gothic architecture. *See*
 Pugin, A. W. N.; Viollet-le-Duc,
 Eugène
politics
 Disney vs. Picasso and, 272–75
 Hugo's, 158–63, 165–66
 Shakespeare's, 53–54
Potter, Beatrice, 121–22
Pound, Ezra, 211–13, 217–19
Powell, Anthony, 284–85
practicality
 Bach's, 91
 Chaucer's, 23
 Dürer's, 45
 Pugin's, 141, 143–44
 Shakespeare's, 51–53
Pride and Prejudice (Austen), 134
printing. *See also* book illustrations
 Dürer and, 37–38
 Hokusai and, 107–13
Pritchett, V. S., 16, 120

productivity. *See also* creativity
 Austen's, 114, 132–35
 Bach's, 85–86
 Dürer's, 35–36, 47–48
 George Eliot's, 123–24
 Picasso's, 249–53
 Shakespeare's, 49–50
proverbs, Chaucer and, 32–33
Pugin, A. W. N., 136–52
 appearance of, 144–45
 business acumen of, 143–44
 drawings and designs of, 137–39
 family of, 136–37
 Gothic style of, 139–42, 145–48
 influence of, on Ruskin, Viollet-le-
 Duc, and Morris, 148–52
pyramid at Saqqâra (Imhotep), 4–5

realism. *See* naturalism
registration, Bach and organ, 89
Regulus (Turner), 104–5
religion. *See* God
restorations, Viollet-le-Duc's,
 150–52
rewards, 5–11, 224. *See also* fame;
 financial status
Ring, The (Wagner), 9
Roosevelt, Theodore, 198–99
Roughing It (Twain), 183
Royal Academy, 95, 103, 116
running gags, Twain's, 175
Ruskin, John, 19, 102–3, 105, 148–49

safety lamp, Davy's, 277–78
St. Chad's cathedral (Pugin), 141
St. Jerome in His Study (Dürer), 40,
 41–42
St. Matthew Passion (Bach), 83–84,
 92–93
Sand, George (Aurore Dupin),
 119–20, 124
Saqqâra pyramid (Imhotep), 4–5
Scarlatti family, 79
Schongauer, Martin, 38–39

sciences, 276–86
 artist-scientists, 277
 careers and creativity, 285–86
 creativity and, 276–77
 Davy's safety lamp, 277–78
 Edison's inventions, 279–80
 experience and, 283–85
 hypotheses as metaphors,
 280–83
 Telford's constructions, 278–79
seascapes, Hokusai's, 110
secretiveness, Turner's, 98
self-confidence
 Austen's, 129–30
 Chaucer's, 24
Sense and Sensibility (Austen), 131
sexuality. *See also* women
 Austen's, 127
 Balenciaga's, 231
 Hugo's, 153, 163–65
 Picasso's, 253–58
 Tiffany's, 199, 201
 Turner's, 95
Shakespeare, William, 49–76
 dialects of, 30
 English language and, 32, 54–56
 Falstaff character in *Henry IV* by,
 59–67
 family and career of, 50–52
 Hamlet by, 67–76
 music and, 56–59
 practicality of, 51–53
 productivity of, 49
 values of, 53–54
Shelley, Mary, 117
shunga, Hokusai's, 112
Snow White and the Seven Dwarfs (Dis-
 ney), 267–68
sound, Disney and, 259, 263–65. *See
 also* music
Spencer, Herbert, 121
spirituality. *See* God
staffage, Turner's, 106
Steamboat Willie (Disney), 264–65

Stendhal, 285
Stevenson, Robert Louis, 15–16
studios. *See* collective creativity
surrealism, Picasso's, 252
symbolism, T. S. Eliot's, 207
synthetic cubism, Picasso's, 251–52

Taming of the Shrew, The (Shakespeare),
 59
technology
 Bach and organs, 85–91
 creativity and, 247
 Disney and, 262–68
 Turner and, 101–2
Telford, Thomas, 278–79
tempering, Bach's keyboard, 90
Tempest, The (Shakespeare), 57
theaters. *See also* plays
 first electric, by Edison and Tiffany,
 279
 movie houses and Disney, 268–69
 Pugin and, 138
 Shakespeare and, 51–52
theme parks, Disney's, 271–72
theory
 Dürer's, 44–45
 Pugin's, 139–41
 Shakespeare's dislike of, 53
 Viollet-le-Duc's, 151–52
Thirty-Six Views of Mount Fuji (Hoku-
 sai), 110
Thomas, Dylan, 7–8
Tiffany, Louis Comfort, 186–202
 art nouveau and, 186–87, 198
 Joseph Briggs's collection and
 Tiffany revival, 201–2
 colored window glass of, 194–95
 as creator facilitator, 192–94
 Edison and, 279
 fame and decline of, 198–201
 family and jewelry business of,
 190–91
 glassmaking methods, 187–90
 lamps of, 195–96

William Morris and, 191–92
 new glass types of, 196–98
time, T. S. Eliot and, 206, 222
Toulouse-Lautrec, Henri, 14–15
travel
 Bach and, 81
 Chaucer, Ruskin, and, 19, 21
 Dürer and, 42–44
 T. S. Eliot and, 209–10
 Hokusai and, 107–8
 Pugin and, 144–45
 Turner and, 94, 96–98, 99
Tree in the Marsh (Tiffany), 194
Tristan und Isolde (Wagner), 11
Troilus and Cressida (Shakespeare),
 53–54
Troilus and Criseyde (Chaucer), 22, 23,
 28, 30
Turner, Joseph Mallord William,
 94–106
 color usage, 99–102, 103–4
 erotica of, 112
 fame and financial status of,
 95–97, 102–4
 family of, 94–95
 Hokusai Katsushika vs., 107,
 112–13
 productivity of, 97–99, 104–6
 travels of, 99
Twain, Mark, 170–85
 American literature and, 170–71
 careers of, 171–72
 "The Golden Arm" story, 179–82
 humor and skills of, 172–79
 productivity of, 183–85

Ursprung (Bach), 78

verse. *See* poetry
Vindication of the Rights of Women
 (Wollstonecraft), 117
Viollet-le-Duc, Eugène, 150–52
vocal music, Bach's, 84–85, 89
vulgar language, 25–31

Wagner, Richard, 8–11, 12
Waste Land, The (T. S. Eliot), 203,
 217–21
watercolors
 Dürer's, 35, 43
 Pugin's, 137
 Turner's, 95, 96–98, 104
Watsons, The (Austen), 133–34
Waugh, Evelyn, 133, 284–85
Weber family, 80
Well-Tempered Clavier (Bach), 89
white school, Turner's, 100–102
widows, artist, 7
wine, Chaucer and, 23. *See also* alco-
 hol
Wolgemut, Michael, 39–40
Wollstonecraft, Mary, 117
women. *See also* sexuality
 artist widows, 7
 Austen (*see* Austen, Jane)
 Balenciaga and, 241
 creativity and families of, 114–19
 George Eliot (Mary Ann Evans),
 120–25

T. S. Eliot and, 213–15, 224
Hokusai's erotica and, 112
Hugo and, 153, 163–65
humor and, 2–3
Picasso and, 253–58, 262
Pugin and, 137, 146
George Sand (Aurore Dupin),
 119–20, 124
Shakespeare's roles, 53
woodcuts
 Dürer's, 38–41
 Hokusai's, 107–8
Woodward, Robert Burns, 280–81
word coinage. *See* English language
Wordsworth, William and Dorothy,
 116, 283
Worth, Charles Frederick, 226–29
Wren, Sir Christopher, 136, 142, 277
Wright, Frank Lloyd, 136
writing, 1–2. *See also* Austen, Jane;
 Chaucer, Geoffrey; Eliot, T. S.;
 Hugo, Victor; nonfiction;
 Shakespeare, William;
 Twain, Mark